Casey C.M. Mathewson

XXSmall houses

Feierabend

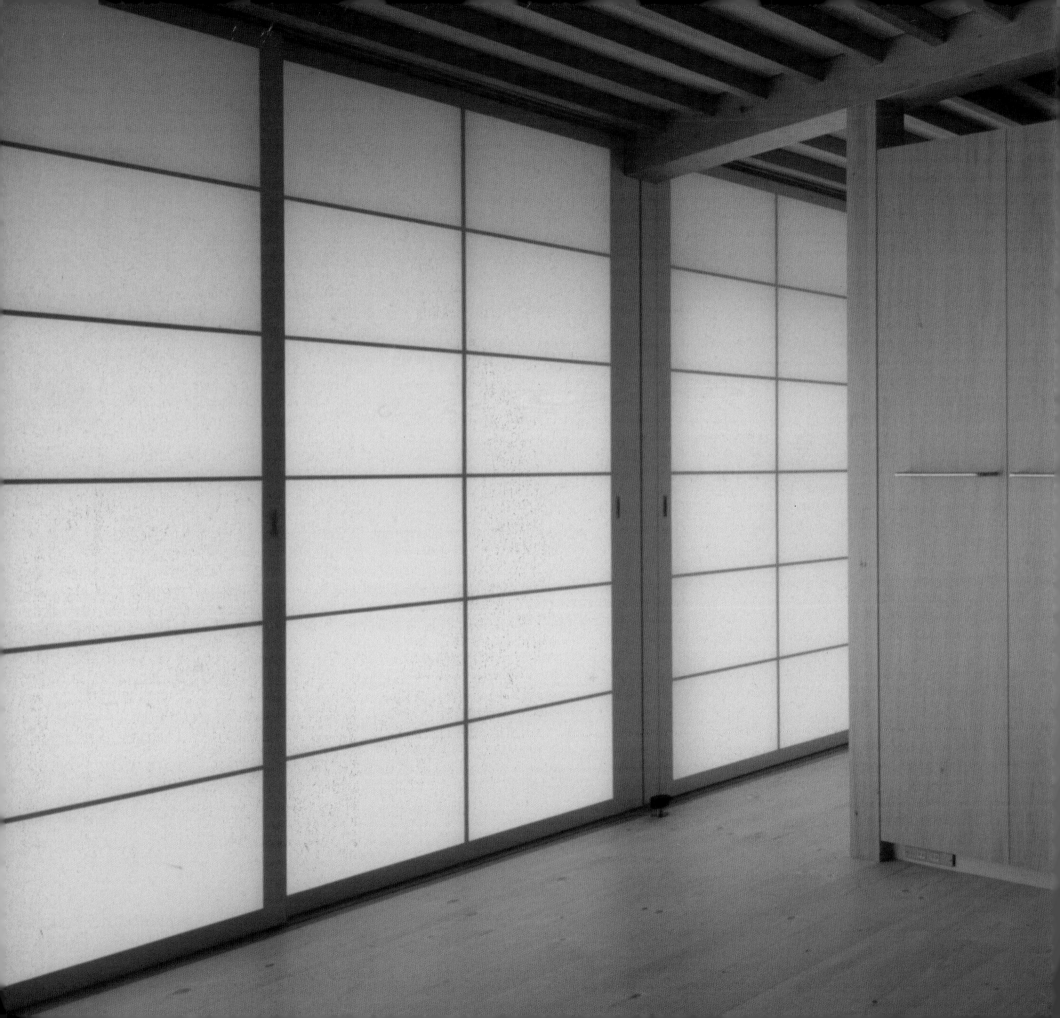

XSmall houses

Contents
Inhalt
Sommaire
Contenido

© 2005 Feierabend Verlag OHG
Mommsenstraße 43, D-10629 Berlin

English and German Text: Casey C.M. Mathewson
Translation into French: Jean-Pierre Dauliac
Proofreading French Text: Christèle Jany
Translation into Spanish: Silvia Gómez de Antonio
Proofreading Spanish Text: Laura Duarte Patiño
Production Management: Stefanie Leifert
Layout, Typesetting & Picture Editing: Casey C.M. Mathewson
Lithography: Studio Leonardo

Idea and Concept: Peter Feierabend, Casey C.M. Mathewson

Printed in the EU

ISBN 3-89985-252-4
40 02091 1

Foreword

This book presents contemporary worldwide solutions to architecture's most elementary task: the creation of the minimal, basic house. And with people everywhere moving into their own homes, this age-old task takes on ever-increasing importance. The trend toward self-ownership has gained momentum with social systems worldwide undergoing major restructuring in recent decades. As such a "place of your own" offers not only the chance to realize individual living ideas. It also serves as a central element in personal investment planning.

One possibility to invest in property is offered by apartments. But such condominiums are subjugated to the collective decision-making process of the varied property owners — a fact that can quickly tarnish the shine on the newly acquired property. This is one of many reasons that explain the strengthening trend toward single-property ownership. The resultant high costs and long-term obligations force most "first-home" owners to pursue inexpensive, minimal house solutions.

To reduce the risks involved, many owners resort to tract homes or prefabricated houses. But when individual wishes are accommodated, these can rapidly become expensive. Ultimately, a house planned by an architect is often a financially viable alternative that also provides clients with houses made to fit their precise specifications.

This book gives insight into the wide range of solutions presently being pursued worldwide. And even though the individual projects offer a surprisingly broad spectrum of possible solutions, one aspect unites them all: their common striving to create places of "being at home" that are much more than basic shelter.

We wish to extend our special thanks to all the architects from Austria, Brazil, Denmark, France, Germany, Japan, the Netherlands, Norway, Switzerland, and the United States, whose innovative works fill this book with life.

Slice House, Porto Alegre, BR
Procter-Rihl Architects, 2004, page 42

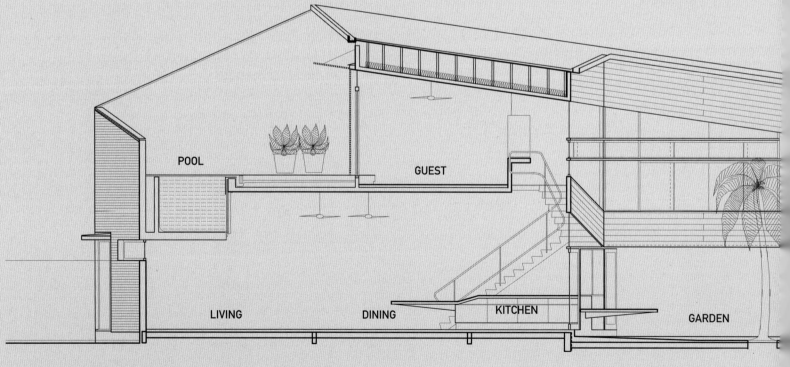

POOL GUEST

LIVING DINING KITCHEN GARDEN

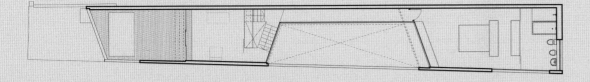

UPPER PLAN

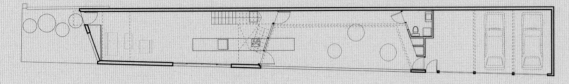

GROUND PLAN

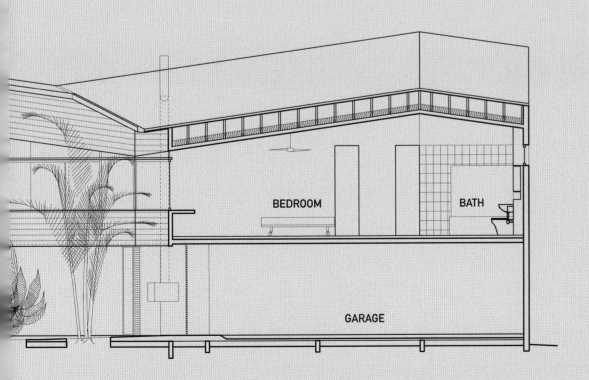

BEDROOM BATH

GARAGE

Vorwort

Dieses Buch stellt aktuelle Lösungen einer elementaren Architektenaufgabe vor: die Kreation einfacher, minimierter Wohnräume. Eine Aufgabe, die weltweit ständig an Brisanz gewinnt. Denn Menschen überall wünschen sich zunehmend ein eigenes Haus. Der Trend weg von der Mietwohnung und hin zum Wohneigentum wird durch die weltweite Umwandlung der Sozialsysteme verstärkt. Denn die „eigenen vier Wände" bieten nicht nur Raum, um individuelle Wohnwelten zu verwirklichen, sie dienen zunehmend auch als zentrale Säule der Altersvorsorge.

Als erste Möglichkeit des Eigentumerwerbs bieten sich Mehrfamilienhäuser an. Doch hierbei ist man der Entscheidungswillkür einer meist zufällig zusammengewürfelten Eigentümergemeinschaft ausgesetzt, was die Freude am Wohneigentum schnell trüben kann. Auch deshalb äußern immer mehr Menschen den Wunsch nach einem eigenen Haus. Da dies aber mit hohen Kosten und langjährigen finanziellen Verpflichtungen verbunden ist, kommen für das „erste Haus" meist nur kostengünstige, minimierte Lösungen in Betracht.

Viele entscheiden sich heute für Fertighäuser, weil sie Bedenken gegen die Unwägbarkeiten eines individuell von einem Architekten geplanten Hauses haben. Doch auch diese werden schnell teuer, sobald individuelle Wünsche berücksichtigt werden.

Dieses Buch zeigt, dass es auch anders geht. Die Bandbreite der möglichen Lösungen überrascht. Doch obwohl sich die einzelnen Projekte in ihrer Gestaltungsvielfalt sehr unterscheiden, vereint ein Aspekt alle hier präsentierten Hausbauten: das gemeinsame Bestreben nach einfachen Formen und Orten des „Behaustseins", die weitaus mehr als nur „ein Dach über dem Kopf" sind.

Unser besonderer Dank gilt den Architekturbüros aus Brasilien, Dänemark, Deutschland, Frankreich, Japan, den Niederlanden, Norwegen, Österreich, der Schweiz und den USA, die mit ihren innovativen Bauwerken dieses Buch tatkräftig mit Leben gefüllt haben.

Préface

Cet ouvrage présente un certain nombre de solutions contemporaines, choisies dans le monde entier, en réponse au problème de base posé à l'architecte : la création d'une habitation minimaliste. Si l'on considère que, sur tous les continents, de plus en plus de personnes accèdent à la propriété, cette très ancienne mission prend chaque jour plus d'importance. Au cours des dernières décennies, les mutations connues par les sociétés partout dans le monde ont accéléré ce processus. Être propriétaire d'un « chez soi » non seulement permet de concrétiser ses propres idées en matière d'habitat, mais encore constitue un élément fondamental de l'épargne-retraite. Qui veut investir dans « la pierre », commence souvent par acheter un appartement. Mais la gestion de ce type de propriété reste soumise aux règles de décision collective observées par les divers copropriétaires, situation susceptible de ternir l'attrait d'un bien nouvellement acquis. C'est une des nombreuses raisons pour lesquelles la maison individuelle a le vent en poupe, les coûts plus élevés et les obligations à long terme qui en résultent amenant beaucoup de candidats à l'indépendance à opter pour leur première maison pour une solution bon marché, voire minimaliste.

Afin de réduire les risques, de nombreux propriétaires s'orientent vers la maison mobile ou préfabriquée. Mais lorsque les desiderata personnels sont pris en compte, ce type d'habitat peut vite devenir très coûteux. Au bout du compte, une maison conçue par un architecte représente souvent une alternative non seulement financièrement viable, mais encore susceptible de répondre aux besoins des clients. Cet ouvrage passe en revue une sélection de réalisations disséminées aux quatre coins du monde. Mais si le spectre des solutions envisageables est étonnamment large, ces projets individuels ont tous pour objectif de créer un « chez soi » qui se révèle être bien plus qu'un simple toit.

Nous adressons aussi nos remerciements à tous les architectes d'Allemagne, d'Autriche, du Brésil, du Danemark, des États-Unis, de France, du Japon, des Pays-Bas, de Norvège et de Suisse dont les idées innovatrices sont la trame vivante de ce livre.

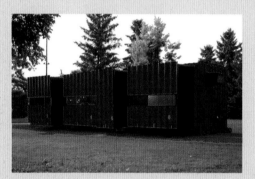

Slice House, Porto Alegre, BR
Procter-Rihl Architects, 2004, page 42

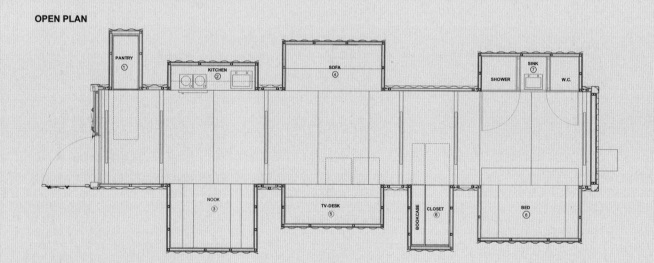

OPEN PLAN

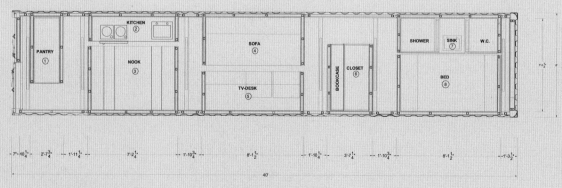

CLOSED PLAN

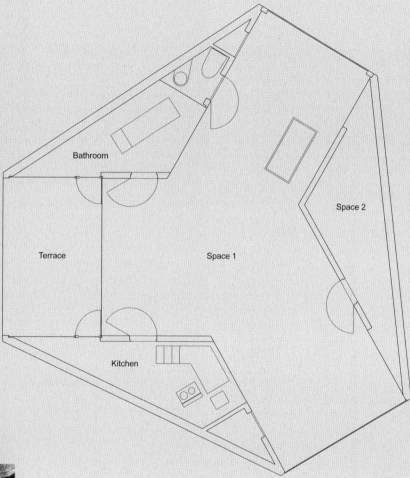

Bathroom

Terrace

Space 2

Space 1

Kitchen

Villa / Gallery, Karuizawa, JP
Office of Makoto Yamaguchi, 2003, page 140

Prólogo

Este libro presenta soluciones modernas para
la tarea más elemental de la arquitectura: la
creación de estancias sencillas y reducidas. Una
tarea cada vez más importante a nivel mundial.
Las personas de hoy en día desean cada vez más
tener una casa propia. Esta tendencia que se
aleja de los pisos alquilados y que lleva cada vez
más a poseer la vivienda, se ve acentuada por la
transformación mundial de los sistemas sociales.
Las cuatro paredes ya no ofrecen exclusivamente
la posibilidad de hacer realidad los mundos
individuales, a menudo se convierten en el pilar
central de la inversión para el futuro.
La primera posibilidad de compra la ofrecen
los edificios plurifamiliares. El problema es que
la composición aleatoria de la comunidad de
propietarios puede empañar rápidamente la
alegría de poseer el piso. Esta es una de las
razones que explica el deseo de muchas personas
de tener una casa propia. Los costes que esto
supone y las obligaciones financieras que se
contraen por muchos años hace que para la
primera casa la mayoría de los interesados se
decante por soluciones económicas y mínimas.
Para reducir el riesgo que esto conlleva o la
indecisión de contratar un arquitecto para
que diseñe el hogar, muchos se inclinan por la
compra de casas prefabricadas. Pero su precio
aumenta rápidamente si se quiere que se tengan
en cuenta los deseos individuales.
Este libro muestra que también es posible
encontrar otras soluciones. La gama de las
posibilidades es sorprendente. A pesar de que
todos los modelos que aquí se presentan difieren
entre sí, siempre hay un aspecto común: el deseo
de formas sencillas y de sentirse "en casa", que
es mucho más que tener simplemente "un techo
sobre la cabeza".
Queremos mostrar nuestro especial
agradecimiento a los despachos de arquitectura
de Alemania, Austria, Brasil, Dinamarca, EE UU,
Francia, Japón, Noruega y Suiza, que con sus
innovativas construcciones han llenado de vida y
de fuerza este libro.

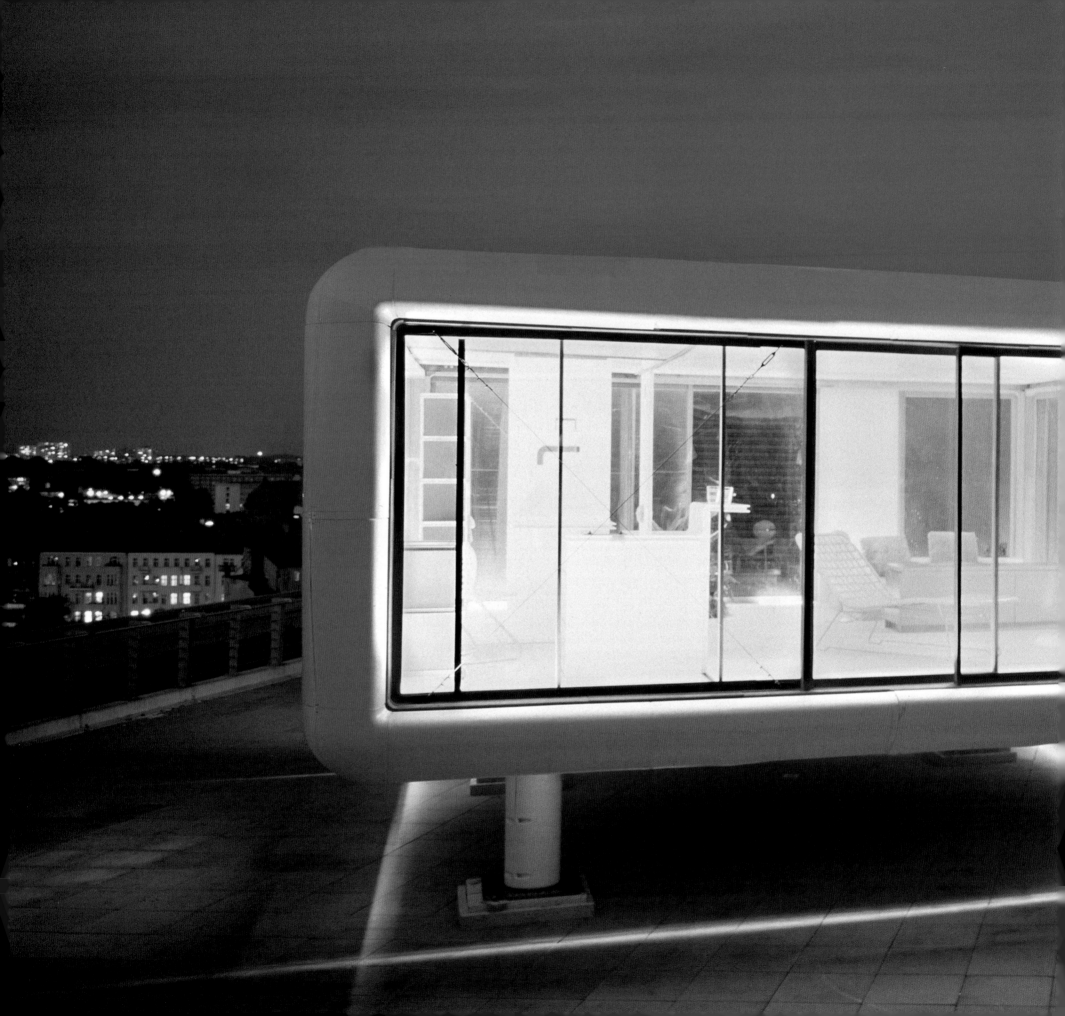

XXS Urban Houses

Stadthäuser | Maisons de ville | Casas urbanas

The Sky above Berlin

Loftcube

Rooftop sites in the large cities are increasingly being discovered as highly inhabitable lots with excellent market potential. The experimental "Loftcube" was developed as a mobile living unit that boasts a sunny location and close proximity to all nearby urban amenities. Flexibility is a major goal pursued both inside and out. The window openings of the wood-framed structure can be filled with an array of materials – glass, acrylic panels or wood slats. Inside, flexibility is attained in the minimal space available. "Function panels" were developed to save space and money – swivel faucets serve both kitchen and bathroom sinks.

Der Himmel über Berlin

Loftcube

Die Dächer der Großstädte werden zunehmend als Lebensraum entdeckt, der optimal genutzt und vermarktet werden kann. Der experimentelle „Loftcube" wurde als mobile Einheit entwickelt, um das Potenzial dieser sonnigen, optimal erschlossenen Wohnlagen auszuschöpfen. Die Fensterfronten des aufgestelzten Holzskelettbaus können flexibel – mit Glas, Acrylglas oder Holz – gestaltet werden. Flexibilität auf kleinstem Raum wird durch „Funktionspaneele" im Inneren erreicht. Sie ermöglichen Einsparungen bei den Rohrleitungen, z. B. mit schwenkbarem Wasserhahn zwischen Spüle in der Küche und Badwaschbecken daneben.

Dans le ciel de Berlin

Loftcube

Le « Loftcube » expérimental est une unité d'habitation mobile bénéficiant d'un bon ensoleillement et située à proximité immédiate de toutes les infrastructures de la ville. La flexibilité a présidé à la conception de l'intérieur comme de l'extérieur de cette structure en bois reposant sur des pieds. Ainsi, à l'extérieur, on joue sur les éléments de remplissage des baies en recourant à différents matériaux. À l'intérieur, la flexibilité a été recherchée dans l'espace minimal disponible. Des « panneaux fonctionnels » permettent de gagner de la place et de réduire les coûts : par exemple, des robinets pivotants alimentent à la fois l'évier et le lavabo.

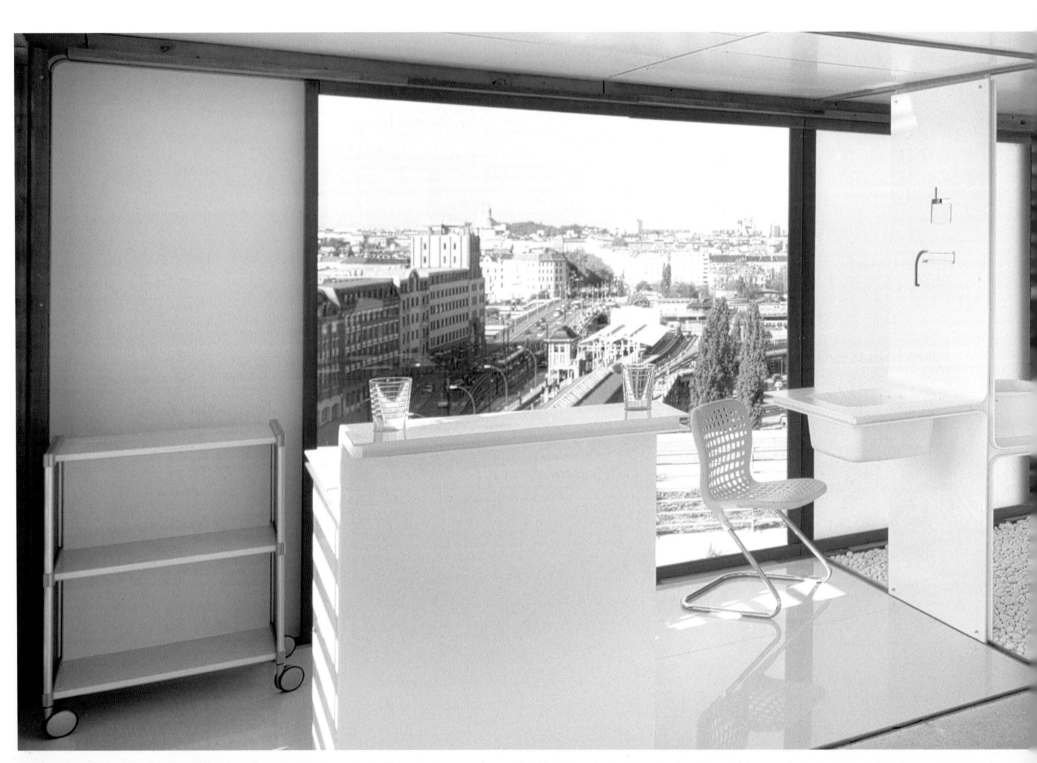

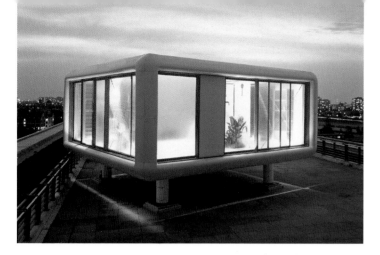

El cielo sobre Berlín

Loftcube

Actualmente los tejados de las grandes ciudades están siendo descubiertos cada vez más como espacios habitables con un excelente potencial de mercado. La construcción experimental "Loftcube" fue desarrollada como una unidad móvil para aprovechar este soleado lugar habitable. Las ventanas de la estructura enmarcada en madera pueden conformarse de forma flexible, con cristal, cristal acrílico o con madera. La flexibilidad en el interior de este espacio mínimo se consigue gracias a los "paneles funcionales", que posibilitan el ahorro en las cañerías, p. ej. con un grifo giratorio entre el fregadero en la cocina y el lavabo del baño situado al lado.

Berlin, Germany, Werner Aisslinger, 2003, 36 m²

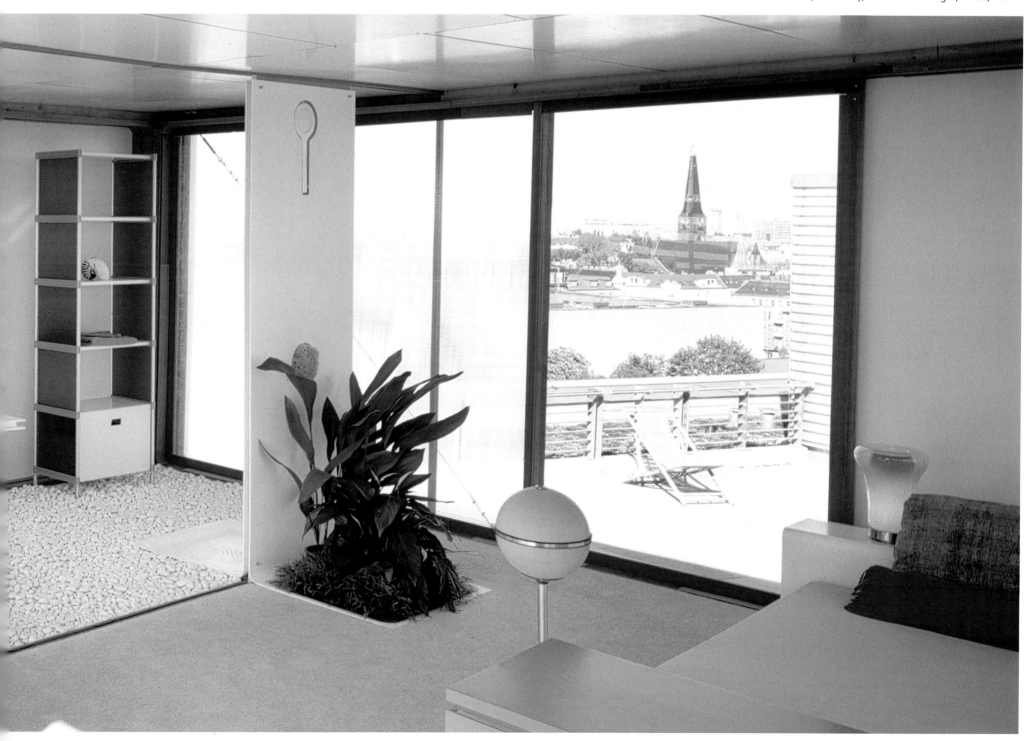

London, Great Britain,
Blencowe & Levine Associates,
2002, 55 m²

A Hidden Strip of Modernity

A Musician's House

Given the astronomical prices on the real estate markets of metropolises such as London, house extensions on minimal space and budget generate especially creative designs. As local authorities allowed building only on a mere 3.9 meter strip, a new urban prototype was created. The existing Victorian townhouse was "hollowed-out".
A new steel frame strengthens the old structure and allows creation of larger openings and transparency toward the garden. The garden facade was imagined as a "large glass" reflecting and projecting over two levels. Sliding glass panels and blinds can be constantly adjusted for light, view, ventilation and privacy.

Ein versteckter Streifen Modernität

Haus eines Musikers

Angesichts der astronomischen Preise für Immobilien in Metropolen wie London können Anbauten auf knappem Raum zu kreativen Lösungen inspirieren. Hier gab die Baubehörde einen nur 3,9 m breiten Streifen zur Bebauung frei – und regte somit die Schaffung eines urbanen Prototyps an. Das alte Haus wird ausgehöhlt und mit einem Stahlrahmen verstärkt, um große Öffnungen und Transparenz zum Garten hin zu ermöglichen. Die Gartenfront wird als „großes Glas" vorgesehen, als eine reflektierende Ebene, die sich über zwei Geschosse erstreckt. Schiebefenster und Markisen ermöglichen es, die Räume je nach Bedarf zu verändern.

Modernisation dans la discrétion

Maison d'un musicien

En raison du prix astronomique des terrains dans des métropoles comme Londres, les extensions de surface habitable doublement limitées par les budgets et les espaces disponibles donnent lieu à des solutions particulièrement innovatrices. Le permis de construire imposant une largeur limitée à 3,90 m. L'ancienne maison de style victorien a été « vidée ». La nouvelle structure en acier qui renforce l'ancienne a permis de percer de plus grandes baies côté jardin. La façade sur le jardin a donc été traitée comme une grande verrière se développant sur une double hauteur. Des panneaux vitrés coulissants permettent de moduler les pièces en fonction des besoins.

Un retazo oculto de modernidad

Casa para un músico

Teniendo en cuenta los astronómicos precios de los pisos en ciudades como Londres, las construcciones en pequeños espacios pueden ser la inspiración de creativas soluciones. Las autoridades solo permitieron construir en una reducida superficie de 3,9 m, estimulando así el nacimiento de un nuevo prototipo urbano. La vieja casa se vació y se reforzó con una estructura de acero para posibilitar la transparencia a través de la apertura de grandes ventanales que dan al jardín. La fachada del jardín se imaginó como un "enorme cristal", un plano reflectante que abarca dos pisos. Las ventanas correderas y las marquesinas permiten transformar los espacios según las necesidades.

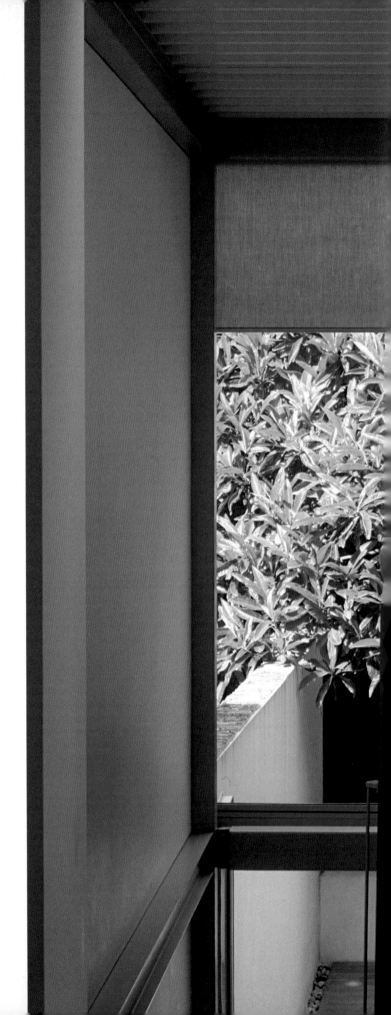

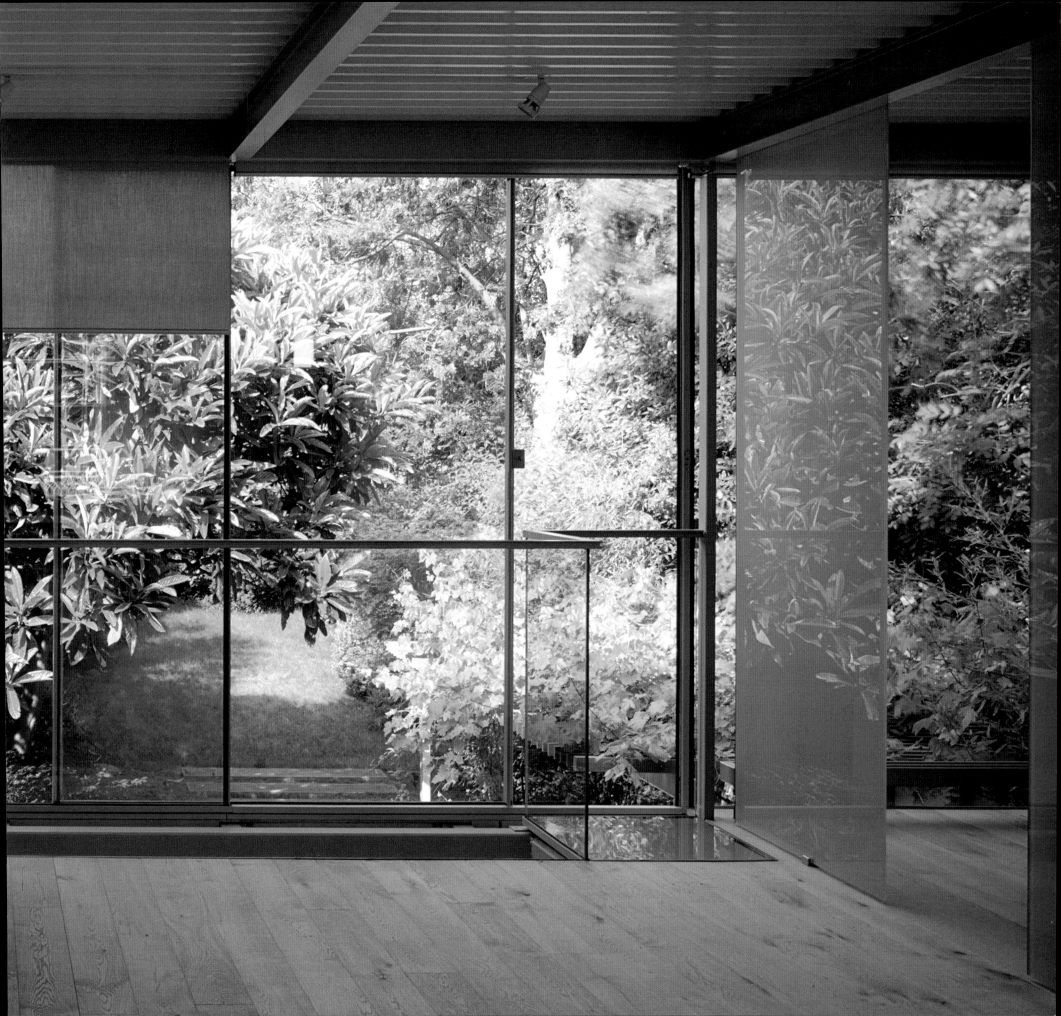

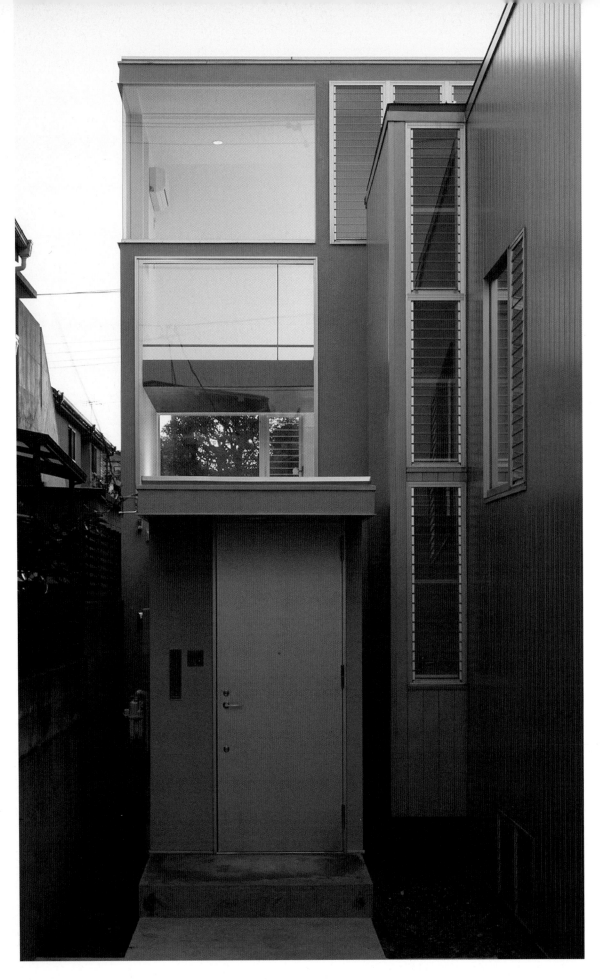

Tight Site
T-Set House
Financing for this house was made possible by dividing the site into two parcels. Two new houses form a T, whereby each house is oriented to its own garden court. The living spaces of this barely 3 meter wide house are distributed over three levels. The 14 m² living room seems much larger. The 1½ story space is extended by a gallery and naturally lit from above. As a response to the limited space available, minimalist aesthetics were employed. The black floors and ceilings form a radical contrast to the radiant white of the walls, another method used to increase the perceived size of the spaces.

Schmales Handtuch
T-Set-Haus
Die Finanzierung dieses Hauses wurde durch Zweiteilung des Grundstücks ermöglicht. T-förmig wurden zwei Häuser angeordnet, jedes auf einen eigenen Gartenhof gerichtet. Die Nutzungen dieses nur 3 Meter breiten Hauses sind auf drei Ebenen verteilt. Das 14 m² große Wohnzimmer wirkt deutlich größer. Der 1½-geschossige Raum wird um eine Galerieebene erweitert und von oben natürlich belichtet. Als Antwort auf den begrenzten Raum wird die Ästhetik zurückgefahren. Die schwarzen Böden und Decken bilden einen radikalen Kontrast zum strahlenden Weiß der Wände, was die Räume ebenfalls größer wirken lässt.

Mouchoir de poche
Maison T-Set
Le lotissement du terrain en deux parcelles a permis de financer cette construction. Les deux habitations nouvelles forment un T, chaque maison donnant sur sa propre cour/jardin. Les espaces de cette maison d'à peine 3 m de largeur sont distribués sur trois niveaux. Le living-room de 14 m² semble plus grand qu'il ne l'est. L'espace du premier étage, agrandi par une galerie, bénéficie d'un éclairage zénithal naturel. En raison de l'exiguïté de l'espace, la décoration est minimaliste. Les sols et plafonds noirs contrastent avec la blancheur éclatante des parois, autre solution qui accroît encore l'impression d'espace.

Mundo pequeño
Casa T-Set
La financiación de esta casa se consiguió con la repartición en dos del terreno. En él se dispusieron dos casas formando una T, levantadas cada una hacia su propio jardín. Los espacios de esta casa de 3 metros de ancho se distribuyen en tres niveles. El salón, de 14 m², parece más grande de lo que realmente es. La habitación de altura y media se amplía con una galería iluminada de forma natural desde arriba. La estética minimalista es la respuesta a este limitado espacio. Los suelos y techos negros contrastan de forma radical con el blanco luminoso de las paredes, otro forma de conseguir que las habitaciones parezcan más grandes de lo que son.

Tokyo, Japan,
Chiba Manabu Architects,
2002, 58 m²

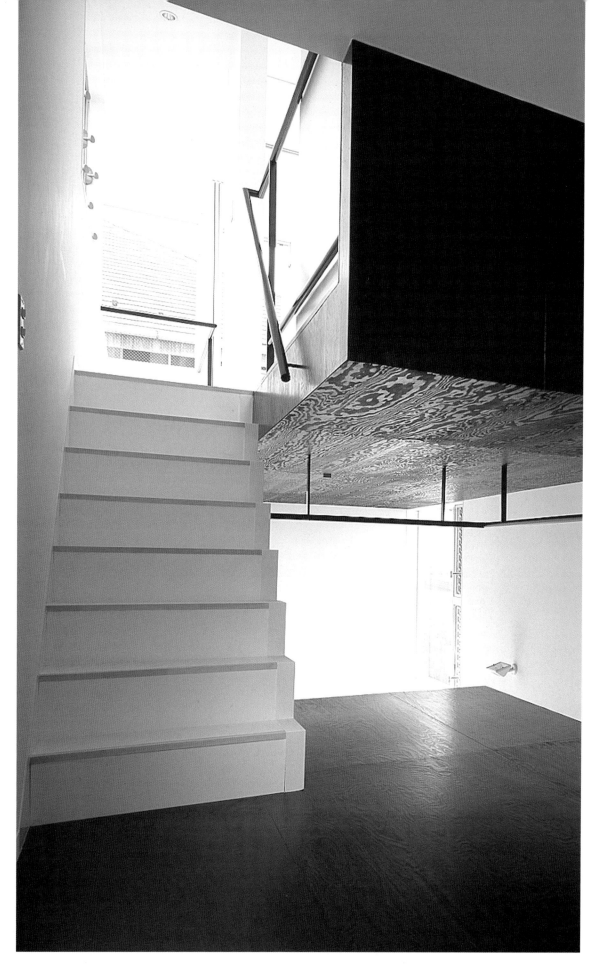

Tokyo, Japan,
Masaki Endoh + Masahiro Ikeda,
2003, 85 m²

The Wedge comes to Town

Natural Wedge House

The wedge form of this house for a young couple on a 60 m² small plot was devised to comply with strict building height regulations and to maximize natural light in the north-facing house. The constraints of the dense urban site were skillfully transcended by using common materials in new ways. Special glass facade panels were developed to assure that the house is full of light and welcoming. They create an opaque surface that at the same time bathes the spaces in natural light. The panels consist of sheets of glass on the exterior and interior with a core of translucent polyester insulation and Gore-Tex® fabric for sun protection.

Der Keil im Quartier

Natural-Wedge-Haus

Die Keilform dieses für ein junges Paar konstruierten Hauses auf 60 m² Baugrund ist eine Reaktion auf die Tokioter Baugesetze, und möchte möglichst viel Licht in das nach Norden gerichtete Haus holen. Durch kreativen Einsatz von gewöhnlichen Materialien werden die Zwänge der urbanen Lage überwunden. Neuartige Fassadenelemente leisten eine gleichmäßige natürliche Beleuchtung. Sie schaffen eine opake Haut, die zugleich lichtdurchlässig ist. Die Paneele bestehen aus innen- und außen liegenden Glasscheiben mit einem Kern aus durchsichtiger Polyester-Wärmedämmung und einer Lage Gore-Tex®-Stoff als Sonnenschutz.

Les recoins de la ville

Maison en coin

La forme en coin de cette habitation sur un terrain de 60 m² a été conçue pour recueillir un maximum de lumière naturelle par la façade nord. Les contraintes dues à la densité d'occupation de ce site urbain ont été habilement contournées grâce à l'emploi innovateur de matériaux courants. Les panneaux de verre spéciaux de la façade ont été étudiés afin que la maison soit aussi bien éclairée qu'accueillante. Ils forment une surface semi-opaque qui, en même temps, inonde les espaces intérieurs de lumière naturelle. Ces panneaux sont constitués de feuilles de verre séparés par un film de polyester translucide isolant et une toile en Gore-Tex® pour protéger du soleil.

La cuña en el barrio

Natural Wedge House

La forma en cuña de esta casa construida para un matrimonio joven sobre un solar de 60 m² es una reacción a las estrictas normativas constructoras de Tokio. Con su orientación norte se quiere conseguir la mayor luz posible. Gracias a la creatividad en el empleo de materiales comunes se superan los límites de la densa situación urbanística. Los novedosos elementos de la fachada permiten una iluminación natural uniforme. Con ellos se crea una piel opaca que, al mismo tiempo, permite la entrada de la luz. Los paneles están compuestos por hojas de cristal exteriores e interiores con un núcleo de aislante térmico de poliéster y una capa de Gore-Tex® como protección solar.

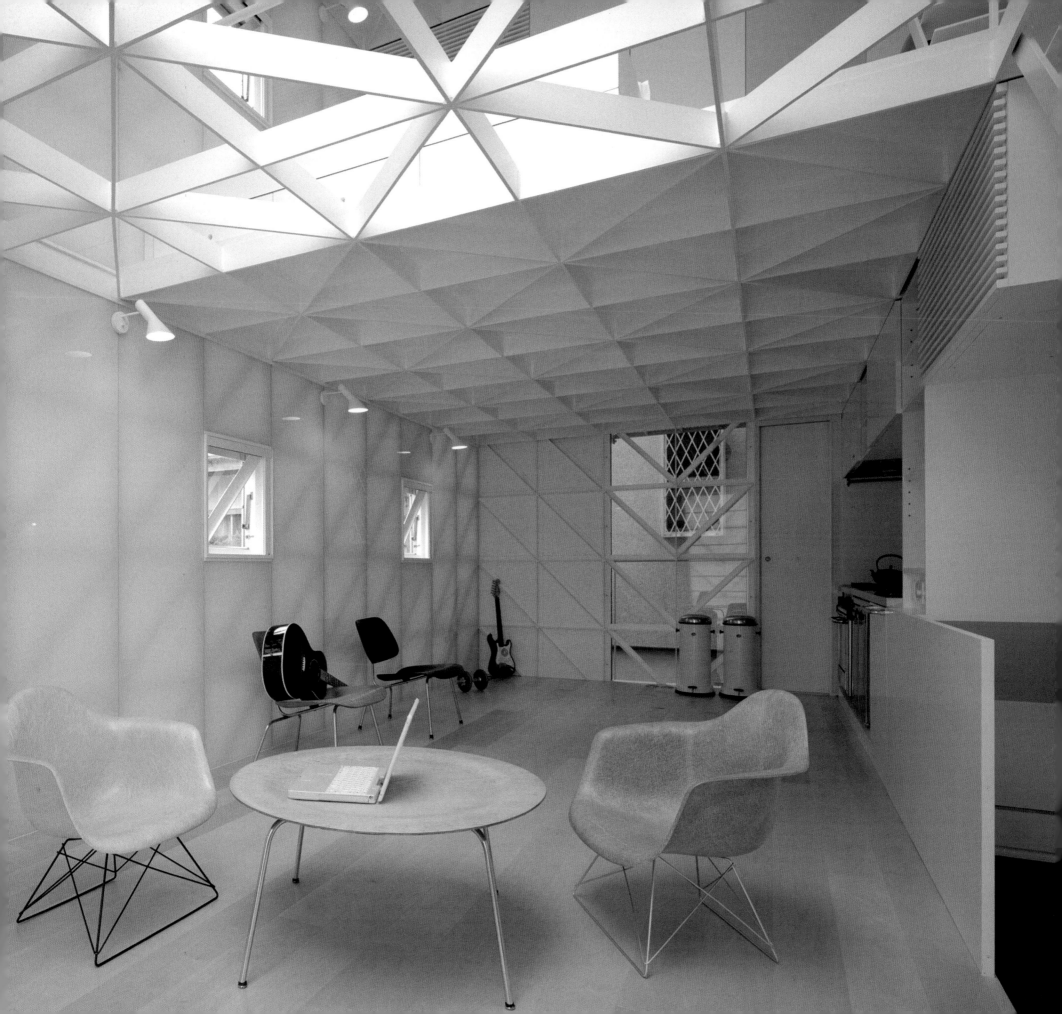

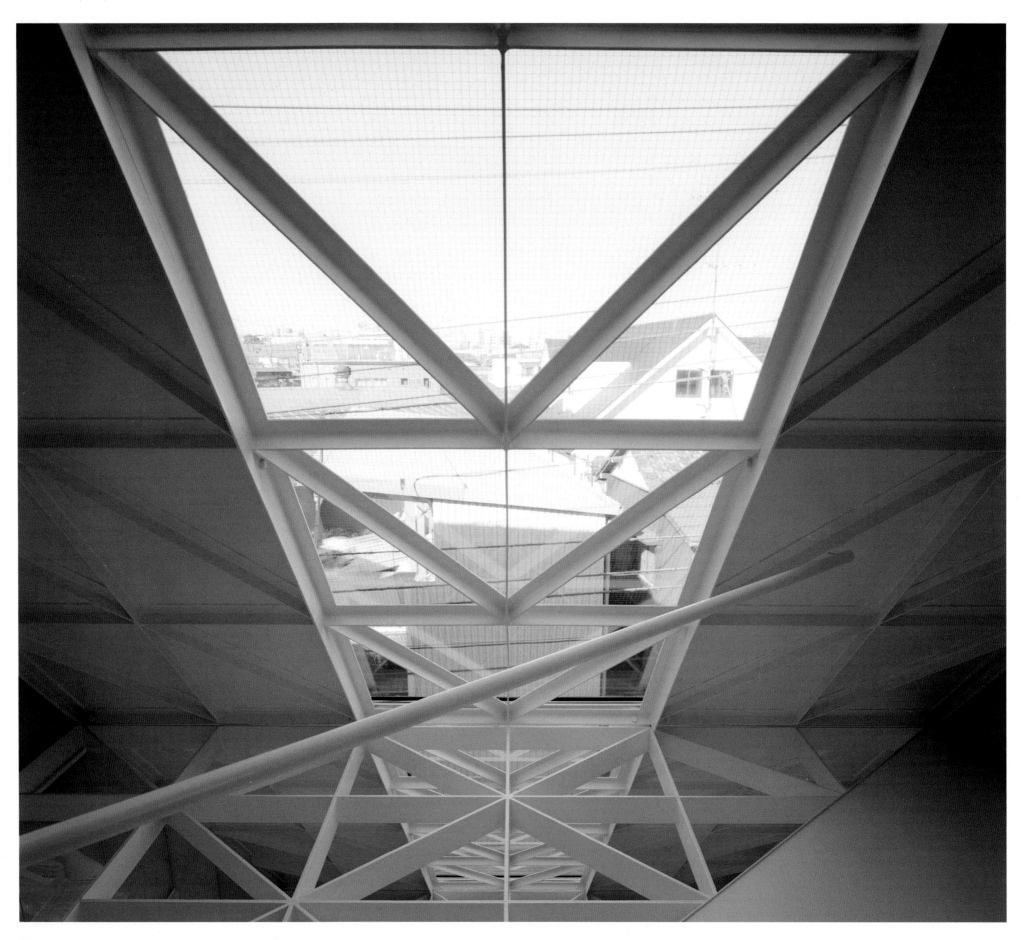

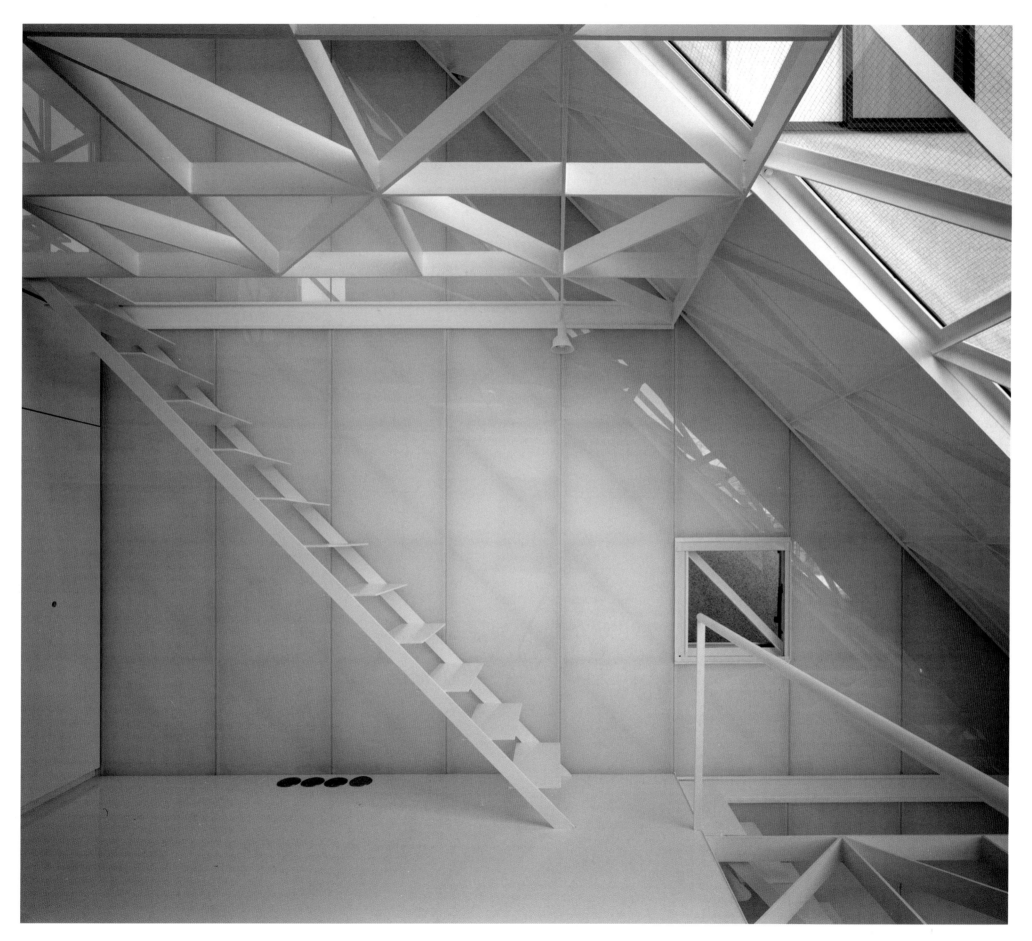

Tokyo, Japan,
Shinichi Ogawa,
2003, 92 m^2

The Light at the End

K-House

A 5 x 18 meter urban slot site bordered on both sides by firewalls was met here with uncompromising formal reduction. To create a revenue-bringing rental space at street level, the living/dining spaces were raised onto the upper level of the three-story house. The residential uses commence on the first floor with the bedrooms and bath. A central fireplace both adjoins and separates the living and dining spaces on the second floor. Courtyards and light wells on all levels, together with floor-to-ceiling glass elements, allow for maximum light inside – in spite of the house's extreme depth.

Das Licht am Ende

K-Haus

Auf eine 5 x 18 Meter große Parzelle, an beiden Längsseiten durch geschlossene Brandwände begrenzt, wird hier mit kompromissloser Reduktion geantwortet. Um eine vermietbare Fläche auf Straßenebene im EG zu schaffen, wird der Wohn-/Essbereich in das 2. OG des dreistöckigen Hauses angehoben. Die Wohnnutzungen fangen im 1. OG mit den Schlafräumen an. Der offene Kamin verbindet die Wohn- bzw. Essbereiche auf der Hauptwohnebene im 2. OG. Innenhöfe und Lichthöfe auf allen Ebenen, gekoppelt mit geschosshohen Verglasungen, führen ein Maximum an Licht in die extreme Tiefe des Hauses.

Tout au fond, la lumière

Maison K

Un petit terrain urbain de 5 x 18 m, limité sur deux côtés par des murs coupe-feu, a été ici le site d'une réduction formelle sans compromis. Pour laisser la place à un espace à louer au rez-de-chaussée, les espaces séjour et repas ont été prévus au dernier niveau de cette construction de trois étages. Les fonctions d'habitation commencent au premier étage avec les chambres et la salle de bain. Une cheminée centrale unit et sépare à la fois les espaces séjour et repas du deuxième étage. Alliés à des baies vitrées intégrales, les cours et les puits de lumière à tous les niveaux font entrer la lumière à flots à l'intérieur, et ce malgré la très grande profondeur du bâtiment.

La luz al final

Casa K

Esta reducción sin compromisos es la respuesta a una parcela de 5 x 18 metros delimitada a ambos lados por tabiques cortafuegos cerrados. Para crear una superficie alquilable al nivel de la calle, la zona del salón comedor se elevó al segundo piso de esta casa de tres alturas. Los espacios residenciales comienzan en el primer piso con los dormitorios y el baño. En el nivel principal, el segundo piso, una chimenea abierta une el salón con el comedor. Los patios interiores y los patios cubiertos presentes en todos los niveles permiten, junto con las ventanas de la misma altura que las plantas, la entrada de la luz hasta el lugar más profundo de la casa.

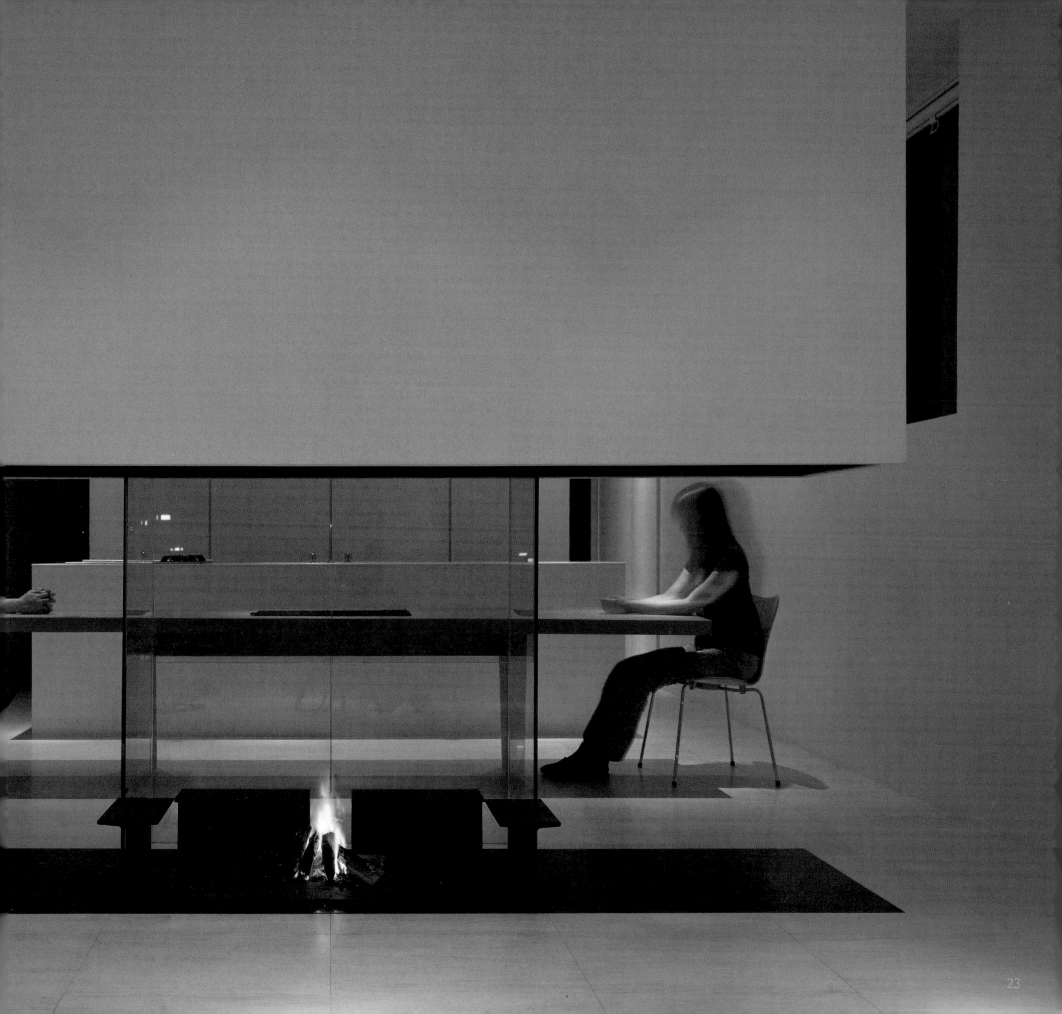

Hiroshima, Japan,
Waro Kishi + K Associates,
2004, 95 m²

Non-Standard Standard

Standard House 2004

This is not a custom-built house, but rather a ready-built house for an imagined client. As the lot is but 5.4 meters wide, a new house typology for narrow sites was developed. Bedrooms and storage are located on the ground floor, the living and dining room and a large sun terrace on the second floor, and a multipurpose Japanese-style room on the third floor. A reinforced wood-frame structure was developed to achieve the gracious 5 meter high living-dining space. The warmth of the wood columns, beams and flooring is contrasted by cooler materials such as translucent acrylic siding and glass.

Nichts mit Standard

Standard-Haus 2004

Das 5,4 m breite Haus wurde nicht für einen spezifischen Bauherrn entworfen. Ausgangsbasis war es, einen neuen Haustyp für besonders schmale Grundstücke zu entwickeln. Schlafzimmer und Abstellraum wurden im Erdgeschoss des Hauses angeordnet. Darüber befindet sich der 5 m hohe Wohn-/Esssaal im 1. OG und ein multifunktionaler Raum im japanischen Stil im 2. OG. Pfosten und Balken aus Holz bilden das ausgesteifte Trageskelett. Zusammen mit dem Parkettboden verleihen sie den Räumen eine Wärme, die durch die kühleren Außenmaterialien wie lichtdurchlässige Acrylpaneele und Glas kontrastiert wird.

Norme hors norme

Maison standard 2004

Pour cette parcelle étroite, de seulement 5,40 m de largeur, il a fallu développer un nouveau type d'habitation. Les chambres et les rangements sont situés au rez-de-chaussée, le séjour et la salle à manger ainsi qu'un grand balcon se trouvent au deuxième niveau, tandis qu'une grande pièce à vivre de style japonais occupe le troisième niveau. Une structure en bois renforcée a été conçue afin de dégager un élégant espace séjour/repas de 5 m de hauteur sous plafond. La chaleur des poteaux, des poutres et des planchers en bois contraste avec les matériaux plus froids tels que les parois translucides en acrylique et en verre.

Nada que ver con lo estándar

Casa Estándar 2004

Esta casa de 5,4 m de ancho no fue construida para ninguna persona en particular. El punto de partida fue desarrollar un nuevo tipo de casa para solares especialmente pequeños. Los dormitorios y el cuarto trastero se han situado en la planta baja de la casa. Encima, en el primer piso de 5 m de altura, se encuentran el salón comedor y una gran terraza y, en el segundo piso, un espacio multifuncional de estilo japonés. Los pilares y las vigas refuerzan el esqueleto de madera y junto con el parquet dan una calidez a los espacios que contrasta con los fríos materiales del exterior, como los translúcidos paneles acrílicos y el cristal

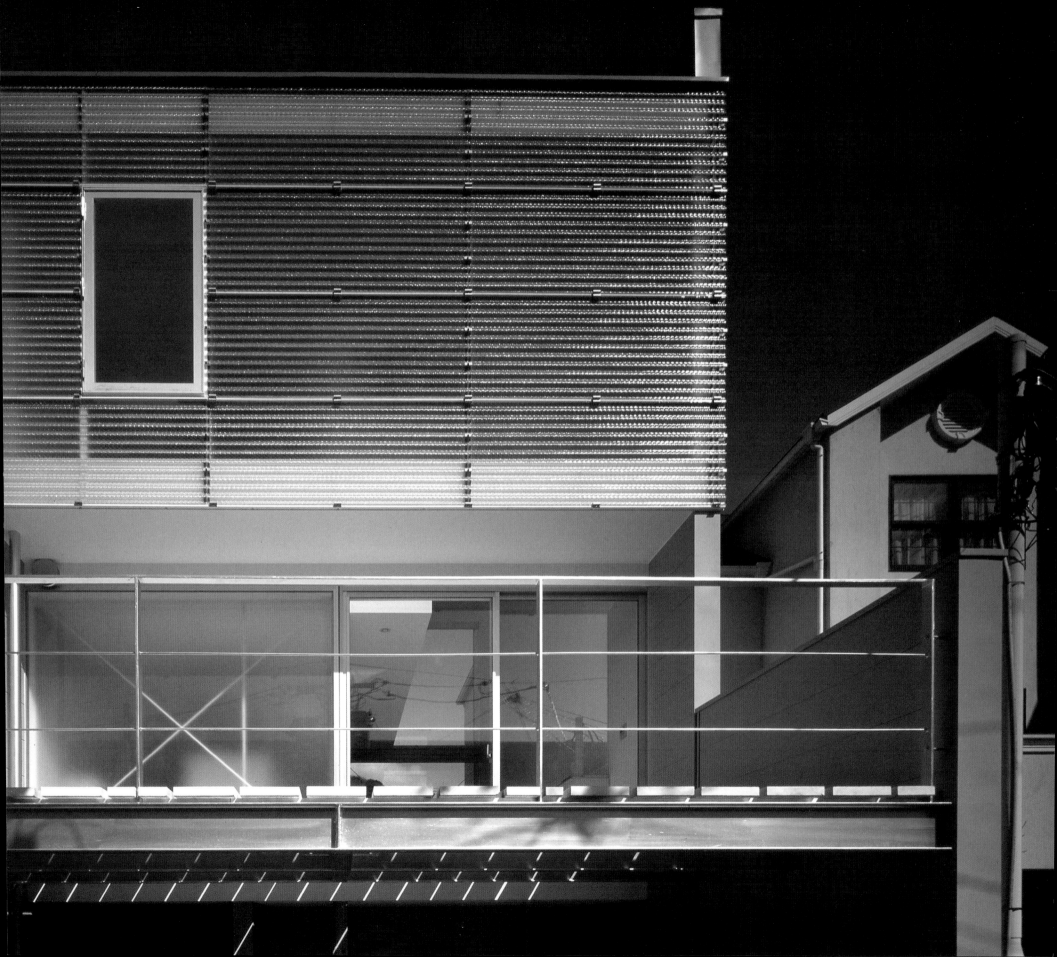

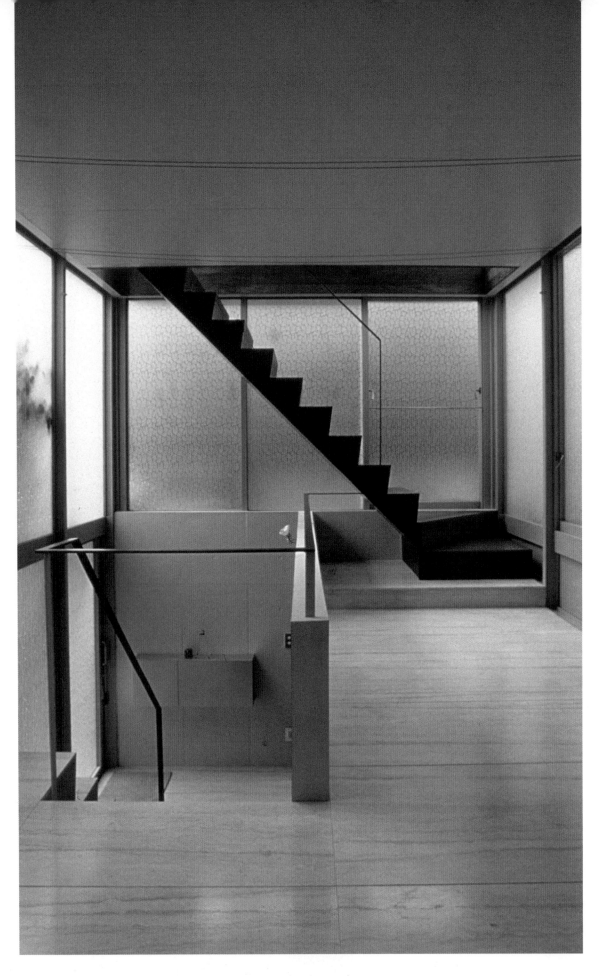

Openness in Density

Tokyo House

The parcel for this house in Tokyo's urban Setagaya district is a mere 4 x 9 m large. The entire site area was built over, leaving no garden spaces. To make up for this, the living room on the third floor is 4 meters high and glazed on three sides. Here, the urbanite inhabitants enjoy a generous sense of openness in the midst of the oftentimes pressing density of the surrounding metropolis. The distribution of uses on three floors creates surprising spatial experiences with alternating rooms of darker and lighter quality. As the house makes do with only 3,8 m width, this is an impressively successfully exercise in reduction.

Offenheit in der Dichte

Tokyo-Haus

Die für dieses Haus zur Verfügung stehende Baufläche in Tokios dicht bebautem Viertel Setagaya beträgt lediglich 4 x 9 m. Das Grundstück wird komplett bebaut. Als Ersatz für die somit fehlenden Gartenflächen wird das helle Wohnzimmer im 2. OG auf drei Seiten verglast und 4 m hoch ausgebildet, um den Großstadtbewohnern hier ein Gefühl von Großzügigkeit inmitten der manchmal drückenden Dichte der Stadt zu geben. Die Verteilung der Nutzungen auf drei Ebenen schafft überraschende Raumsituationen mit abwechselnd hellen und dunkleren Raumzonen. Bei nur 3,8 m Hausbreite eine gelungene Übung in Reduktion.

Une brèche dans la densité

Maison à Tokyo

L'emprise au sol de cette maison du quartier de Setagaya, à Tokyo, qui ne mesure que 4 x 9 m, est totale. Pour compenser l'absence de jardin, le séjour situé au troisième niveau et de 4 m de hauteur sous plafond est vitré sur trois côtés. Là, les citadins peuvent jouir d'une généreuse impression d'espace au cœur de cette métropole d'une densité parfois oppressante. La distribution des pièces sur trois niveaux crée de surprenantes impressions d'espace avec une alternance d'ambiances claires et sombres. Cette réalisation n'excédant pas 3,80 m de largeur est un exercice de réduction spatiale particulièrement réussi.

Transparencia en la densidad

Casa Tokio

La parcela disponible para esta casa en Setagaya, un barrio densamente urbanizado de Tokio, era solamente de 4 x 9 m. El solar ha sido completamente aprovechado para la construcción. En sustitución del jardín se han acristalado tres de las paredes de 4 m de altura del luminoso salón situado en el segundo piso para transmitir a sus habitantes un sentimiento de amplitud en medio de esta densidad, a veces opresora, de la ciudad. La distribución de los espacios en tres niveles crea una increíble disposición de las habitaciones con zonas claras y oscuras. Teniendo en cuenta que la casa tiene sólo 3,8 m de ancho, nos encontramos ante un logrado ejercicio de reducción.

Tokyo, Japan,
Hideki Yoshimatsu + Archipro Architects,
2001, 97 m²

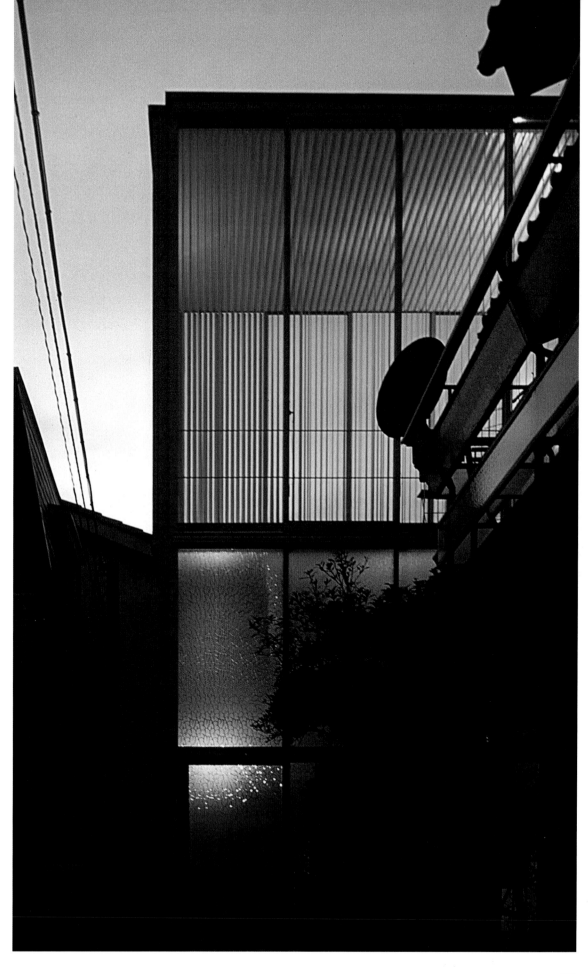

Eichstätt, Germany,
Diezinger & Kramer Architekten,
2000, 100 m²

New replaces Old

Studio House Lang

The new studio-house fills the exact contours of the circa 1500's ruinous townhouse that it replaces on the site. To achieve a welcoming sense of openness in spite of the binding restrictions, the house was designed with two stories — not with three as the preceding house had. This allows the creation of high, light-filled spaces. Windows are "cut out" of the walls to create interesting views from outside to inside and vice versa. At night, the house is "swallowed" by darkness and the glowing windows transmit the inner life of the house to the outside.

Neu statt Alt

Atelierhaus Lang

Wo zuvor ein ruinöses Handwerkerhaus aus dem 16. Jahrhundert stand, errichtete man in den gleichen Konturen ein zeitgemäßes Atelierhaus. Um Großzügigkeit trotz der einengenden Bedingungen zu erreichen, wird der Neubau zweigeschossig — nicht dreigeschossig wie der Vorgängerbau — geplant, was hohe, helle Räume ermöglicht. Fensterausschnitte wurden von innen heraus entwickelt, um interessante Ein- und Ausblicke zu gewähren. In der Nacht wird das Haus regelrecht von der Dunkelheit „verschluckt", und die leuchtenden Fensterflächen bringen das Innenleben nach außen.

Du neuf pour de l'ancien

Maison-studio Lang

Cette maison-studio neuve s'insère exactement dans l'espace occupé autrefois par une maison de ville du XVIᵉ siècle délabrée. Pour donner une agréable impression d'espace malgré d'inévitables contraintes, la maison a été conçue sur deux niveaux au lieu des trois de l'ancienne construction. On bénéficie ainsi d'une plus belle hauteur sous plafond et d'un meilleur éclairage. Les baies sont « découpées » dans les murs afin de créer des vues agréables sur l'extérieur et inversement. La nuit, la maison est noyée dans l'obscurité, mais les fenêtres illuminées révèlent la vie qui anime l'intérieur.

Lo nuevo sustituye lo viejo

Casa Estudio Lang

Donde antes había un ruinoso taller de artesanía del siglo XVI se levanta ahora un taller moderno que ha conservado los antiguos contornos. Para conseguir amplitud a pesar de las limitaciones del espacio se planeó una casa de dos pisos y no de tres, como el edificio anterior, posibilitando la creación de espacios claros y de gran altura. Las aperturas de las ventanas fueron desarrolladas desde el interior hacia el exterior para crear interesantes vistas desde dentro hacia fuera y viceversa. Por la noche la oscuridad "se traga" literalmente la casa y las iluminadas superficies de las ventanas transmiten la vida interior de la casa hacia afuera.

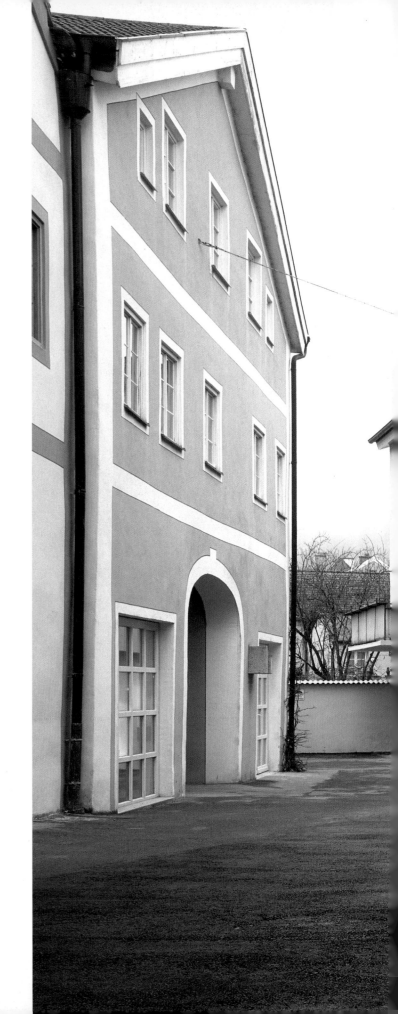

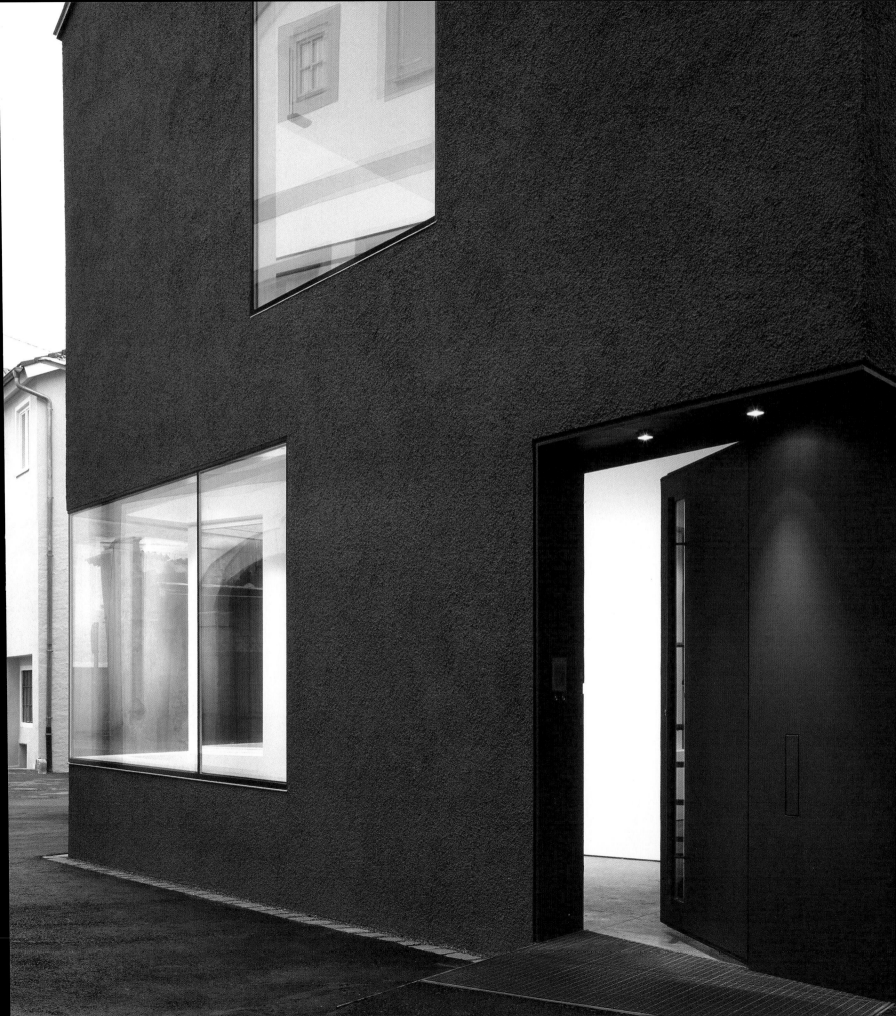

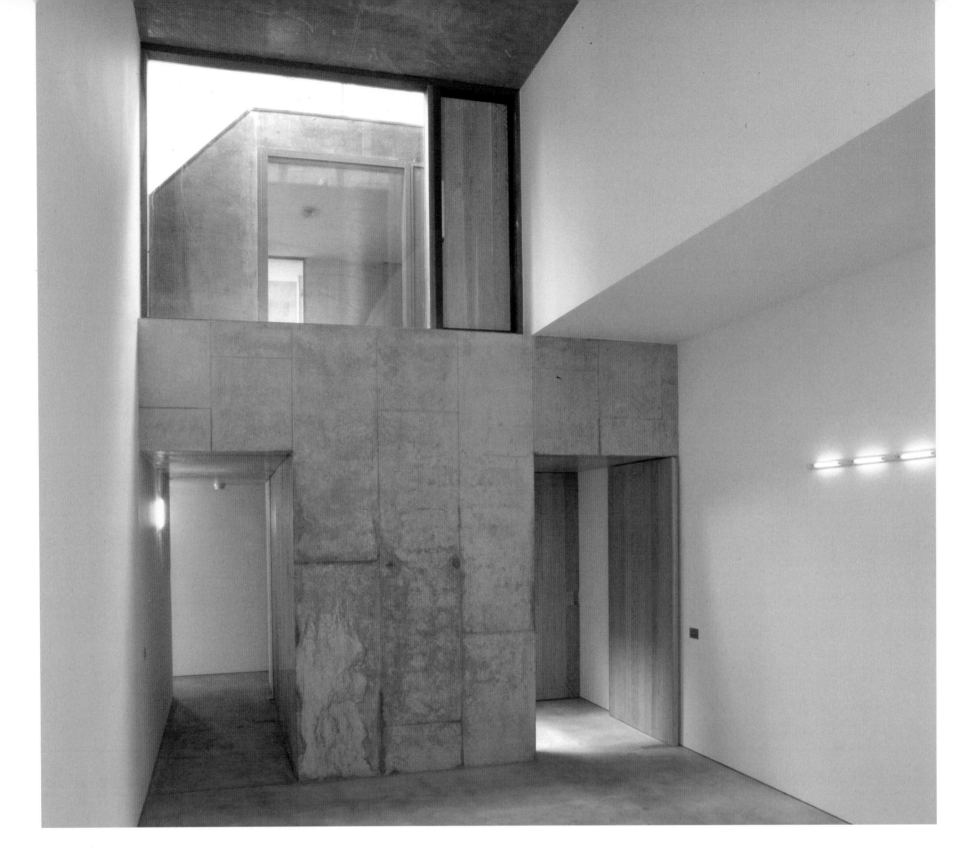

Voyage architectural

Anderson House

Built-in on all sides and with one full level below grade, this house shows that highest living quality can be attained under even the most difficult conditions. An ingenious circulation path leads from the entrance down a long flight of steps to the subterranean level, which seems all but underground. Skylights oriented in different directions bathe the high living room space here in church-like light. The path continues via a second stairway to the upper level where the bedrooms are located. A lucid window wall in the master bedroom leads to the roomy terrace that culminates the dramatic voyage through the house.

Architektonische Reise

Anderson-Haus

An allen Seiten eingebaut und mit einem vollen Geschoss im Erdreich liegend, zeigt dieses Haus, dass höchster Wohnwert unter schwierigsten Bedingungen erreicht werden kann. Ein virtuos komponierter Weg durch das Haus führt vom Eingang aus über eine Treppe in das Untergeschoss, das wie keines wirkt. Oberlichter, in unterschiedliche Himmelsrichtungen orientiert, führen das Licht hier so in den hohen Wohnraum, dass er beinah sakral wirkt. Der Weg führt weiter über eine zweite Treppe zur Schlafebene empor. Im Schlafzimmer angekommen, bildet eine helle Fensterfront mit davorliegender Terrasse den Wegesabschluss.

London, Great Britain, Jamie Fobert Architects, 2002, 120 m²

Voyage au cœur de l'architecture

Maison Anderson

Close de tous côtés et dotée d'un niveau intégral en sous-sol, cette habitation démontre qu'une très grande qualité de vie peut être obtenue en dépit de grandes contraintes. Un trajet de circulation virtuose descend de l'entrée par une longue volée de marches jusqu'au niveau inférieur qui ne donne pas l'impression d'être en sous-sol. Des lanterneaux différemment orientés inondent le haut espace du séjour d'une sorte de lumière sacrée. Le trajet se poursuit par un second escalier jusqu'au niveau supérieur qui regroupe les chambres. Une paroi translucide de la chambre principale ouvre sur une vaste terrasse qui conclut ce voyage spectaculaire à travers toute la maison.

Voyage architectural

Casa Anderson

Esta casa empotrada en sus cuatro lados y con toda una planta bajo tierra muestra que se puede alcanzar una elevada calidad de vida incluso en las más difíciles condiciones. Un camino concebido virtuosamente recorre toda la casa desde la entrada, pasando por una escalera, hasta el piso subterráneo, que parece todo menos un sótano. Las claraboyas, orientadas en todas las direcciones, introducen la luz de tal forma en este salón de gran altura que parece un espacio casi sacro. El camino continúa a través de una segunda escalera hasta el nivel de los dormitorios. En el dormitorio principal una gran ventana lleva a la terraza, el final del camino.

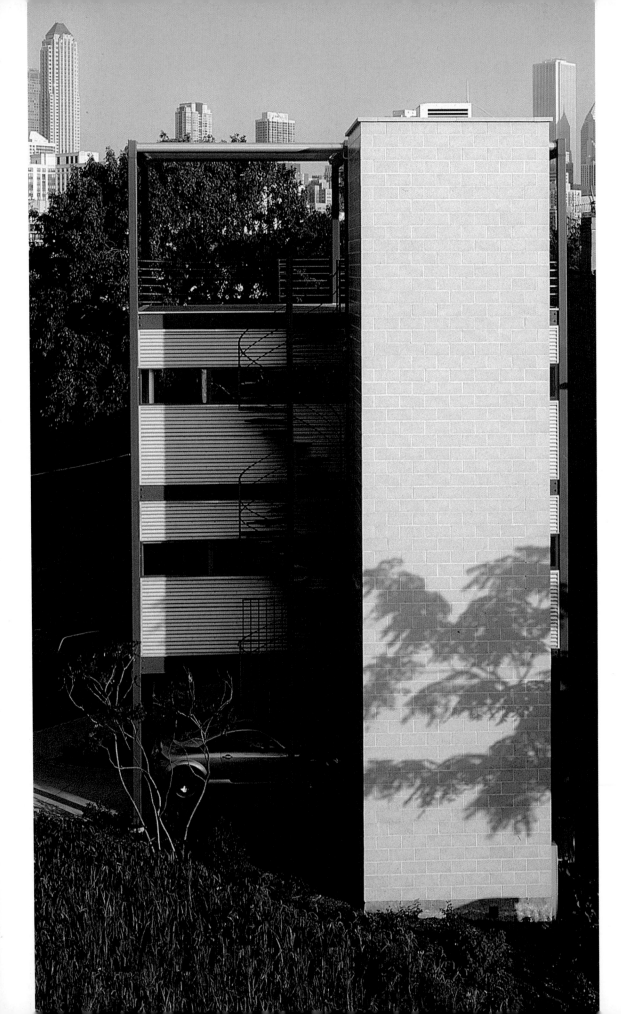

High Roller
Tower House

Built on a small, thought-to-be-unbuildable, triangular lot, the house is comprised of two principal components: a four-story exposed steel structure and an adjoining massive stair tower. Inspired by a comprehensive view of Chicago's skyline, the house is vertically inverted with the principal outdoor space occupying a fourth level roof terrace, the living, dining, kitchen spaces the third level, and bedrooms the second. The ground level provides space for parking and covered access to the front door at the base of the tower. The concrete block tower stabilizes the steel frame structure, allowing thin steel columns, lightness and delicacy.

Hoch gestapelt
Tower Haus

Das auf einem kleinen, schwierigen Grundstück errichtete Haus besteht aus zwei Baukörpern: einem viergeschossigen Stahlskelettbau und einem anschließenden massiven Treppenturm. Der einmalige Ausblick auf die Skyline Chicagos inspiriert dazu, das Haus vertikal invertiert zu organisieren. Die Dachterrasse im 4. OG wird somit der wichtigste Freiraum. Wohn-, Ess- und Kochbereiche befinden sich im 3. OG, Schlafräume im 1. OG. Das EG fungiert als Stellplatz, von dem aus die Eingangstür direkt erreicht wird. Der Turm aus Betonsteinen stabilisiert den Stahlskelettbau, der somit möglichst grazil und leicht ausgebildet wird.

Haut perchée
Maison-tour

Édifiée sur un petit terrain triangulaire, cette maison comprend deux éléments principaux : une structure en acier visible sur quatre niveaux et une massive tour/cage d'escalier adjacente. Inspirée par l'immense panorama de Chicago, la maison, conçue dans la verticalité, a son principal espace extérieur au quatrième niveau sur le toit, les espaces séjour, repas et cuisine étant situés au troisième et les chambres au deuxième. Le rez-de-chaussée est réservé au garage et à l'accès couvert à la porte d'entrée située au pied de la tour. Cette tour en béton stabilise la structure en acier dont la gracilité des éléments donne une délicate impression de légèreté.

Hacia las alturas
Casa Torre

Construida sobre un pequeño solar de complicada forma, esta casa se compone de dos cuerpos: un esqueleto de acero de cuatro alturas y una torre masiva de escaleras. La increíble vista sobre el horizonte de Chicago inspiró la construcción vertical de la casa, que está organizada de forma invertida. La terraza del tejado en el 4° piso es el lugar abierto más importante. Las zonas del salón, el comedor y la cocina se encuentran en el 3er piso, los dormitorios en el 1°. La planta baja hace las veces de trastero y desde él se alcanza la puerta principal. La torre de bloques de hormigón dan estabilidad al esqueleto de acero, lo que permite una estructura grácil y ligera.

Chicago, IL, USA
Frederick Phillpis & Associates,
2001, 106 m²

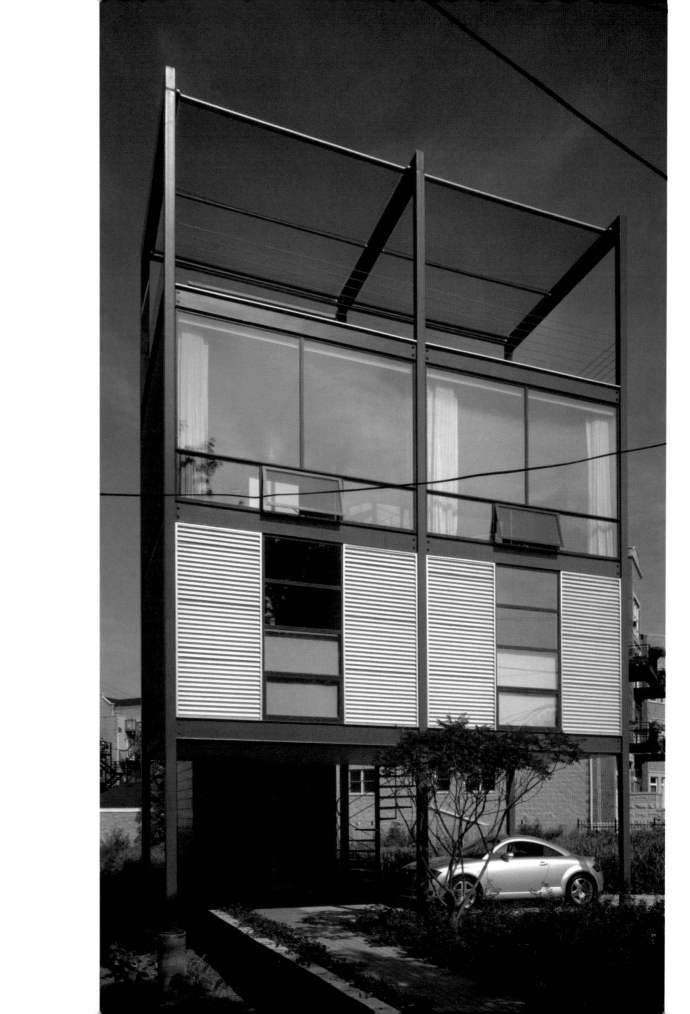

Sydney, Australia,
Engelen Moore Architects,
2001, 109 m²

Tough Shell, Soft Inside

Dodds House

Simplicity of form and material produce a tough exterior as an answer to the nearby industrial buildings. All external elements are painted silver/gray, with shadow, texture and detail providing the only surface relief. The open plan inside complements the austere exterior. The double height volume of the living area with its mezzanine bedroom creates an especially generous interior space. Sliding glass doors allow the adjoining patio court to extend the interior. Another set of glazed doors open to the rough brick wall of the neighboring building which contrasts the lightweight steel-frame construction utilized here.

Harte Schale, weicher Kern

Dodds-Haus

Einfache Formen und Materialien erzeugen strenge Außenfronten als Reaktion auf nahe gelegene Industriebauten. Sämtliche Außenmaterialien sind silbergrau gehalten – Schatten und Texturen gliedern das Fassadenrelief. Offenheit im Inneren bildet einen Gegenpol zum verschlossenen Äußeren. Eine zweigeschossige Wohnhalle mit anschließender Schlafgalerie schafft hier Großzügigkeit. Gläserne Schiebetüren ermöglichen es, den angrenzenden Hof nahtlos mit dem Wohnraum zu verbinden. Weitere Fenster eröffnen den Blick auf die alte Ziegelwand des Nachbarhauses, die im markanten Kontrast zur leichten Stahlkonstruktion steht.

Coque solide, intérieur moelleux

Maison Dodds

La simplicité des formes et des matériaux employés donne à l'extérieur un aspect solide faisant écho aux bâtiments industriels avoisinants. Tous les éléments extérieurs sont peints en gris métallisé, le relief étant donné par les ombres et la texture des matériaux. Le plan libre de l'intérieur contraste avec l'austérité de l'extérieur. L'espace séjour de hauteur double avec la chambre en mezzanine libère un généreux volume intérieur. Des portes vitrées coulissantes permettent d'unir directement le patio à l'intérieur. Un autre jeu de portes vitrées donne sur le mur de briques du bâtiment adjacent sur lequel tranche la structure légère en acier de cette habitation.

Duro por fuera, blando por dentro

Dodds House

La simplicidad de las formas y de los materiales crean unas fachadas exteriores duras como respuesta a las cercanas fábricas. Todos los materiales exteriores son de color gris plateado y las sombras y las texturas dan relieve a la superficie de las fachadas. El plano abierto del interior es el polo opuesto del austero exterior. El cuarto de estar, que abarca dos plantas y que termina con una galería dormitorio, crea un generoso espacio interior. Puertas correderas de cristal permiten que el vecino patio se una sin fisuras al cuarto de estar. Otras ventanas abren la vista a la vieja pared de ladrillo de la casa de al lado, que contrasta con la ligera construcción de acero.

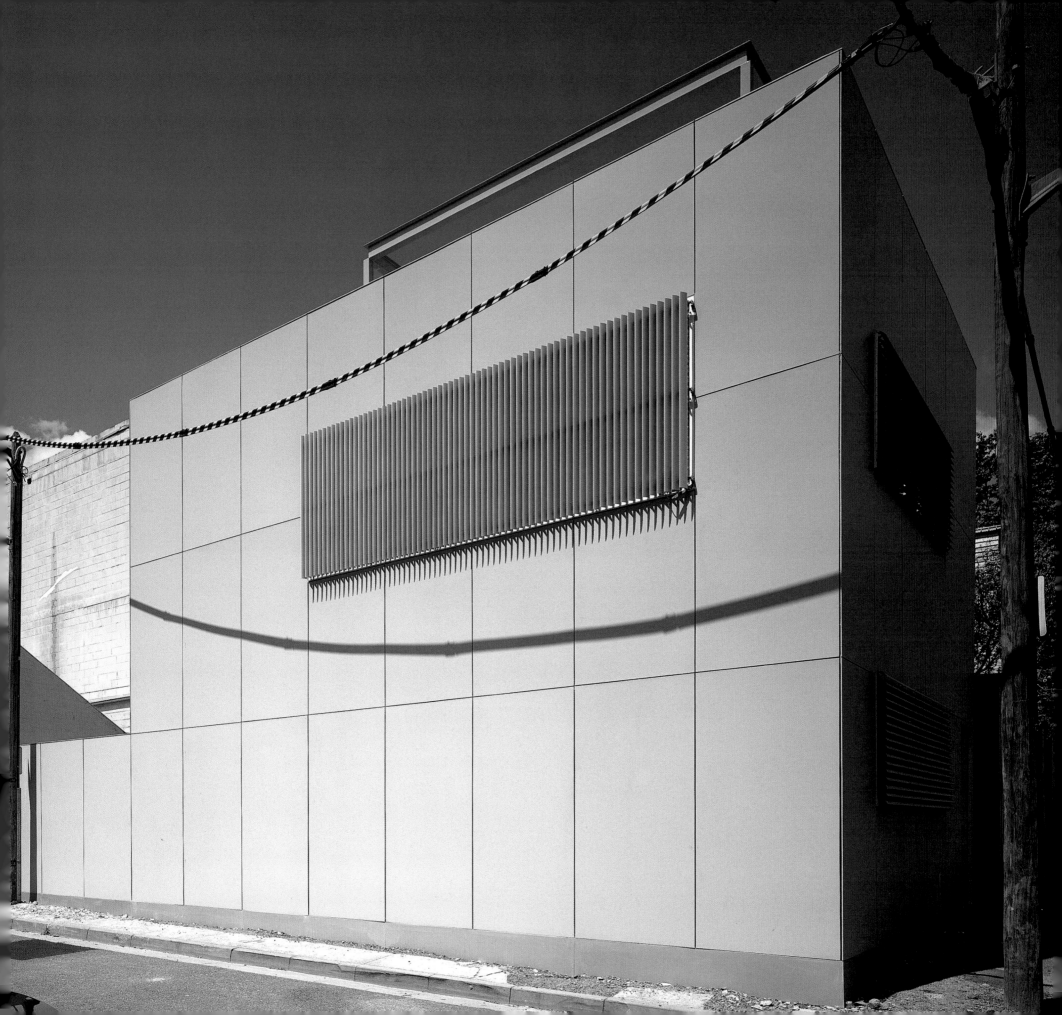

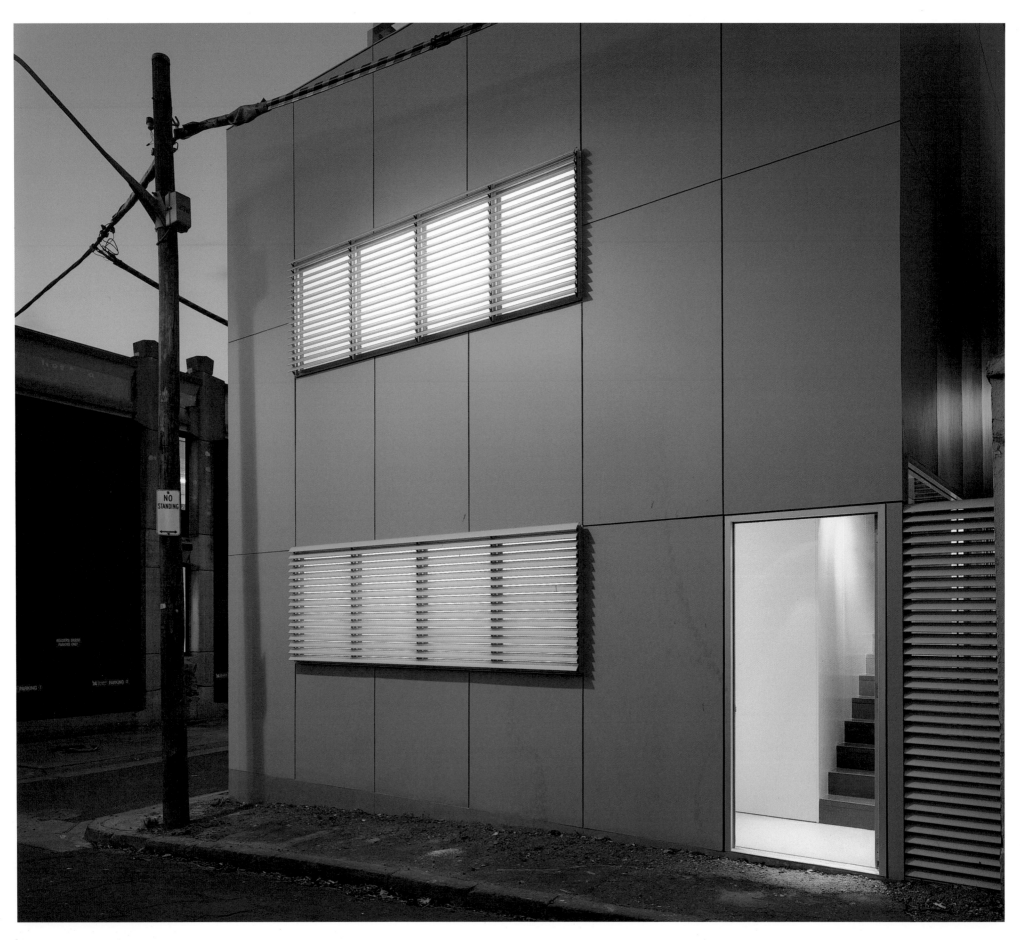

House as Mini-City
C-House

The C-house accommodates both residential and café uses. This combination results from the urban lifestyle in Tokyo where private life-space merges with public/semi-public spaces. The result? A house conceived as a microcosm of the city. The C-shape of the transparent café spaces on ground and top floor literally wraps around the opaque box of the residential unit. The residential box accommodates only minimal living functions which are complemented by the semi-public café spaces. As such, the building breaks with the traditional notion of a house as an autonomous unit and explores the boundaries between public and private realm.

Haus als Mini-Stadt
C-Haus

Das C-Haus vereint Wohn- mit Cafénutzungen als Ausdruck des urbanen Alltags in Tokio, wo private Lebensräume sich zunehmend mit halböffentlichen Räumen vermischen. Das Ergebnis? Ein Haus als Mikrokosmos der Stadt. Die verglaste C-Form des Cafés im EG und 2. OG wickelt sich um die schwarze Wohnbox im 1. OG, die minimale Funktionen aufnimmt. Normalerweise zur Wohnung gehörende Räume wie das Wohnzimmer befinden sich im halböffentlichen Bereich des Cafés. So bricht das Gebäude mit der Definition eines abgeschlossenen Hauses und erforscht die Grenzen zwischen öffentlichem und privaten Raum.

Ville en réduction
Maison C

La « maison C » cumule les fonctions d'habitation privée et de café. Cette combinaison découle du mode de vie habituel à Tokyo où les espaces privés se mêlent facilement aux zones publiques et semi-publiques. Le résultat ? Un microcosme urbain. La forme en C des espaces café transparents, réservés aux deux niveaux extrêmes, s'enroule littéralement autour du bloc opaque de la partie privée. Ce compartiment résidentiel n'abrite que les fonctions d'habitation essentielles, qui dialoguent avec les espaces semi-publics du café. Ainsi, ce bâtiment rompt avec la notion traditionnelle de l'habitation autonome en explorant les limites entre les domaines privé et public.

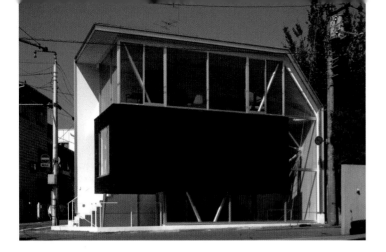

La casa como una miniciudad

Casa C

La Casa C une los espacios residenciales con los de la cafetería como expresión de la vida urbana diaria en Tokio, donde lo privado se mezcla cada vez más con los espacios semipúblicos. ¿El resultado? Una casa como microcosmos de la ciudad. El café, acristalado y con forma de C, se encuentra en la planta baja y en el 2° piso y envuelve la caja negra del 1er piso destinado a la vivienda y que acoge unas funciones de vida mínimas. Espacios como el salón que suelen pertenecer a la vivienda se encuentran en la zona semipública del café. De este modo el edificio rompe con la definición de una casa cerrada y explora los límites entre el espacio público y el privado.

Tokyo, Japan, Toshimitso Kuno + Nobuyuki Nomura + tele-design, 2002, 114 m²

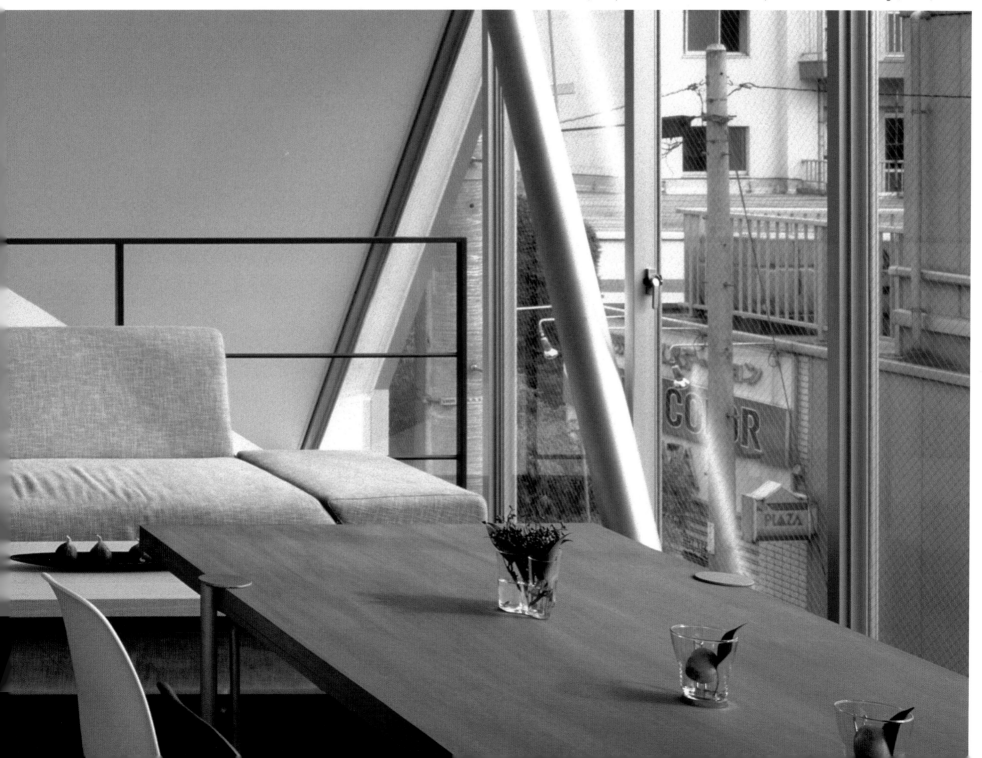

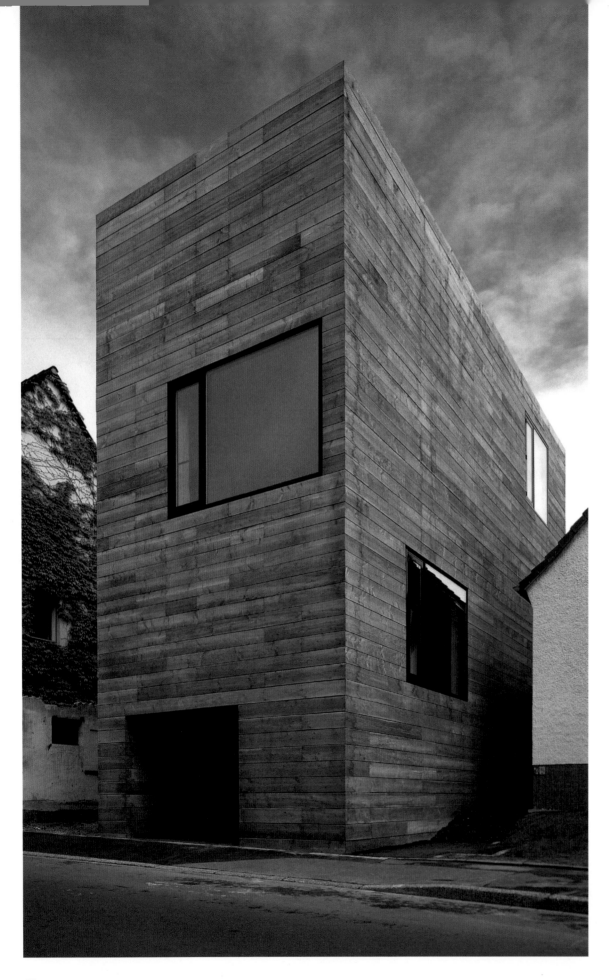

Shifted Scale

Ebeling House

The street is like countless others, lined by "normal" houses concerned with little more than maintaining normalcy. In response to this context, the building, constructed of massive wood planks, is conceived as a sculptural object. The resultant play of lightness and sheer mass shifts the house's scale and strikes up an engaging dialogue with the neighbors. Inside, ground floor and mezzanine levels create a zone of flowing spaces where living, eating, cooking and working all happen in their respective spatial niches. The enclosed roof terrace on the third floor serves as a place of contemplation open to the heavens.

Entrückte Maßstäblichkeit

Ebeling-Haus

Eine Straße wie tausend andere, gesäumt von „normalen" Häusern - alle bemüht, keineswegs aufzufallen. Um in dieser Umgebung bestehen zu können, wird der Bau aus massiven Holzbohlen als skulpturales Objekt aufgefasst. Im Zusammenspiel aus Leichtigkeit und Schwere entrücken so Maßstab und Erscheinungsform des Baus den Nachbarhäusern. Im Inneren wird das Erd- und Galeriegeschoss als fließendes Raumgefüge über zwei Ebenen gestaltet, in der die Funktionen Wohnen, Essen, Kochen und Arbeiten einzelne Zonen einnehmen. Auf der vierten Wohnebene liegt als Ort des Rückzugs die allseitig umschlossene Dachterrasse nah am Himmel.

Décalage d'échelle

Maison Ebeling

Une rue comme il en existe des milliers d'autres, bordée de maisons ordinaires qui n'ont apparemment d'autre but que de respecter la normalité. Face à ce contexte, le bâtiment fait de planches massives est conçu comme une sculpture. L'interaction entre sa légèreté et son aspect massif perturbe la perception de l'échelle de la maison et fait naître un dialogue intéressant avec le voisinage. À l'intérieur, le rez-de-chaussée et les mezzanines créent un espace mouvant où le séjour, les repas, la cuisine et le travail ont chacun leur zone respective. Le toit/terrasse ceint de murs du troisième niveau ne permet que la contemplation du ciel.

Escala cambiada

Casa Ebeling

Una calle como tantas otras, llena de casas "normales" que se esfuerzan por no destacar. Para poder existir en este entorno el edificio se ha concebido como un objeto escultural construido a partir de tablones masivos de madera. El juego resultante entre ligereza y pesadez modifica la escala y la apariencia de las casas vecinas. En el interior la planta baja y la del entresuelo crean una zona de espacios que fluyen entre los dos niveles y en los que las funciones de vivir, comer, cocinar y trabajar se disponen de sus propias zonas. En la cuarta planta se encuentra la terraza de la azotea, un lugar abierto al cielo para la contemplación y el retiro .

Dortmund, Germany,
ArchiFactory.de,
2000, 116 m²

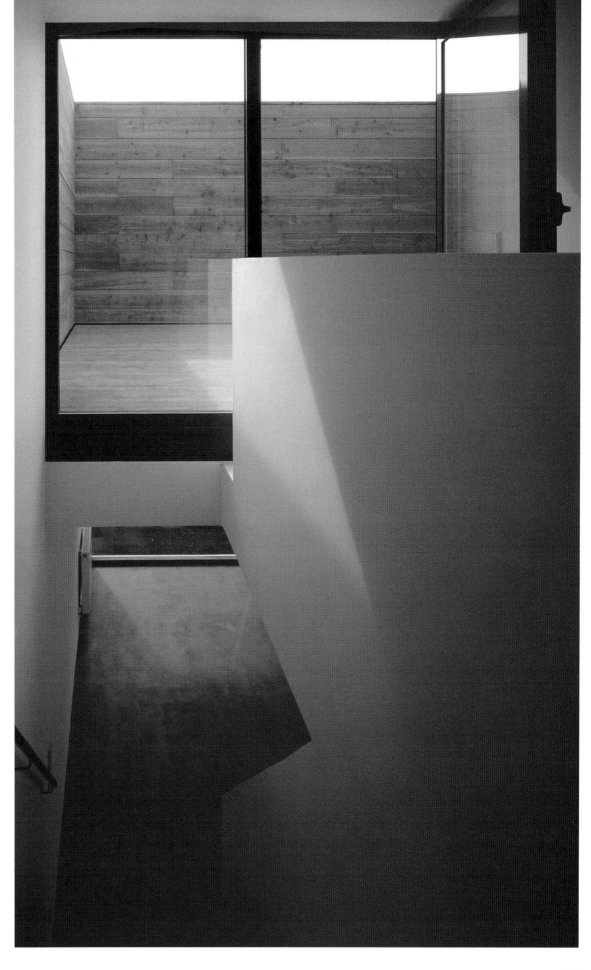

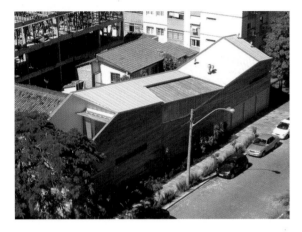

Porto Alegre, Brasil,
Procter-Rihl Architects,
2004, 125 m²

A Slice of House

Slice House

The project was conceived as a built slice on a 3.5 m wide x 40 m long site. A series of unique spaces, such as an 8 m long kitchen counter/outdoor dining table linking the internal courtyard with the living area, emphasize the dramatic narrowness of the site. Throughout, understated materials are used to create finely knit spaces, with ceiling height gradually rising as one moves through the house. Natural light is filtered inside through a courtyard, louvers and the glass side of the second floor swimming pool. The dreamlike light achieved during the day through the movement of water and daylight is extended at night with artificial illumination.

Eine Scheibe Haus

Slice-Haus

Das Haus wurde als gebaute Scheibe, die ein 3,5 x 40 Meter schmales Grundstück füllt, aufgefasst. Eine Kette von eigenwilligen Räumen, wie die 8 Meter lange Tischscheibe zwischen Innenhof und Wohnbereich, betont die dramatische Enge des Grundstückes. Einfache Materialien werden verwendet, um feingestrickte Raumerlebnisse zu schaffen, z. B. indem die Decke graduell ansteigt. Natürliches Licht wird über Lamellen, den kleinen Innenhof, und die verglaste Seite des Schwimmbeckens im 2. OG ins Innere gefiltert. Dieses traumähnliche, durch das Wasser gebrochene Licht illuminiert die Räume auch nachts, wenn Strahler das Lichtspiel fortsetzen.

Une tranche de maison

Maison en tranche

Ce projet a été conçu comme une tranche de maison de 3,50 x 40 m. Une série d'espaces séparés, tels qu'une table-comptoir de cuisine extérieure de 8 m de long reliant la cour intérieure à la partie séjour souligne l'étroitesse spectaculaire du terrain. Partout, des matériaux discrets permettent la création d'espaces finement imbriqués, tandis que la hauteur sous plafond s'élève au fur et à mesure que l'on progresse dans la maison. La lumière naturelle filtre par des jalousies ouvrant sur une cour et par la paroi de verre de la piscine au deuxième niveau. Cette clarté de rêve obtenue durant le jour par le mouvement de l'eau est prolongée la nuit par des éclairages artificiels.

Una casa como una rebanada

Casa Slice

Esta casa fue concebida como una rebanada que ocupa un solar de 3,5 x 40 metros. Una serie de espacios únicos, como la hoja de mesa de 8 metros de longitud situada entre el patio interior y el salón, acentúan la dramática estrechez del solar. Se han empleado materiales sencillos para tejer finos espacios, p. ej. aumentando gradualmente la altura del techo por toda la casa. La luz natural se filtra hacia el interior a través de las laminas del pequeño patio interior y por el lado acristalado de la piscina en el 2° piso. Esta luz que parece irreal es rota por el movimiento del agua e ilumina los espacios también durante la noche cuando los focos artificiales la sustituyen.

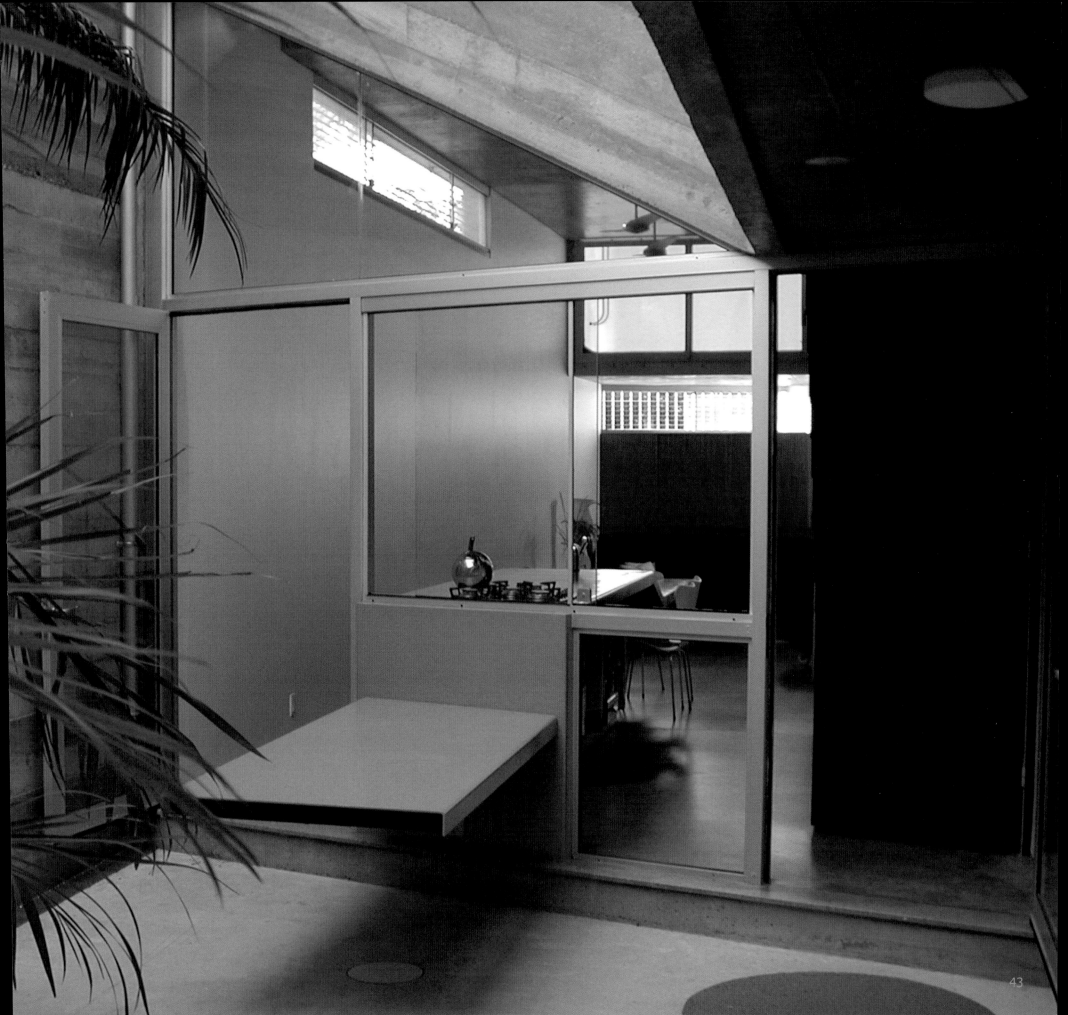

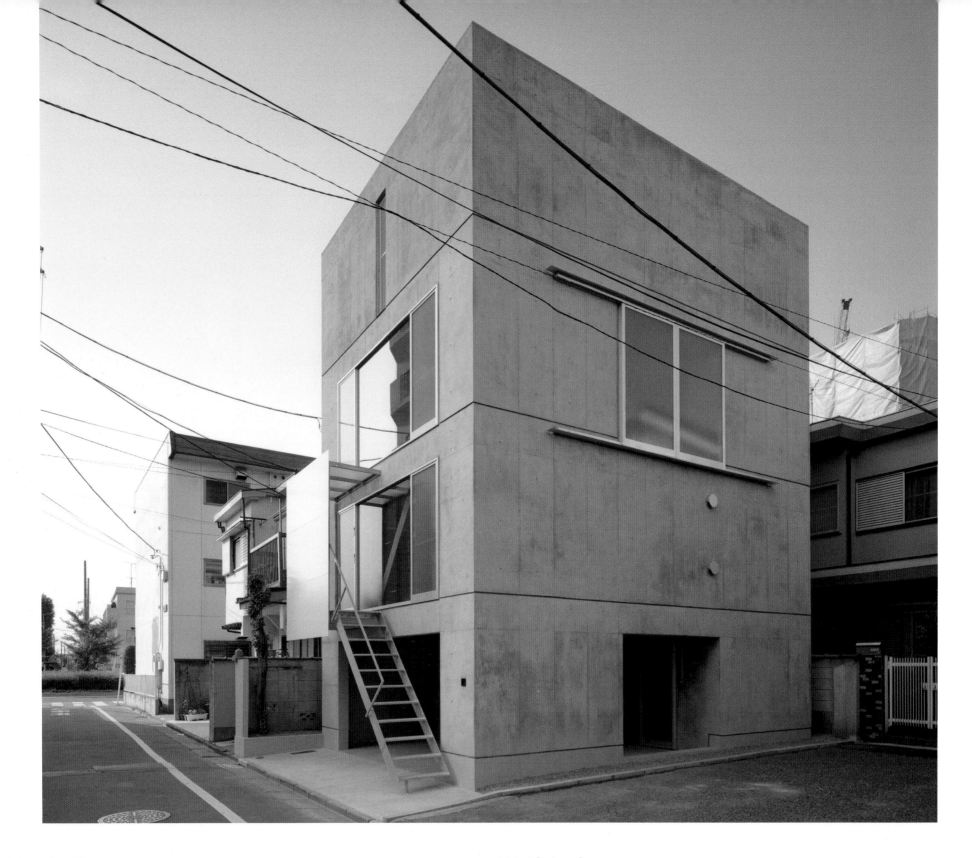

White in Gray
K-House
Based on a 5 x 7.4 meter plan, the towering house volume is distributed on four floors. On the ground floor, a parking space is carved out of the block-like mass. Living functions begin elevated off street level on the second floor. A central skylight bathes the interior spaces in natural light. Spatial expansion of the tight floor plan occurs vertically and horizontally via interconnected, flowing spaces. The open, continuous spaces unite the four-level structure. The exposed concrete floors, walls and ceiling hover in the light and assume an airy, ephemeral quality reminiscent of tautly-spanned sail cloth.

Weiß in Grau
K-Haus
Auf einer Grundfläche von 5 x 7,4 Metern entwickelt sich das Haus über vier Etagen in die Höhe. Der turmartige Baukörper wird im Erdgeschoss mit einem PKW-Stellplatz ausgehöhlt. Erst darüber fangen die Wohnräume ab dem 1. OG an. Das zentrale Oberlicht über dem 3. OG flutet die Innenräume mit natürlichem Licht. Um die enge Grundrissfläche zu erweitern, fließen Räume horizontal und vertikal ineinander. Es entsteht somit ein zusammenhängendes Raumgebilde über vier Etagen, innerhalb dessen die Wand- und Deckenoberflächen aus Sichtbeton hell und leicht, wie gespannter Segelstoff, scheinbar schweben.

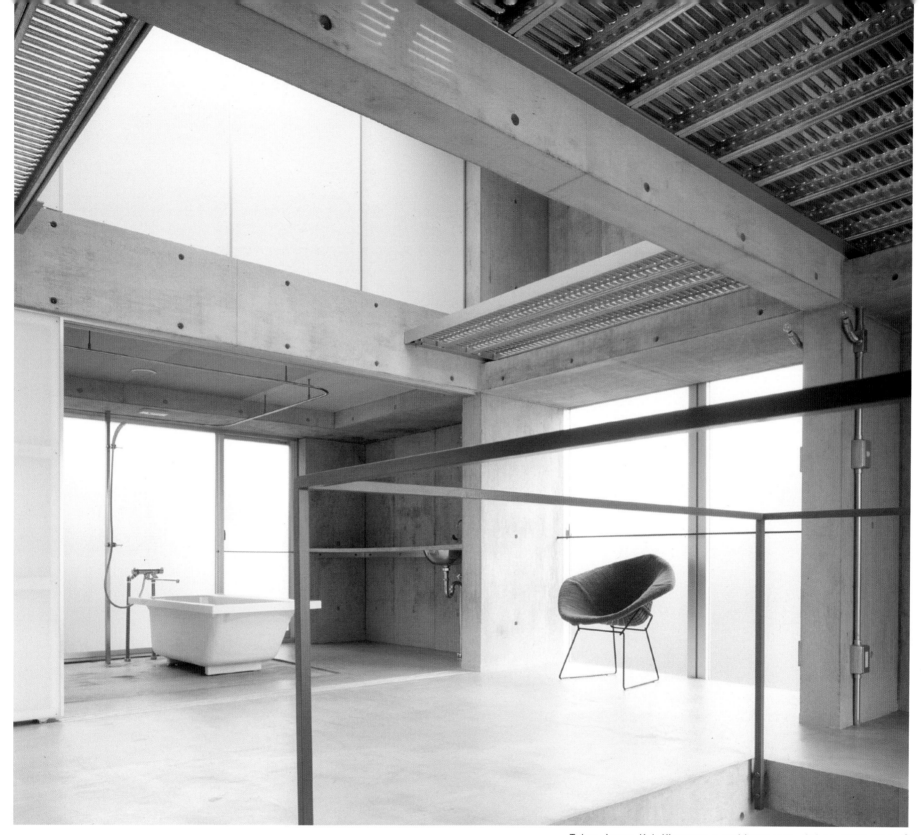

Tokyo, Japan, Koh Kitayama + architecture workshop, 2002, 134 m²

Blanc sur gris

Maison K

Sur une surface de 5 x 7,40 m, le volume vertical de cette maison est divisé en quatre niveaux. Au rez-de-chaussée, le garage est taillé dans la masse du bloc. Les fonctions habitation commencent au deuxième niveau. Un lanterneau central inonde l'espace intérieur de lumière naturelle. L'expansion spatiale des étages limités en surface s'exerce verticalement et horizontalement par des espaces de circulation interconnectés. Ces espaces continus ouverts assurent l'unité de cette structure étagée. Les planchers, les murs et les plafonds en béton apparent flottent dans la lumière en prenant l'aspect aérien et fugitif d'une voile bien bordée.

Blanco y gris

Casa K

Situada en un solar de 5 x 7,4 metros, esta casa se eleva como una torre de cuatro pisos. En la planta baja un aparcamiento ha vaciado la estructura de este bloque. Los espacios destinados a la vivienda empiezan a partir del 1er piso. Una claraboya central baña los espacios interiores con luz natural. Para ampliar el estrecho plano del edificio los espacios fluyen entre sí de forma vertical y horizontal. De este modo se consigue una unidad que abarca las cuatro plantas en las que las luminosas superficies de las paredes y de los techos, de hormigón visto, parecen flotar efímeras como si fueran una vela blanca tensada.

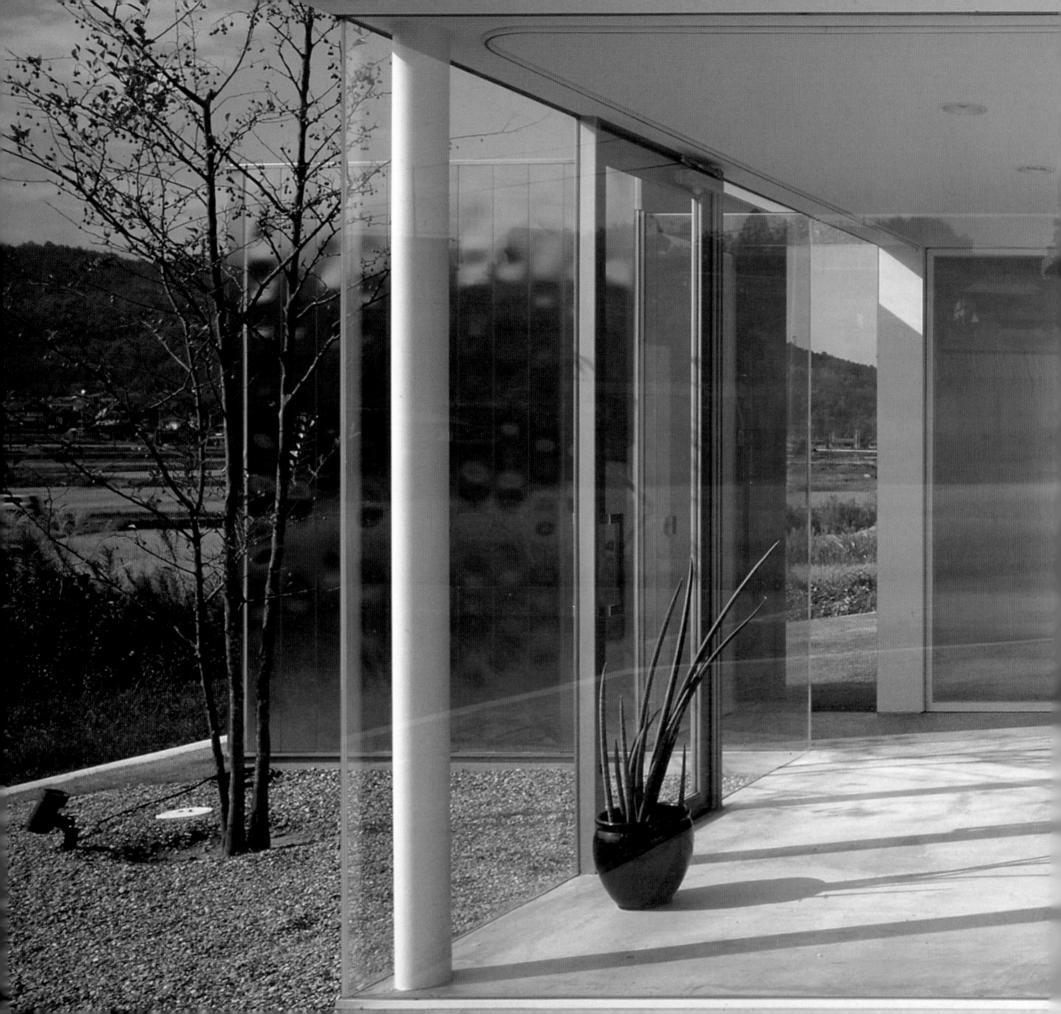

XXS Suburban Houses

Vorstadthäuser | Maisons de banlieue | Casas suburbanas

Linz, Austria,
x architekten,
2004, 18 m²

Solar Sail

Kollross House

In the midst of an unspectacular suburb a new neighbor, elevated one level above terrain and clad in metal, seems to float on steel stilts. The 18 m² space is conceived as a gesture of generosity in a nondescript neighborhood where snug timidity prevails. Balconies to both the east and west side extend the 18 m² space. Light is directed into the extension, located in the shadow of the northern side of the existing structure, via a south-facing skylight. Its angled sail-like wall reinterprets the theme of the old building's conventional pitched roof to achieve an engaging synthesis of old and new.

Sonnensegel

Kollross-Haus

Inmitten der unspektakulären Vorstadt erhebt sich, ein Geschoss hoch über dem Terrain, die Wohnraumerweiterung aus verzinktem Stahl auf ebenso verzinkten Beinen. Der 18 m² große Raum ist als Geste der Großzügigkeit in einem auf Unauffälligkeit bedachten Wohnquartier angelegt. Balkone im Osten und Westen des Raumes erweitern den kleinen Wohnraum nach außen. Sonnenschein wird in den auf der Nordseite des Hauses gelegenen Anbau über das nach Süden gerichtete Oberlicht gelenkt. Die abgewinkelte Segelwand nimmt das Motiv des Satteldaches auf, das sich nun als Teil des Altbaus im Neuen wiederfindet.

Voile solaire

Maison Kollross

Au milieu d'un faubourg sans caractère, une nouvelle venue, élevée d'un niveau au-dessus de son terrain et habillée de métal, semble flotter sur ses échasses d'acier. Cet espace de 18 m² est considéré comme un signe de générosité envers son environnement anonyme. Des balcons à l'est et à l'ouest prolongent ces 18 m². La lumière atteint cette extension, située dans l'ombre orientée au nord d'une structure existante, par une ouverture zénithale orientée au sud. Sa paroi en dièdre ressemblant à une voile réinterprète le thème du toit à double pente traditionnel du bâtiment d'origine en réalisant une synthèse intéressante de l'existant et de la nouveauté.

Vela solar

Casa Kollross

En medio de un suburbio muy poco espectacular se levanta muy separado del suelo una planta de metal galvanizado que se sostiene sobre unos zancos del mismo material. Es la ampliación del salón. Este espacio de 18 m² es un gesto de generosidad en un barrio residencial bastante discreto. Los balcones situados en los lados este y oeste de la habitación amplían el pequeño salón hacia el exterior. La luz es conducida hacia el anexo de la cara norte de la casa a través de la claraboya orientada hacia el sur. La pared con forma de vela reinterpreta el tema del clásico tejado inclinado para conseguir una divertida síntesis entre el viejo y el nuevo edificio.

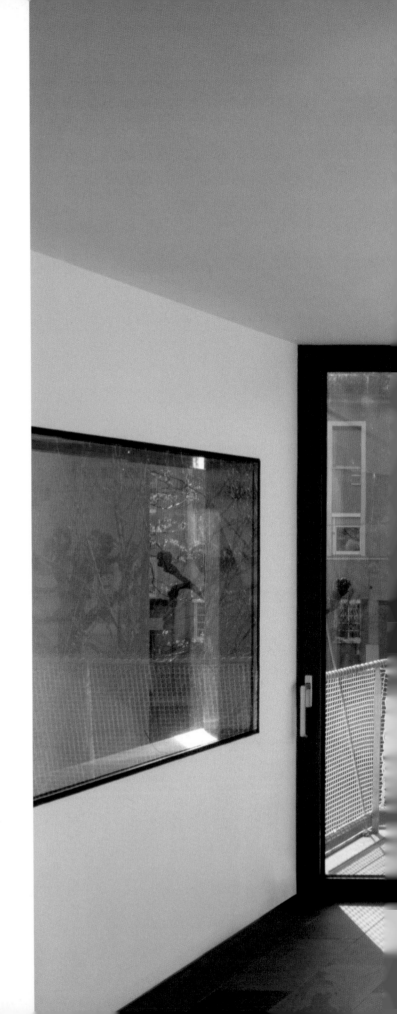

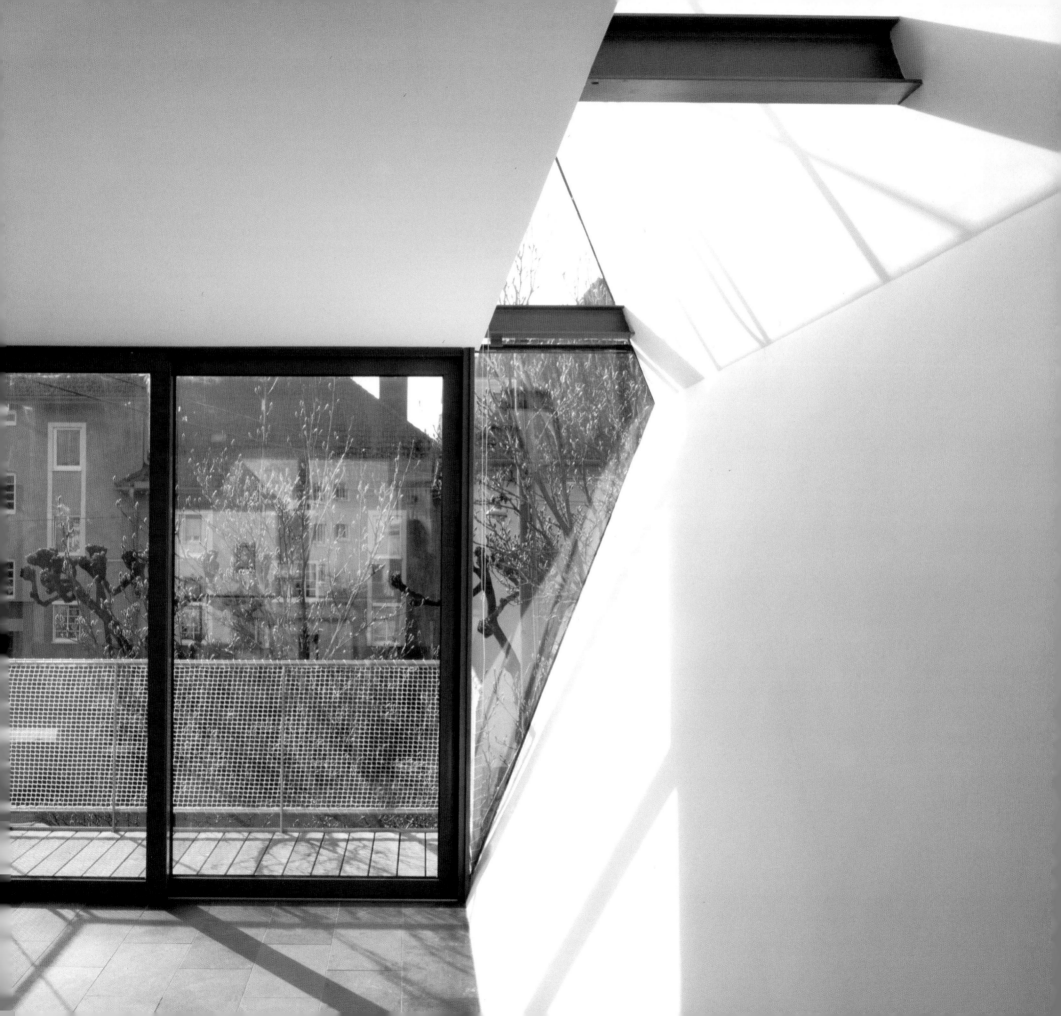

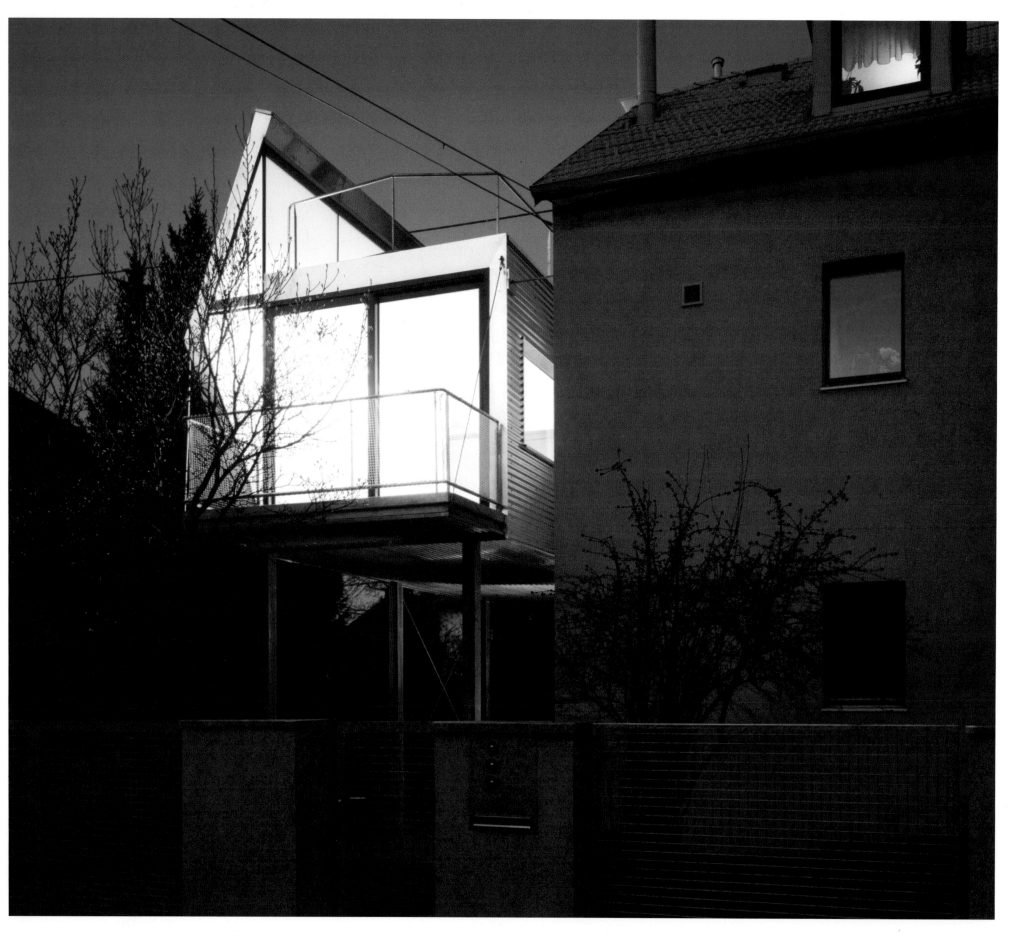

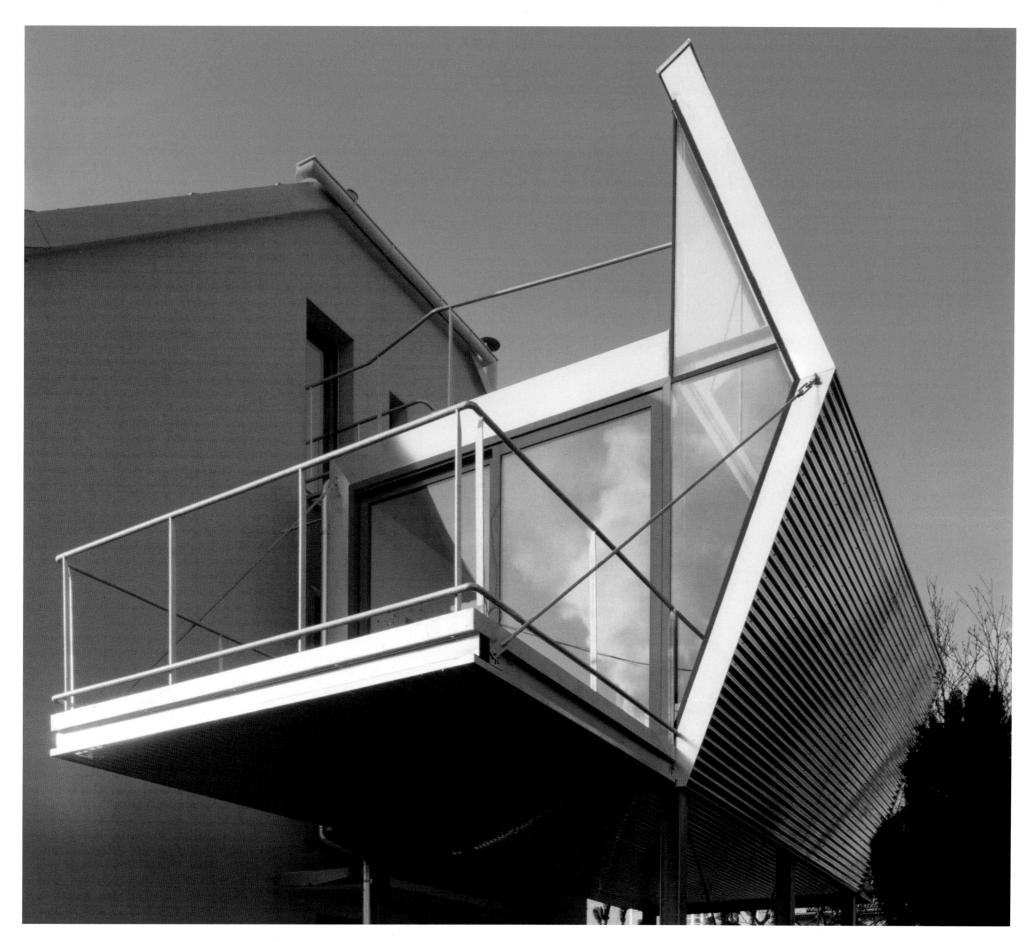

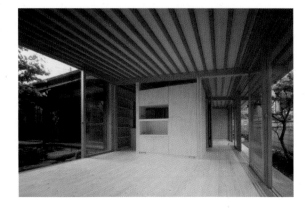

Kanagawa, Japan,
Tezuka Architects,
2001, 45 m²

Tradition of Innovation
Thin Roof House
The repertoire of the traditional Japanese house has fascinated generations of Western architects. "Shojis", wood-framed sliding walls with translucent rice paper panels, allow both spatial flexibility and open connection between interior and exterior spaces, which also responds to the humid tropical climate. This house extension is based in this tradition, yet transcends it effectively. Changing the spanning direction of the rafters to run parallel, not perpendicular, to the eaves creates a virtually column-less perimeter and achieves a perfect union between architecture and nature.

Tradition der Innovation
Thin-Roof-Haus
Das Repertoire des traditionellen japanischen Wohnhauses hat bereits Generationen von westlichen Architekten in seinen Bann gezogen. Schiebewände aus Reispapier, „shoji" genannt, erlauben hier die Verschmelzung von Innen- und Außenraum, was jedoch auch schlicht als Antwort auf das extrem schwüle Monsun-Klima entstanden ist. Bei diesem Anbau entsann man sich der Tradition, übertraf sie aber, indem die Spannrichtung der Dachbalken nicht quer, sondern parallel zur Längsseite verläuft. Dies ermöglicht eine stützenfreie Sicht auf den Garten und somit die vollkommene Vereinigung von Architektur und Natur.

Une tradition d'innovation
Maison au toit mince
Le vocabulaire de l'architecture japonaise traditionnelle a fasciné des générations d'architectes occidentaux. Les *shoji*, ces cloisons coulissantes faites de papier translucide tendu sur des cadres de bois offrent une excellente modularité spatiale et une relation parfaite entre l'intérieur et l'extérieur. Elles étaient à l'origine une simple réponse à la touffeur du climat de mousson. Cette extension transcende la tradition sur laquelle elle se fonde. Le changement de sens des poutres désormais parallèles et non plus perpendiculaires aux égouts de toit crée un espace fluide en réalisant une union parfaite entre l'architecture et la nature.

La tradición de la innovación
Thin Roof House
El repertorio de la casa tradicional japonesa ha fascinado a muchas generaciones de arquitectos occidentales. Aquí las paredes correderas y translúcidas de papel de arroz, llamadas "shoji", permiten la fusión entre el espacio interior y el exterior. Estos elementos responden también al clima extremadamente sofocante del monzón. Esta construcción está basada en dicha tradición, aunque la supera porque la dirección de las vigas del techo discurre de forma paralela y no transversal al lado más largo de la casa. Esta disposición hace posible que la vista al jardín sea libre y que se produzca una unión completa entre la arquitectura y la naturaleza.

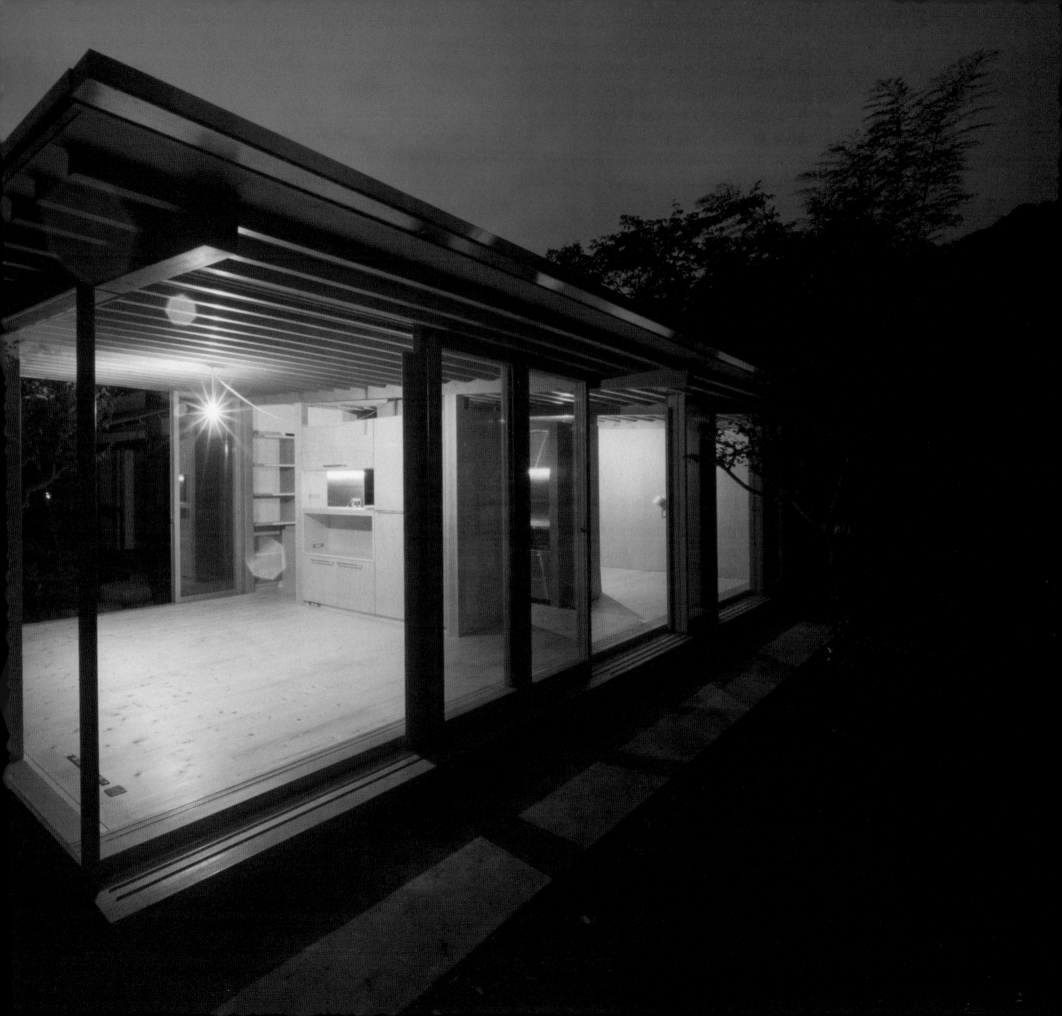

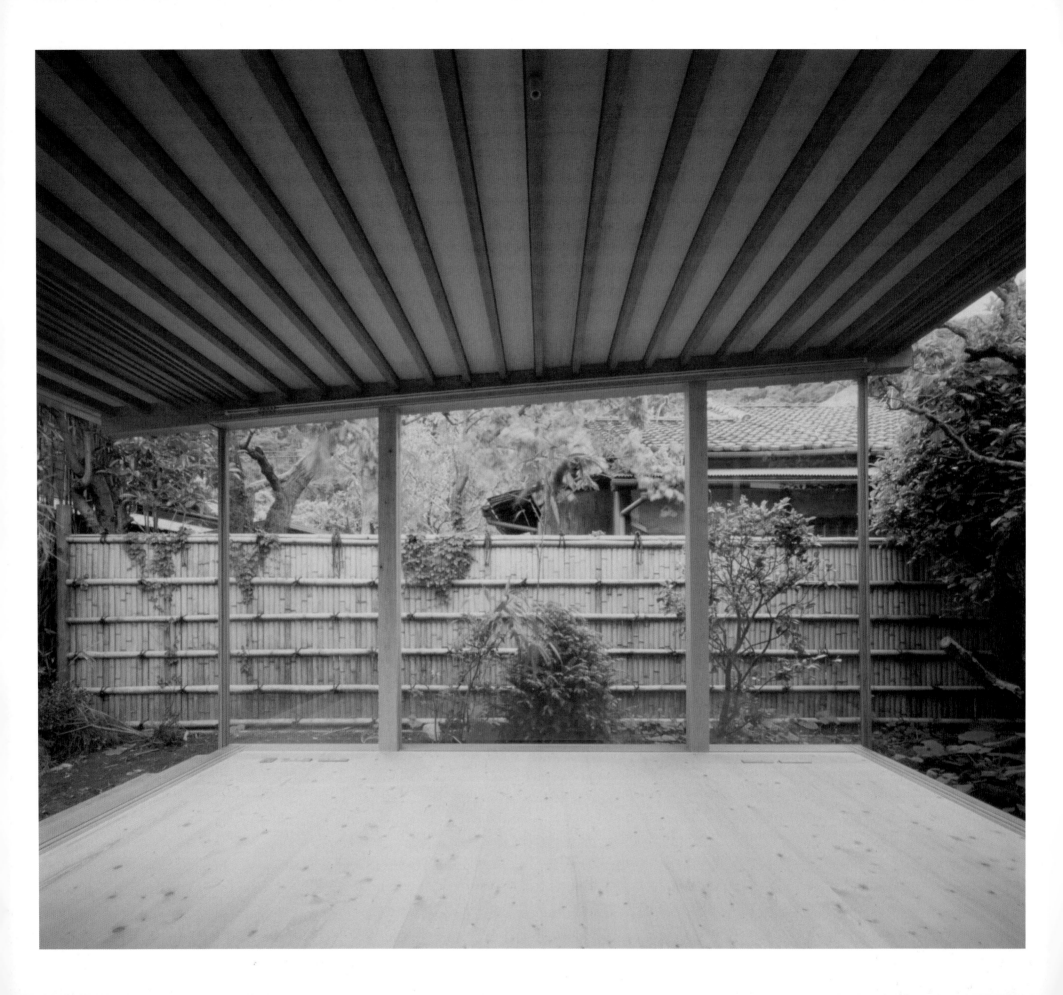

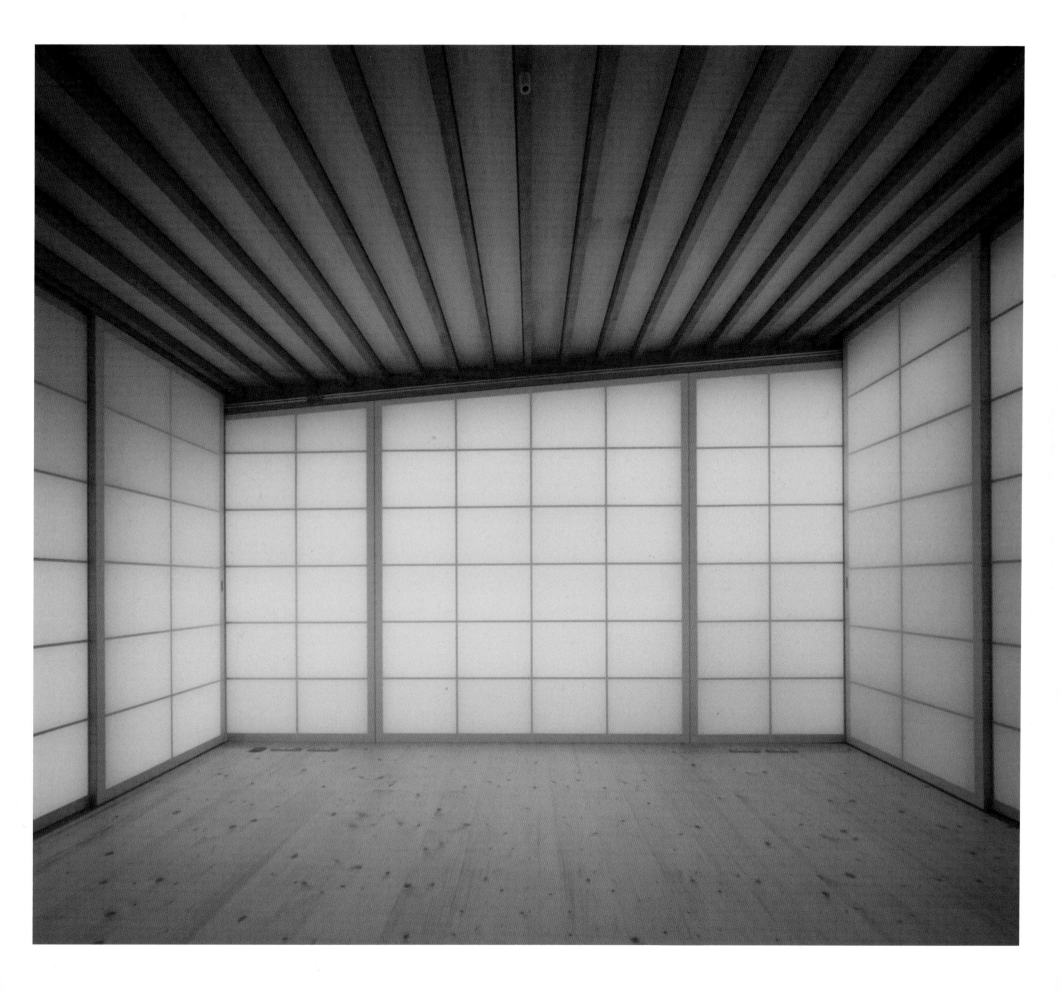

Doing the Wright Thing
Guest House

The guest house complements the existing main house designed in 1938 by a student at Frank Lloyd Wright's Taliesin school. As a response, the new building develops its own language that purposefully avoids stylistic confrontation, yet convinces through utilization of modern means. The living room walls are fully glazed to allow views out to nearby hills, the old stand of oak trees and the Pacific. This blurring of outdoor and indoor spaces is further enhanced by the 12 meter long fireplace wall. It originates outside in the courtyard, continues through the living space and culminates, outside again, in the northern garden.

Wright Ritus
Gästehaus

Das Gästehaus ergänzt das bereits existierende Haupthaus auf dem Grundstück, das 1938 von einem Schüler von Frank Lloyd Wright erbaut wurde. Als Antwort darauf reagiert der kleine Neubau mit einer selbstbewussten, eigenen Sprache, die nicht auf Konfrontation setzt, sondern sich mit modernen Mitteln profiliert. So wurden die Wohnzimmerwände an zwei Seiten völlig verglast, um Ausblicke auf nahe Höhenzüge, den alten Eichenbestand und den Pazifik zu ermöglichen. Diese Verschmelzung von Innen und Außen wird auch durch die Kaminwand betont, die sich vom Hof über das Wohnzimmer und weiter in den Vorgarten zieht.

Dans le style de Wright
Maison d'amis

Cette maison d'amis complète une maison principale conçue en 1938 par un étudiant de l'atelier que Frank Lloyd Wright animait à Taliesin. En réponse, la nouvelle construction exploite son propre vocabulaire qui évite délibérément la confrontation stylistique tout en convainquant par le recours à des moyens modernes. Les parois du séjour sont totalement vitrées afin de dégager les vues sur les collines alentour. Cet effacement des frontières entre intérieur et extérieur est souligné par le mur de la cheminée de 12 m de longueur. Il prend naissance à l'extérieur dans la cour, se poursuit dans le séjour et regagne l'extérieur pour s'achever dans le jardin nord.

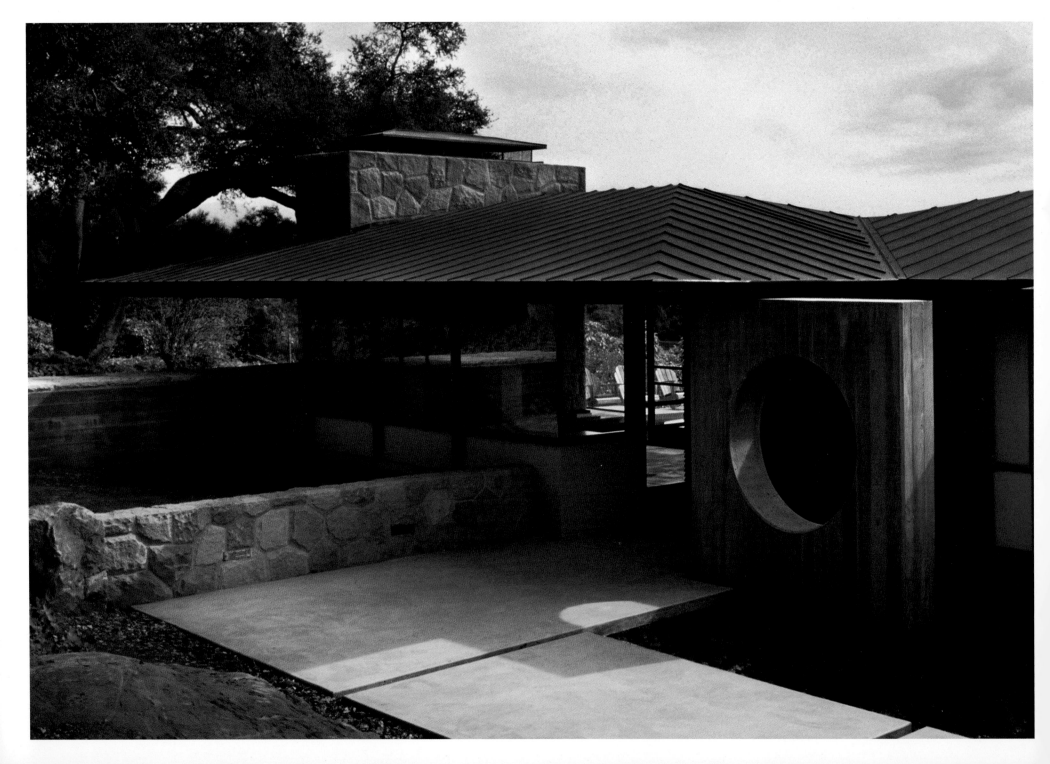

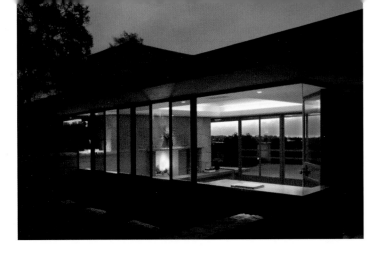

El rito de Wright

Casa de invitados

Esta casa de invitados complementa la casa principal ya existente y que fue diseñada en 1938 por un estudiante del colegio Frank Lloyd Wright's Taliesin. Como respuesta, el nuevo edificio desarrolla su propio lenguaje que evita intencionadamente la confrontación estilística para convencer con el uso de medios modernos. Así dos de las paredes del salón se acristalaron completamente para posibilitar las vistas hacia las cercanas colinas, el viejo almacén de madera y el Pacífico. Esta fusión entre el interior y el exterior se ve acentuada con la pared de la chimenea, que nace en el patio, se extiende por el salón y llega hasta el jardín.

Carpenteria, CA, USA, Shubin + Donaldson Architects, 2004, 74 m²

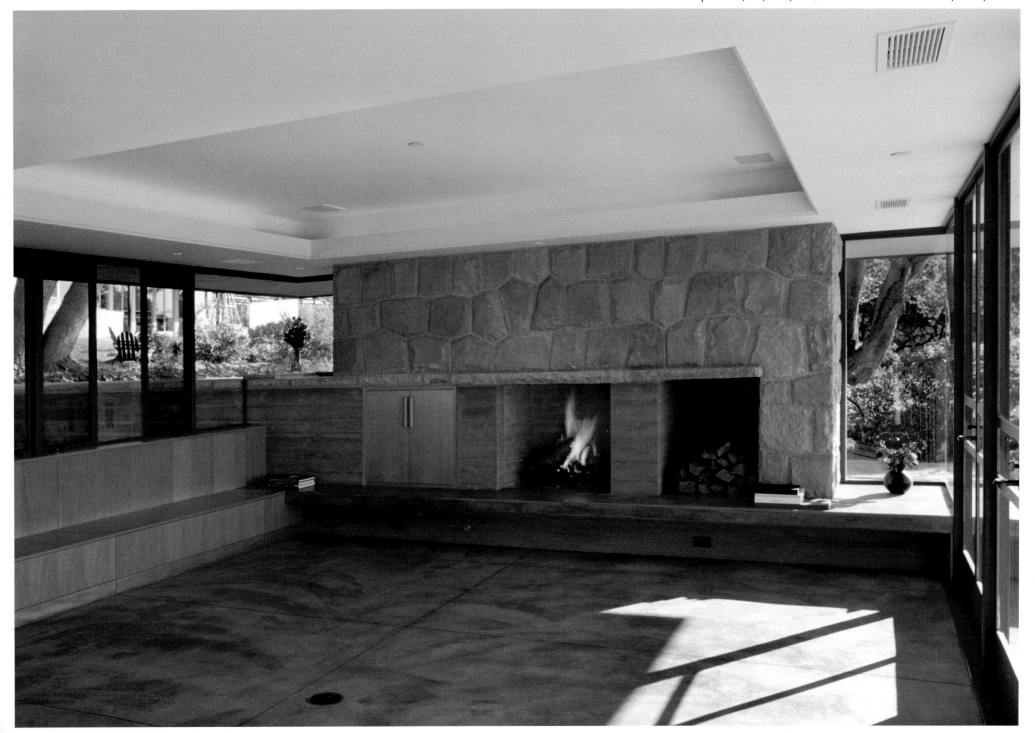

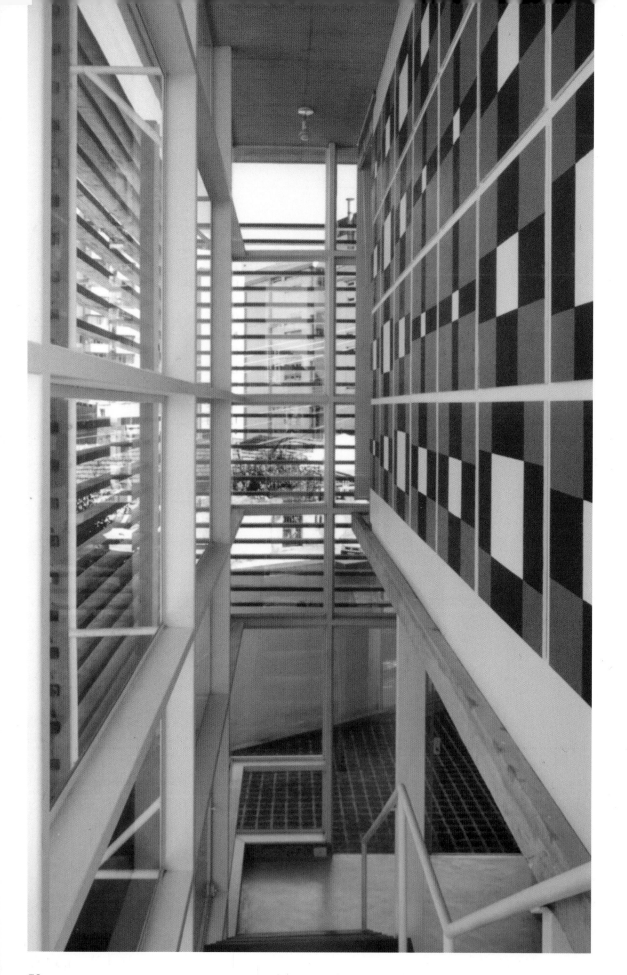

Undecorated Box

Vila Madalena House

This home is comprised of two contrasting volumes – a fully transparent, south-facing living hall and a more enclosed spatial zone with bedroom, kitchen and bathrooms to the north. This dichotomy between transparency and enclosure is emphasized, allowing the small spaces to feel much larger than they are. The gallery wall enclosing the private zone upstairs is used to present a house-wide art installation that creates a visual link between interior and exterior and imbues the small house with generous ambience. Fixed wooden "brise-soleil" slats mounted on the steel frame provide sun protection and filter warm light into the interior.

Vielfältige Kiste

Vila-Madalena-Haus

Das Haus besteht aus zwei sich ergänzenden Volumen: eine transparente, nach Süden gerichtete Wohnhalle und eine geschützte Raumzone im Norden mit Schlafzimmer, Bädern und Küche. Diese Dichotomie zwischen Transparenz und Geschlossenheit wird betont, um die kleinen Räume größer wirken zu lassen. Die Galeriewand, welche die obere Raumzone zur Halle hin abschließt, ist zugleich ein Ort der Kunst. Die hier montierte Installation schafft eine optische Verbindung zwischen Innen und Außen und verleiht dem kleinen Haus Großzügigkeit. Holzlatten vor dem leichten Stahlskelett leisten Sonnenschutz und filtern warmes Licht ins Innere.

Une boîte multiforme

Maison Vila Madalena

Cette maison comprend deux volumes contrastants : un séjour totalement transparent orienté au sud et un espace plus clos comprenant la chambre, la cuisine et la salle de bain au nord. Cette dichotomie entre transparence et enfermement est soulignée de telle sorte que les petits volumes paraissent plus grands qu'ils ne le sont. Le mur/galerie qui sépare la partie privée à l'étage accueille une installation artistique qui crée un lien visuel entre l'intérieur et l'extérieur et imprègne cette petite maison d'une ambiance généreusement accueillante. Des « pare-soleil » fixes en bois montés sur une structure en acier protègent l'intérieur du soleil et de la chaleur.

Caja polifacética

Casa Vila Madalena

Esta casa se compone de dos volúmenes que se complementan: una sala de estar transparente orientada hacia el sur, y una zona con el dormitorio, los baños y la cocina orientada hacia el norte. Esta dicotomía entre la transparencia y el recinto cerrado se acentúa para que los pequeños espacios parezcan más grandes de lo que son. La pared de la galería, que aísla la parte superior de la sala de estar, es al mismo tiempo una superficie para el arte. La instalación que aquí se ha montado crea una unión óptica entre el interior y el exterior y consigue que la casa parezca más espaciosa. Los listones de madera del exterior protegen del sol y filtran una cálida luz hacia el interior.

São Paulo, Brasil,
Nave Arquitetos Associados,
2003, 80 m²

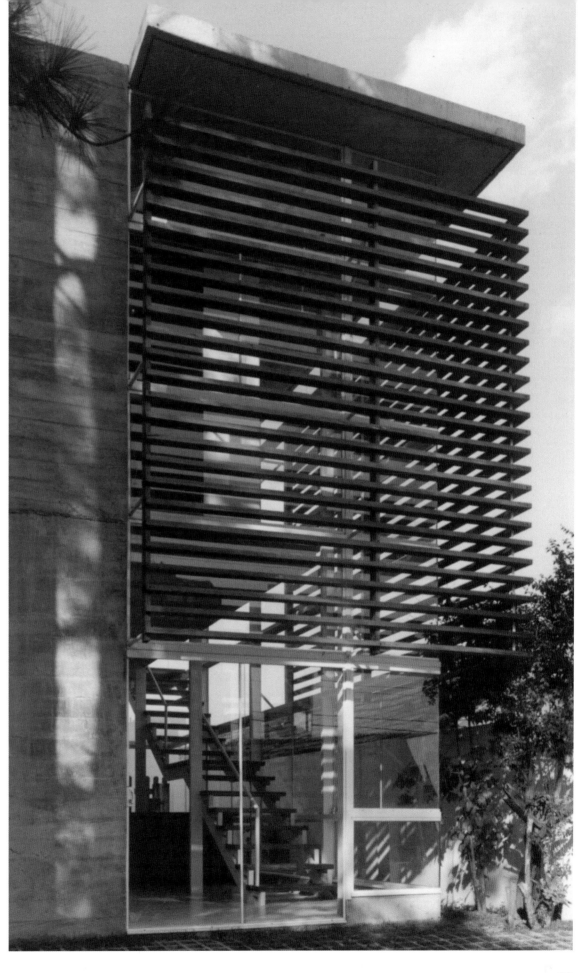

Berlin, Germany,
Nägeli Architekten,
2002, 96 m²

New Memories
Lakeside House
An old, memory-imbued, 1930's summer house on the site was replaced with a new home that effectively transcends the ever present associations of the old. Room sizes and distribution of uses echo those of the razed predecessor. The wood-frame house was erected along the existing foundation line. The wood structure extends to form a pergola that integrates the house with its lakeside surroundings. Red cedar was used for wood sheathing on the exterior. White-stained maple, leather and lacquered surfaces were used to create a maritime atmosphere inside.

Neue Erinnerungen
Haus am See
Ein mit Erinnerungen behaftetes Sommerhaus aus den 1930er Jahren wird durch ein neues Haus ersetzt, das eingeprägte Assoziationen transzendiert. Die Dimensionen und die Disposition der Räume des abgebrochenen Hauses wurden weitgehend erhalten. Das Holzhaus folgt sorgfältig den vorhandenen Fundamenten. Die Holzkonstruktion setzt sich im Freien in einer Pergola fort, die das Haus mit der umliegenden Seenlandschaft verbindet. Die Außenhülle besteht aus Zedernholz, die Oberflächen im Innern aus weiß lasiertem Ahorn, Leder und farbig lackierten Oberflächen.

Un souvenir tout neuf
Maison en bord de lac
Une ancienne maison des années 1930, noyée dans la mémoire, a été remplacée sur ce terrain par une nouvelle habitation qui transcende en fait des souvenirs toujours présents. La taille et la distribution des pièces reproduisent celles de la maison rasée. Cette maison à structure en bois a été bâtie sur les anciennes fondations. Cette structure se prolonge par une pergola qui assure la transition avec l'environnement lacustre. Le revêtement extérieur est en cèdre rouge. Le bois d'érable cérusé, le cuir et les surfaces laquées concourent à la création d'une ambiance marine à l'intérieur.

Nuevas memorias
Casa del Lago
Una vieja casa de verano llena de recuerdos y construida en la década de 1930 ha sido sustituida por una nueva que transciende las siempre presentes asociaciones con la antigua construcción. Se mantuvieron las dimensiones y la disposición de los espacios de la vieja casa. La estructura de madera respeta los fundamentos ya existentes y se extiende además hasta una pérgola que une la casa con el paisaje del cercano lago. En el exterior se empleó madera roja de cedro, mientras que en el interior se utilizaron la madera de arce con veladura blanca, el cuero y las superficies de diferentes colores para recrear una atmósfera marina.

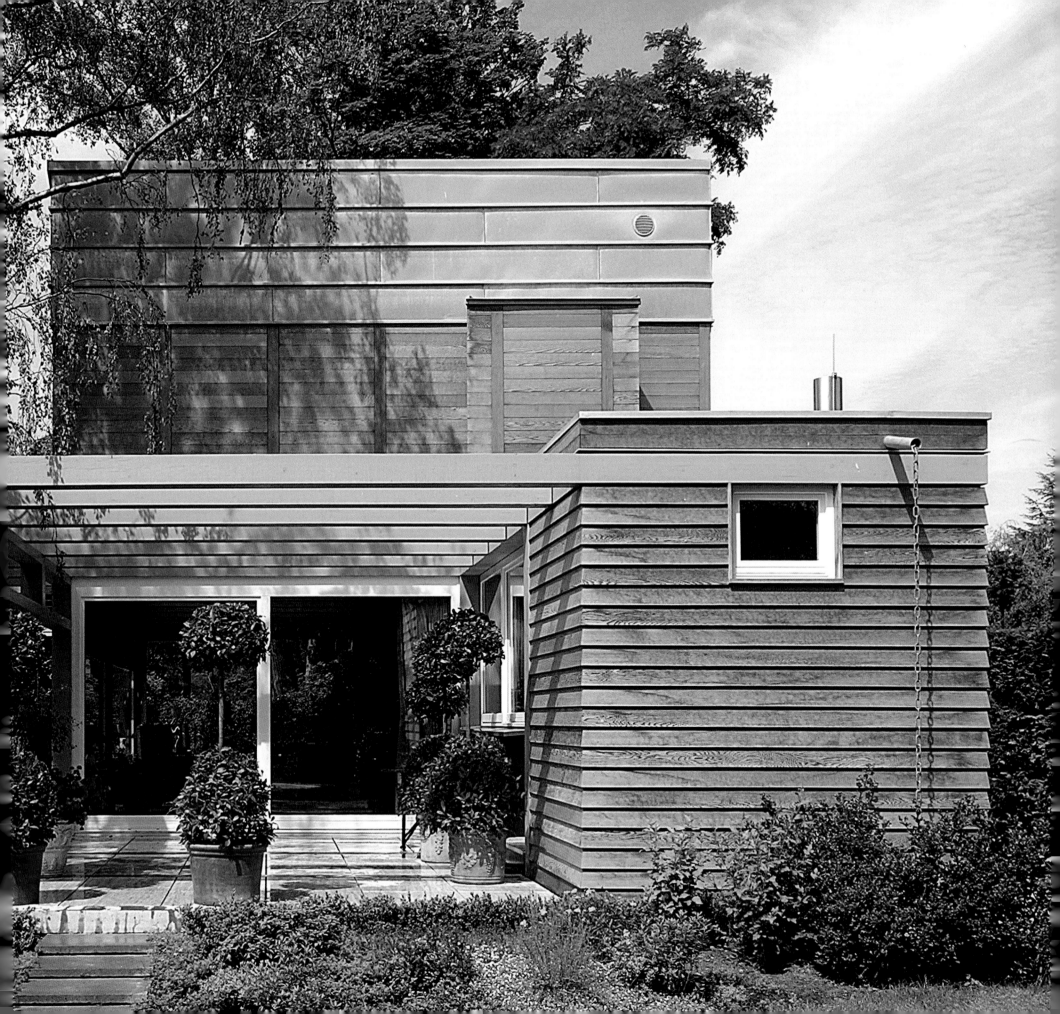

Weekend in Wood

Weekend House

The existing lakeside house was extended with a new wing to create a generous courtyard that opens out to the lake. A two-story winter garden connects the old and new and allows transparent views of the lake from the street. All wood elements – including load bearing walls and floors, ceilings; stairs and furniture – are made of the same material: 2-7 cm thick Finnish pine plywood. The resultant building forms seem as if carved out of single block of wood. Other benefits of this construction system, such as reduction of wall thickness and excellent heat insulation, achieve a sustainable house that also boasts sculptural qualities.

Wochenende in Holz

Wochenend-Haus

Das bestehende Haus am Seeufer wird durch einen winkelförmigen Neubau ergänzt, um einen zum See hin geöffneten Hof zu schaffen. Ein hoher Wintergarten, dessen Transparenz den Seeblick von der Straße aus ermöglicht, bildet das Zwischenglied zwischen Alt und Neu. Alle Holzelemente – tragende Wände, Böden, Treppen und Möbel – sind aus einem Material. Finnische Sperrholzplatten aus Fichte von 2 bis 7 cm Dicke erlauben die Minimierung von Wanddicken bei guten Dämmwerten und verleihen dem Haus eine homogen-massive Wirkung, als wäre es aus einem massiven Holzblock geschnitzt.

Week-end dans le bois

Maison de week-end

La maison existante au bord d'un lac a été agrandie par construction d'une aile en créant une vaste cour donnant sur le lac. Un jardin d'hiver à deux niveaux relie l'ancienne partie à la nouvelle en donnant une vue directe de la rue sur le lac. Tous les éléments en bois sont exécutés dans le même matériau : du contreplaqué de pin de Finlande de 27 mm d'épaisseur, si bien que le bâtiment semble sculpté dans un même bloc de bois. Les autres avantages de ce système de construction, comme la réduction de l'épaisseur des parois et une excellente isolation thermique, confèrent à cette maison des plus agréables des qualités sculpturales.

Fin de semana en madera

Casa de Fin de Semana

La casa que ya existía a orillas del lago ha sido complementada con una nueva construcción angulosa para conseguir un patio abierto hacia el lago. La transparencia de las altas paredes del invernadero permite ver el lago desde la calle y actúa como elemento conector entre lo viejo y lo nuevo. Todos los elementos de madera, como las paredes de carga, los suelos, las escaleras y los muebles, están chapeados con pino finlandés de 2 a 7 cm de grosor. Este material permite que el grosor de las paredes sea mínimo y que el aislamiento térmico sea bueno. Además da a la casa un aspecto masivo como si hubiera sido esculpida de un bloque de madera maciza.

Hornstein, Austria, Stadtgut Architekten, 2003, 99 m²

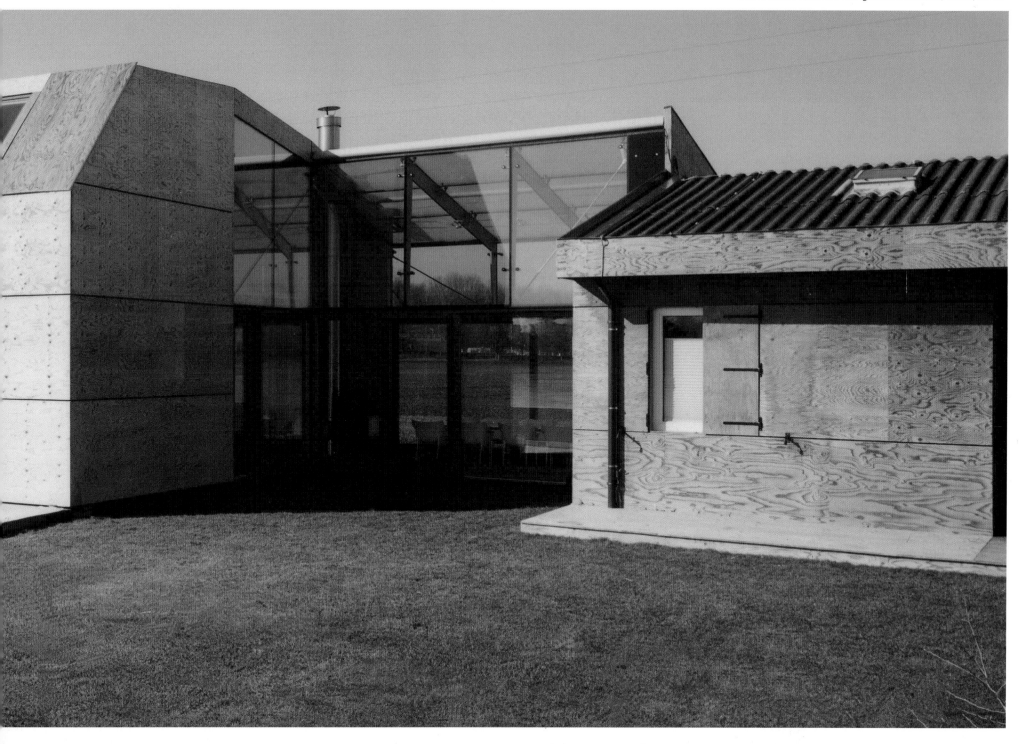

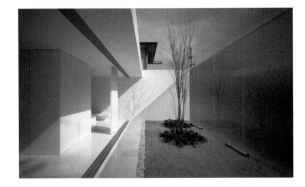

Hiroshima, Japan,
Shinichi Ogawa,
2002, 90 m^2

House, Patio, Court

Abstract House

The place? A non-place that resembles many others on the outskirts of Hiroshima and elsewhere. Nondescript, repetitive suburban "villas" tell their stories of long-yet settled mortgages – tales of architecture are seldom related in such places. In the middle of this endless expanse of monotony one suddenly encounters a blank wall with but a single door opening. Behind it, the intimate world of an introverted patio house awaits. The 8 x 16 meter parcel was all but completely built over with the one-story house. Fully glassed sliding window fronts allow the interior spaces to seamlessly extend into the private garden courtyards.

Haus und Hof

Abstrakt-Haus

Der Ort? Eher ein Unort in einem Viertel wie viele andere am Rande Hiroshimas oder sonstwo. Gesichtslose, sich wiederholende Vorstadthäuser erzählen viel von noch lange nicht abgezahlten Immobiliendarlehen, weniger von Architektur. Inmitten dieses endlosen Meers der Eintönigkeit stößt man plötzlich auf eine blanke Wand mit einer einzigen Türöffnung. Dahinter verbirgt sich die intime Welt eines nach innen gekehrten Patiohauses. Die 8 x 16 Meter große Parzelle wird mit der eingeschossigen Anlage beinah komplett überbaut. Vollverglaste Schiebefensterfronten ermöglichen eine totale Öffnung der Räume in die privaten, nicht einsehbaren Gartenhöfe hinein.

Maison, patio et cour

Maison Abstraction

Où ? Nulle part sinon dans ces banlieues d'Hiroshima ou d'ailleurs, là où d'innombrables « pavillons » sans style ni individualité évoquent d'interminables crédits et nient jusqu'à la notion même d'architecture. Au milieu de cet océan de monotonie, on bute soudain sur un mur aveugle percé d'une unique porte. Par cette porte, on pénètre dans un univers intime, un patio replié sur lui-même. La parcelle de 8 x 16 m a été totalement recouverte par une construction de plain pied. Des baies coulissantes totalement vitrées permettent aux espaces intérieurs de se fondre sans hiatus apparent dans les cours/jardins privées.

Casa y patio

Casa Abstracta

¿El lugar? Más bien un sitio en ninguna parte como tantos otros en la periferia de Hiroshima y de otras ciudades. Las casas, repetitivas y faltas de personalidad, nos cuentan mucho de los préstamos inmobiliarios todavía sin pagar y poco de arquitectura. En medio de este infinito mar de monotonía encontramos de repente una pared desnuda con una única puerta. Detrás de ella se esconde el mundo íntimo de una casa orientada hacia su patio interior. Esta vivienda de un solo piso ocupa casi por completo el solar de 8 x 16 metros. Las fachadas totalmente acristaladas hacen posible que todas las habitaciones se abran hacia el oculto jardín privado.

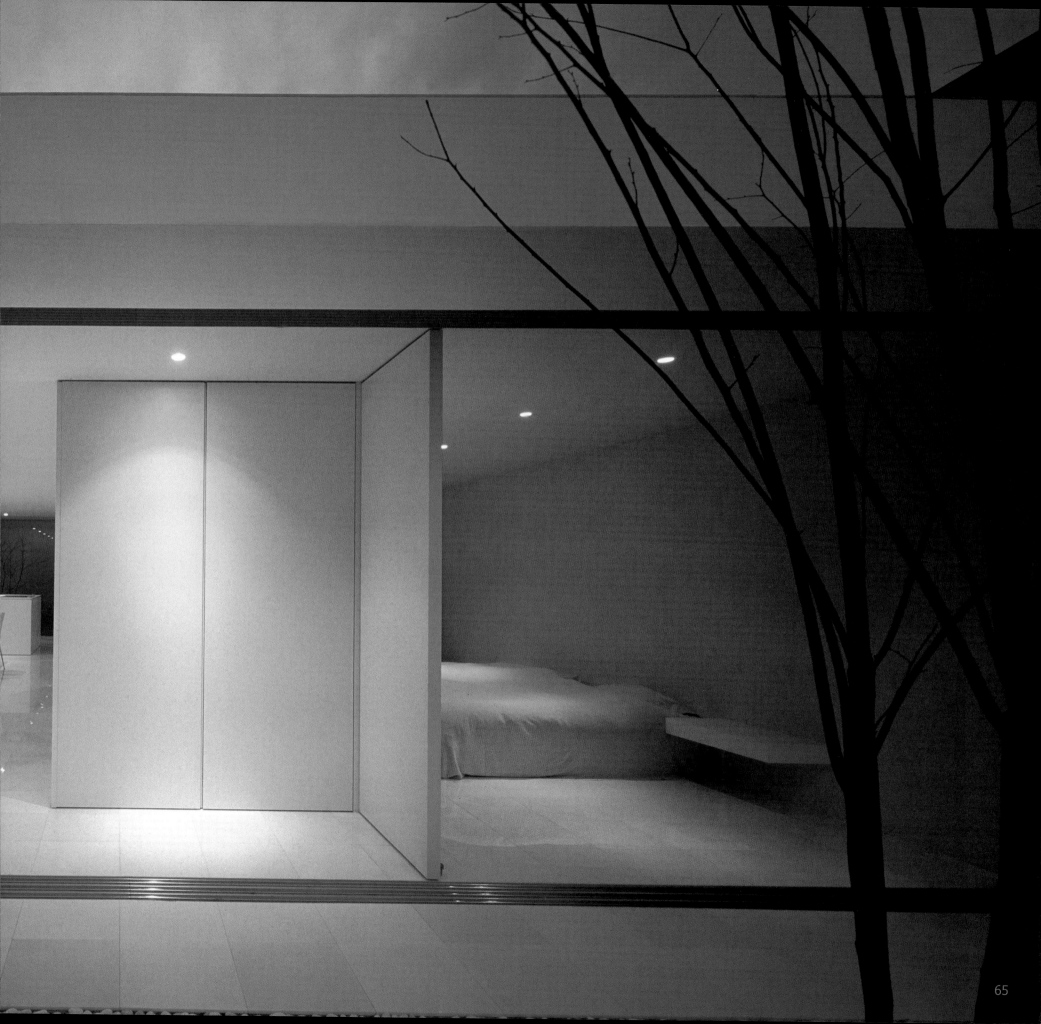

Inside, Outside

Machiya House

Inspired by traditional Japanese elements such as "onsen" outdoor baths and Machiya courtyard houses, the architects created a house where interior spaces extend directly into enclosed private terrace spaces outside. Separated by the courtyard, the living/dining wing is linked to the sleeping/bathroom wing via a glass corridor. It subdivides the courtyard into a patio terrace and a private outdoor bath reminiscent of an "onsen". Sliding cloth canopies in the courtyard allow creating of both intimate outdoor rooms and, when fully opened, a generous terrace connected to the sky.

Innen, Außen

Machiya-Haus

Inspiriert von traditionellen japanischen Elementen wie „onsen"-Naturbädern und Machiya-Hofhäusern schufen die Architekten ein Gefüge nahtlos ineinander übergehender Innen- und Außenräume. Die getrennten Flügel mit Wohn-/Essnutzung bzw. Schlafzimmer/Bad werden über den Hof mit einem gläsernen Korridor verbunden. Dieser definiert eine offene, nicht einsehbare Terrasse und eine private, „onsen"-ähnliche Badezone im Freien. Verschiebbare Stoffbahnen über dem Hof erlauben es, niedrige Außenräume zu schaffen. Wenn sie beiseite geschoben werden, orientiert sich der Hofraum völlig offen zum Himmel hin.

Dedans, dehors

Maison Machiya

Inspirée par des éléments traditionnels japonais comme les bains extérieurs appelés *onsen* et les maisons à cour intérieure *machiya*, les architectes ont créé une maison dont les espaces internes se fondent avec des terrasses privées extérieures fermées. Séparée par la cour, l'aile séjour/salle à manger est reliée à l'espace chambre/bain par un corridor en verre qui sépare la cour en une terrasse patio et un bain extérieur privé rappelant l'*onsen*. Des stores en toile coulissant au-dessus de la cour permettent de créer un volume extérieur intime ou, si on les ramasse totalement, une terrasse largement ouverte sur le ciel.

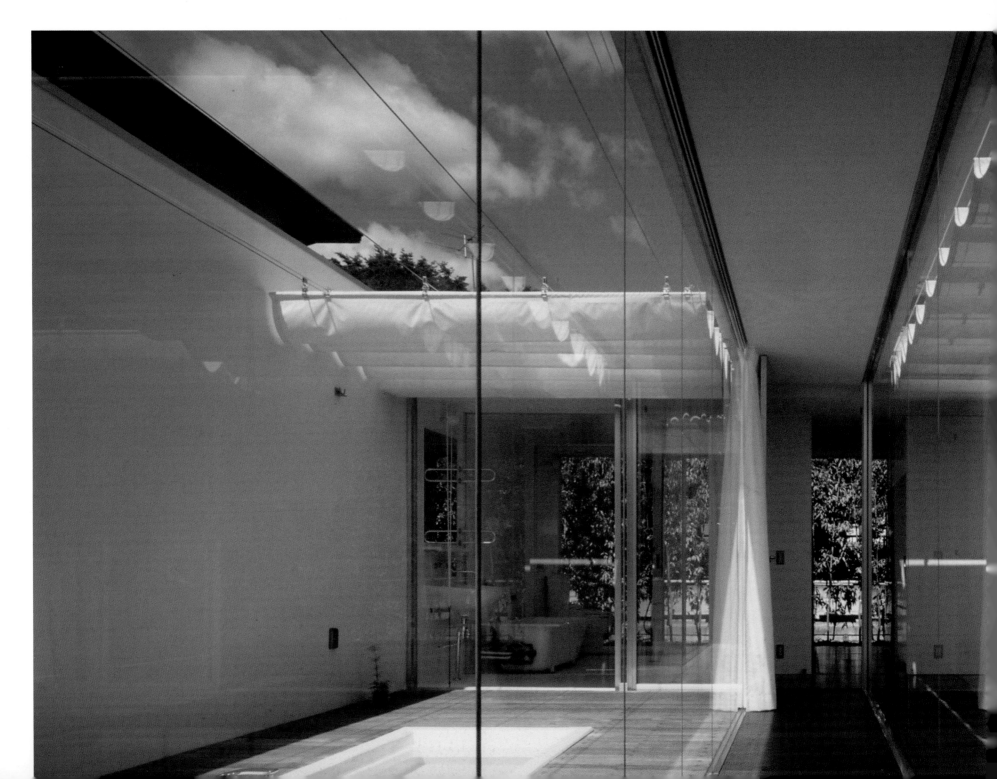

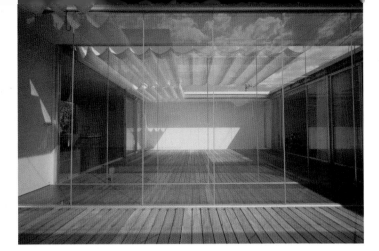

Dentro, fuera

Casa Machiya

Los arquitectos se inspiraron en los elementos tradicionales japoneses como los baños al aire libre "onsen" y las casas con patio Machiya para crear una estructura en la que los espacios interiores y exteriores se mezclan entre sí. Un pasillo acristalado que recorre el patio une las dos alas separadas, en una se encuentra el salón comedor y en la otra los dormitorios y el baño. El corredor de cristal define una terraza no visible y una zona de baños al aire libre similar a un "onsen". Los baldaquines de tela correderos sobre el patio permiten reducir el espacio exterior. Cuando están completamente descorridos el espacio se encuentra completamente bajo el cielo abierto.

Tokyo, Japan, Tezuka Architects, 2000, 99 m²

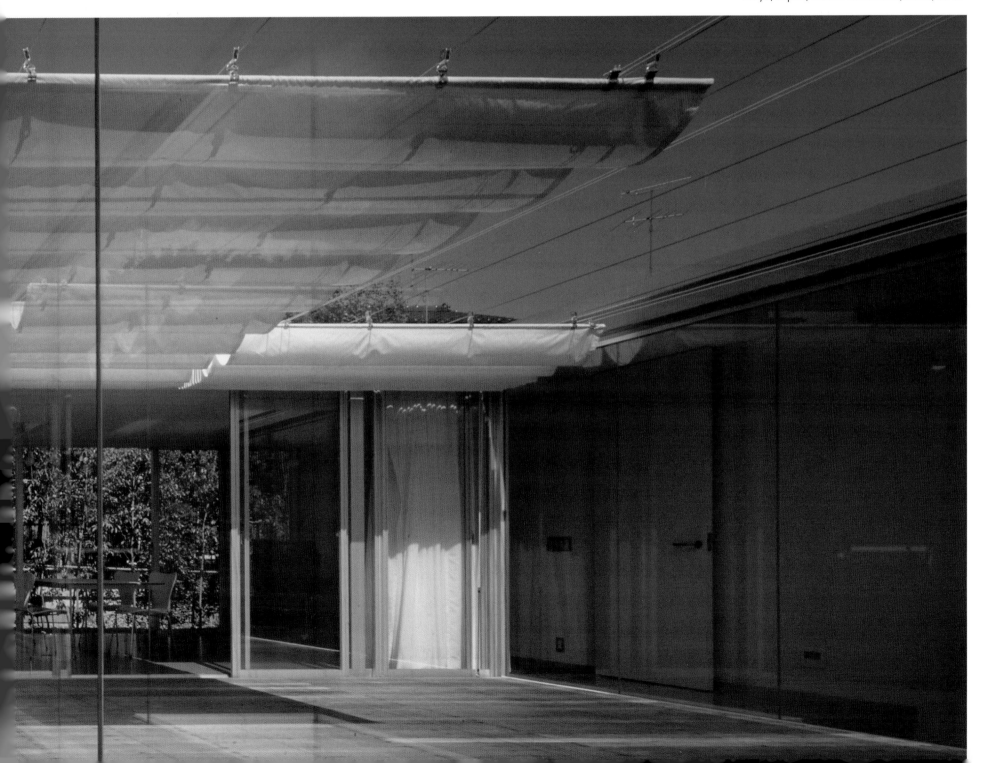

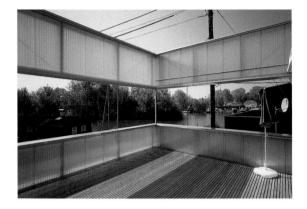

Fussach, Austria,
Josef Fink,
2002, 100 m^2

The Cube Next Door
Boathouse
The brief for designing a boathouse inspired an evocative architecture that seems temporary, light, transparent and mobile. The ground floor integrates an in-house boat moorage. The upper level accommodates the living and sleeping spaces that open via sliding windows onto the large, private deck with its view to the lake and the nearby port. In addition to the concrete used for foundations and boat dock, wood was used extensively, both for the structural frame and as flooring and ceiling material. The translucent polycarbonate siding panels reflect light in the daytime and glow from within at night.

Der Kubus nebenan
Bootshaus
Die Aufgabe, ein Bootshaus am See zu konzipieren, inspirierte zu einer Architektur, die temporär, leicht, transparent und beweglich wirkt. Im Erdgeschoss beherbergt der einfache Kubus einen integrierten Bootsliegeplatz. Im Obergeschoss befinden sich die Aufenthalts- und Schlafräume, die sich über Schiebefenster zur großen, nicht einsehbaren Terrasse mit Blick zum See und zur Hafeneinfahrt öffnen. Neben Beton für die Bootseinfahrt und das Fundament kam Holz für alle Bauteile des aufgeständerten Obergeschosses zum Einsatz. Transluzente Polycarbonatplatten umhüllen den Gebäudekern.

Le cube d'à côté
Maison-hangar
Le cahier des charges pour cette maison-hangar a inspiré une architecture suggérant l'éphémère, la lumière, la transparence et la mobilité. Le rez-de-chaussée comprend un garage à bateau. Le niveau supérieur accueille le séjour et les chambres qui s'ouvrent, par des baies coulissantes, sur un grand pont privé donnant sur le lac et le port voisin. Outre le béton utilisé pour les fondations et le garage à bateau, le bois a été largement employé à la fois pour la structure et les planchers et plafonds. Les panneaux transparents coulissants en polycarbonate renvoient la lumière du jour et s'illuminent de l'intérieur la nuit.

El cubo de al lado
Casa Barco
El encargo de crear una casa barco a orillas de un lago inspiró una arquitectura que parece pasajera, ligera, transparente y móvil. En la planta baja el cubo alberga un amarradero interior integrado. En la planta superior se encuentran los dormitorios y los cuartos de estar que se abren a través de las grandes ventanas correderas hacia la gran terraza privada con vistas al lago y a la entrada del puerto. Aparte del hormigón concreto utilizado para el amarradero y para los cimientos, en el piso superior se ha empleado la madera para todos los elementos estructurales. Planchas translúcidas de policarbonato envuelven el núcleo del edificio.

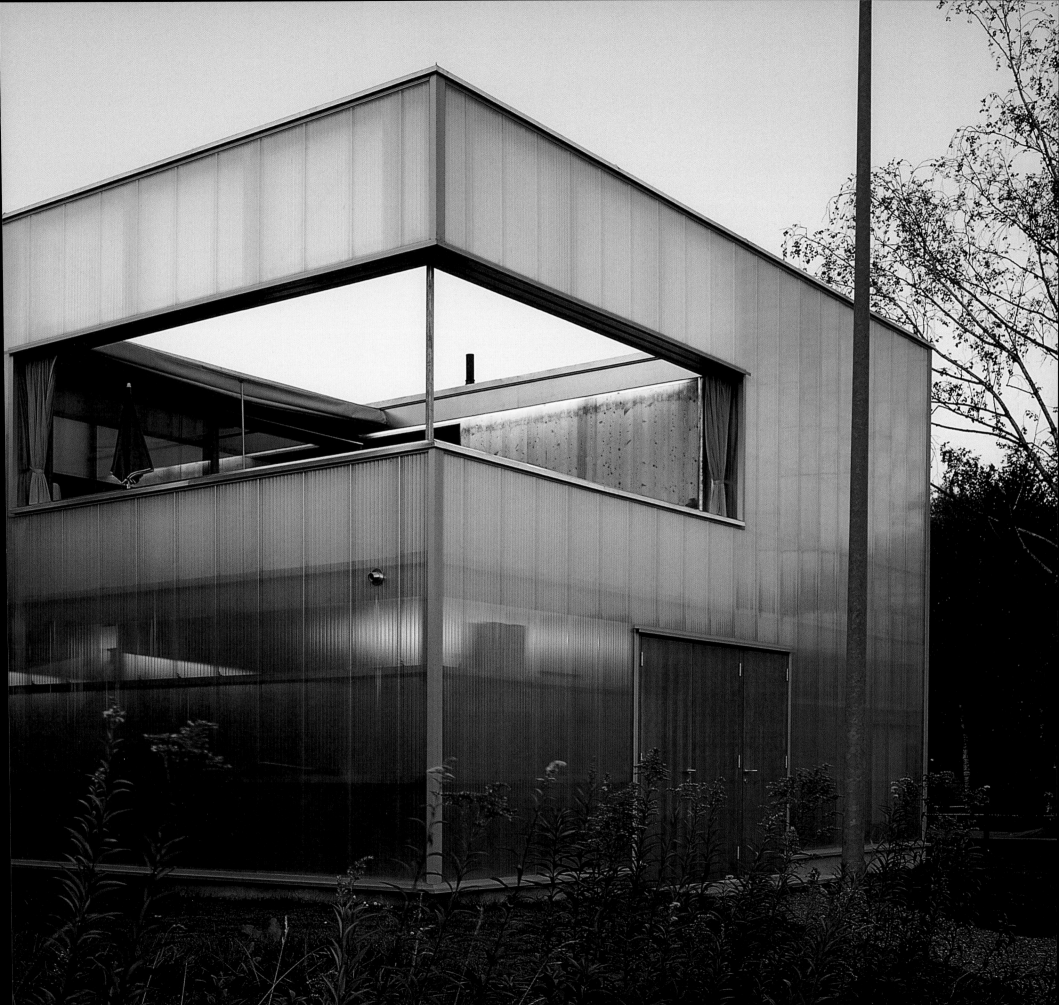

Oundle, Great Britain,
SpaceLabUK,
2002, 100 m²

A House with a View

Westlake House

The low-budget house is designed to be simple, yet elegant, with a large glazed double-height space oriented to views of the English countryside. The living/dining hall becomes the house's light-filled heart. The other spaces open to this hall, allowing natural light to penetrate into what would normally be the darker areas of the house. The main bedroom upstairs overlooks the hall and is an elevated viewpoint onto the landscape panorama. Exterior sheathing is a stained Scandinavian softwood that contrasts with lighter-stained marine plywood infill panels and wraps back into the house to connect external and internal spaces.

Haus mit Ausblick

Westlake-House

Kostengünstig entsteht hier ein einfaches, jedoch elegantes Haus, dessen Organisation um einen zweigeschossigen Hallenraum möglichst ungehinderte Ausblicke in die umgebende englische Landschaft ermöglicht. Die anderen Räume öffnen sich zur Halle hin. Somit erhalten auch diese oftmals dunklen Raumzonen natürliches Licht. Ein großes Schlafzimmer auf der oberen Ebene blickt sowohl in die Halle als auch auf das Landschaftspanorama. Außen kommt lasiertes Weichholz aus Skandinavien zum Einsatz, das teilweise in die Wohnräume geführt wird. Infill-Paneele aus hell-lasiertem Sperrholz bilden einen Kontrast dazu.

Maison avec vue

Maison Westlake

Cette maison à petit budget a été voulue simple, mais élégante avec un volume généreusement vitré sur deux niveaux. L'espace séjour/salle à manger devient le cœur baigné de lumière de la maison. Les autres espaces s'ouvrent sur ce hall en laissant pénétrer la lumière naturelle dans ce qui serait normalement la partie la plus sombre de la maison. La chambre principale située à l'étage surplombe le hall et offre une vue panoramique sur les alentours. L'habillage extérieur en bois tendre de Scandinavie teinté qui contraste avec des panneaux de contreplaqué marine plus clairs se retrouve à l'intérieur de la maison, qu'il unit ainsi plus intimement à son environnement.

Casa con vistas

Casa Westlake

Esta casa de bajo presupuesto se diseñó para que fuera sencilla pero elegante. Su organización alrededor de una sala de dos alturas posibilita la vista libre sobre el paisaje inglés que la rodea. Los otros espacios interiores se abren a la sala. De este modo la luz natural llega también hasta las zonas normalmente oscuras de estas habitaciones. Desde el gran dormitorio en el piso superior pueden verse la sala y el paisaje. En el exterior se ha empleado madera blanda velada de Escandinavia que en algunas ocasiones penetra en el interior. Los claros paneles de relleno de madera contrachapada velada de los espacios interiores contrastan con el exterior.

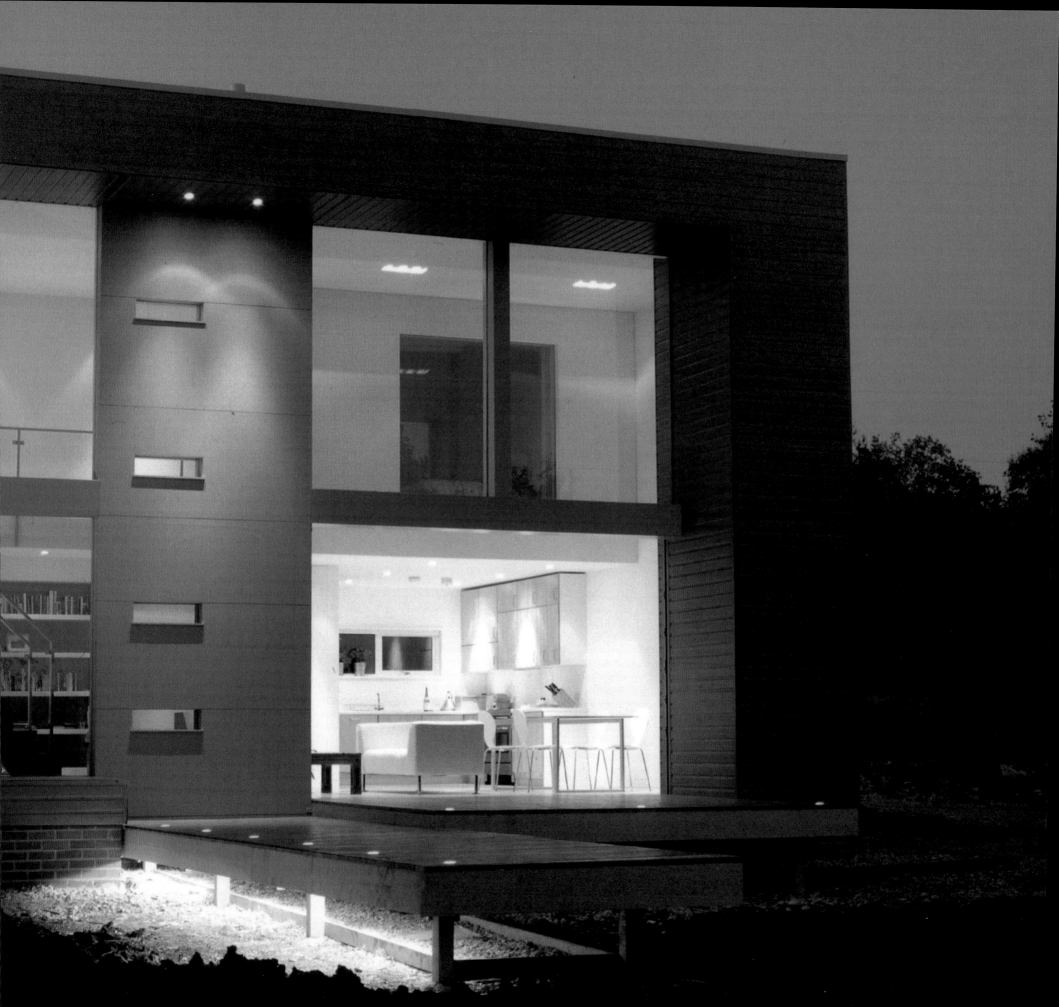

Shock of the New

House in Büren

In a setting dominated by single-family homes with small windows and uniformly pitched roofs, the client asked the architects to create a platform for family life in close proximity to the surrounding natural settings. A massive plinth forms a generous elevated level upon which an open concrete framework with slim, slanting columns is erected. Continuous glazing runs behind the columns, defining the transparent outer containment for the interior living spaces arrayed across the raised platform. Tent-like tarp "roofs" are a creative answer to local building codes requiring pitched roofs.

Provokation des Neuen

Haus in Büren

Wo träge Satteldachhäuser mit kleinen Fenstern die Umgebung prägen und Familien Privatheit in ihren vier Wänden finden, wünschte sich der Bauherr eine Wohnplattform, auf der sich das Familienleben abspielen kann und gleichzeitig der Bezug zur Landschaft immer präsent ist. Auf einem massiven Sockel wird eine offene Betonstruktur aufgebaut, die von verschieden geneigten Betonstützen getragen wird. Eine hinter den Betonstützen durchlaufende Verglasung definiert den Wohnbereich auf der Plattform. Der zeltartige Dachaufbau ist eine kreative Antwort auf die örtlichen Bauvorschriften, die ein „Satteldach" verlangen.

Le choc de la nouveauté

Maison à Büren

Dans un paysage uniforme de maisons individuelles, dotées de petites fenêtres et de toits à double pente, le client a demandé aux architectes de créer une plate-forme de vie familiale intégrée à la nature environnante. Un socle massif constitue un vaste support surélevé sur lequel a été érigée une structure ouverte en béton faite de minces poteaux obliques. Un vitrage continu, qui double ces colonnettes, constitue une frontière transparente entre l'extérieur et les espaces intérieurs distribués sur la plate-forme. Des « couvertures » en toile à la manière de tentes se conforment de manière créative au règlement d'urbanisme local exigeant des toits à deux pentes.

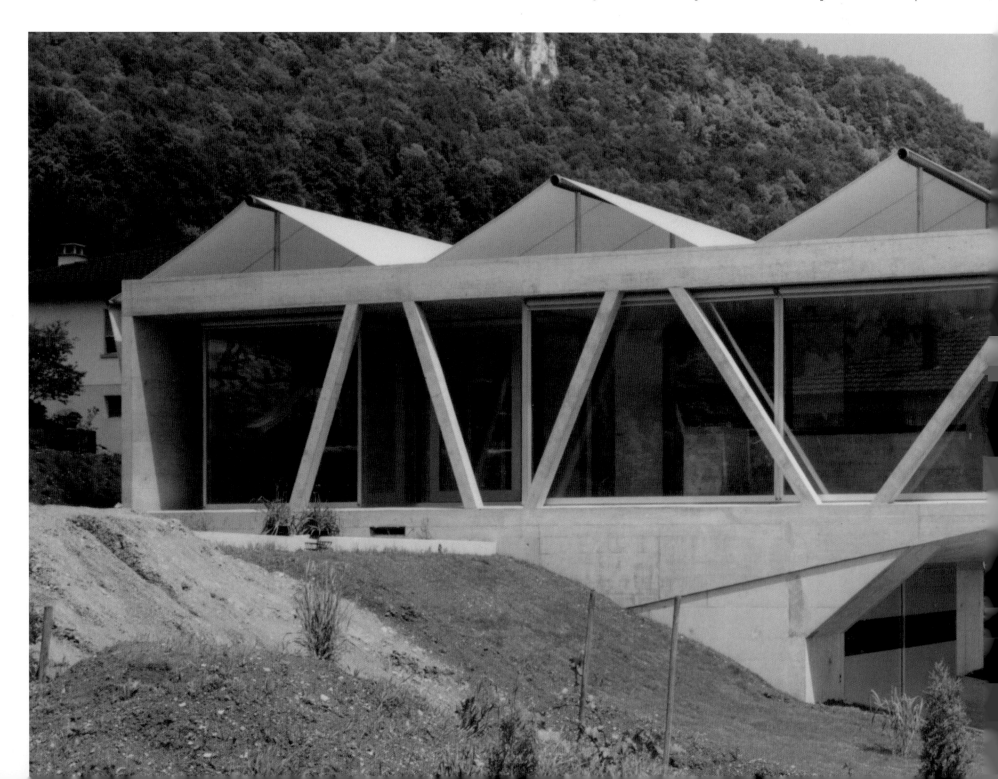

La Provocación de lo Nuevo

Casa en Büren

En un a zona donde predominan las casas con tejados a dos vertientes y pequeñas ventanas para garantizar la privacidad a las familias, el dueño de esta casa deseaba una plataforma en la que se desarrollase la vida familiar y en la que, al mismo tiempo, estuviera siempre presente el paisaje. Sobre un zócalo masivo se levanta una estructura de hormigón que es soportada por unas columnas del mismo material. Una pared acristalada y continua por detrás de las columnas define el espacio del salón. La construcción del tejado, parecida a una tienda de campaña, es una creativa respuesta a las normativas constructoras locales que exigen un tejado a dos vertientes.

Büren, Switzerland, Buchner Bründler, 2001, 100 m²

Work House

Gisinger Fessler Studio

The clients already had a large 1980's house and room left on the site for a small, freestanding new structure. The rectangular plan of the atelier accommodates dual workspaces for a photographer and a painter. The roof level is modulated into three spatial planes. Two of these are raised as skylights to direct natural light emanating from different directions into the building and define two subspaces within the whole. Steel, with its characteristic red rust patina, serves as the predominant exterior material. Inside, ever-changing natural light, white walls and dark pavement on the floors create an atmosphere conducive to creativity.

Haus zum Arbeiten

Atelier Gisinger-Fessler

Die Bauherren hatten ein großes Haus aus den 1980er Jahren und noch freien Platz auf dem Grundstück für einen kleinen, freistehenden Neubau. Das Atelier für einen Fotografen und eine Malerin wird auf einem einfachen, rechteckigen Grundriss entwickelt. Auf der Dachebene wird dieser in drei Ebenen aufgeteilt. Zwei davon werden als Oberlichter angehoben, die natürliches Licht aus verschiedenen Himmelsrichtungen in das Gebäude führen. Stahl mit einer natürlichen Patina aus rotem Rost ist das prägende Außenmaterial. Im Inneren bestimmen helles Licht, weiße Wände und der dunkle Estrich des Bodens das kreative Ambiente.

Maison d'activités

Studio Gisinger Fessler

Les clients qui possédaient déjà une grande maison des années 1980 avaient encore du terrain disponible pour une nouvelle construction indépendante. Le plan rectangulaire de l'atelier comporte deux espaces de travail pour un photographe et un peintre. Le toit est modulé selon trois plans. Deux d'entre eux sont surélevés sous forme de baies zénithales qui reçoivent la lumière naturelle de diverses directions et définissent deux sous-espaces dans le bâtiment. L'acier constitue l'habillage extérieur principal. À l'intérieur, l'évolution de la lumière naturelle, la blancheur des murs et les sols sombres créent une atmosphère propice à la création.

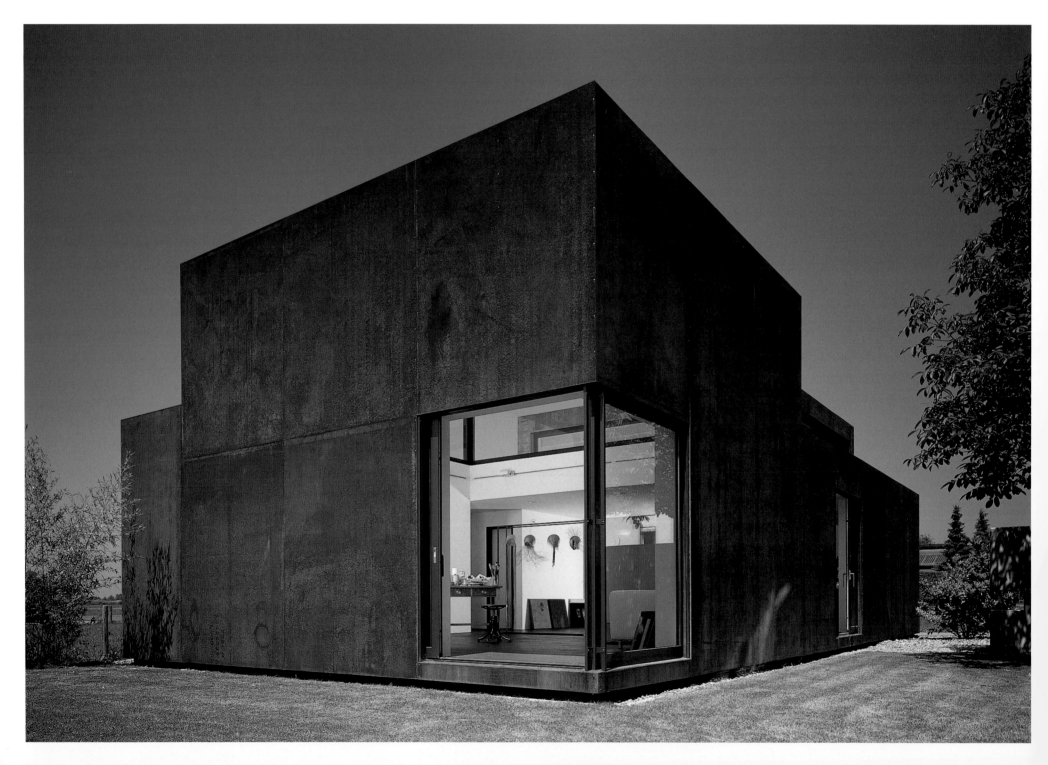

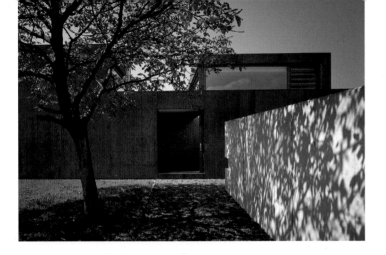

Casa para trabajar

Estudio Gisinger Fessler

Los dueños tenían una gran casa de la década de 1980 y espacio suficiente en el solar como para construir una pequeña edificación exenta. El taller para un fotógrafo y una pintora se desarrolla sobre un sencillo plano rectangular. El piso de la buhardilla se ha modulado en tres planos espaciales. Dos de ellos se han elevado como claraboyas para dejar pasar la luz natural desde las diferentes orientaciones. El acero, con una patina de óxido rojo, es el material predominante en el exterior. En el interior la luz clara natural siempre cambiante, las paredes blancas y el pavimento oscuro del suelo consiguen un ambiente que induce a la creatividad.

Lauterach, Austria, Philip Lutz, Christian Prassler, 2001, 100 m²

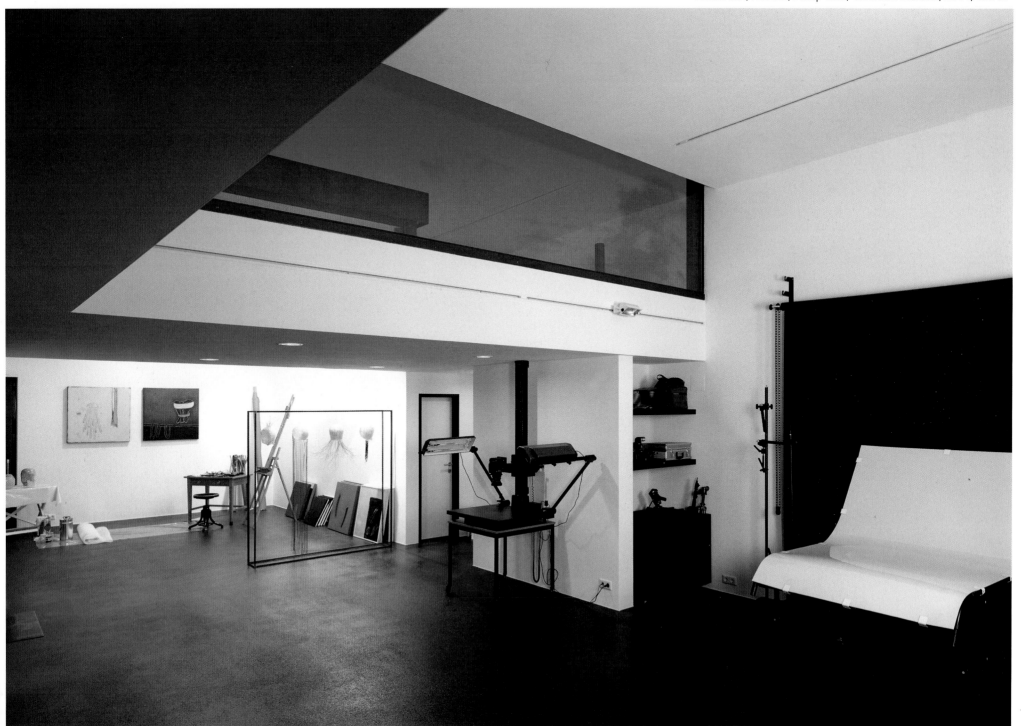

Activated Lot

Moosmann/Hämmerle House

This home for a young family utilizes a tight parcel right next door to one of the clients' parents' house. Site topography allows for direct streetside access into the upper living level. The lower level, dug in one meter into the gentle slope, houses the bedrooms and main bathroom. The upper level is constructed in pre-fabricated wood framing elements, whereas the more massive lower level is built of concrete. Optimal insulation, coupled with passive ventilation and heat recovery technology, allows the house to attain excellent energy consumption values that make a real difference in snowy Alpine winters.

Aktivierter Baugrund

Moosmann/Hämmerle-Haus

Dieses Haus für eine junge Familie wurde auf einem Grundstück neben dem Elternhaus der Bauherrin erbaut. Die abfallende Topographie ermöglicht den direkten Zugang zur Wohnebene von der Straßenebene aus. Im unteren Geschoss, einen Meter unter Gartenniveau gelegen, befindet sich die Schlafzone. Das Obergeschoss ist in Holzbauweise errichtet, das Untergeschoss aus Stahlbeton. Mit der optimiert gedämmten Gebäudehülle in Kombination mit Komfortlüftung und Wärmerückgewinnung erreicht das Haus annähernd Passivhaus-Energiewerte, was in schneereichen alpinen Wintern zu deutlichen Energieeinsparungen führt.

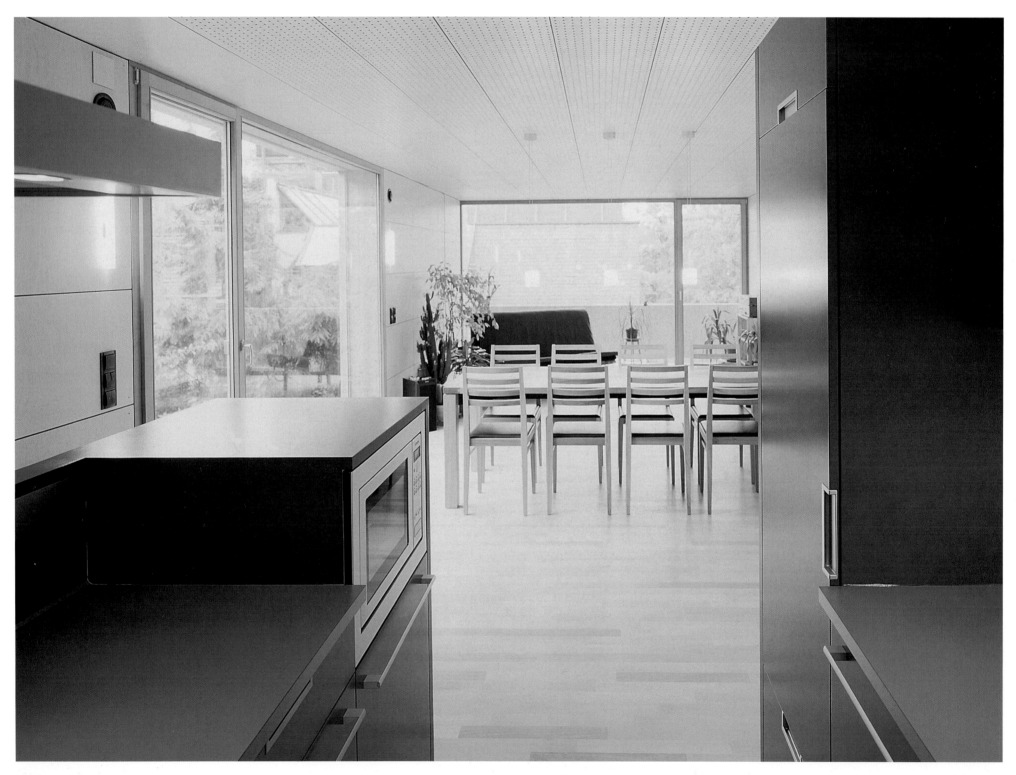

Lieu d'activités

Maison Moosmann/Hämmerle

Cette maison destinée à une jeune famille utilise un terrain exigu adjacent à celui de l'un des parents des clients. La topographie des lieux permet d'accéder directement depuis la rue au niveau d'habitation supérieur. Le niveau inférieur, enfoncé d'un mètre dans la pente, regroupe les chambres et la salle de bain principale. Le niveau supérieur est construit en éléments de bois préfabriqués, tandis que le niveau inférieur, plus massif, est en béton. Une isolation très étudiée associée à une ventilation passive et à des techniques de récupération de chaleur concourent à réduire au minimum les dépenses en énergie très importantes dans ces régions alpines en hiver.

Solar activado

Casa Moosmann/Hämmerle

Esta casa para una joven familia se levantó al lado de la casa paterna de la mujer. La topografía en declive hace posible la entrada directa al nivel del salón desde la calle. En el piso de abajo, situado a un metro por debajo del nivel del jardín, se encuentra la zona destinada a los dormitorios. La estructura del piso superior está realizada en madera, y la del piso inferior en hormigón concreto. La combinación entre un recubrimiento exterior aislante con una ventilación pasiva y la tecnología de recuperación del calor permite que la casa tenga unos excelentes niveles de consumo energético que hace incluso posible el ahorro en el nevado invierno alpino.

Lauterach, Austria, ArchitekturBüro Hermann Kaufmann, 2002, 103 m²

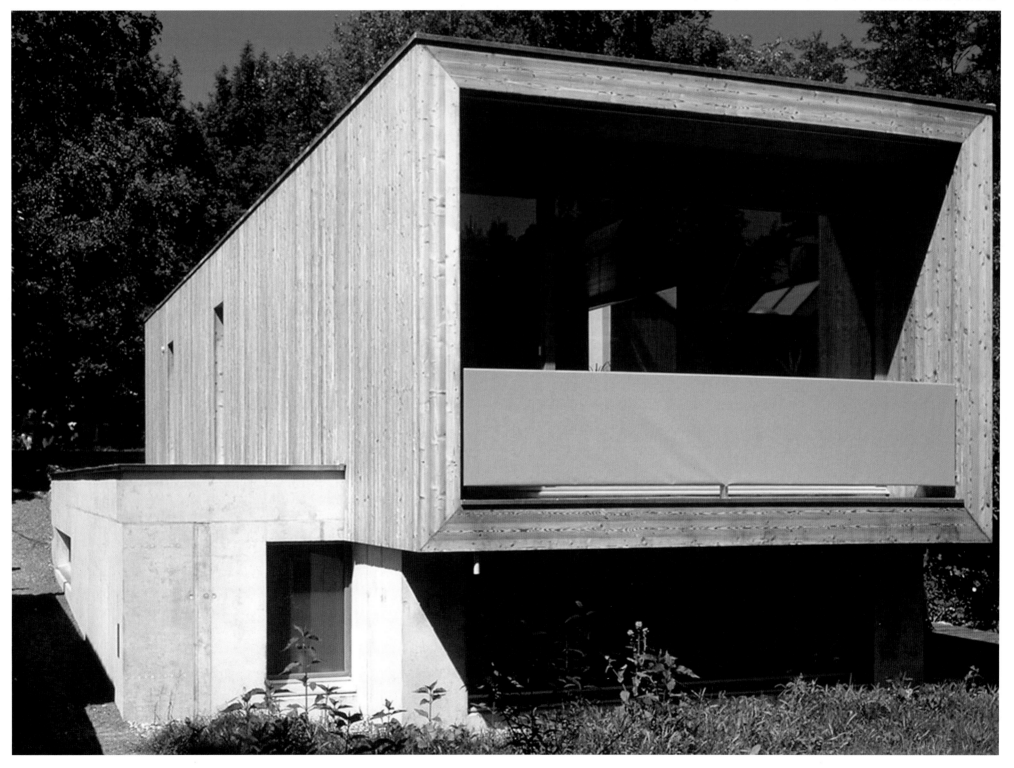

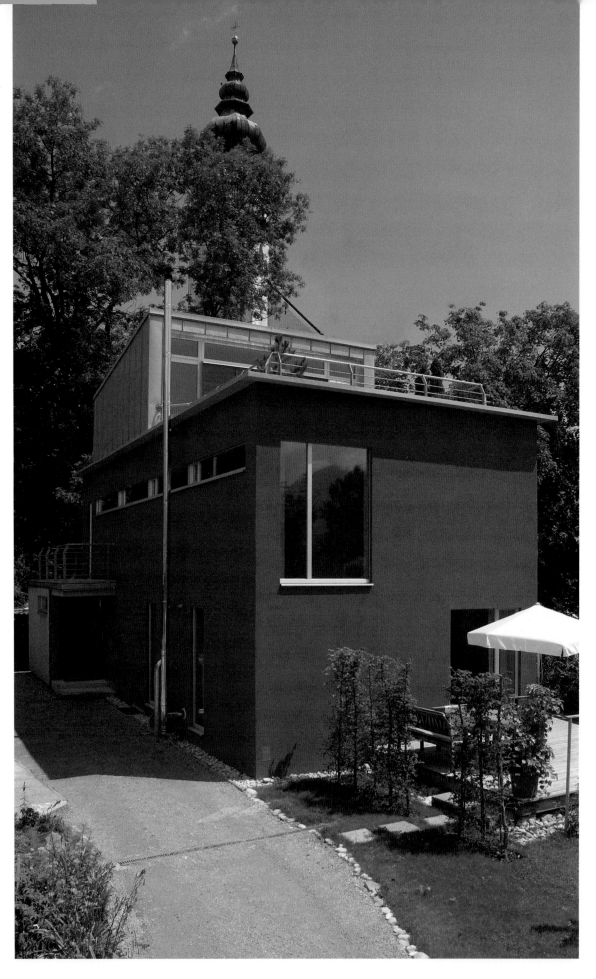

One House, Three Terraces
House in the Trees
The natural characteristics of a site located in a transitional zone between the city center and an adjacent stream generated the design of this energy-efficient home for a four-person household. The rooftop studio opens onto two terraces – the southern-oriented sundeck and a more secluded, shaded terrace high in the tree crowns. The wood-frame construction is finished in colorful red stucco. Green technology such as earth thermal cooling, solar panels and the wood pellet furnace effectively lower consumption of primary energy resources and energy costs.

Ein Haus, drei Terrassen
Baumhaus
Die landschaftlichen Besonderheiten auf einem schmalen, lang gestreckten Grundstück zwischen Stadtzentrum und Bach beeinflussten den Entwurf für das Vierpersonenhaus. Der kompakte Baukörper öffnet sich im Dachgeschoss nach Süden, die Nordterrasse bietet im Gegensatz dazu einen schattigen Sitz in den Baumkronen. Das Haus wurde in Holzriegelbauweise mit verputzten Wandoberflächen errichtet. Ökologische Maßnahmen wie eine Wohnraumlüftung mit Erdkollektor, Wandsonnenkollektoren und Holzpellet-Heizanlage erzielen zudem eine effektive Senkung des Bedarfs an Primärenergien.

Une maison, trois terrasses
Maison dans les arbres
Les caractéristiques naturelles de cette parcelle située dans une zone de transition entre le centre-ville et un cours d'eau ont a présidé à la conception de cette habitation pratique destinée à une famille de quatre personnes. Le studio sur le toit donne sur deux terrasses : l'une orientée au soleil du sud, l'autre plus intime, abritée par les cimes des arbres voisins. La structure en bois est revêtue d'un stuc de couleur rouge. Des techniques « vertes » pompe á chaleur, panneaux solaires et poêle á bois contribuent à réduire la consommation des ressources énergétiques primaires, donc les coûts d'habitation.

Una casa, tres terrazas
Casa del árbol
Las características naturales de un estrecho solar alargado situado en una zona de transición entre el centro de la ciudad y un arrollo, influyeron en el diseño de esta casa para cuatro personas. El cuerpo compacto de la construcción se abre en el piso superior hacia el sur, mientras que la otra terraza orientada hacia el norte ofrece un lugar a la sombra en las coronas de los árboles. La construcción con estructura de madera está terminada con un colorido estuco rojo. Las medidas ecológicas, como la ventilación de las estancias con un colector de tierra, los colectores solares y la calefacción con pastillas de madera, reducen el consumo de energías primarias.

Salzburg, Austria,
Simon Speigner - sps architekten,
2001, 112 m²

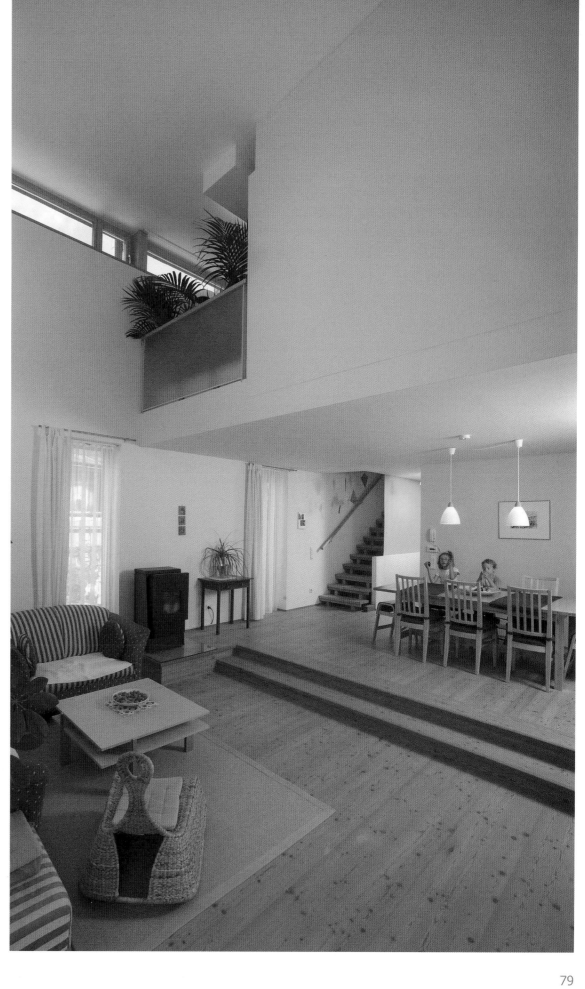

Chicago, IL, USA,
EHDD Architecture,
2003, 114 m²

The Green Red House

Factor 10 House

The Factor 10 House strives to reduce environmental impacts by a factor of 10 compared to the average home built in the U.S. today. Energy-efficient features, such as the passive ventilation system, solar chimney, and sod roof, reduce both environmental impact and living expenses. The solar chimney at the center of the home houses the staircase and brings light to the core of the house, reduces artificial lighting and minimizes mechanical ventilation. This shaft pulls warm air up and out of the house in the summer, pushing it down in the winter. Materials were chosen with regard to life span and production impact.

Das grüne, rote Haus

Faktor-10-Haus

Das Faktor 10 Haus ist bestrebt, Energiebedarf und Umwelteinwirkung um ein 10-faches – verglichen mit dem heute üblichen Haus in den USA – zu reduzieren. Es integriert energiesparende Maßnahmen wie natürliche Belüftung, einen Solarkamin und ein wärmedämmendes Gründach. Der Solarkamin, zugleich Treppenkern, führt natürliches Licht in die Tiefe und ermöglicht den Verzicht auf Kunstlicht und mechanische Entlüftung. Dieser Schacht zieht im Sommer warme Luft aus dem Haus, behält sie jedoch im Winter. Sämtliche Materialien wurden hinsichtlich ihrer Lebensdauer und Umweltverträglichkeit ausgesucht.

La verte maison rouge

Maison Factor 10

Factor 10 House vise à réduire l'impact sur l'environnement par un facteur 10 par rapport à la moyenne des habitations construites actuellement aux États-Unis. Des équipements peu gourmands en énergie tels qu'un système de ventilation passive, une cheminée solaire et un toit recouvert de terre limitent à la fois l'impact sur l'environnement et les coûts d'habitation. Placée au centre de la maison, la cheminée solaire, qui intègre l'escalier, introduit la lumière au cœur du bâtiment, réduit l'usage de l'éclairage artificiel et remplace partiellement la ventilation mécanique. Les matériaux ont été choisis pour leur tenue dans le temps et leur caractère écologique.

La casa verde y roja

Casa Factor 10

Con la Casa Factor 10 se quiere reducir a la décima parte el consumo de energía y el impacto medioambiental característicos de las casas estadounidenses actuales. Para ello se han tomado diferentes medidas como la ventilación natural, una chimenea solar y un tejado verde termoaislante. La chimenea solar, que a la vez es el núcleo de la escalera, permite el paso de la luz natural hasta abajo haciendo innecesaria la necesidad de luz artificial y de ventilación mecánica. Este conducto deja que el aire caliente salga al exterior en verano conservándolo en el invierno. Los materiales fueron escogidos por su durabilidad y compatibilidad con el medio ambiente.

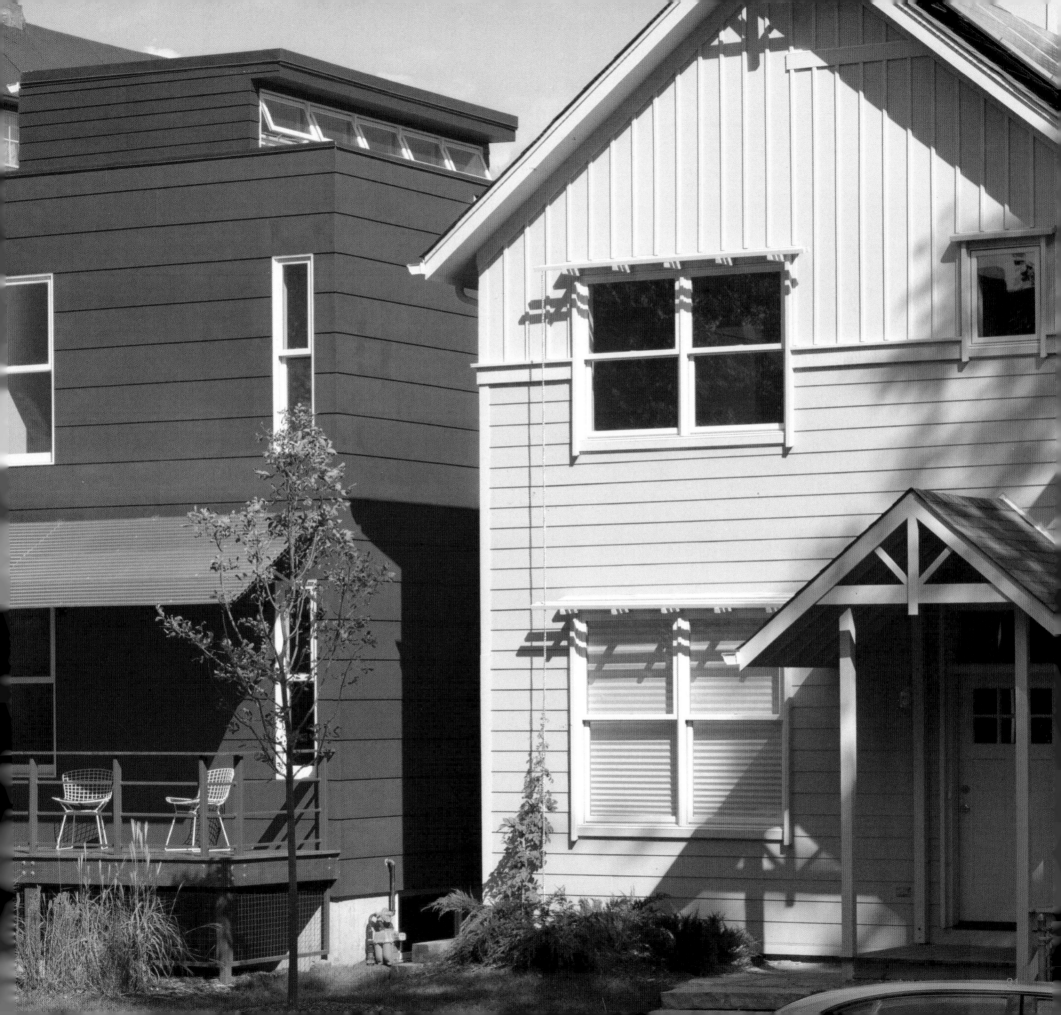

A Stage for Nature

Misonou House

Rolling hills and open fields form the backdrop for this house. To take advantage of a unique site seldom found in densely settled Japan, this home forms a stage for the adjacent natural setting. Its mass hovers above the ground floor, forming covered indoor and outdoor zones that allow the living spaces to merge with the surrounding landscape. The windows slide open to give an unimpeded view in and out. The far-spanning cantilevers of the upper levels allow column-free corners on the ground floor and emphasize the blur of the building mass with both the horizon and heavens.

Bühne für die Natur

Misonou-Haus

Sanfte Hügelketten, offene Felder am Rande eines Siedlungskörpers: Um die im dicht besiedelten Japan kostbare Lage optimal auszunutzen, wird das Haus als Bühne für den Naturraum konzipiert. Seine Masse schwebt über dem Terrain und bildet im Erdgeschoss überdachte Bereiche, die mal innen, mal außen, eine Verschmelzung der Wohnräume mit der umliegenden Landschaft bewirken. Hier lassen sich die Fensterfronten mittels Schiebeschienen gänzlich öffnen. Weite Auskragungen der Obergeschosse darüber erlauben stützenfreie Ecken und die optische Verzahnung der Baumasse mit der Umgebung.

Une scène pour la nature

Maison Misonou

Des collines ondoyantes et des champs ouverts à proximité d'une agglomération urbaine. Pour bénéficier d'une situation unique rarement trouvable dans un Japon surpeuplé, cette maison offre une scène face au paysage naturel adjacent. Sa masse qui surplombe le rez-de-chaussée recouvre les zones intérieures et extérieures qui permettent aux espaces de vie de se fondre dans le paysage environnant. Le grand porte-à-faux des niveaux supérieurs qui a permis la suppression partielle de piliers porteurs au rez-de-chaussée accentue ainsi la fusion entre le bâtiment, le ciel et l'horizon.

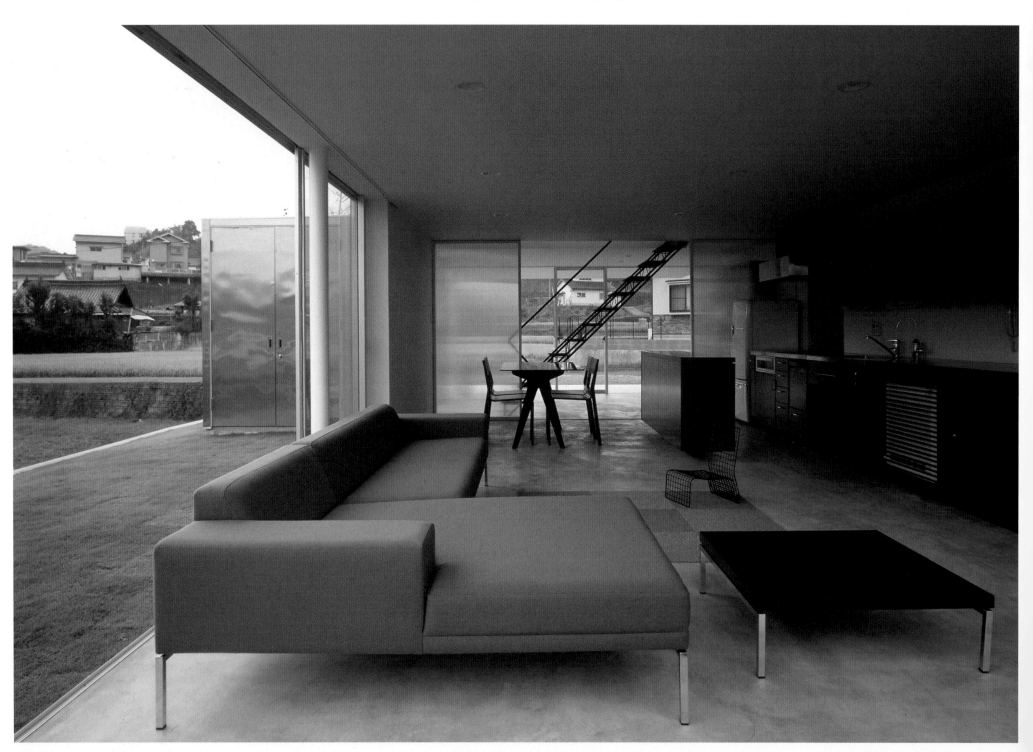

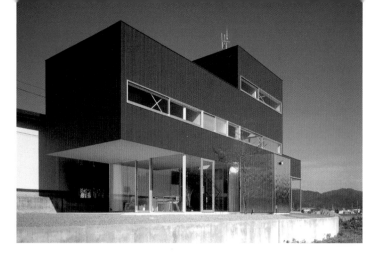

Naturaleza delante del escenario

Casa Misonou

Suaves colinas y campos abiertos en el borde de una urbanización: para poder sacar provecho de esta situación única en el densamente urbanizado Japón, se pensó en la construcción de una casa como un escenario ante la naturaleza. Su masa flota sobre el terreno y forma así en la planta baja una zona techada interior y exterior que permite la fusión entre los espacios interiores con el paisaje circundante. En este piso las fachadas acristaladas pueden abrirse completamente gracias a un sistema de ventanas correderas. Los amplios voladizos de los pisos superiores permiten esquinas libres y la impresión de una unión del edificio con el horizonte y el cielo.

Hiroshima, Japan, Tanijiri Makoto - suppose design office, 2003, 116 m²

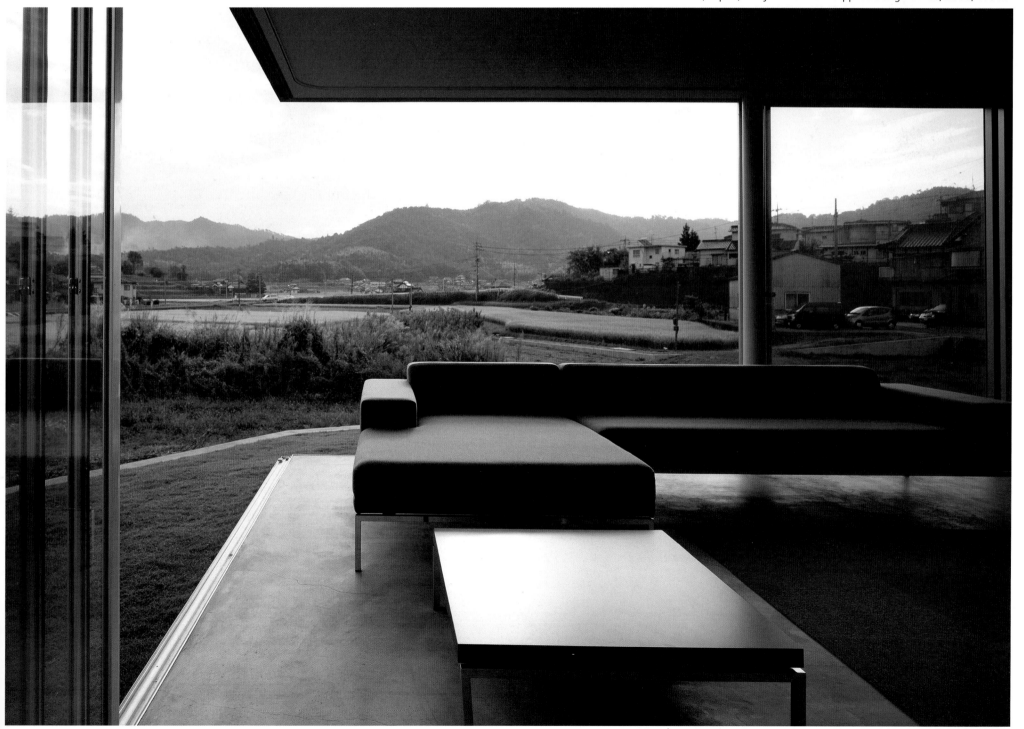

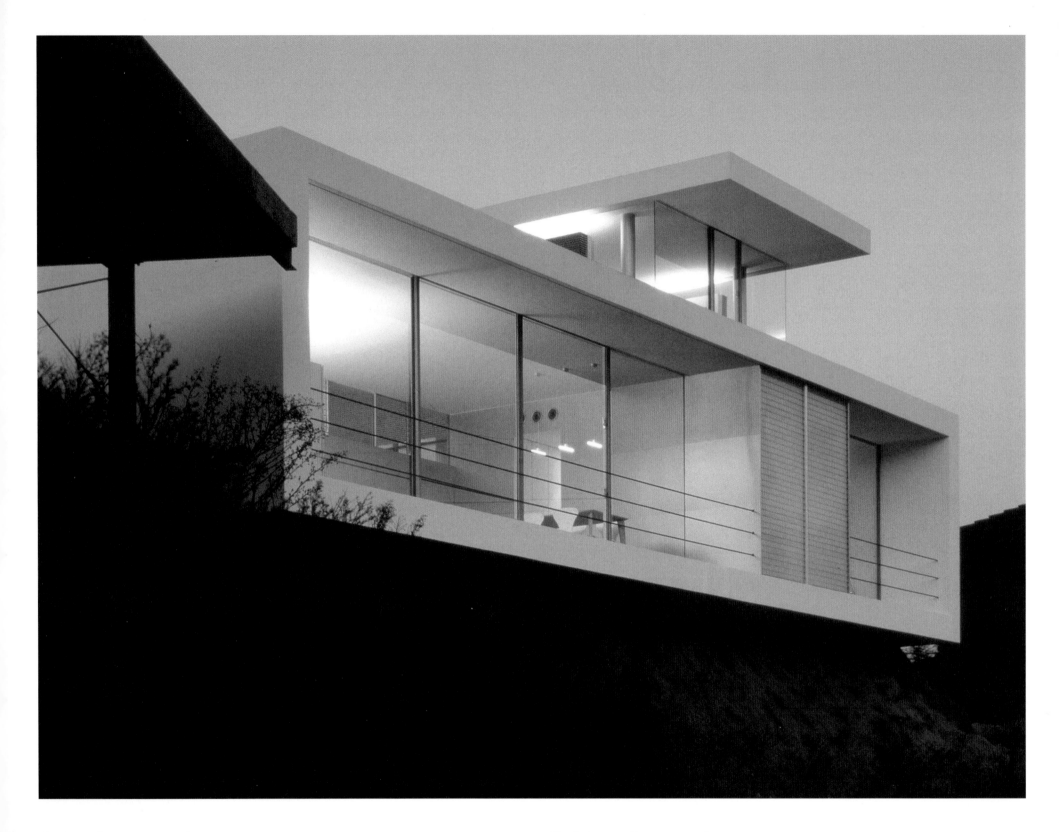

Calm Counterpoint
Y House

This house creates a calm counterpoint to the visual chaos prevalent everywhere today. The spaces are intended to attain a spiritual blend of natural elements – sun, sky and wind – to augment pragmatic functions. Two building masses are clearly delineated: a steel-framed wing facing the street forms a barrier to street noise, while a second wing in painted concrete embraces the steep valley-side slope. Merging with nature is facilitated here via an entirely glazed elevation allowing dramatic views over the nearby valley. The sliding windows here employ frames sunken into the floor and ceiling to achieve maximum transparency.

Ruhiger Gegenpol
Y-Haus

Dieses Haus stellt einen ruhigen Gegenpol zum visuellen Chaos des Alltags her. Die Räume streben eine spirituelle Mischung aus Naturelementen wie Sonne, Himmel und Wind mit der pragmatischen Erfüllung von Funktionen an. Hierzu werden zwei Baumassen vorgesehen: ein Flügel in Stahlrahmenbauweise bildet eine Barriere zum Lärm der Straße, während der zweite Flügel in gestrichenem Beton sich am Hang anfügt und zum Talblick öffnet. Die Fensterrahmen der Schiebefenster werden in den Boden und in die Decke eingesenkt, um maximale Transparenz zu ermöglichen.

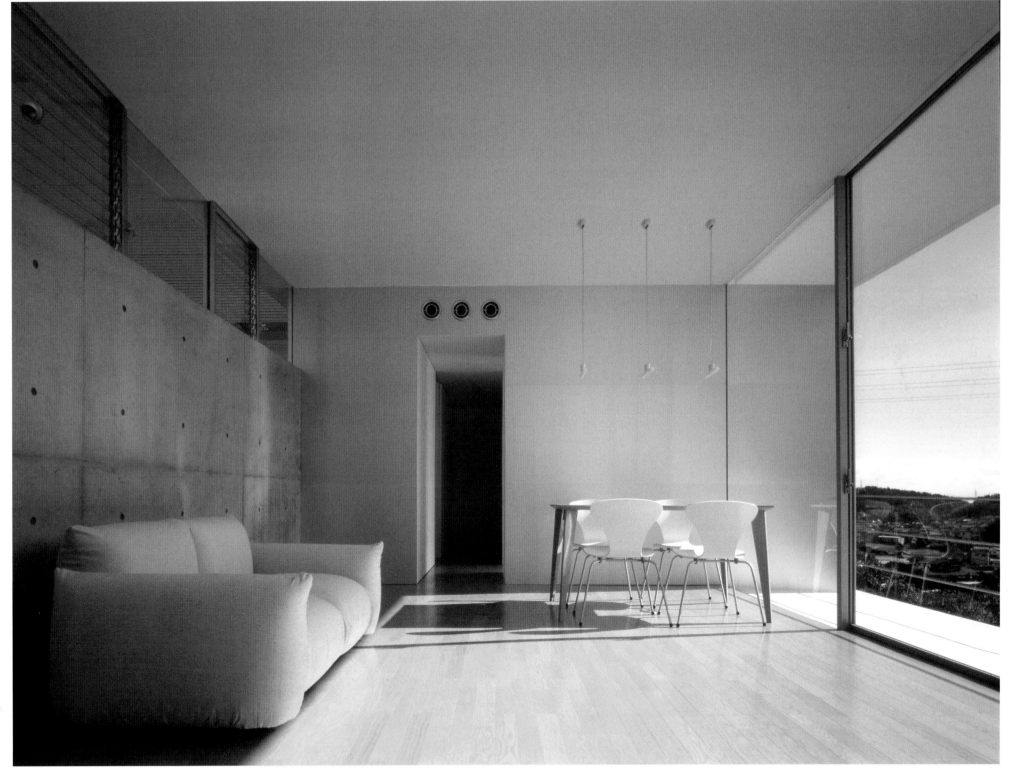

Iwakuni, Japan, Katsufumi Kubota, 1997, 114 m²

Paisible contrepoint

Maison Y

Cette maison crée un paisible contrepoint au chaos visuel omniprésent de nos jours. Les espaces sont conçus de façon à favoriser un mélange inspiré d'éléments naturels – soleil, ciel et vent – renforçant les fonctionnements pragmatiques. Deux masses construites sont clairement délimitées : une aile à structure en acier face à la rue forme une barrière aux bruits tandis qu'une autre aile en béton peint domine la pente côté vallée. La liaison intime avec la nature est favorisée par une façade totalement vitrée qui permet d'admirer le panorama spectaculaire de la vallée. Les fenêtres coulissantes sont enchâssées dans des cadres affleurant dans le plancher et le plafond.

El contrapunto tranquilo

Casa Y

Esta casa supone un tranquilo contrapunto al caos visual diario. Los espacios están pensados para conseguir una mezcla espiritual de los elementos naturales, como el sol, el cielo y el viento, con el cumplimiento de las funciones pragmáticas. Se han delineado claramente dos edificios: un ala con una estructura de acero forma una barrera frente al ruido de la calle, mientras que una segunda ala en hormigón pintado abraza la cuesta escarpada del valle. Aquí los marcos de las ventanas correderas se han hundido en el techo y en el suelo para conseguir la máxima transparencia .

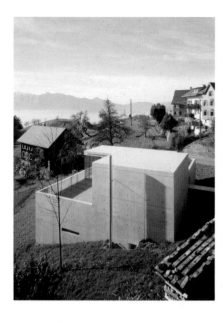

Defins, Austria,
Marte.Marte Architekten,
1996, 120 m²

Hillside Reduction
Marte House
A gravel road winds along the ridge. Turning right, the driveway accesses an entrance courtyard at mid-slope. From the entry, the path branches off. Three stairs lead to separate spatial zones. One leads downward into the lower bedroom level. The other two rise upward to access the separate kitchen/dining and living room cubes on the rooftop terrace. Exposed concrete on the exterior extends the color and texture of the sheer-granite cliffs in the nearby Alps into the building. Warmer materials – wood and stucco – are used inside to create a sense of protection in a rugged natural environment.

Ein Hang zur Reduktion
Marte-Haus
Eine Schotterstraße führt am Hang entlang. Rechts abbiegend führt der Weg zum Vorhof auf mittlerer Hanghöhe. Bei Eintritt ins Haus gabelt sich der Weg. Drei Treppen erschließen getrennte Raumbereiche. Eine davon führt nach unten in das Schlafgeschoss. Die anderen führen hinauf in die getrennten Baukörper der Wohnhalle und des Koch-/Essraums. Sichtbeton im Äußeren setzt die Farbigkeit und Textur der stummen alpinen Granitwände im Bauwerk fort. Im Inneren hingegen vermitteln warme Materialien wie Holz und Putz eine geschützte Wohnwelt inmitten der rauen natürlichen Umgebung.

Une colline modèle réduit
Maison Marte
Un chemin de gravier qui serpente sur la crête. À droite, l'allée carrossable mène à une cour d'entrée à mi-pente. De cette entrée, les chemins divergent. Trois escaliers mènent à trois espaces séparés. L'un descend au niveau inférieur des chambres. Les deux autres s'élèvent pour mener sur le toit en terrasse aux cubes abritant respectivement les espaces cuisine/repas et le séjour. Le béton apparent de l'extérieur prolonge dans le bâtiment la texture et la teinte des falaises de granit des Alpes voisines. À l'intérieur, des matériaux plus chaleureux – bois et stuc – contribuent à faire naître un sentiment de sécurité au sein d'un environnement naturel plus rude.

Reducción de la ladera
Casa Marte
Una carretera de grava recorre la ladera. Torciendo hacia la derecha, el camino conduce a una entrada con un patio situado a media altura de la ladera. Al entrar en la casa el camino se bifurca. Tres escaleras conducen a zonas espaciales separadas. Una de las escaleras lleva a abajo, a la planta con los dormitorios. Las otras dos se dirigen hacia arriba, a los dos cubos del salón y la cocina comedor. El hormigón visto del exterior es la continuación del color y la textura de las mudas laderas de granito de los Alpes. En cambio en el interior los materiales cálidos como la madera y el estuco se han empleado para crear un sentimiento de protección en el rudo ambiente natural.

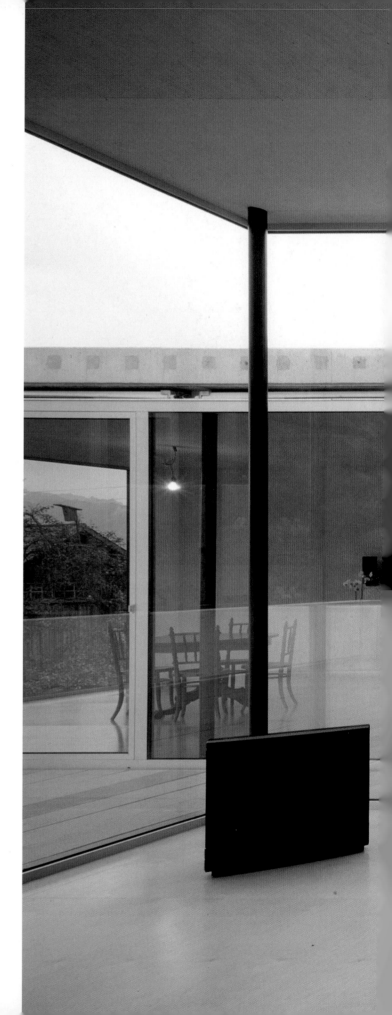

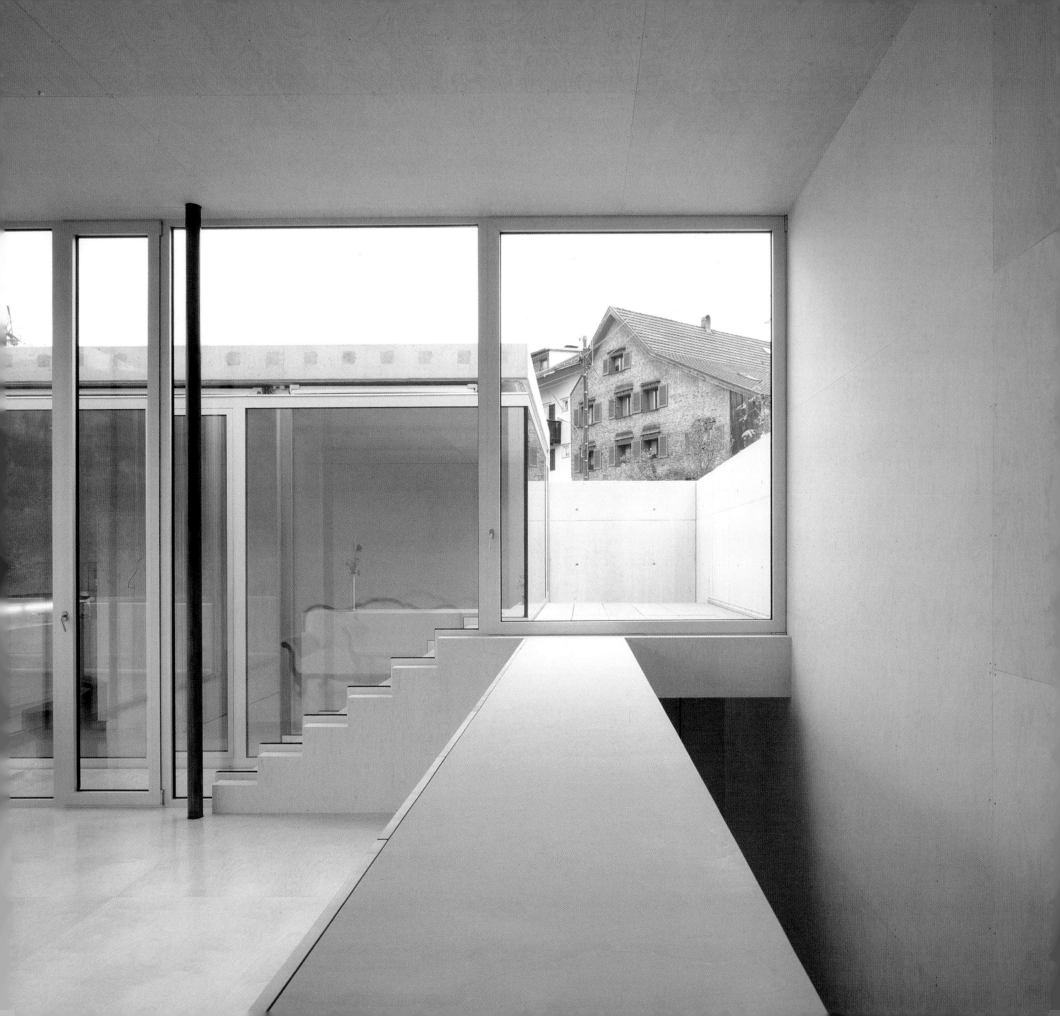

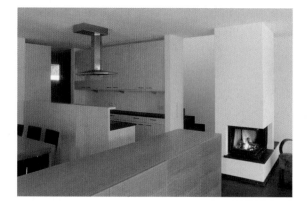

Lauterach, Austria,
Elmar Ludescher Architektur,
2003, 120 m²

Oblique Piece
Kosnjak House
The trapezoidal site with a street to the south and access from the west is located in the busy town center. In response to these restraints, the home for a four-person family answers with an assertive building volume. A seemingly monolithic "hammer" clad in dark-gray fiber-cement panels contains the recessed ground floor with living and kitchen spaces and the cantilevered upper floor with the bedrooms. This allows creation of a protected, south-facing terrace that extends the living spaces outside. To the north, the covered porch creates a generous entrance space and doubles as a carport.

Schräges Stück
Kosnjak-Haus
Ein trapezförmiges Grundstück, im Süden die Straße, im Westen die Zufahrt – mitten im Ortskern. Der Beengtheit des Grundstückes entgegnet das Einfamilienhaus für eine vierköpfige Familie mit einer starken Volumetrie. Ein monolithisch anmutender „Hammer" in anthrazitfarbener Eternithaut beherbergt Erdgeschoss mit Wohn- und Küchenräumen und das auskragende Obergeschoss mit Schlafräumen. So entsteht südseitig eine überdachte Terrasse. Nordseitig bildet sich der großzügige Eingangsbereich, der auch als Carport genutzt wird, als eine Geste des Empfangs.

Pièce oblique
Maison Kosnjak
Le terrain trapézoïdal, bordé par une rue au sud et auquel l'accès se fait à l'ouest, est situé dans un centre ville très animé. Face à ces contraintes, cette maison pour quatre personnes répond par l'affirmation de son volume. La forme en « marteau » apparemment monolithique, habillée de panneaux de fibrociment gris foncé, comprend le rez-de-chaussée en retrait, groupant le séjour et la cuisine, surmonté du niveau supérieur en double porte-à-faux comprenant les chambres. Cette forme a permis la création au sud d'une terrasse protégée dans le prolongement du séjour. Au nord, le porche couvre un généreux espace d'accès servant aussi de garage.

Pieza oblicua
Casa Kosnjak
La forma trapezoidal de este solar con la calle en la parte sur y la entrada en la parte oeste, se encuentra en el centro de esta pequeña ciudad. Esta casa unifamiliar para cuatro personas responde a la estrechez del solar con un gran volumen. Un impresionante "martillo" monolítico revestido con paneles de cemento de color gris oscuro alberga la planta baja con los espacios destinados para el salón y la cocina, la planta superior levantada en voladizo contiene los dormitorios. Esto permite la construcción de una terraza techada con orientación sur. En la parte norte, el porche cubierto crea una amplia entrada que hace también las veces de garaje abierto.

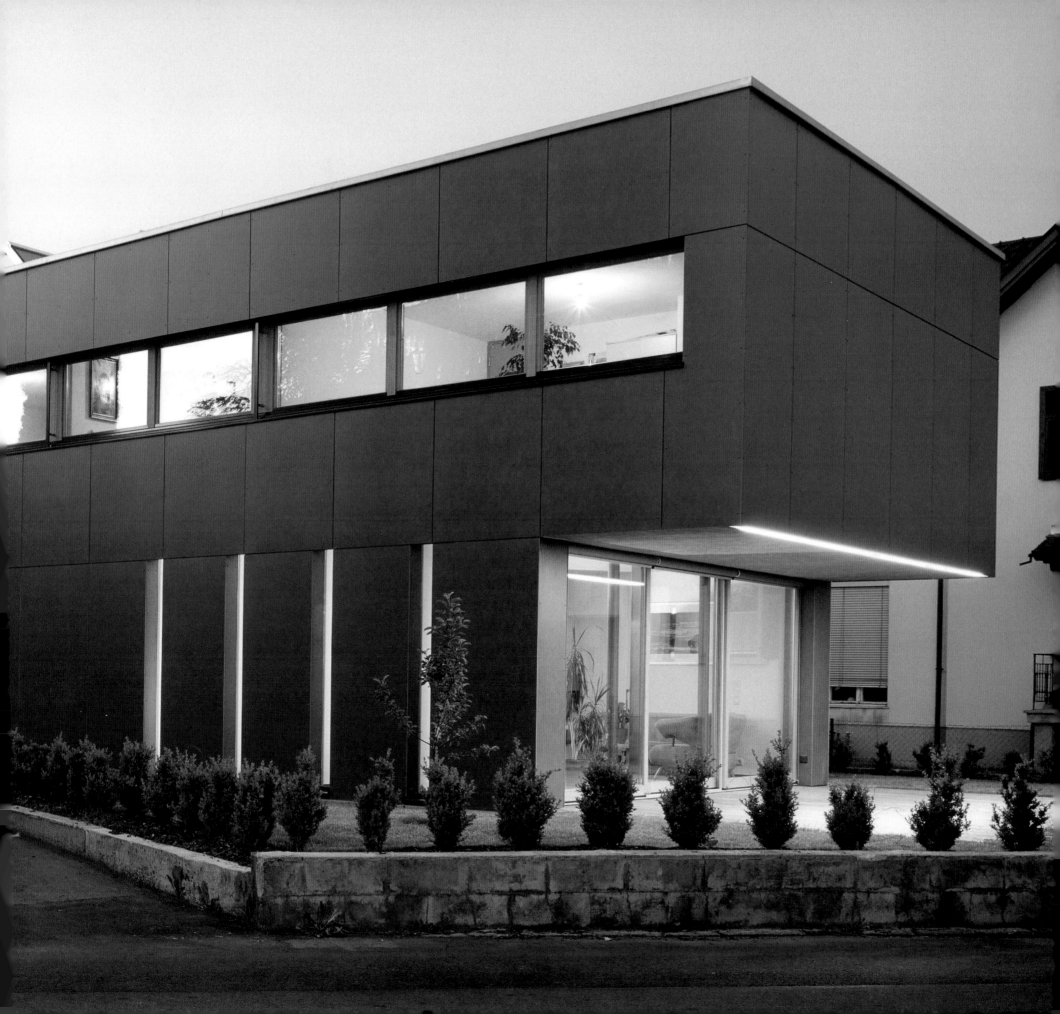

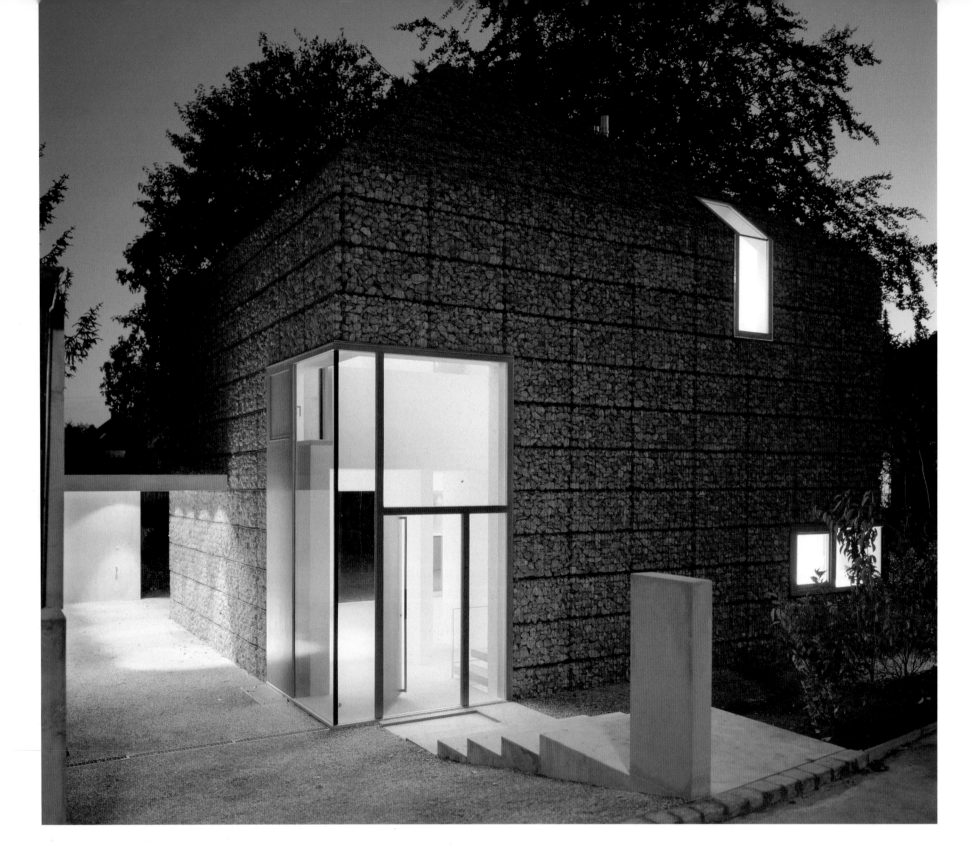

Successful Experiment

9 x 9 House

Built within the square 9 x 9 meter plan required by code, the house, conceived as an inhabitable sculpture, develops new creative ideas that meet building regulations yet transcend bureaucratic constraints. Inside, open spaces interconnect the living, dining, and kitchen spaces on the ground floor, bedrooms and office gallery on the second floor and a reading room under the asymmetrical pyramid roof. A facade constructed of Gabion stone elements was built here for the first time. 365 hand-filled baskets filled with 40,000 stones create 28 tons of insulating mass. The rough exterior is contrasted by the light-filled interior spaces.

Erfolgreiches Experiment

9 x 9-Haus

Konzipiert als bewohnbare Skulptur für ein Paar, baut sich das Haus auf einem quadratischen, vom Bebauungsplan vorgegebenen Grundriss von 9 x 9 Metern auf. Hieraus entwickelt sich eine zweigeschossige offene Raumfolge mit Wohn-, Ess-, und Küchenbereich im EG, Arbeitsgalerie, Schlafzimmern, Ankleide und Bad im 1. OG und einer Lesegalerie unter dem asymmetrischen Pyramidendach. Zum ersten Mal wurde eine Gabionenfassade als vorgehängte Fassade realisiert. 365 handbefüllte Körbe mit ca. 40.000 Steinen bilden 28 Tonnen Speichermasse. Die rauhe Außenhaut wird kontrastiert durch helle Innenräume.

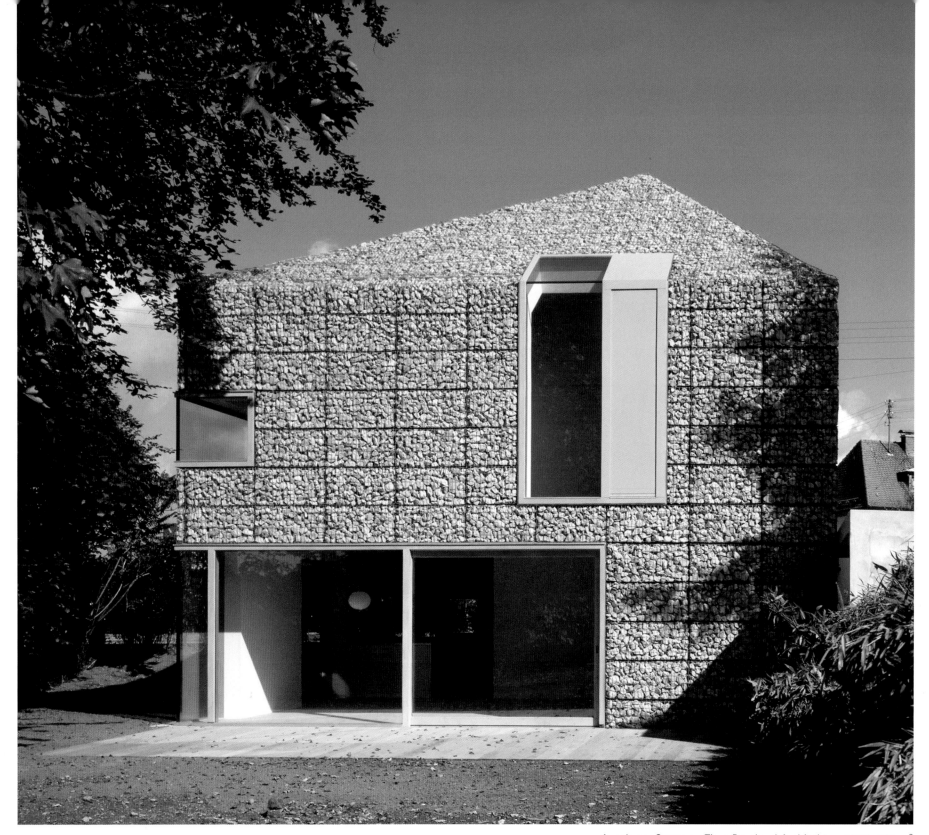

Augsburg, Germany, Titus Bernhard Architekten, 2003, 120 m²

Experience réussie

Maison 9 x 9

Construite dans le plan de 9 x 9 mètres imposé par le règlement d'urbanisme local, cette maison développe des idées créatives qui respectent les obligations administratives tout en les transcendant. À l'intérieur, les espaces ouverts connectent le séjour, la salle à manger et la cuisine au rez-de-chaussée, les chambres et la galerie/ bureau au deuxième niveau et une bibliothèque sous le toit pyramidal asymétrique. C'est la première façade construite avec des gabions. 365 paniers remplis manuellement de 40 000 cailloux forment une masse isolante de 28 tonnes. La rugosité de l'extérieur constraste avec la grande luminosité de l'intérieur.

Exitoso experimento

Casa 9 x 9

Esta casa, concebida como una escultura habitable para una pareja, se levanta sobre un solar de 9 x 9 metros. La estructura se desarrolló como una sucesión abierta de espacios en dos plantas donde el salón comedor y la cocina se encuentran en la zona de abajo, y la galería destinada al trabajo, el dormitorio, el vestidor y el baño en el primer piso. Debajo del tejado asimétrico con forma piramidal hay una pequeña sala de lectura. Es la primera vez que se construye una fachada de gabiones. 365 cajas llenadas a mano con aprox. 40.000 piedras forman una masa de 28 toneladas. La áspera piel exterior contrasta con los luminosos espacios interiores.

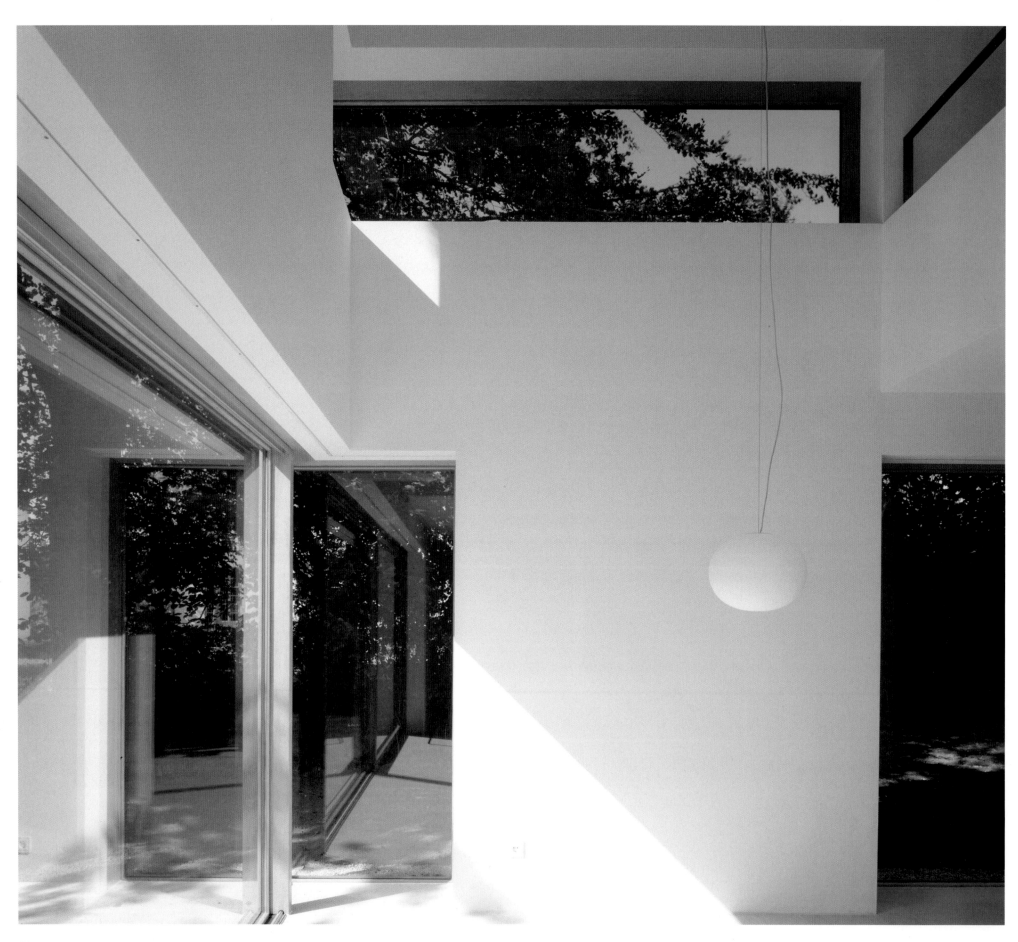

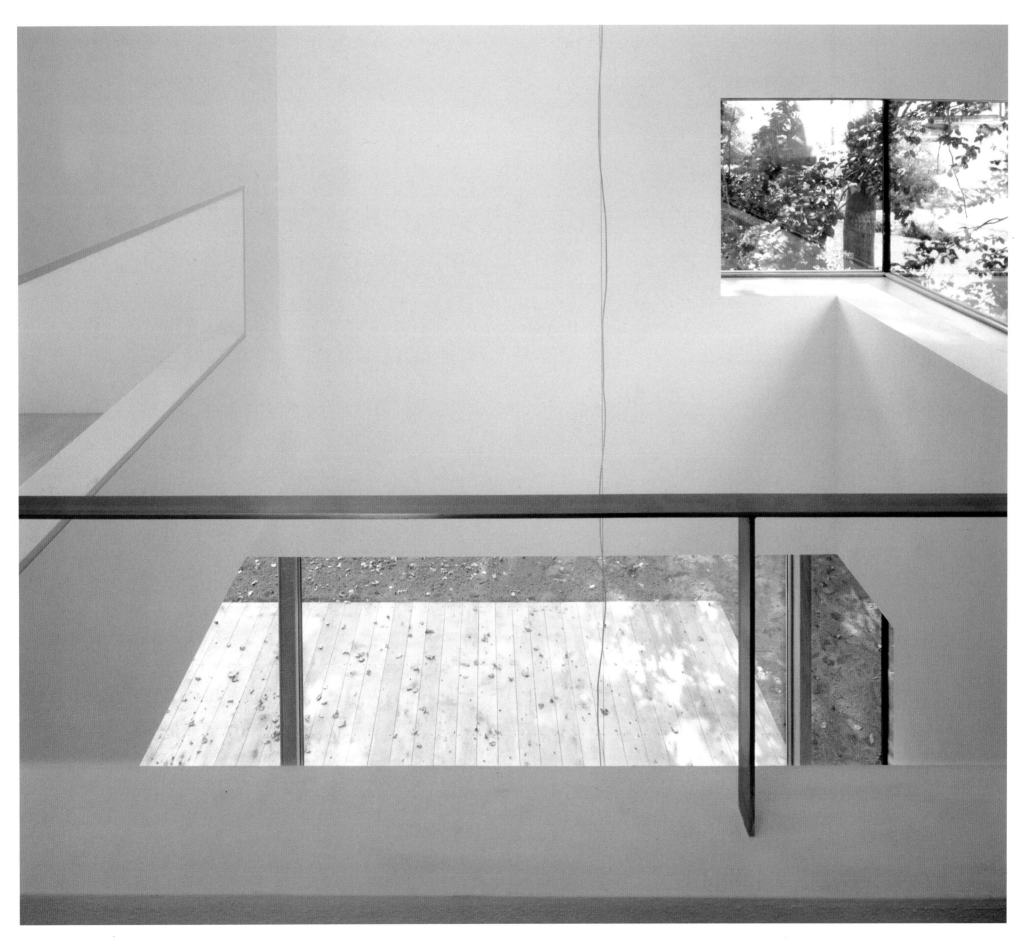

Ipsach, Switzerland,
:mlzd, 2000, 120 m^2

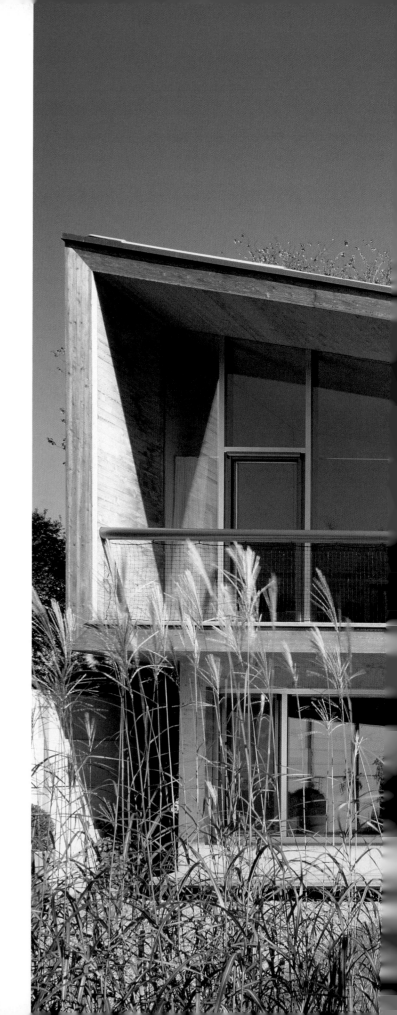

Alpine Geometry

Weidner House

The site offers excellent views of the nearby Alpine landscape and Biel Lake. Its park-like character is underscored by the surrounding groves of tall cottonwood trees. The ground floor includes living, dining and kitchen spaces with direct access to the adjacent garden. The ground floor is constructed in concrete, enabling south-facing windows over the entire building length. The prefabricated wood-frame construction of the upper level rises above this plinth. Its unique form, a seemingly hovering box with a slanting rooftop, echoes the nearby traditional pitched roofs, without thoughtlessly copying them.

Alpine Geometrie

Weidner-Haus

Das Grundstück ist umgeben von hohen Pappeln und bietet einen ungehinderten Ausblick auf die nahe Alpenlandschaft und den Bielersee. Im Erdgeschoss befinden sich die Küche und der Wohn-/Essbereich mit direktem Zugang zum Garten. Das Erdgeschoss wird als tragender Betonsockel mit durchgehender Südverglasung ausgebildet. Auf diesem Sockel ruht die vorfabrizierte Holzkonstruktion des Obergeschosses, welche die Schlafzimmer und eine offene Galerie beherbergt. Die scheinbar schwebende Holzkiste mit schrägem Deckel nimmt das Motiv der geneigten Satteldächer auf, ohne sie nachzuahmen.

Géométrie alpine

Maison Weidner

Le site offre une vue imprenable sur les Alpes et le lac de Bienne. Son allure de parc est soulignée par des alignements de hauts peupliers du Canada. Le rez-de-chaussée comprend le séjour, l'espace repas et la cuisine avec accès direct au jardin adjacent. Ce niveau construit en béton permet d'étendre les vitrages orientés au sud sur toute la largeur de la façade. La structure en bois préfabriquée du niveau supérieur repose sur ce socle. Sa forme originale, une boîte au couvercle posé de guingois qui semble en lévitation, fait écho aux toits pentus de la région non sans volonté de les imiter.

Geometría alpina

Casa Weidner

Este solar está rodeado de altos chopos y desde él se disfruta de una vista libre sobre el cercano paisaje alpino y el lago Bieler. En la planta baja se encuentra la cocina y la zona destinada para el salón comedor que tiene acceso directo al jardín. Esta planta está concebida como un zócalo de hormigón con ventanas continuas por todo su lado sur. Sobre este zócalo descansa la construcción de madera prefabricada del piso superior, que alberga los dormitorios y una galería abierta. Esta caja de madera que parece flotar con una tapa inclinada reproduce el motivo de los tejados tradicionales de dos vertientes pero sin imitarlos.

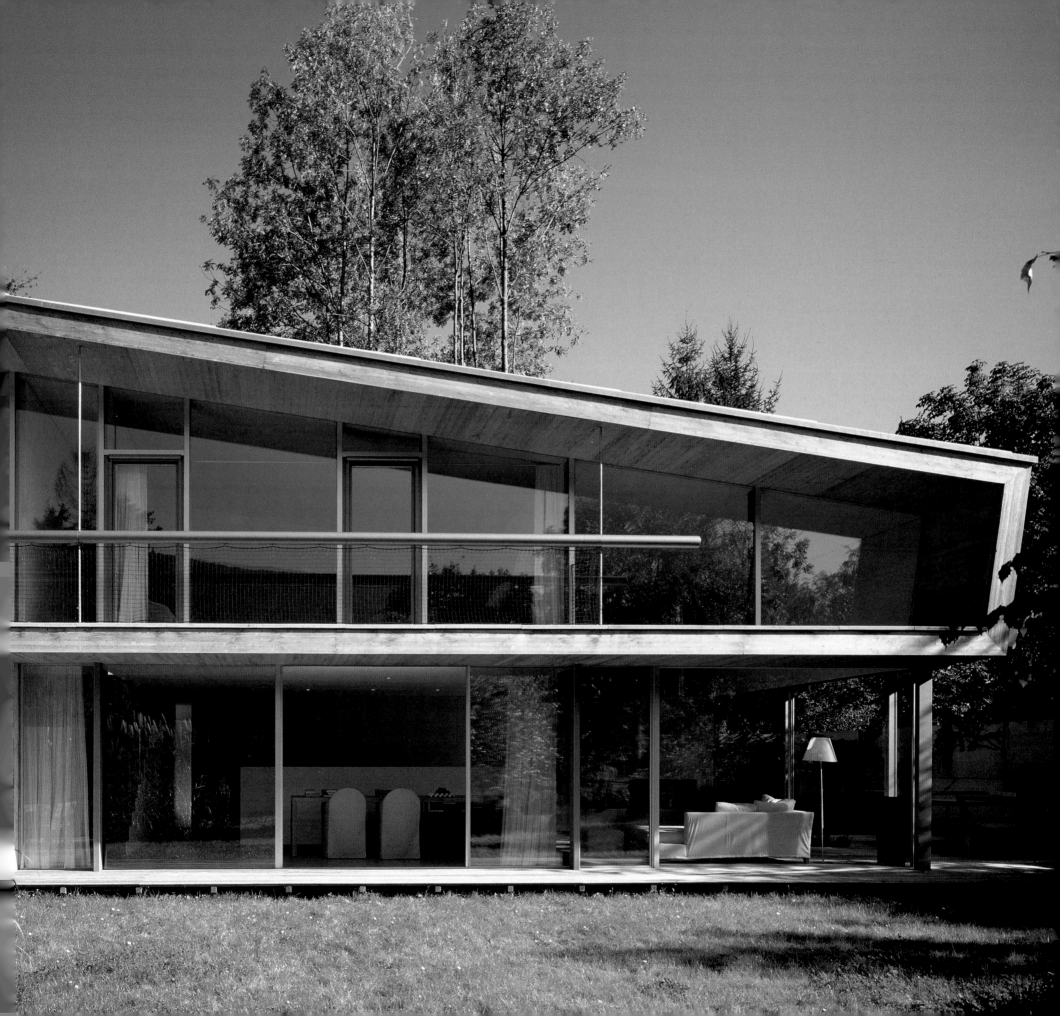

Rodenbach, Germany,
Beyer I Uhrig Architekten,
2000, 125 m²

Built Deregulation

Steuerwald House

The building site lies within the jurisdiction of zoning that extends the bland suburban setting. In this case, these seemingly inevitable constraints were creatively transformed into a unique building form. By using wood window shutters, it was possible to fully clad the building in wood, although merely 75% wood surfaces were permitted. By shifting the roof geometry, it was possible to eliminate dormers and reduce the building to an abstract sculptural form. Inside, the sense of protection offered by the wood-wrapped exterior is countered with unexpectedly high, light-filled and open spaces.

Das Regelwerk aufgehoben

Steuerwald-Haus

Das Haus liegt im Gebiet eines Bebauungsplanes, dessen Festsetzungen das eher gesichtslose Bild der Umgebung unterstützen. Die unausweichlichen Vorgaben wurden hier kreativ aufgefasst und mit einem untypischen Baukörper aufgehoben. So wurde durch Klappläden eine homogene Fassadenfläche aus Holz erreicht, obwohl maximal 75% Holzfläche vorgeschrieben waren. Durch Verschiebung der Dachgeometrie entsteht ein volles Obergeschoss unter Verzicht auf Gauben. Im Inneren wird die schutzvermittelnde Geschlossenheit des konsequent ummantelten Baus mit Offenheit in unerwartet hohen und hellen Räumen kontrastiert.

Jeu de lois

Maison Steuerwald

Le site de cette construction se trouve soumis aux règlementations d'une zone qui prolonge une insipide banlieue. De ce fait, des contraintes apparemment incontournables ont été exploitées de manière créative pour donner une forme de construction originale. L'utilisation de volets en bois a permis d'habiller totalement le bâtiment de ce matériau. En rompant la symétrie du toit, on a éliminé les lucarnes et réduit le bâtiment à une forme sculpturale. À l'intérieur, l'impression de protection donnée par l'habillage de bois extérieur est contrebalancée par des espaces ouverts, de belle hauteur sous plafond et très lumineux.

La ruptura de la norma

Casa Steuerwald

La vivienda está situada en una urbanización cuyas casas son un reflejo del insulso entorno. Aquí estas inevitables limitaciones han sido creativamente transformadas en una edificación que se levanta con una estructura única. A través de los postigos se consiguió una superficie homogénea en la fachada completamente en madera, a pesar de que la máxima superficie permitida de este material era del 75%. Al inclinar la geometría del tejado fue posible eliminar los tragaluces y simplificar el edificio en una forma escultural abstracta. En el interior los espacios inesperadamente amplios y luminosos contrastan con el sentimiento de protección que ofrece un exterior revestido en madera.

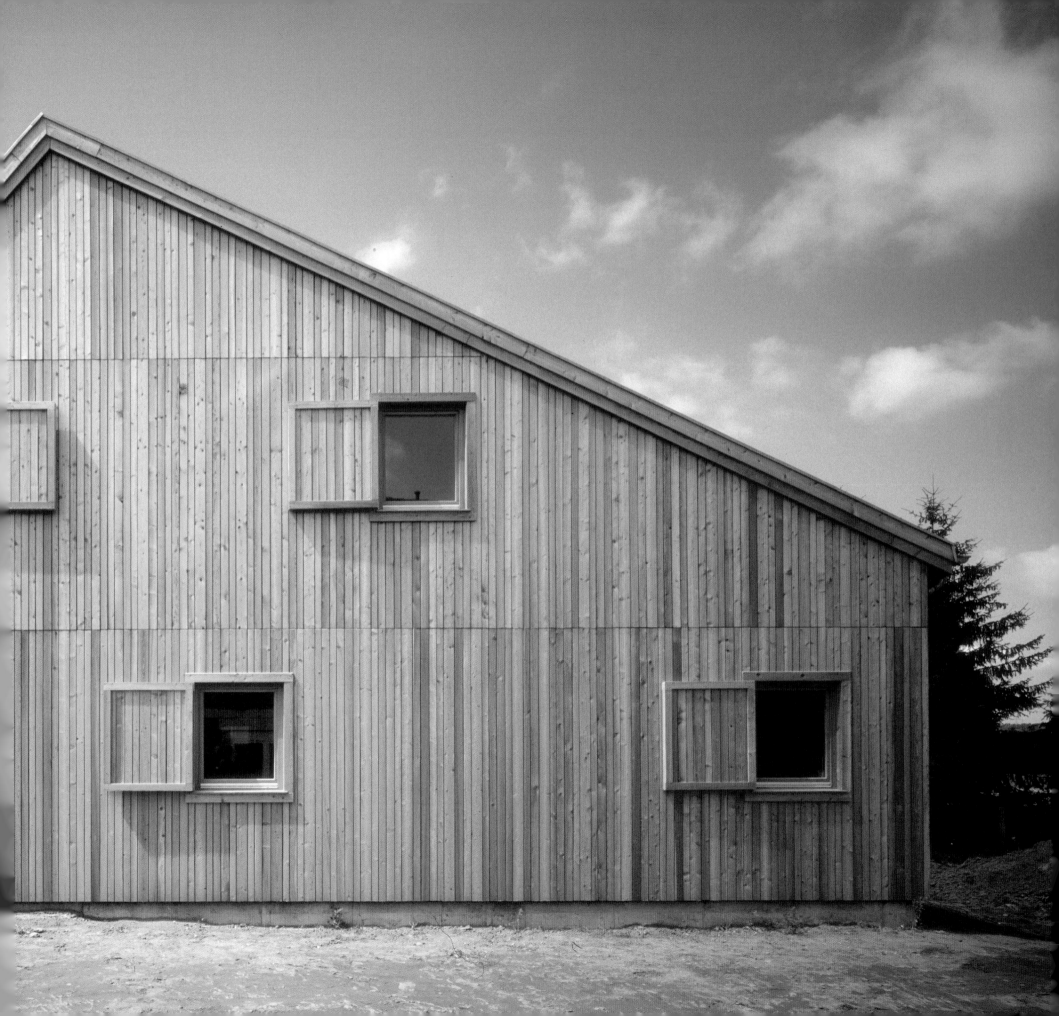

Black and White Composition
Susi-K House
Pre-fabricated houses offer an increasingly viable alternative to conventional construction. This example shows that open, flexible solutions can be realized in pre-fab technology. It is based on the "open architecture" wood system developed by the architects in cooperation with a local construction company. The system, with its 1.2 x 1.2 meter basic module, allows creation of countless spatial combinations. Spaces in this house are contained in two distinct wings. The open living zone, sunken 80 cm below grade, interconnects via a split-level plan with the bedroom wing that hovers 80 cm above grade.

Komposition in Schwarz-Weiß
Susi-K-Haus
Fertighäuser stellen zunehmend eine Alternative zum konventionellen Hausbau dar. Dieses Beispiel zeigt, dass hierbei auch moderne Lösungen möglich sind. Es basiert auf dem in Kooperation mit einem lokalen Holzbauunternehmen entwickelten „open architecture" Holzbausystem. Hierbei entstehen die Räume aus 1,20 x 1,20 m Modulen, die in zahllosen Kombinationen zusammengesetzt werden können. Das Haus teilte man in zwei halbgeschossig versetzte Teile auf. Der Wohn-/Ess-/Kochbereich liegt 80 cm in der Erde, Schlafräume sind in einem zweiten, 80 cm über Terrain aufgestelzten Bauteil zusammengefasst.

Composition en noir et blanc
Maison Susi-K
Les maisons préfabriquées offrent une alternative de plus en plus intéressante à la construction conventionnelle. Cet exemple montre que le domaine de la construction préfabriquée peut fournir des solutions flexibles. Cette maison est fondée sur un système d'architecture « ouverte » en bois développée par des architectes en collaboration avec une entreprise de construction locale. Le système reposant sur des modules de 1,20 x 1,20 m permet de réaliser dans l'espace d'innombrables combinaisons. La partie séjour ouverte enfoncée de 80 cm sous le niveau du sol est reliée par un plan brisé à la partie chambre qui « flotte » à 80 cm au-dessus du sol.

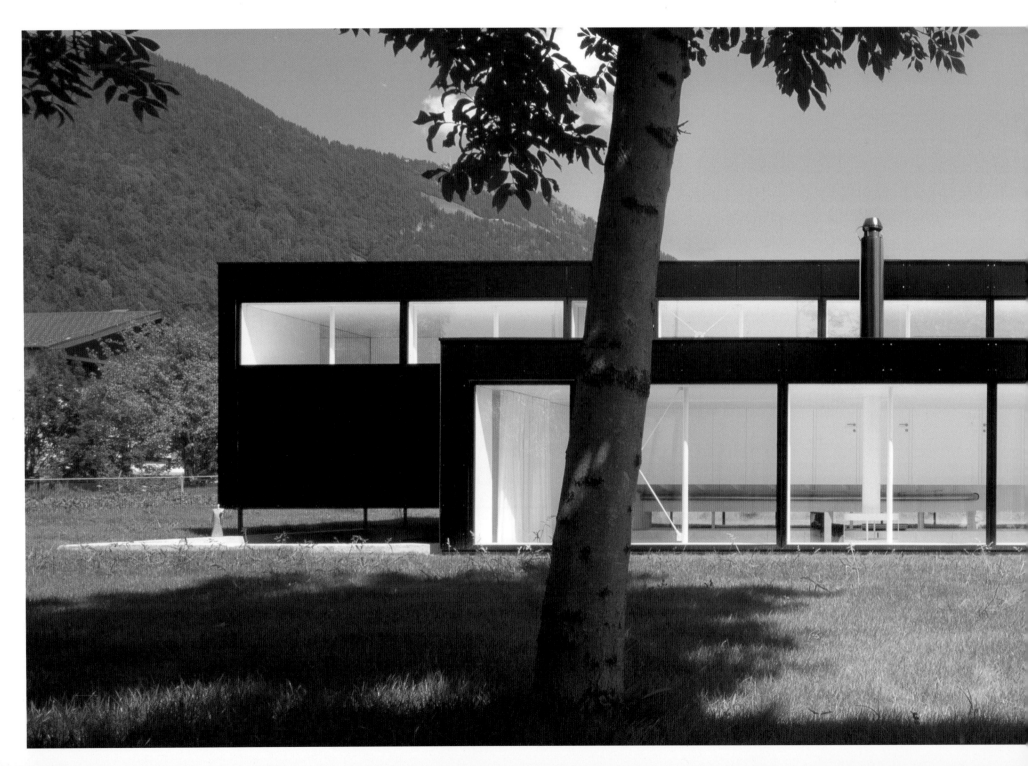

Composición en blanco y negro

Casa Susi-K

Las casas prefabricadas son cada vez más una alternativa viable a las construcciones convencionales. Este ejemplo muestra que las soluciones abiertas y flexibles también son posibles con esta tecnología. Esta construcción se basa en la cooperación entre los arquitectos y una empresa maderera local para desarrollar una sistema de construcción en madera con una "arquitectura abierta". El sistema, con sus módulos básicos de 1,2 x 1,2 metros, permite infinitas combinaciones espaciales. La casa fue dividida en dos alas distintas. La zona del salón comedor y de la cocina está hundida 80 cm en la tierra, mientras que los dormitorios se sitúan 80 cm por encima del suelo.

Bezau, Austria, Oskar Leo Kaufmann, 2003, 129 m²

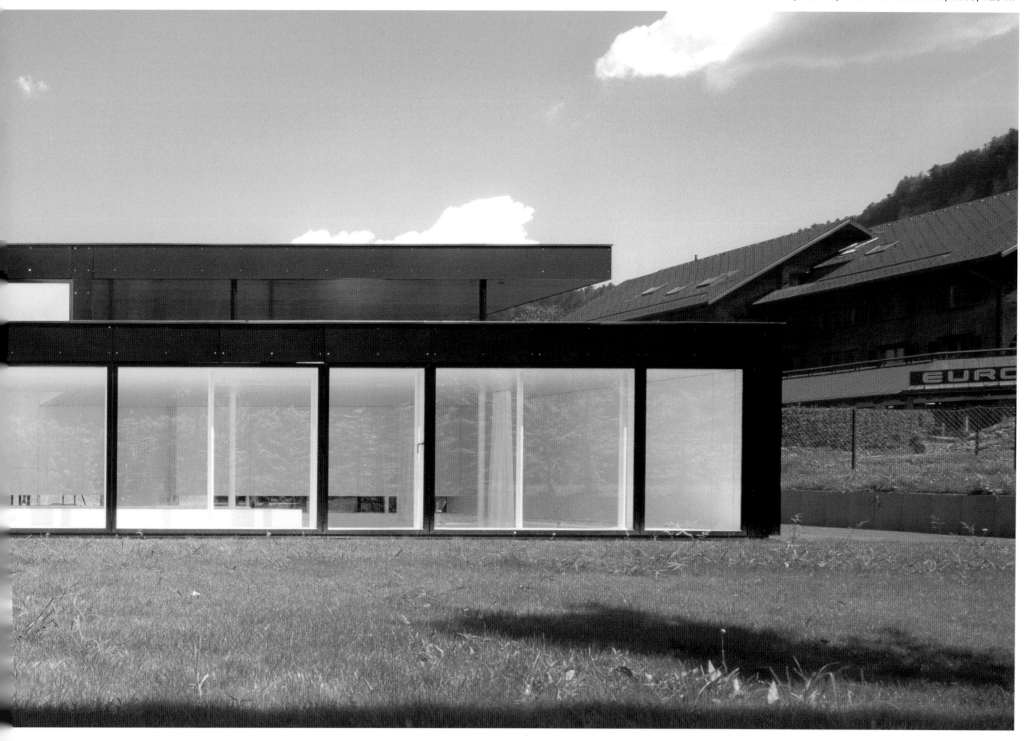

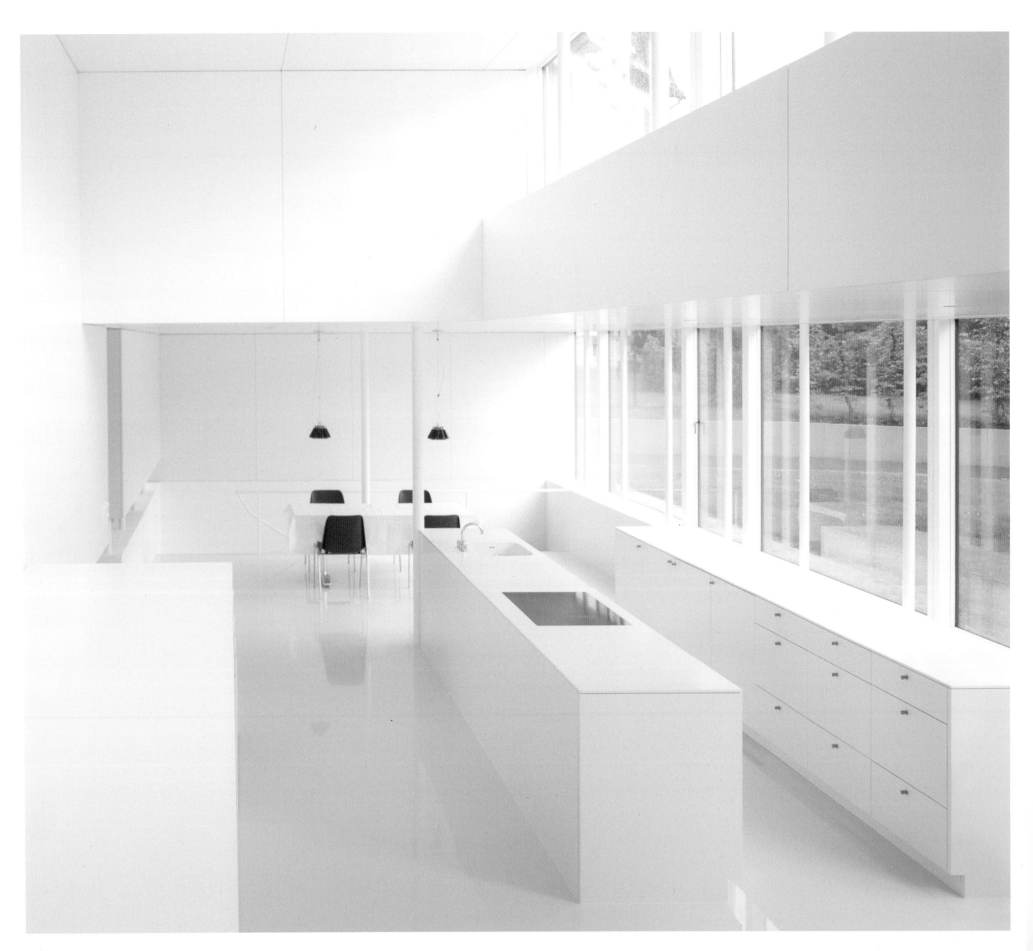

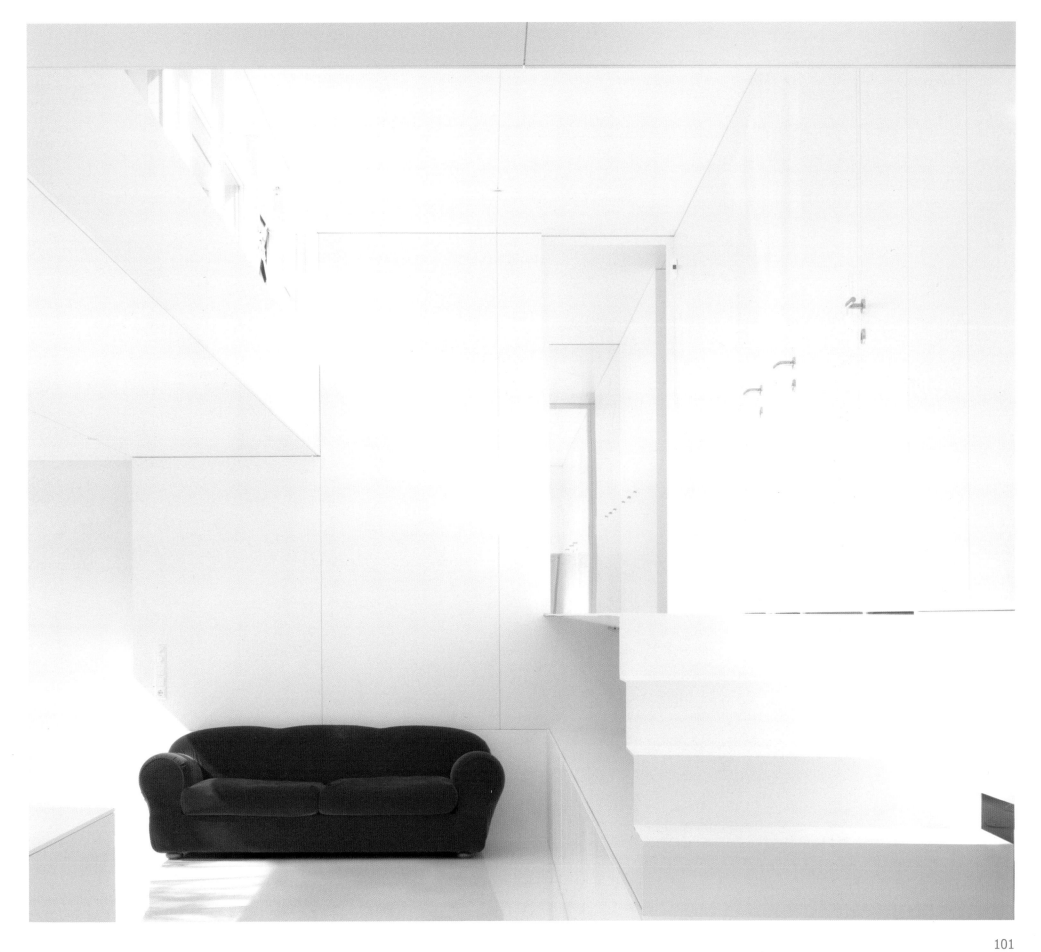

Hot Tin Box

Hammerweg House

Nestled into the slope, the forms of the three-level house step back to follow the topography. The street-side elevations are largely windowless – carefully placed window slits allow framed views from inside to outside. The house is sheathed in galvanized zinc metal sheeting. The expressive standing seams of the metal sheets help soften the simple building mass. The floor plan is simple and compact. From the ground floor entrance at the base of the hillside structure, an axial stair leads straight up to the bedroom zone on the first floor and the living/kitchen space with roof terrace on the second floor.

Heiße Blechbox

Hammerweg Haus

Das Haus wächst aus dem natürlichen Gefälle eines sanften Wiesenhanges, dessen Neigung der dreigeschossige Baukörper folgt. Die straßenseitigen Fassaden sind geschlossen – nur wenige Sehschlitze sind in sie eingelassen. Das Haus ist mit verzinkten Blechen eingekleidet, deren markante Stehfälze dem Baukörper Tiefe und Konturen verleihen. Die Grundrissorganisation ist einfach und kompakt. Der Eingang liegt im Sockelgeschoss, das ein Studio beherbergt. Über die einläufige Treppe gelangt man ins 1. OG mit den Schlafzimmern und in den Wohn-, Ess- und Küchenbereich mit Dachterrasse im 2. OG.

Boîte en fer blanc

Maison Hammerweg

Ancrés dans le dénivelé, les volumes de cette maison bâtie sur trois niveaux épousent la topographie. Les élévations côté rue sont pratiquement dépourvues d'ouvertures à l'exception de petites baies en bandeau judicieusement placées qui permettent des vues très cadrées vers l'extérieur. La maison est habillée de tôle zinguée. Les nervures de raidissement des tôles atténuent l'aspect massif du volume construit. Le plan au sol est simple et ramassé. De l'entrée en rez-de-chaussée tournée vers la colline, un escalier axial mène directement à la partie chambres au premier étage et à l'espace séjour/cuisine avec terrasse au deuxième étage.

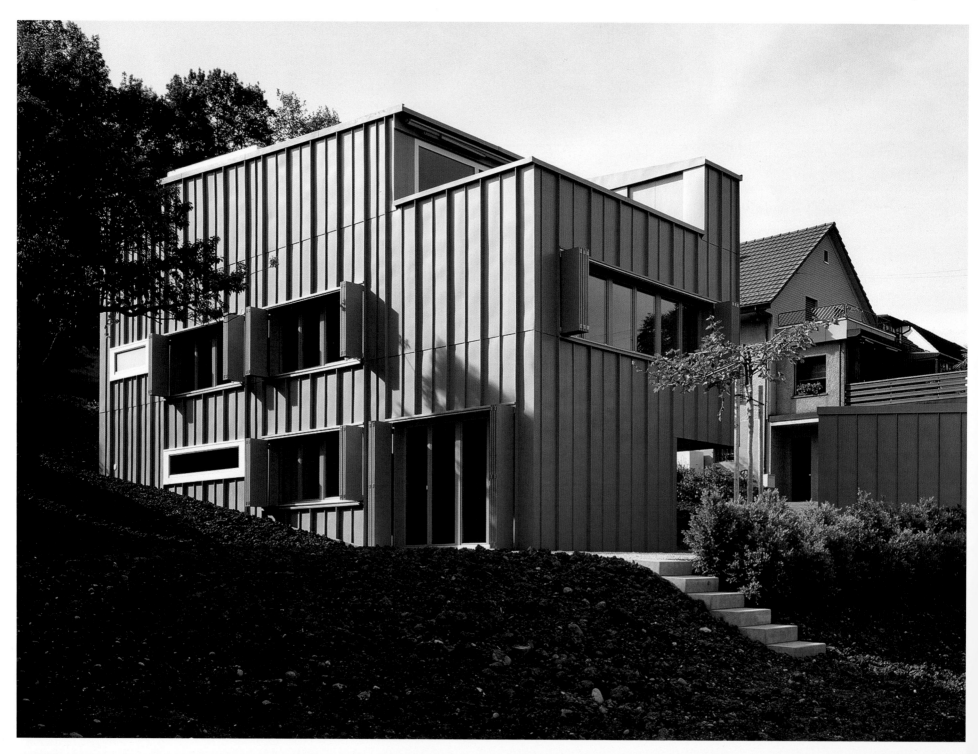

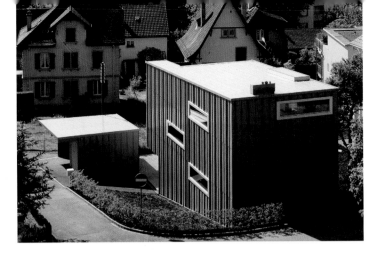

Caja de chapa

Casa Hammerweg

Esta casa se levanta en la pendiente de una suave ladera y continúa su inclinación natural con su cuerpo de tres plantas. Las fachadas que dan a la calle son cerradas y sólo presenta pequeñas hendiduras que permiten la vista hacia el exterior. La casa está revestida con metal galvanizado. Las profundas estrías de este material dan a la construcción profundidad y contornos. La organización de la planta es simple y compacta. La entrada se encuentra en el piso bajo, que alberga un estudio. A través de las escaleras se llega al 1er piso donde están los dormitorios. En la 2ª planta se han dispuesto las estancias del salón, el comedor y la cocina con una terraza en la azotea.

Winterthur, Switzerland, Beat Rothen Architekt, 2002, 131 m²

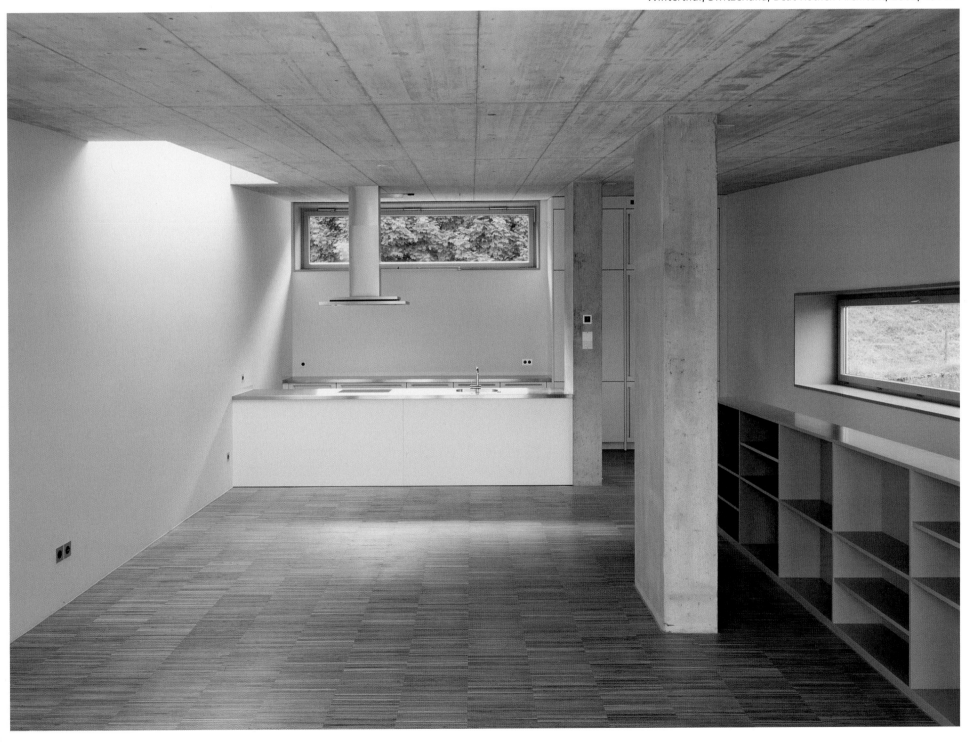

Windisch, Switzerland,
Liechtl Graf Zumsteg Architekten,
2002, 138 m²

A Tempting Inclination
Riverside House
Integrating into the sharp slope with a pitched roof in identical inclination, this house rises to form a two-story street facade with but two openings: the entrance and a large window. The building mass in exposed concrete is an exercise in formal reduction that respects the scale of the surrounding neighborhood and is at the same time unconventional. Inside, the pitched roof becomes the ceiling in the living room space. Descending downhill, the bedrooms are located on the lower level. The sober street facade is contrasted by the more open, east-facing facade, which opens to views of the river valley.

Verlockend geneigt
Haus am Fluß
Durch ein im gleichen Winkel geneigtes Dach in den Steilhang integriert, steigt das Haus zur Straße zweigeschossig an. Zwei Öffnungen gliedern die Fassade: der Eingangsschlitz und ein großes Fenster. Der Sichtbetonbau ist eine Übung in formaler Reduktion, welche den Maßstab der Umgebung respektiert und zugleich eine unkonventionelle Architektursprache entwickelt. Das geneigte Dach bildet im Inneren die Decke des hohen Wohnsaals. Hangabwärts befinden sich die Schlafzimmer auf der unteren Ebene. Die schlichte Straßenfront wird durch die offene Ostseite kontrastiert, die sich zum Ausblick über das Flusstal öffnet.

Inclination tentante
Maison Riverside
Intégrée sur une pente raide et dotée d'un toit d'une inclinaison égale, cette maison s'élève sur deux niveaux en façade sur la rue. Celle-ci n'est percée que de deux ouvertures : l'entrée et une grande baie vitrée. La construction en béton brut apparent est un exercice de réduction à l'échelle qui respecte les formes environnantes tout en étant non conventionnelle. À l'intérieur, le toit pointu forme le plafond du séjour. En descendant la pente, on gagne les chambres situées en sous-sol. La sobriété de la façade sur la rue contraste avec l'aspect plus ouvert de la façade est qui donne sur la vallée et la rivière.

Tentadora inclinación
Casa Riverside
Esta casa, que se integra en la pronunciada pendiente por su tejado con la misma inclinación, se levanta en dos plantas por el lado de la calle. La fachada está dividida por dos aberturas: la de la entrada y una gran ventana. La construcción de hormigón visto es un ejercicio de reducción formal que respeta las medidas del entorno y al mismo tiempo desarrolla un idioma arquitectónico poco convencional. El tejado inclinado es en el interior el techo del elevado salón. Bajando por la ladera se llega a los dormitorios, en el piso inferior. La sobria fachada que da a la calle contrasta con el lado este, más abierto y que permite la vista sobre la rivera.

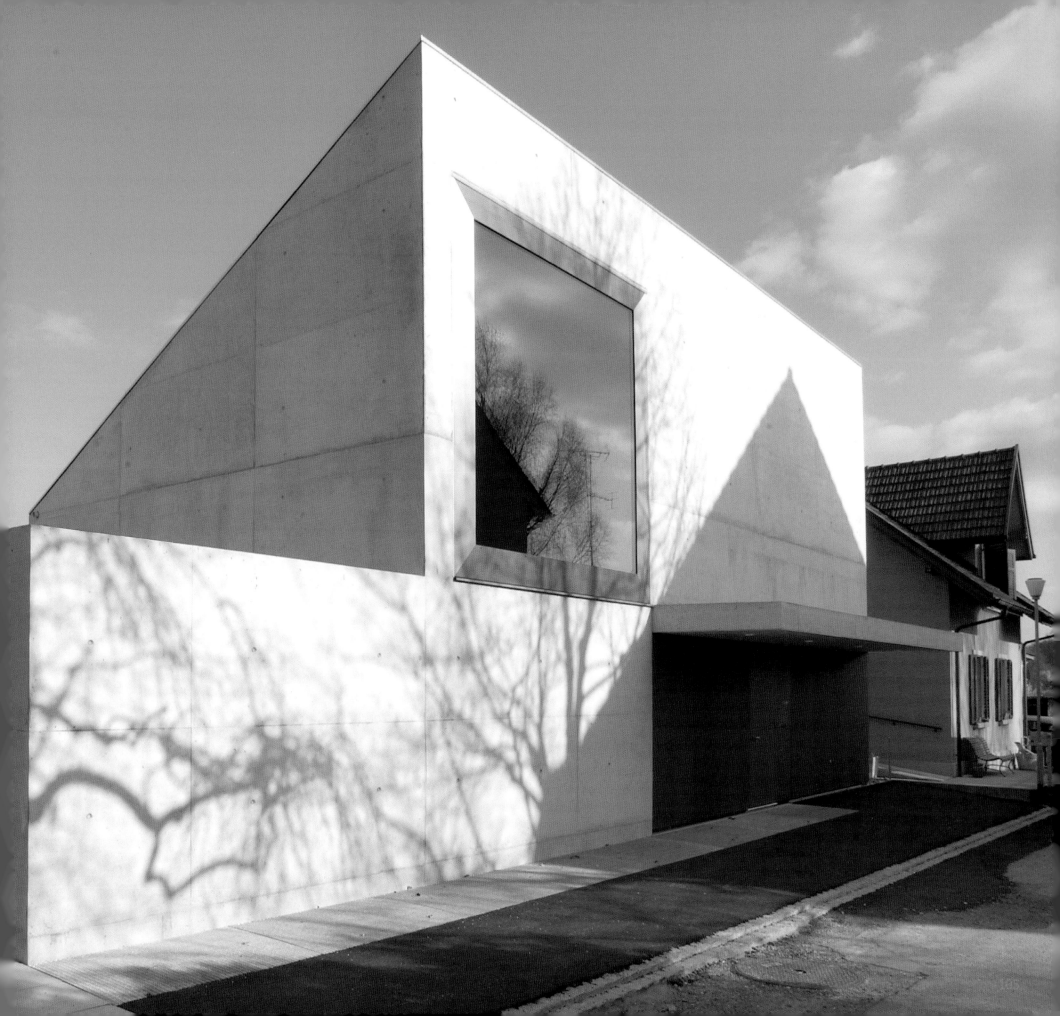

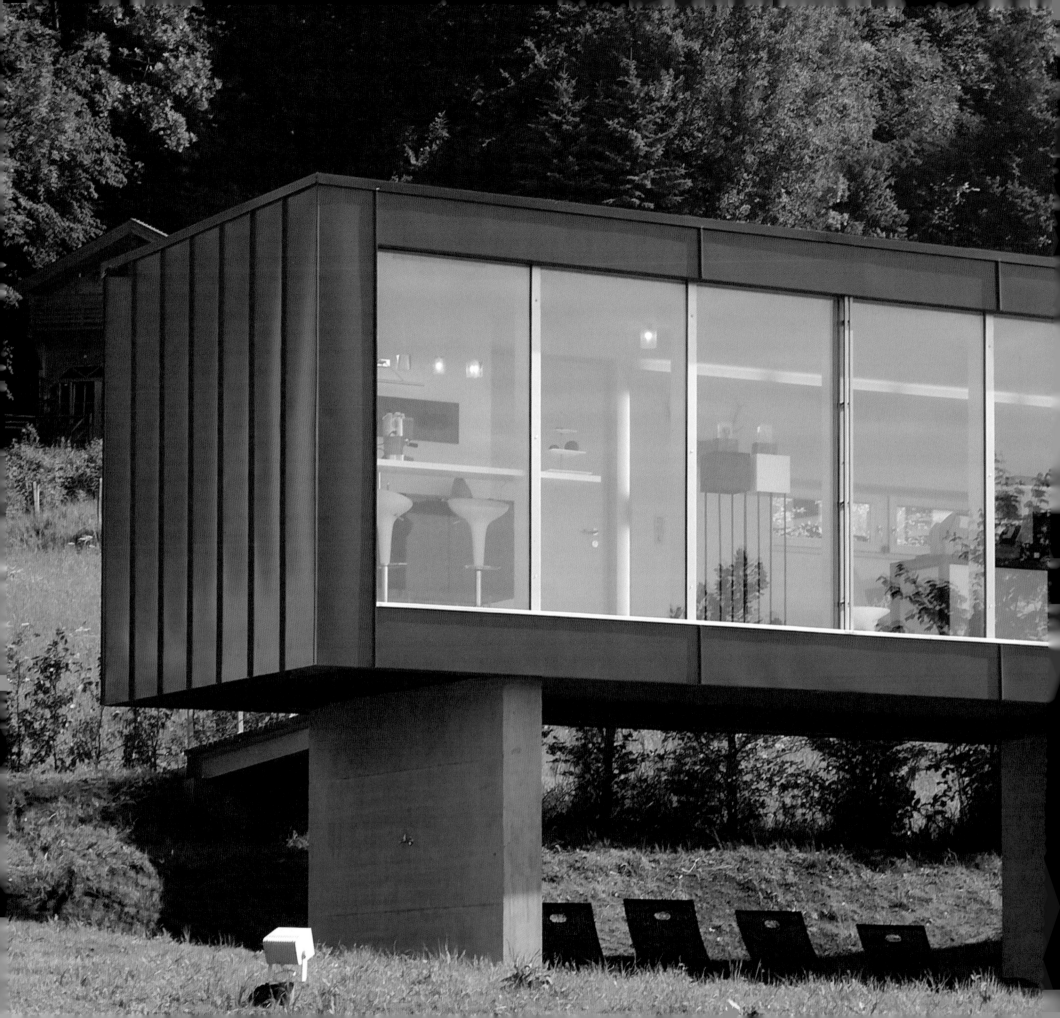

XXS Mobile Houses

Mobile Häuser | Maisons mobiles | Casas móviles

(Tuusula), Finland,
Markku Hedman,
2000, 8 m²

Housebox
Summer Container
The Summer Container is a mobile wood-frame holiday cabin built solely with sustainable building materials. The experiment explores the notion of temporary dwelling, the relationship of building and nature, and flexible use concepts. Rooted in the history of Finnish architecture, it effectively reinterprets holiday cabin typology. During transportation on a car-, or sled-pulled trailer, the house is a closed cube. Upon arrival, the shutters are opened and the inner cube is slid out. Sleeping/living and kitchen spaces are accommodated in the cube in colors based on those found in the Finnish forest.

Hausbox
Sommer-Container
Der Sommer-Container ist eine mobile Holzhütte aus nachhaltigen Materialien. Das Experiment erforscht das Potenzial von Temporärbauten, den Bezug zwischen Gebautem und Natur sowie flexible Nutzungsformen. Tief verwurzelt in der finnischen Baugeschichte interpretiert es das Thema des Ferienhauses neu. Während des Transports per Auto oder Schlitten ist es ein verschlossener Kubus. Vor Ort angekommen, werden die Fensterläden geöffnet und der innere Kubus ausgefahren. Wohn-/Schlaf- und Kochbereiche werden im bunten Würfel untergebracht, dessen Farben sich aus dem finnischen Wald ableiten.

Une simple boîte
Summer Container
Le « Summer Container » est une cabine estivale en bois construite uniquement dans des matériaux faciles à entretenir. Cette création expérimentale explore le concept de résidence provisoire et la relation entre nature et construction. Lié à la tradition architecturale finlandaise, elle réinterprète en fait le thème de la cabane de vacances. Transportée par la route ou tractée derrière un traîneau, cette maison se présente alors comme un cube fermé. À l'arrivée, on ouvre les volets et le cube intérieur se déploie. La chambre/séjour et la cuisine équipées qu'abrite le cube sont peintes dans des couleurs inspirées par de celles des forêts finlandaises.

Casa-caja
Summer Container
Esta especie de caja para el verano es una cabaña de madera móvil hecha con materiales resistentes. El experimento investiga el potencial de las construcciones temporales, la relación entre edificios y naturaleza y las flexibles formas de aprovechamiento. Profundamente arraigada en la historia de la arquitectura finesa, esta casa reinterpreta el tema de la casa vacacional. Durante el transporte, con el coche o en trineo, es un cubo cerrado. Una vez en el lugar de destino los postigos se abren y el cubo se despliega. Las zonas del salón, el dormitorio y la cocina se han pintado en llamativos colores inspirados en el bosque finés.

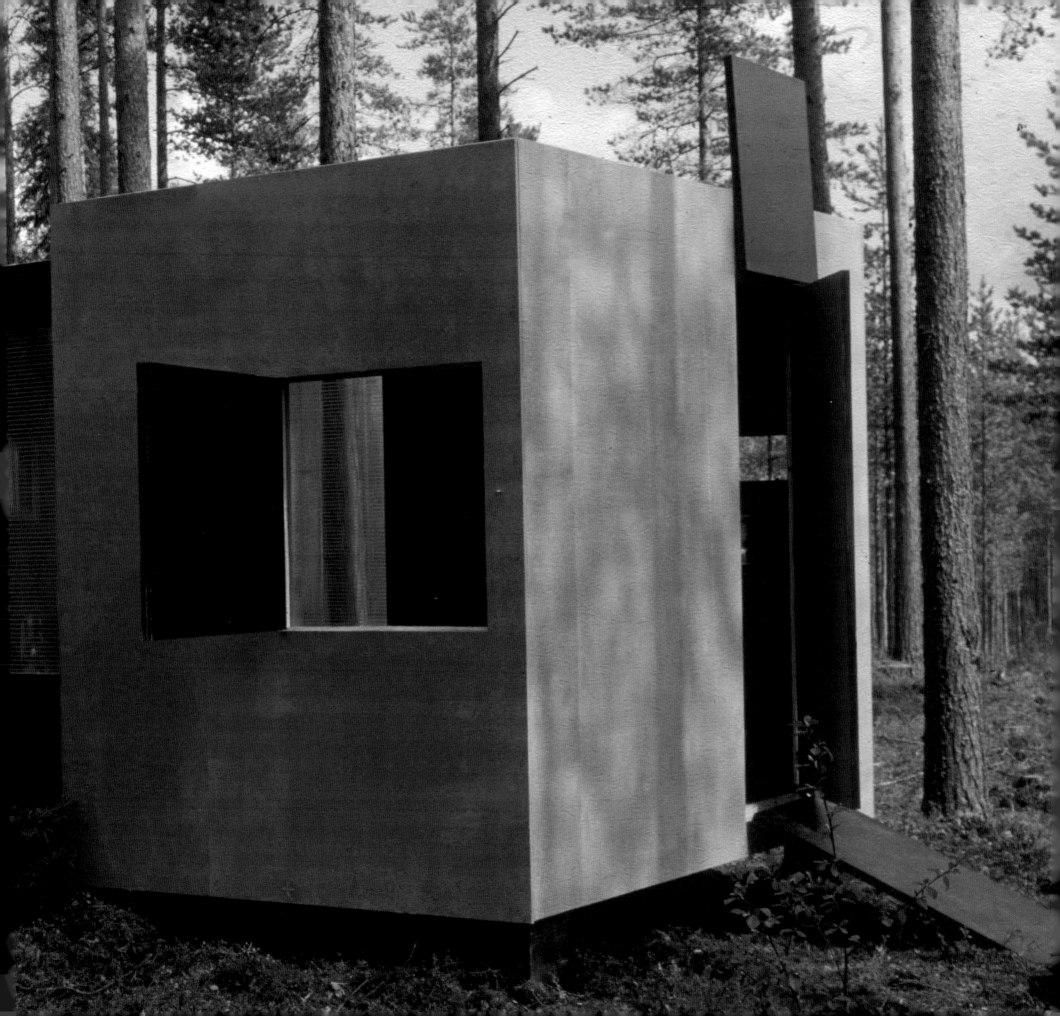

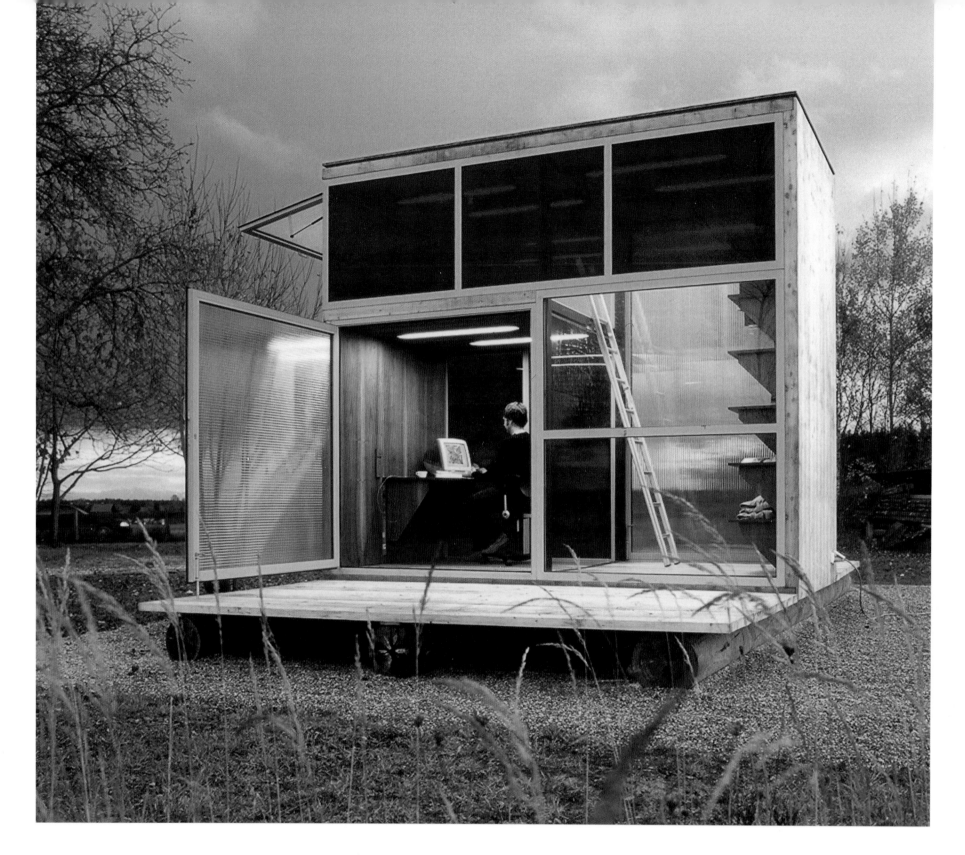

A Room of One's own
Extra Space

The ever-increasing flexibility of new working and living environments requires quickly accessible, mobile spatial units. The prefab "Zusatzraum" can be used as a single unit, or coupled to create multiple spaces. It can be transported by truck to the site and docked on to the existing technical infrastructure. The ground level (8 m²) is extended by an upper gallery (4 m²). Wood decks on both sides extend the space outside. The main structural elements are formed by 9 cm thick wood panels that are stabilized by a steel frame. Windows and doors are infilled with acrylic panels in various colors.

Ein Zimmer für sich allein
Zusatzraum

Durch die zunehmende Flexibilität von neuen Wohn- und Arbeitswelten werden mobile und schnell verfügbare, additive Räume benötigt. Der Zusatzraum wird als fertige Einheit per LKW an seinen Einsatzort transportiert und dort an die bestehende Infrastruktur angedockt. Das Erdgeschoss (8 m²) wird durch eine Galerie (4 m²) ergänzt. Im Erdgeschoss befinden sich beidseitig erhöhte Terrassen mit jeweils 8 m² Außenfläche. Die Konstruktion besteht aus einer 9 cm starken Holzschale, die im Inneren durch einen Stahlrahmen stabilisiert wird. Die Öffnungen werden mit farbigen Kunststoffscheiben geschlossen.

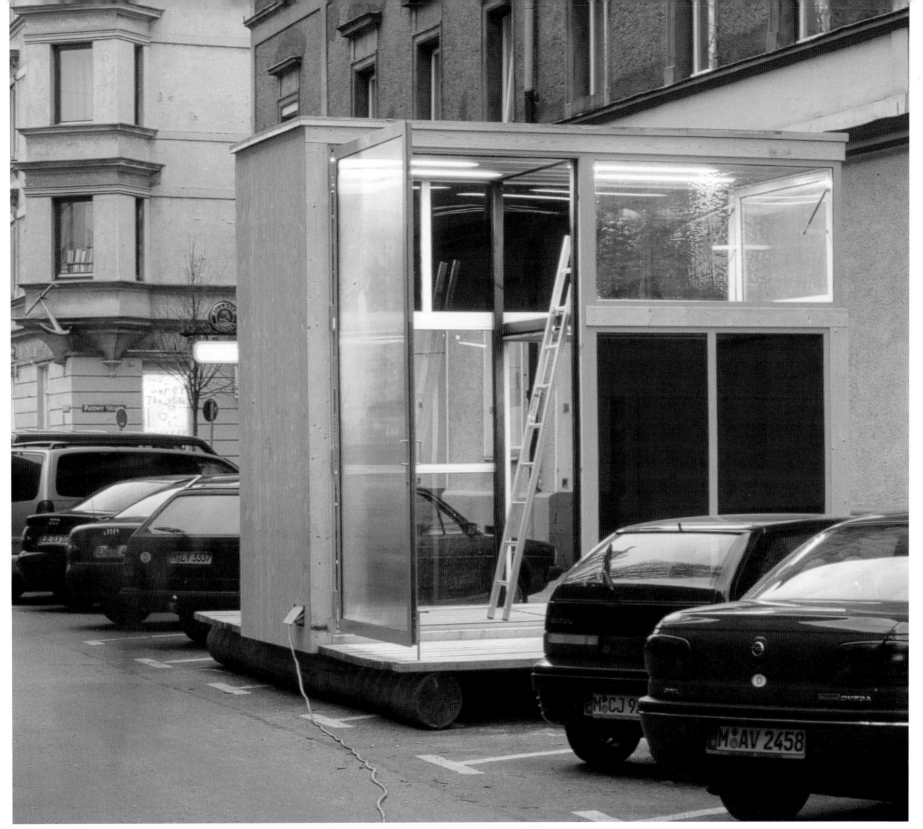

(Munich), Germany, architekturbüro exilhäuser, 2000, 10 m²

Une chambre à soi

Pièce supplémentaire

Les changements toujours plus rapprochés d'environnement de travail et de domicile exigent des unités d'habitation mobiles facilement disponibles. Cette « Zusatzraum » (pièce supplémentaire) préfabriquée peut être utilisée unitairement ou par assemblage afin de créer des espaces multiples. Elle est transportable par camion sur le site, où elle est déposée sur l'infrastructure existante. Le rez-de chaussée (8 m²) est complété par une mezzanine de 4 m². Des extensions en bois agrandissent l'espace habitable de chaque côté. Les principaux éléments structurels sont composés de panneaux de bois de 9 cm d'épaisseur maintenus par un cadre en acier.

Una habitación propia

Espacio Adicional

La creciente flexibilidad de los mundos de la vivienda y del trabajo exige espacios suplementarios móviles de los que se pueda disponer rápidamente. La habitación adicional se transporta como una unidad completa en un camión hasta el lugar deseado, donde se fijará a la infraestructura ya existente. La planta baja (8 m²) se complementa con una galería (4 m²). Los tejados de madera a ambos lados extienden el interior hacia el exterior. La construcción formada por paneles de madera de 9 cm de grosor se asegura en el interior con una estructura de acero. Las ventanas y las puertas están cubiertas con paneles de diferentes colores.

(Melbourne), Australia,
Sean Godsell,
2001, 13 m²

In Case of Emergency

Future Shack

The need 'to house' offers architects the opportunity to provide shelter for fellow human beings in need. The Future Shack is a mass-produced relocatable house for emergency and relief housing. Recycled shipping containers are used to form the main volume of the building. A parasol roof packs inside the container. When erected, the roof shades the container and reduces heat load on the building. Legs telescope from the container enabling it to be sited without excavation on uneven terrain. Fully erectable in 24 hours, the Future Shack can be packed back into itself and relocated or stockpiled for future use when presence on a given site is no more required.

Für den Notfall

Future Shack

Das Elementarbedürfnis des Wohnens in seiner einfachsten Form stellt für Architekten eine Grundherausforderung dar. Das seriell hergestellte Future Shack ist ein mobiles Haus für den Einsatz in Katrastrophen- und Kriegsgebieten. Transportcontainer bilden die Bauhülle. Zusammenklappbare Dachschirme verschatten diese und schützen vor Überhitzung. Teleskop-Beine erlauben den schnellen Aufbau ohne Fundamente vor Ort, auch auf unebenem Terrain. Innerhalb von 24 Stunden komplett aufstellbar, lässt sich das Future Shack ebenso schnell wieder zusammenpacken, um andernorts neu eingesetzt werden zu können.

En cas d'urgence

La hutte du futur

Confrontés à la mission de « loger », les architectes font preuve d'imagination dans la conception d'abris pour leurs semblables. La « Future Shack » (hutte du futur) est une habitation produite en très grande série et susceptible d'être déplacée en situation d'urgence ou pour servir d'appoint. Des conteneurs recyclés constituent le corps principal d'habitation. Un toit parasol est inclus dans le conteneur. Une fois érigé, le toit abrite le conteneur de la chaleur solaire. Des pieds télescopiques supportent le conteneur même sur sol inégal et sans excavation. La « hutte du futur » peut être repliée sur elle-même et repositionnée ailleurs ou stockée.

En caso de emergencia

Future Shack

La necesidad elemental de vivir en una casa en su forma más sencilla es un reto para los arquitectos. La Future Shack (cabaña del futuro) se fabrica en serie y es una casa móvil pensada para ser utilizada en zonas catastróficas o en guerra. La estructura exterior es un contenedor de transporte reciclado. Los tejados exteriores desplegables sirven para dar sombra y para evitar el calentamiento excesivo del interior. Las patas telescópicas permiten levantar estas viviendas sin necesidad de cimientos y sobre terrenos poco uniformes. La Future Shack puede montarse o desmontarse en 24 horas para que pueda utilizarse rápidamente en otro lugar.

Signed, Sealed, Delivered

xbo House

The dimensions of a semi-truck flatbed trailer dictate the size of this house – in transport mode. Upon arrival on site, the truck crane hoists it onto the track work of the steel foundation frame. Assembly continues by rolling out the bedroom container. Slowly, the two complementary spatial units assume their positions. The larger container houses the kitchen and living node, the smaller container the bedroom and bathroom. A terrace between them connects the composition with an inside/outside transition space that makes the 30 m² floor space seem much larger. And, abracadabra, you move in.

Ausfahren, aufklappen – fertig!

xbo-Haus

Die Dimensionen eines Lastwagenanhängers geben die Größe dieses Hauses – im Transportzustand – vor. Am Standort angekommen, wird das Haus vom Laster gehoben und auf einen Fundamentrahmen aus Stahlschienen abgeladen. Der Aufbau setzt sich fort mit dem Ausfahren des Schlafcontainers. Es entpuppen sich zwei Raumeinheiten – der größere Container zum Wohnen und Kochen und der kleinere mit einer Schlafkabine und dem Badezimmer. Eine große Terrasse dazwischen verbindet die Raumeinheiten und schafft einen Raum zwischen innen und außen, der die 30 qm Nutzfläche wesentlich größer erscheinen lässt. Und fertig ist das Haus.

Commandée, transportée, livrée

MAison xbo

Les dimensions d'une plate-forme de semi-remorque ont dicté la taille qu'a cette habitation pour le transport. Une fois sur le site, la grue du camion la dépose sur les rails en acier qui constituent ses fondations. L'assemblage se poursuit par l'extraction du conteneur chambre. Peu à peu, les deux éléments sont mis en place. Le conteneur le plus grand abrite les espaces cuisine et séjour, le plus petit, la chambre et la salle de bain. Une terrasse les relie avec un espace de transition entre l'intérieur et l'extérieur qui fait paraître plus grands les 30 m² occupés au sol. Et abracadabra... vous êtes chez vous.

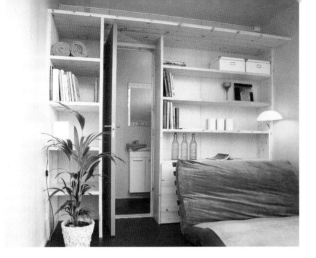

Salir, montar y listo

Hogar xbo

Las dimensiones del remolque de un camión determinan el tamaño de esta casa durante el transporte. Una vez que se ha llegado al sitio deseado, la grúa del camión alza la casa y la coloca sobre una estructura de acero. El montaje continúa sacando el contenedor del dormitorio. Se descubren así dos unidades espaciales, el contenedor más grande con el salón y la cocina, y el más pequeño con el dormitorio y el baño. Una gran terraza situada en el medio une las estancias y crea un espacio entre el interior y el exterior que hace que la superficie habitable de 30 m² parezca mucho mayor. La casa ya está lista.

(Tromsø), Norway, 70°N arkiitektur as, 2004, 30 m²

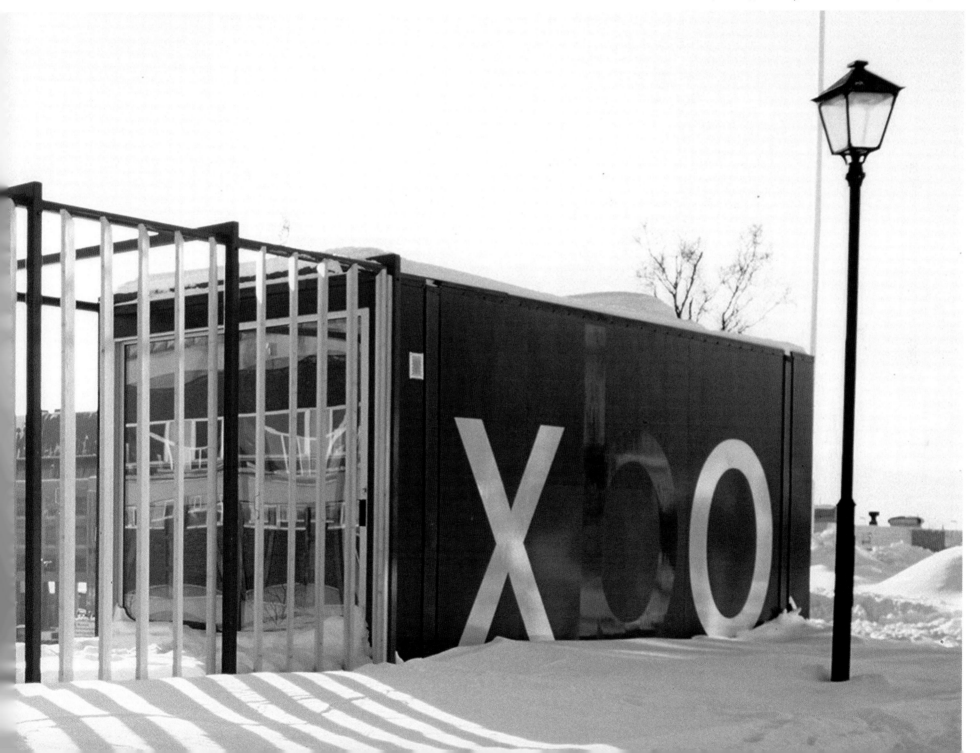

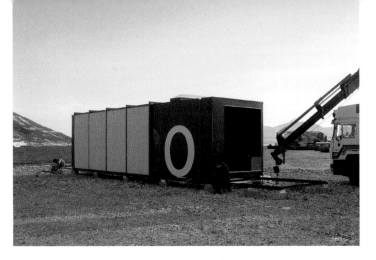

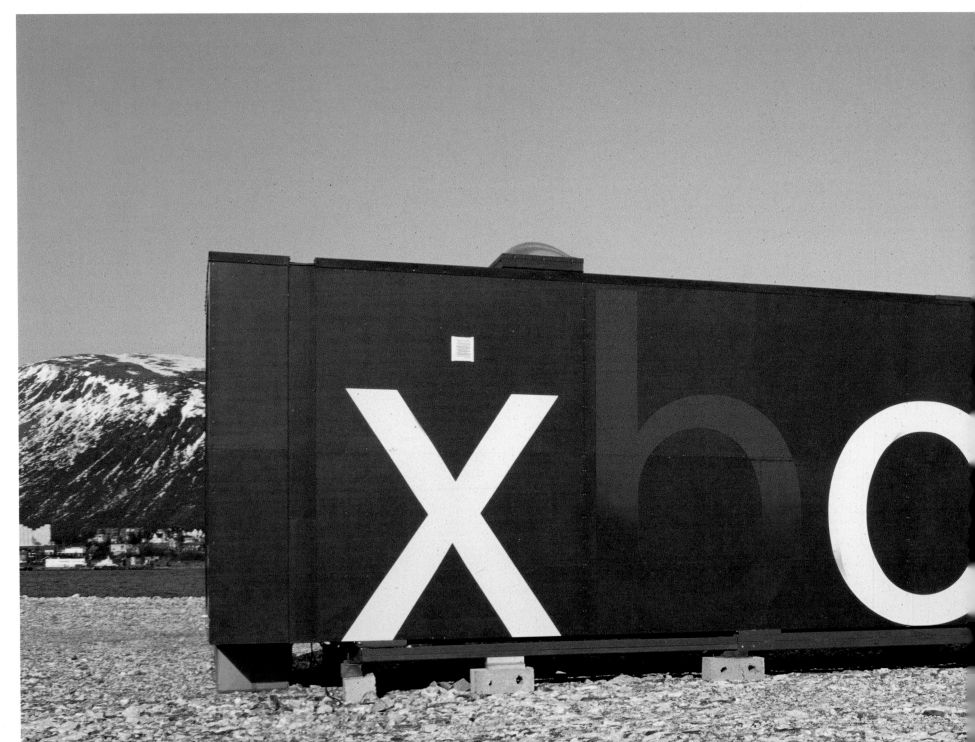

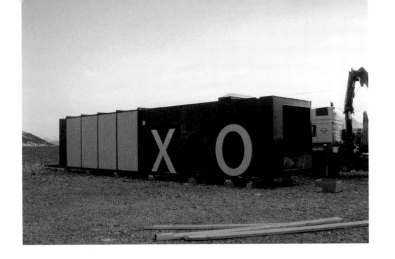
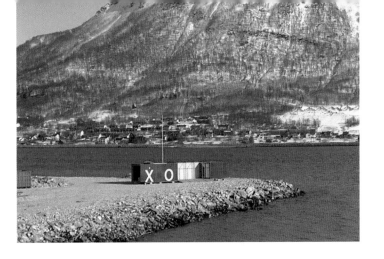
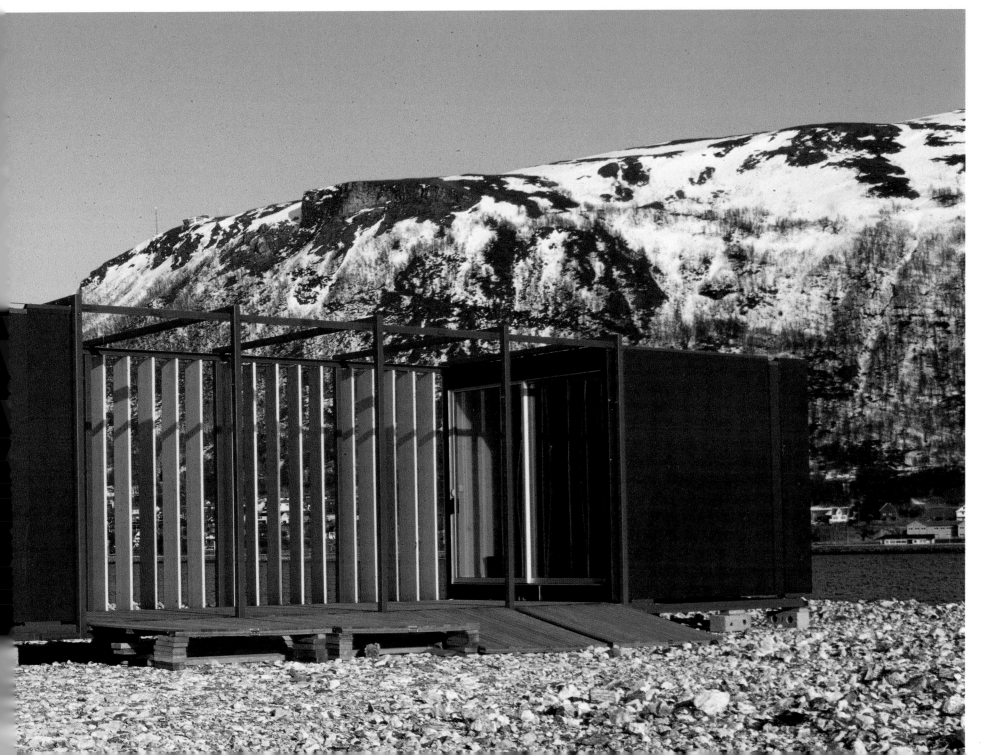

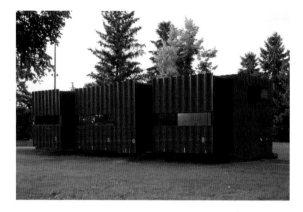

(New York), USA,
LOT-EK,
2003, 41 m²

One for the Road
MDU Mobile Dwelling Unit

MDU's are conceived for individuals moving around the globe. They travel with the dweller to the next long-term destination, fitted with all live/work equipment and filled with the dweller's belongings. Mobile Dwelling Units are made of shipping containers. Cuts in the metal walls of the container generate extruded sub-volumes, each encapsulating one living, working or storage function. When traveling, these sub-volumes are pushed in, leaving the outer skin of the container flush to allow worldwide shipping. When in use, all sub-volumes are pushed out, leaving the plywood surfaces on the interior completely unobstructed with all functions accessible along its sides.

Eins für den Weg
Mobile Wohneinheit

MDUs ermöglichen es, den Wohnort weltweit unproblematisch zu wechseln. Sie begleiten ihre Bewohner zum nächsten Wohnort, versehen mit der nötigen Wohn- und Arbeitsausstattung und beladen mit dem Besitztum des Bewohners. MDUs werden aus Transportcontainern hergestellt. Einschnitte in die Metallwände schaffen ausfahrbare Volumen für Wohn-, Arbeits- und Abstellnutzungen. Beim Transport werden diese Volumen eingeschoben, um den weltweiten Versand des Containers zu ermöglichen. Am Einsatzort werden sie ausgefahren, um die mit Sperrholzeinbauten versehenen Räume unverzüglich in Betrieb zu nehmen.

Une pour la route
MDU (Unité d'habitation mobile)

Les MDU (Mobile Dwelling Units) se déplacent avec leur propriétaire de lieu de résidence en lieu de résidence. Les MDU sont fabriquées à partir de conteneurs maritimes. Des découpes pratiquées dans les parois métalliques permettent d'extraire des espaces secondaires chacun dévolu à une activité ou une fonction particulière : habitation, travail ou rangement. Pour le transport, ces espaces repoussés à l'intérieur reforment la paroi au gabarit du conteneur standard. En utilisation statique, les espaces secondaires déployés dégagent totalement les surfaces intérieures en contreplaqué, permettant ainsi une mise en service rapide.

Una para la carretera
MDU Mobile Dwelling Unit

Las MDU's hacen posible que podamos trasladar nuestro lugar de residencia por todo el mundo. Estas casas viajan con sus habitantes hasta el próximo destino equipadas con todo lo necesario para vivir y trabajar y transportando las pertenencias de los dueños. Las MDU's se fabrican como contenedores para el transporte. Los cortes en las paredes de metal generan volúmenes extraíbles para su uso como lugar de trabajo, vivienda o almacenamiento. Durante el transporte estos volúmenes vuelven a meterse para permitir enviar los contenedores a cualquier parte del mundo. Una vez en el lugar de destino los subvolúmenes vuelven a extraerse para dejar libres los espacios interiores.

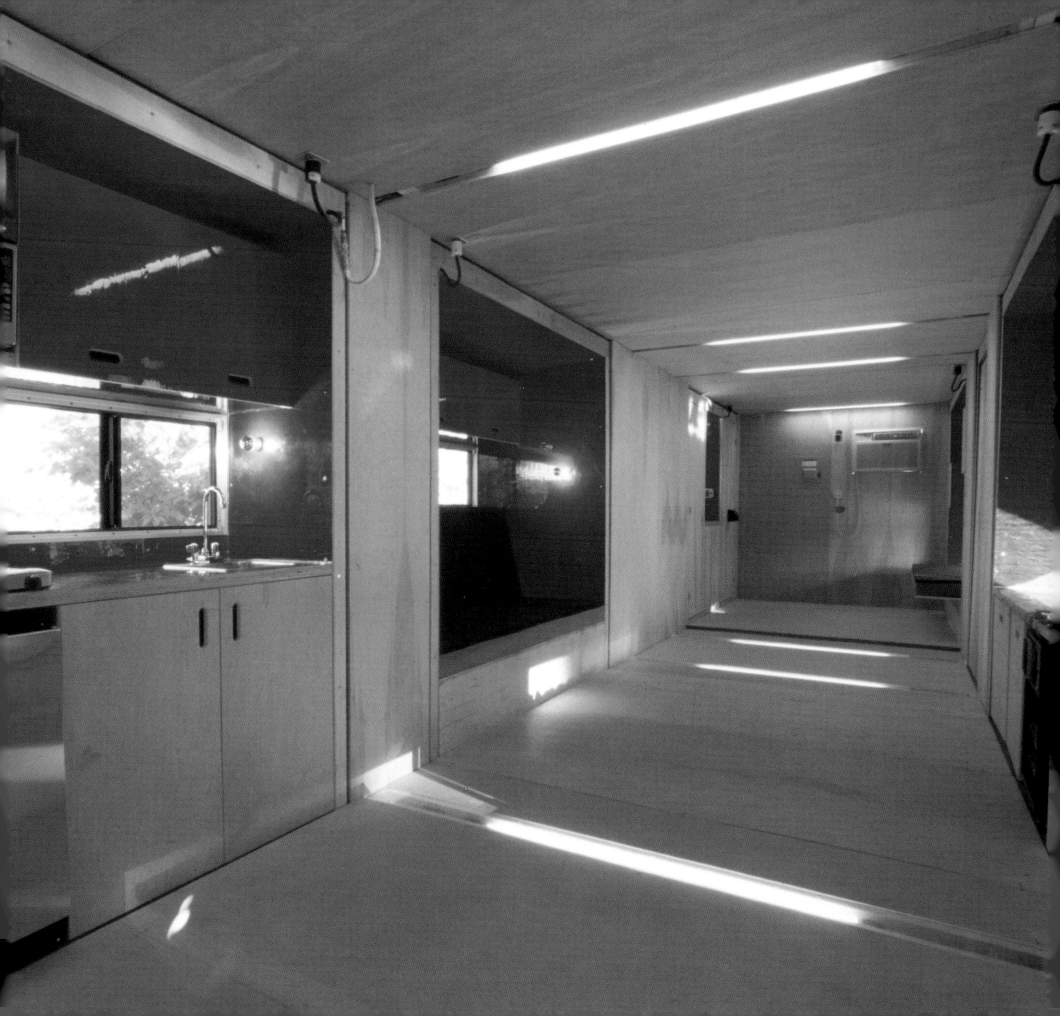

On the Road again

Espace Mobile

This house can swiftly react to accommodate changing family and employment situations. All that is required to move on to the next town is a mobile crane and a semi truck. The readymade home is delivered directly from the factory. It arrives on site completely fitted out with everything – facades, windows, doors, floors and ceilings, electrical, plumbing and even a fireplace. The high level of prefabrication provides major cost reductions while at the same time assuring hand-made quality. Additionally, the time span required for construction of a conventional home – usually a year or longer – is completely eliminated.

Ein bewegliches Haus

Espace Mobile

Ein Haus, das flexibel auf veränderte Arbeits- oder Familiensituationen reagieren kann. Sollten diese eintreten, wird es vom Lastkran auf einen LKW gehoben und zum nächsten Wohnort gefahren. Geliefert wird das in Holzbauweise erbaute Niedrigenergiehaus schlüsselfertig vom Werk. Fassade, Fenster, Türen, Böden, Wasser-, Elektro- und Sanitärinstallationen bis hin zum offenen Kamin: Alles wird bereits im Werk vorgefertigt und montiert, um die Kosten zu optimieren. Zudem entfallen Bauzeiten, die bei konventionellen Häusern ein Jahr oder auch länger betragen können und unvorhersehbare Risiken für die Bauherrschaft bergen.

Maison à emporter

Espace E-mobile

Cette maison s'adapte rapidement aux changements de lieu de travail et intervenant dans la composition de la famille. Pour déménager, il suffit d'une grue sur camion et d'une semi-remorque. Cette maison préfabriquée arrive sur le site choisi totalement équipée et finie : façades, fenêtres, portes, planchers et plafonds, électricité, plomberie et même une cheminée, tout est là. Le degré élevé de préfabrication permet d'obtenir d'intéressantes réductions de coûts tout en garantissant une grande qualité d'exécution. En outre, la maison est livrée rapidement, contrairement aux maisons conventionnelles pour lesquelles un délai de livraison est nécessaire.

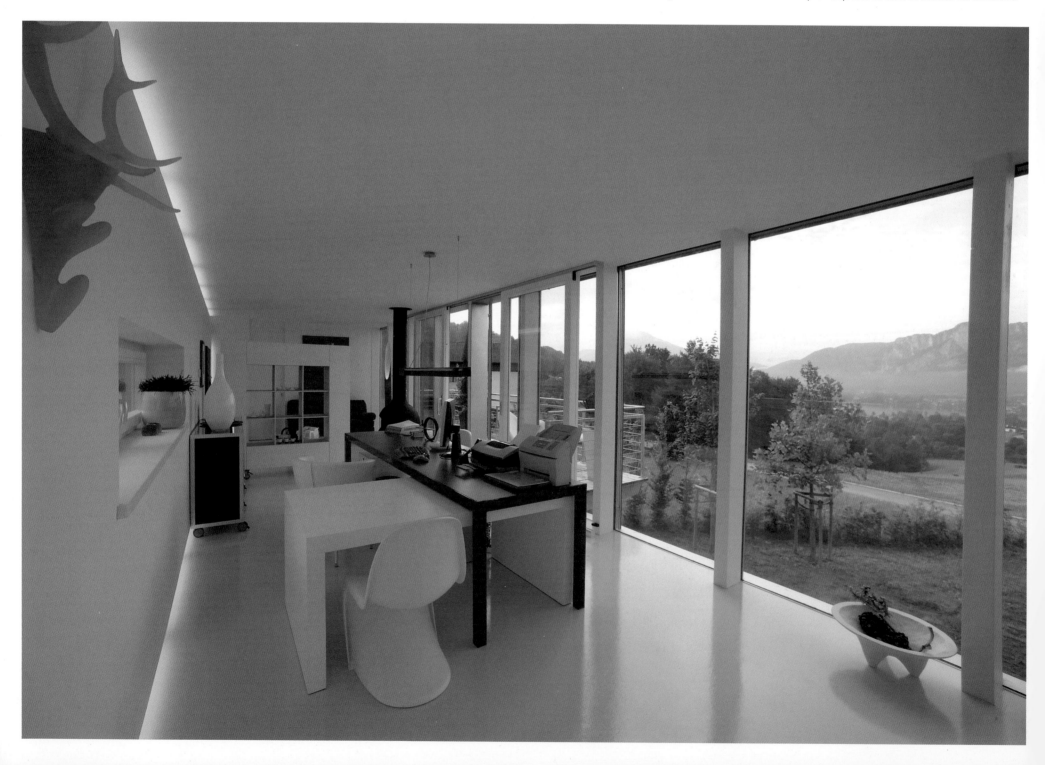

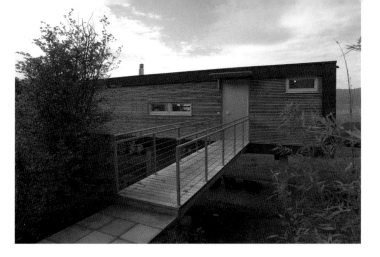

Una casa móvil

espacio móvil

Se trata de una casa que puede reaccionar de forma flexible a los cambios en la familia o en el trabajo. Todo lo que se necesita para transportarla hasta la próxima ciudad es una grúa y un camión. Esta casa prefabricada se entrega directamente de fábrica y llega al lugar completamente equipada: fachadas, ventanas, puertas, suelos, instalaciones de agua, eléctrica y sanitaria, incluso la chimenea abierta. De este modo se consigue optimizar lo costes, además se reduce el tiempo de construcción de una casa convencional de un año o más y se evitan también las posibles sorpresas desagradables que puedan surgir.

(Mondsee), Austria, spa architekten Simon Speigner, 2004, 50 m²

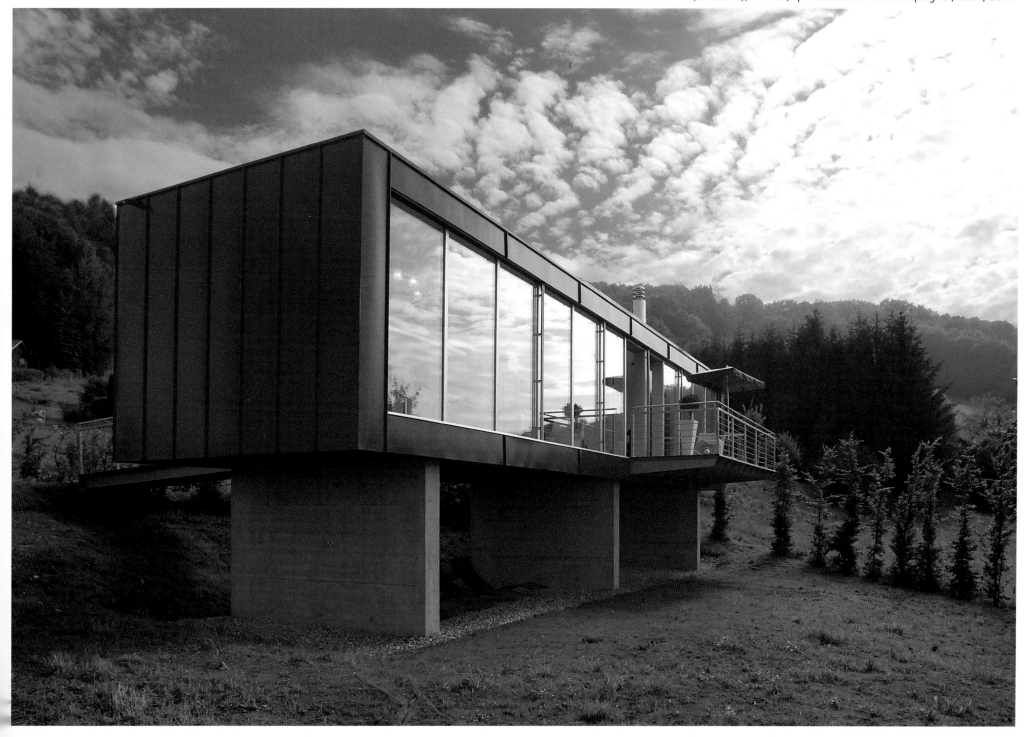

XXS Country Houses

Landhäuser | Maisons de campagne | Casas de campo

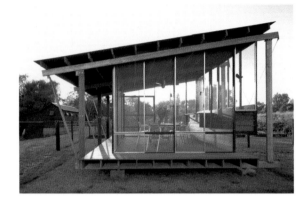

Edgerton, MO, USA,
el dorado inc ,
2002, 24 m²

Out on the Farm

Taylor Pavillon

Located on a site in the rolling landscape, this garden dining pavilion is a comment on living elegantly in the rural Midwest. The clients, active professionals who live on the land and work in the city, wished a meditative place of seclusion detached from the main house. Steel trusses form the primary construction elements and are used to elevate the building 50 cm above ground. These trusses are filled in by wood rafters and decking. The material palette is completed with window glazing on all sides. Integrated insect screens allow for maximum openness in the hot summers when the insect population forces most locals to flee to the hot confines inside.

Auf dem Landsitz

Taylor-Pavillon

Inmitten rollender Hügel gelegen, zeigt dieser Gartenpavillon, dass auch im ländlichen mittleren Westen der USA anspruchsvoll gewohnt werden kann. Die Bauherren, die in der Stadt arbeiten und auf dem Land wohnen, wünschten sich einen meditativen Ort des Rückzugs weitab des Haupthauses. Leichte Stahlrahmen bilden das Tragwerk des 50 cm über Terrain angehobenen Baus. Diese werden mit Holzbalken und Terrassenplanken ausgefacht. Komplettiert wird die Materialienpalette durch Vollverglasung an allen Seiten. Insektenschutzgitter erlauben die völlige Öffnung an heißen Sommertagen, wenn die Bewohner der Umgebung in stickigen Räumen ausharren.

Vivre à la ferme

Pavillon Taylor

Érigé dans la verte nature, cet abri de jardin/salle à manger d'été est une façon de vivre élégamment dans le ruralité du Middle West. Les clients voulaient un endroit calme et retiré séparé de l'habitation principale. Des poutres en acier formant la structure de base élèvent la construction de 50 cm au-dessus du niveau du sol. Ces poutres sont recouvertes par un plancher posé sur lambourdes. Cette plate-forme est fermée par des vitrages sur les quatre côtés. Des moustiquaires intégrées permettent d'ouvrir l'espace au maximum même en été quand les nuées d'insectes obligent les habitants à se réfugier dans les intérieurs surchauffés.

En el campo

Pabellón Taylor

Situado en medio de una redondeada colina, este pabellón de jardín es una muestra de que también se puede vivir de forma elegante en medio del rural oeste de los EE UU . Los dueños, que trabajan en la ciudad y viven en el campo, deseaban un lugar para la meditación donde poder retirarse lejos de su vivienda principal. Los ligeros marcos de acero forman la estructura de esta construcción, 50 cm por encima del nivel del suelo. Las estructuras se completan con vigas de madera y tablones para la terraza. La gama de materiales se completa con los paños de cristal en los cuatro lados. Las pantallas antimosquitos permiten abrir completamente la casa en verano.

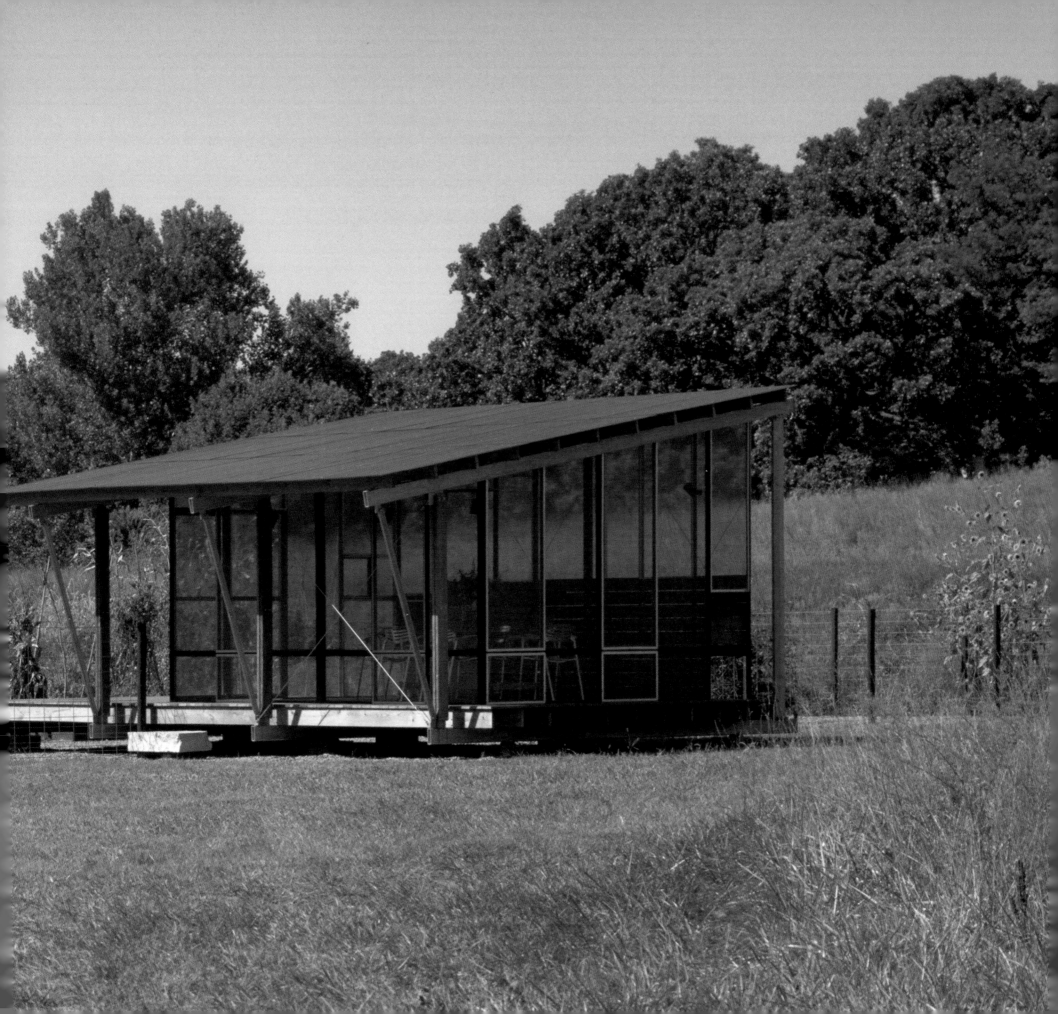

Prefabricated Sanctuary

weeHouse

The weeHouse was built in response to the client's limited budget, to minimally impact the site, and to create a quiet space for retreat. With no electricity, running water, or sewer connection, the quality of space was more important than amenities. The weeHouse serves as a weekend getaway, a decompression zone, essentially a log cabin in the country. The location, a small plot on Minnesota farmland, was remote and lacking in basic facilities, so the house was prefabricated and transported whole. It took eight weeks to complete, was trucked to the site, and hoisted onto its foundation by crane.

Instant-Refugium

weeHaus

Die Bauherrin wünschte sich ein kostengünstiges Refugium im Einklang mit der Natur. Die Qualität des Raumes hatte Priorität; auf Stromanschluss, fließendes Wasser oder Sanitärausstattung wurde verzichtet. So dient das Haus als Zufluchtstätte an Wochenenden oder als Sommerhaus. Nach dem Vorbild der Pionierhütten konzipiert, ist es ein Ort, um zum einfachen Leben zurückzufinden. Das Grundstück, eine kleine Parzelle inmitten landwirtschaftlicher Flächen, ist abgelegen und unerschlossen. Per LKW wurde das komplett fertige Haus geliefert und mittels Lastkran auf seine Fundamente gehoben.

Refuge préfabriqué

weeHouse

Le programme de la « weeHouse » (maison minuscule) était
le suivant : budget limité du client, impact minimal sur
l'environnement et création d'un refuge calme et tranquille. Sans
électricité, ni eau courante, ni tout-à-l'égout, la qualité du site
comptait plus que les équipements de confort. La « weeHouse » sert
de refuge de week-end, de lieu de relaxation : c'est essentiellment
une cabane dans la nature. Sa localisation, un petit terrain non
viabilisé sur une ferme du Minnesota, loin de tout, a nécessité sa
préfabrication complète. Il a fallu huit semaines pour la construire,
la transporter par camion sur le site et la gruter sur ses fondations.

Refugio prefabricado

weeHouse

La dueña de esta construcción deseaba un refugio económico y en
armonía con la naturaleza. La calidad del espacio era lo prioritario y
se renunció al agua corriente, a la electricidad y a la conexión con
el alcantarillado. De este modo la casa sirve como lugar de refugio
durante los fines de semana o como casa de verano. Inspirada en las
cabañas de los pioneros, es un lugar donde reencontrarse con la vida
sencilla. El terreno, una pequeña parcela en medio de superficies
destinadas al cultivo, está en un lugar retirado y virgen. Por eso se
tardó 8 semanas en levantarla. Fue transportada ya montada en un
camión y colocada encima de los cimientos con la grúa.

Pepin, WI, USA, Warner + Asmus Architects, 2003, 31 m²

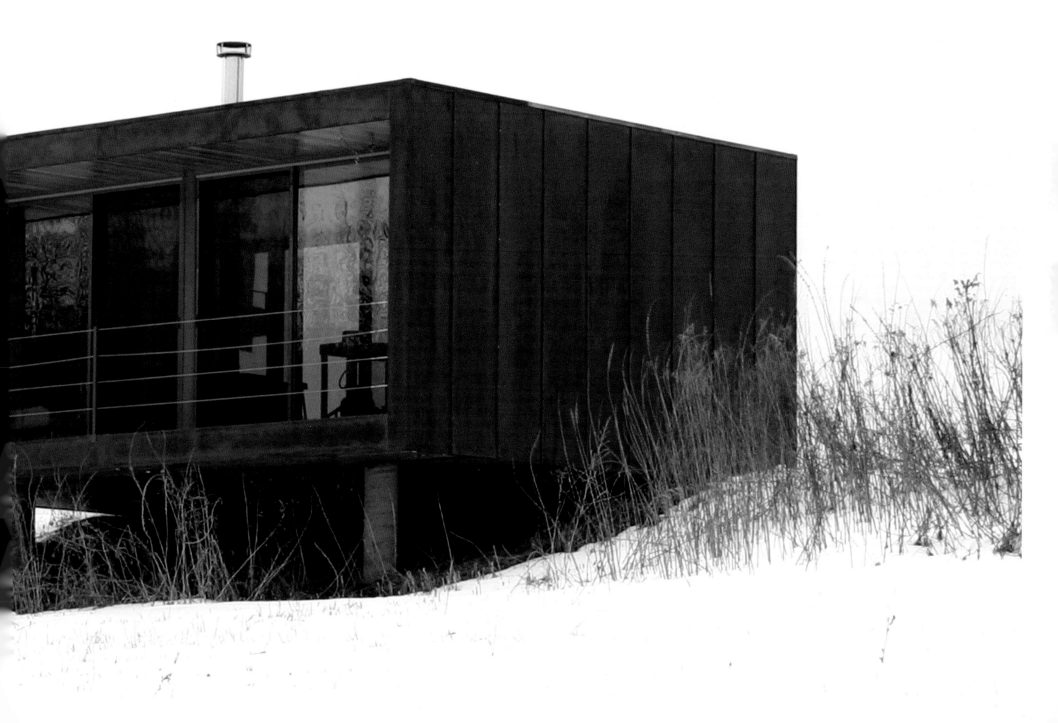

Åaland, Finland
Saunders and Wilhelmsen Architects,
2003, 42 m²

Folded House

Summer House

The Summer House is situated in a pine forest on a Finnish island. The concept was to create a continuous long folding wooden structure that moves up, down, over, and under through the various spaces, and includes all the functions. The folding structure creates all the parts of the house: the walls, floor, roof, roof garden, stair and sitting spaces. The house is constructed on pillars to conserve the natural landscape and the roots of all the trees. The house almost doubles in size when opened to the outdoor room between the kitchen and bedroom, creating one large room with a view through the pine forest.

Gefaltetes Haus

Sommerhaus

Das Sommerhaus liegt inmitten eines Kiefernwaldes auf einer finnischen Ostseeinsel. Leitgedanke des Entwurfs war es, ein durchgehendes Holzgefüge um sämtliche Hausfunktionen zu „falten". Die gefalteten Holzebenen wickeln sich um alle Hausteile: Wände, Decken, Dach, Dachgarten, Treppe und Sitzbereiche. Auf Stützen errichtet, greift das Haus so wenig wie möglich in das vorhandene Ökosystem ein und ermöglicht so den Erhalt des Baumbestands. Die Platzierung der Terrasse als Zimmer im Freien bildet zwischen Küche und Schlafzimmer einen großzügigen Raum mit Blick in den Kiefernwald.

Une maison dépliée

Maison d'été

Cette maison d'été est située dans une forêt de pins sur une île de Finlande. Le concept consistait à créer un long continuum de bois délimitant par pliages divers espaces et incluant toutes les fonctions. La structure dépliée forme toutes les parties de l'habitation : murs, toit, jardin sur le toit, escalier et espaces techniques. La maison a été posée sur des piliers afin de respecter le tracé du terrain et de préserver les racines des arbres existants. La maison double pratiquement de taille quand elle s'ouvre sur l'espace extérieur entre la cuisine et la chambre, avec la création d'une grande pièce donnant sur la forêt de pins.

Casa doblada

Casa de Verano

Esta casa de verano está situada en medio de un pinar en una isla de Finlandia. El concepto del proyecto era crear una larga estructura continua de madera para "plegar" todas las funciones de la casa. Los planos de madera plegados se enrollan alrededor de todos las partes de la casa: paredes, techos, tejado, jardín cubierto, escaleras y los espacios para sentarse. La casa se ha construido sobre pilares para respetar en todo lo posible el entorno natural y poder mantener intactas las raíces de los árboles. La organización de la terraza como habitación al aire libre forma una amplia estancia entre la cocina y el dormitorio con vistas al pinar.

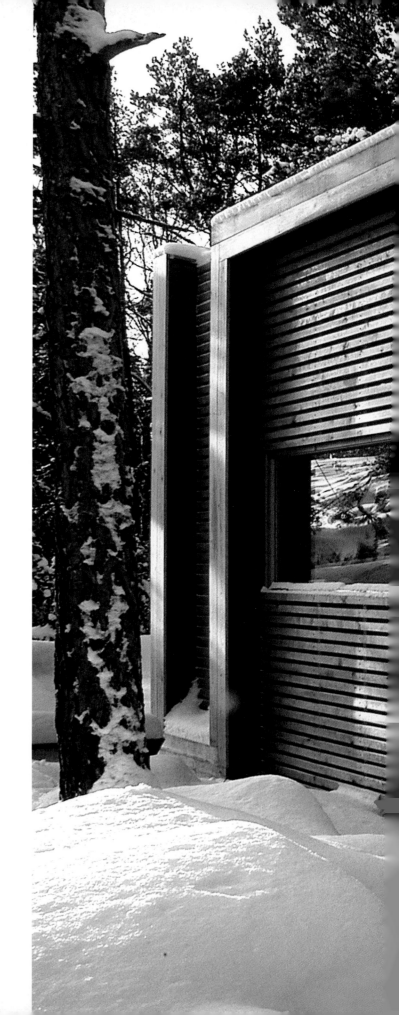

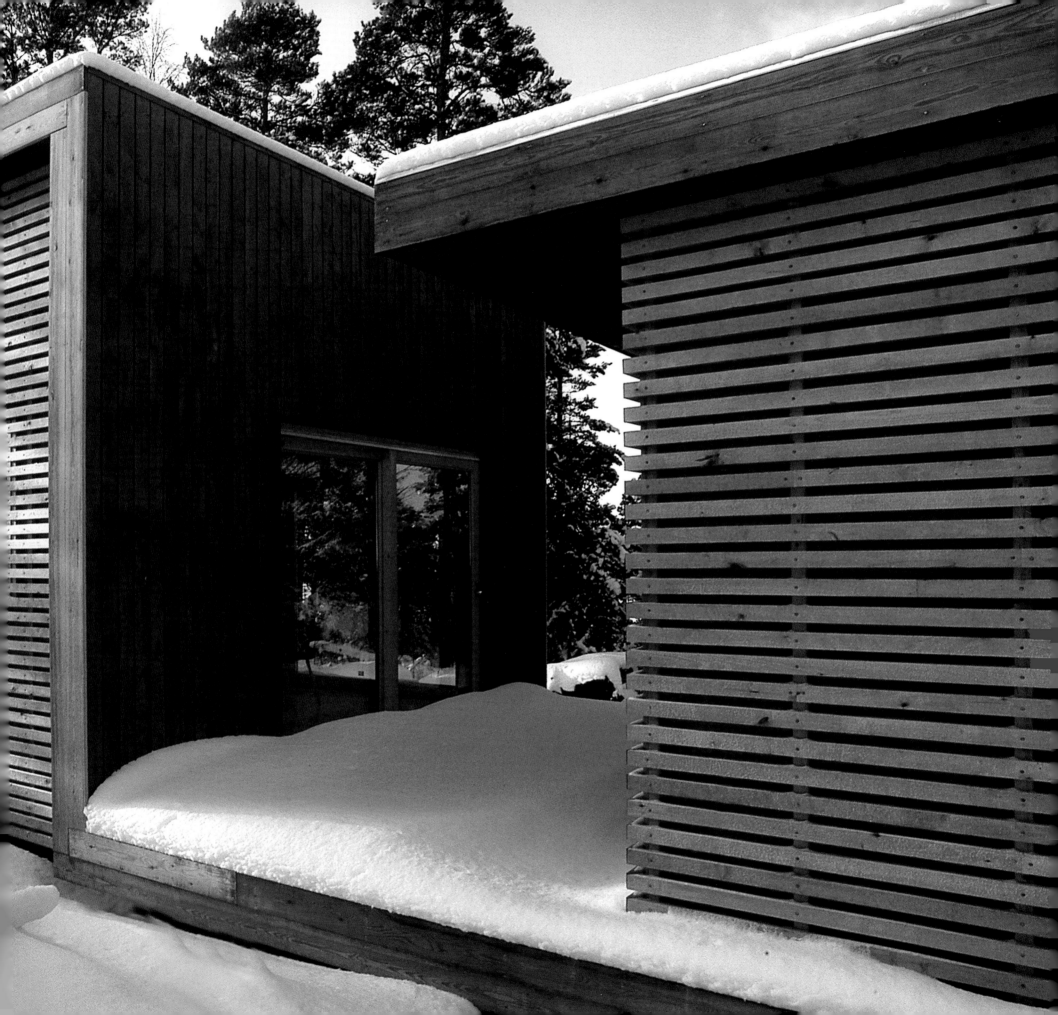

Work-Home

Barker Pod

Living in the country while maintaining a connection to the pulse of urban life is increasingly possible. The Internet, satellite television, and inexpensive air travel allow ever-more people to work from "home". The pod serves as a home office in the woods near an existing main house. The materials used reflect the family's desire for low impact living. The siding is a corrugated copper rain screen. The interior consists of two, partially subterranean rooms, cooled by cross ventilation and heated by a radiant concrete slab fed from the main house. Walls and roofs are super-insulated. Photovoltaic panels mounted on the main house provide supplemental power.

Arbeitshaus

Barker Pod

Das Wohnen auf dem Land ohne Verzicht auf das urbane Leben ist zunehmend möglich. Das Internet, Satellitenfernsehen und preisgünstige Flüge erlauben immer mehr Menschen, von "zu Hause" aus zu arbeiten. Dieser Bau, mitten im Wald gelegen, dient als ein Heimbüro nahe des Wohnhauses. Die Materialien unterstreichen den Wunsch der Familie nach nachhaltigem Wohnen. Kupferbleche prägen das Bild von außen. Innen werden die teils in das Erdreich eingelassenen Räume natürlich querentlüftet und über Fußbodenheizung beheizt. Wände und Decken wurden maximal gedämmt, und Photovoltaik-Paneele am Haupthaus liefern Solarstrom.

Maison de travail

Barker Pod

Vivre à la campagne tout en maintenant des liens étroits avec la vie urbaine trépidante est désormais possible. La « pod » (capsule) sert de lieu de travail privé aménagé dans les bois à proximité d'une habitation principale. Les matériaux utilisés reflètent la volonté de la famille de ne pas nuire à l'environnement. Le revêtement protecteur contre la pluie est en cuivre ondulé. L'intérieur comprend deux pièces partiellement enterrées, rafraîchies par ventilation transversale et chauffées par un bloc radiant en béton alimenté depuis la maison principale. Des panneaux solaires installés sur la maison principale fournissent de l'énergie en appoint.

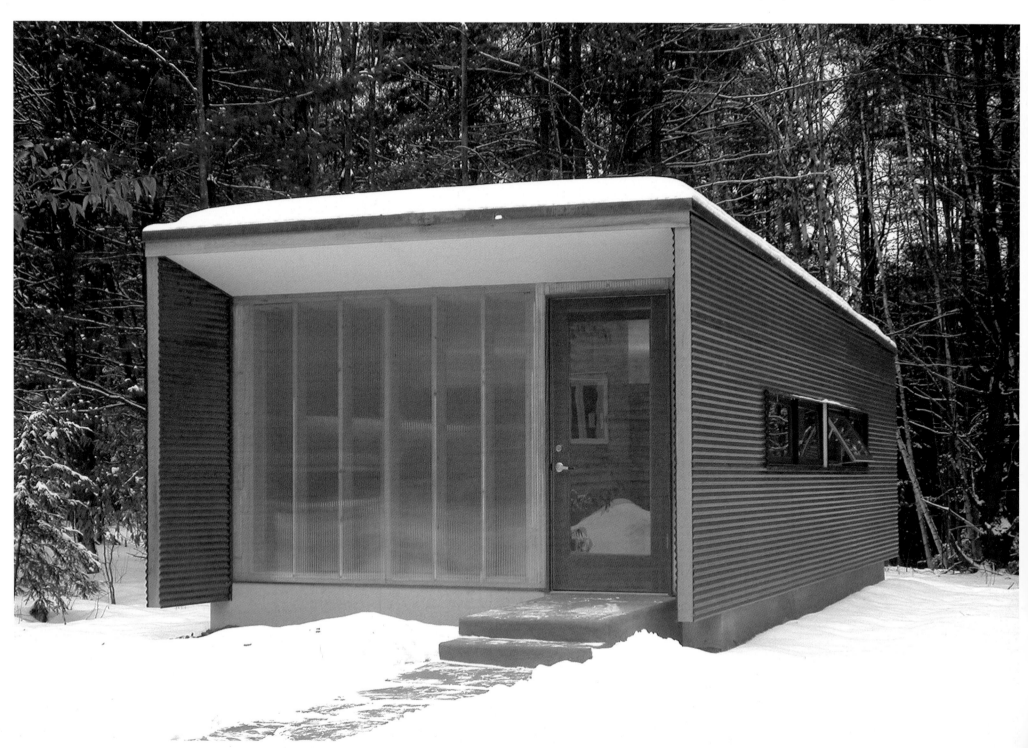

Casa de trabajo

Barker Pod

Vivir en el campo sin renunciar a las ventajas y comodidades de la vida urbana es cada vez más posible. Internet, televisión por satélite y vuelos baratos permiten ya a muchas personas trabajar "desde casa". Esta construcción, situada en un bosque, sirve como una oficina cercana a la vivienda. Los materiales reflejan el deseo de la familia de vivir de una forma respetuosa con el medio ambiente. La chapa de cobre caracteriza el exterior. El interior está compuesto por dos habitaciones parcialmente hundidas en la tierra, con ventilación cruzada y calefacción radiante. Las paredes y los techos han sido completamente aislados. Los paneles solares de la casa principal suministran la electricidad.

Jericho, VT, USA, el dorado inc , 2002, 42 m²

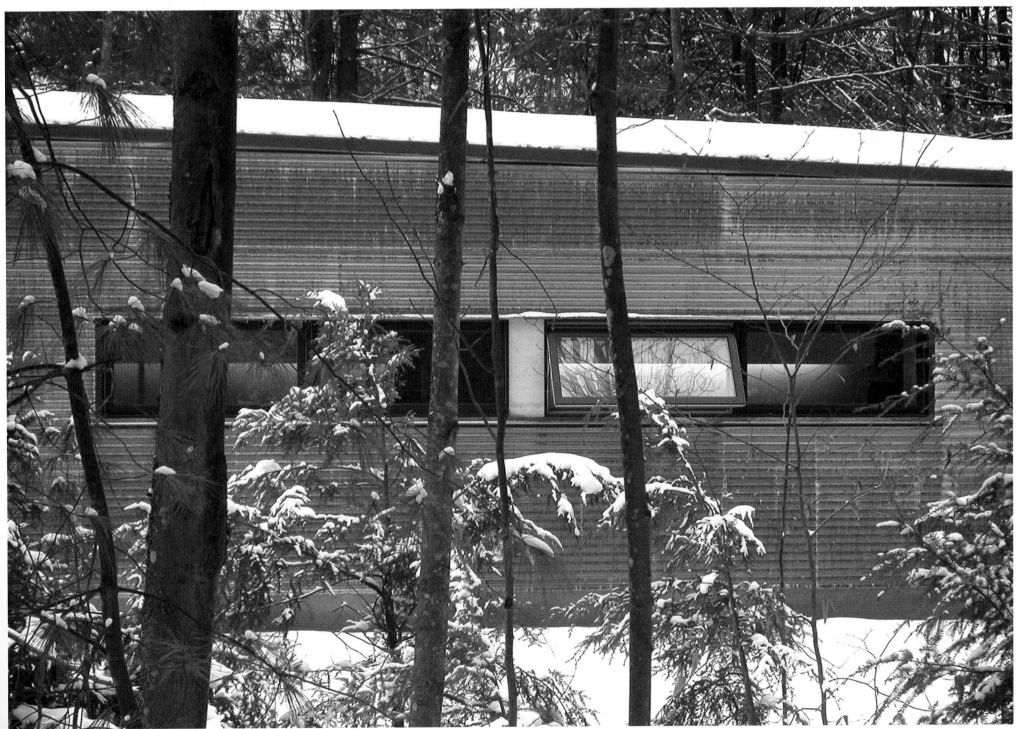

At the Bridgehead

Temple de l'Amour II

The idea for this pavilion built on the abutment of a dismantled rail bridge was born when a chamber-like room was discovered in the lower level and converted into a guest bedroom. On the upper level, a new meditative space was built on the remnants of the bridge. To best take advantage of this vista point, which offers views of the river, a fully transparent solution was required. Laminated glass panels were utilized to carry the two-ton load of the copper-clad wooden roof and fully eliminate columns. Four glass doors offer multiple access points and allow for excellent cross ventilation.

Am Brückenkopf

Temple de l'Amour II

Die Idee für den Glaspavillon auf dem Widerlager einer demontierten Eisenbahnbrücke entstand nach Entdeckung einer kleinen Kammer im Untergeschoss, die zu einem Gästezimmer umgebaut wurde. Oben, auf den Resten der Brücke, entstand ein meditativer Raum, von dem aus man die Aussicht auf den Fluß genießen kann. Um einen ungehinderten Ausblick zu ermöglichen, wird die kupfergedeckte Holzkonstruktion des Daches durch Verbundglasscheiben getragen, was Stützen überflüssig macht. Glastüren dienen als Zugang und sorgen zugleich für eine gute Durchlüftung.

Une tête de pont

Temple de l'Amour II

L'idée de ce pavillon construit sur la culée d'un pont ferroviaire démoli est née de la découverte d'un espace équivalent à une pièce dans le sous-sol et transformé en chambre d'amis. Au-dessus, un nouvel espace de recueillement a été édifié sur les ruines du pont. Pour profiter au maximum du point de vue sur la rivière, une solution totalement transparente s'est imposée. Des panneaux de verre laminé, qui supportent le toit en bois revêtu de cuivre pesant deux tonnes, sont les seuls éléments porteurs. Quatre portes en verre multiplient les accès et assurent une excellente ventilation transversale.

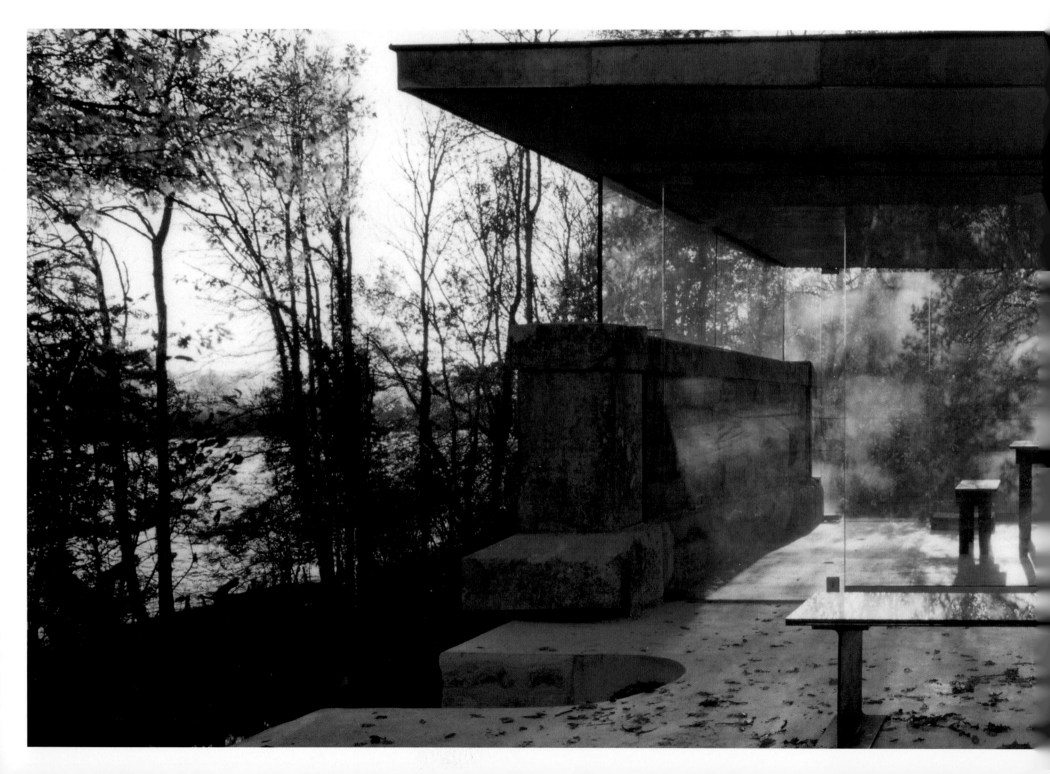

En la cabeza del puente

Temple de l'Amour II

La idea para levantar un pabellón de cristal sobre el espolón de un puente ferroviario desmantelado surgió después del descubrimiento de una pequeña cámara bajo tierra que después fue convertida en la habitación de invitados. Arriba, sobre los restos del puente, se levantó una estancia para la meditación desde la que se puede disfrutar de la vista sobre el río. Para posibilitar una vista libre la construcción de madera cubierta de cobre del tejado está soportada por paños de cristal unidos que hacen innecesarias las columnas. Las puertas de cristal sirven de entrada y hacen posible una buena ventilación cruzada.

Burgundy, France, Dirk Jan Postel, 2002, 44 m^2

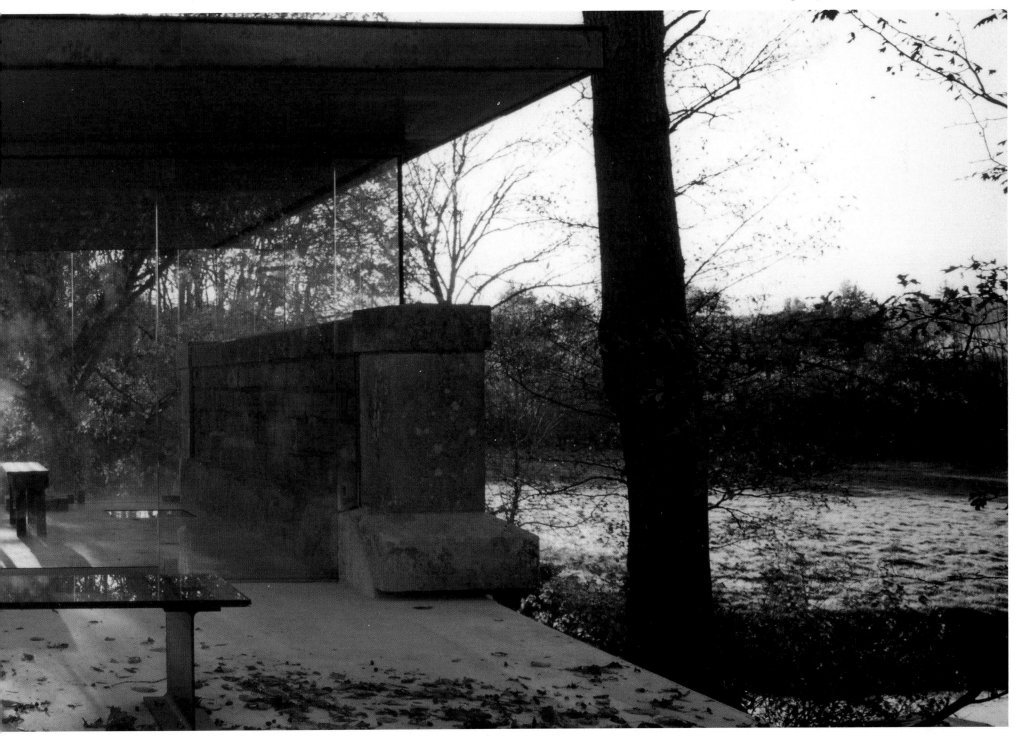

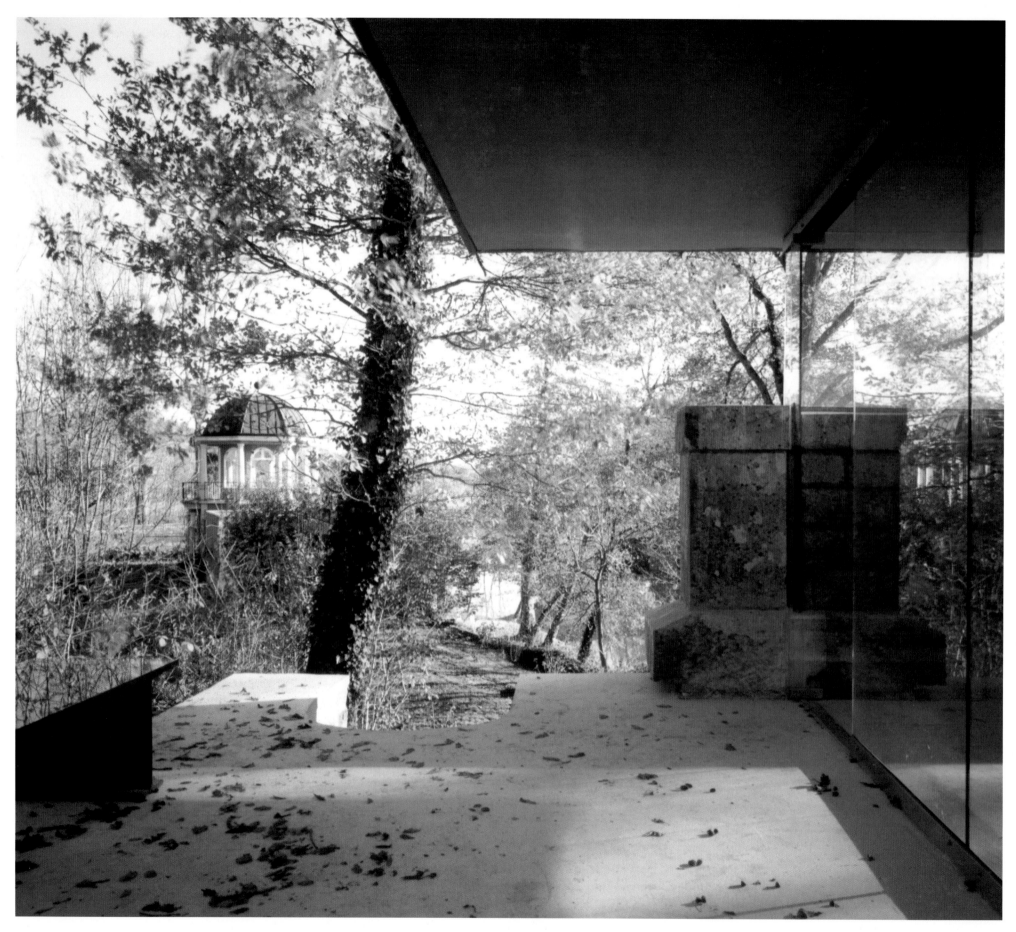

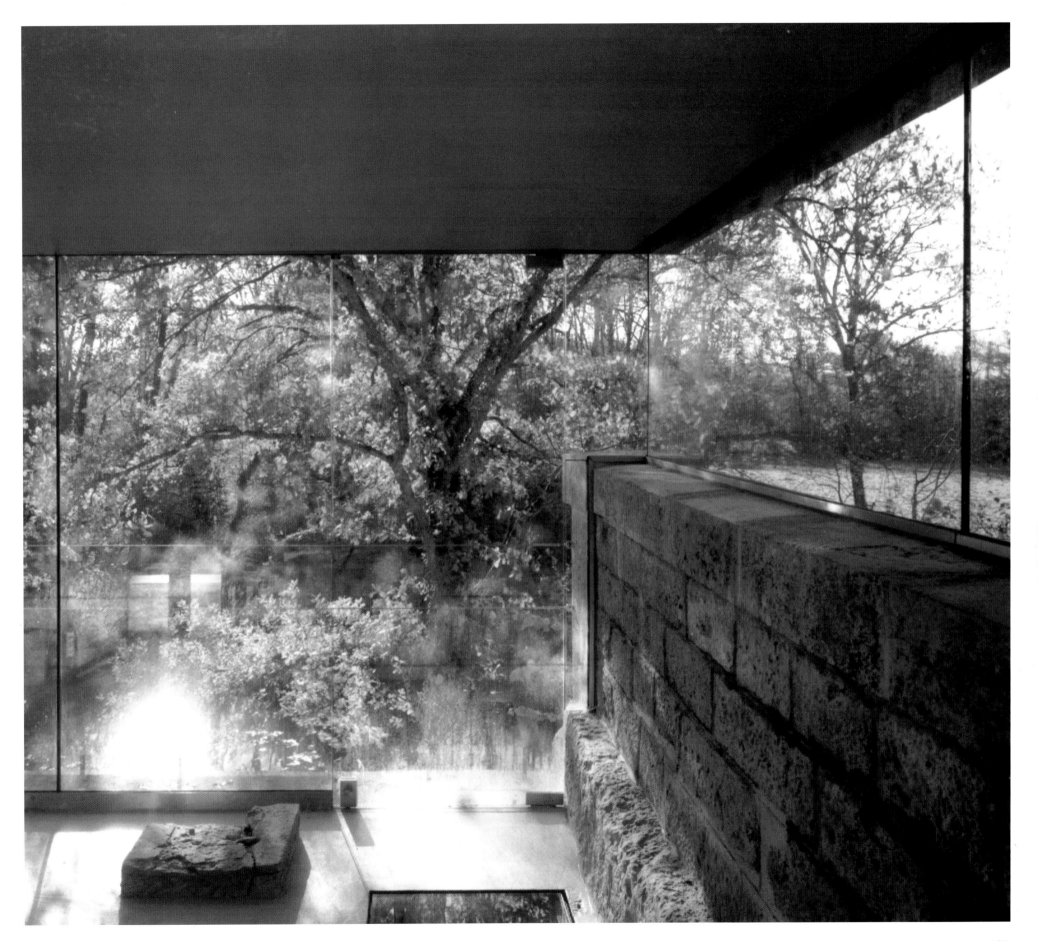

The Light Box

D'Allesandro House

Sited to avoid destruction of the natural jungle setting, the basic structure of the house consists of two contrasting building volumes. The main living volume, a hall space built in light wood-frame construction, is enclosed by semi-transparent polycarbonate panels, which alternate with glass to allow dramatic open views out to the nearby lake. The hall espouses open informality due to the undulating light and the high level of connection between inside and out. This "light box" stands detached from the ground. The slanting metal roof emphasizes the main volume. Service rooms are grouped in the second, massive building volume with its thick brickwork walls.

Lichtkiste

D'Allesandro-Haus

Angelegt, um den Naturraum des Dschungels nicht zu zerstören, besteht das Haus aus zwei gegensätzlichen Bauvolumen. Der Wohnsaal, in leichter Holzbauweise erbaut, wird mit halbtransparenten Acrylplatten behängt. Diese wechseln sich mit Glas ab, um traumhafte Freiblicke nach außen, z. B. zum nahen See, zu ermöglichen. Der Wohnsaal wirkt informell dank des changierenden Lichteinfalls und des starken Bezugs zwischen innen und außen. Diese Lichtkiste schwebt über dem Terrain. Ein geneigtes Metalldach betont den Wohnsaal. Die Serviceräume werden hinter den dicken Mauern des zweiten Bauvolumens zusammengefasst.

Boîte de lumière

Maison D'Allesandro

Positionnée pour ne pas détériorer le paysage de jungle naturel, la structure de base de cette maison consiste en deux volumes contrastants. Le volume d'habitation principal, un hall doté d'une charpente en bois légère, est fermé par des panneaux de polycarbonate semi-transparent qui alternent avec des panneaux de verre permettant une vue imprenable sur le lac voisin. Le hall dégage une ambiance naturelle changeante au gré de la luminosité et aux liaisons étroites entre l'intérieur et l'extérieur. Cette « boîte de lumière » paraît détachée du sol. Le toit incliné en métal accentue l'effet du volume principal.

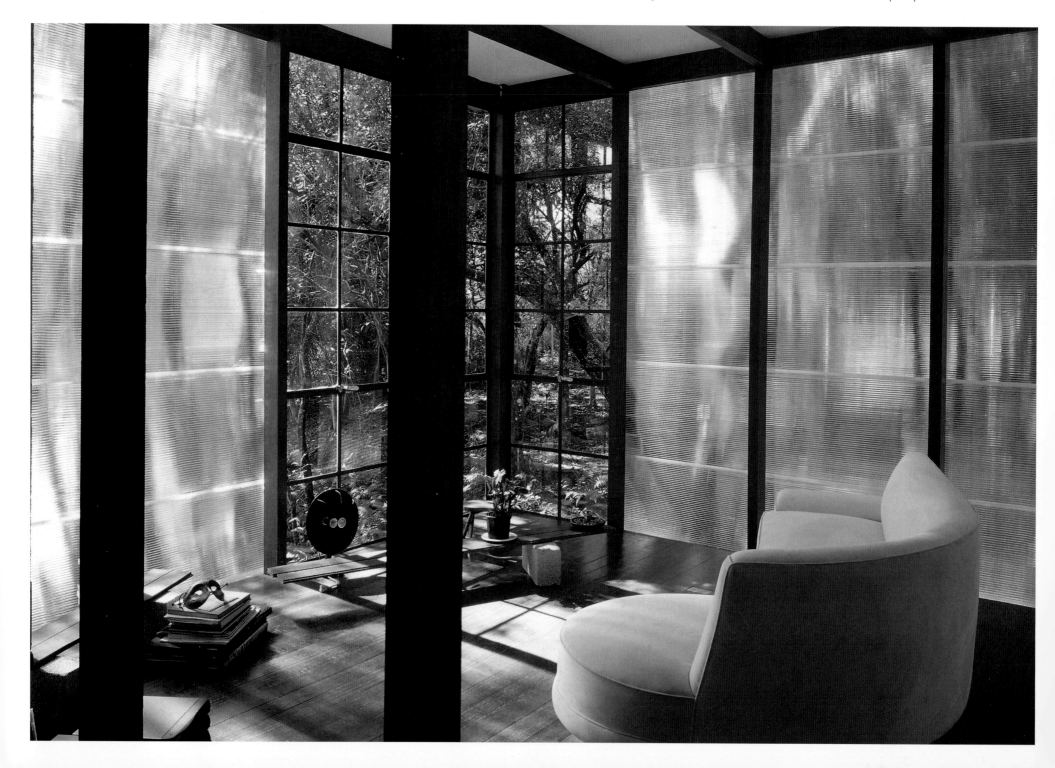

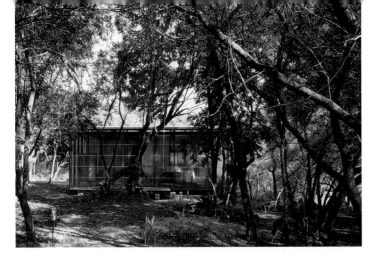

La caja de luz

Casa D'Allesandro

Construida de tal forma que no afectara a la jungla que la rodea, esta casa se compone de dos volúmenes opuestos. La estancia del salón, un espacio abierto contenido en una ligera estructura de madera, está rodeada de paneles acrílicos semitransparentes. Estos se alternan con cristal para posibilitar maravillosas vistas hacia el exterior, como por ejemplo al cercano lago. El salón tiene una apariencia informal gracias a la luz ondulante y a la fuerte relación entre el interior y el exterior. Esta caja de luz flota sobre el terreno. Un tejado metálico inclinado acentúa la estancia del salón. Los espacios de servicio se agrupan en el segundo volumen, detrás de los gruesos muros.

Sao Paulo, Brasil, Andrade & Morettin Arquitetos, 1998, 62 m²

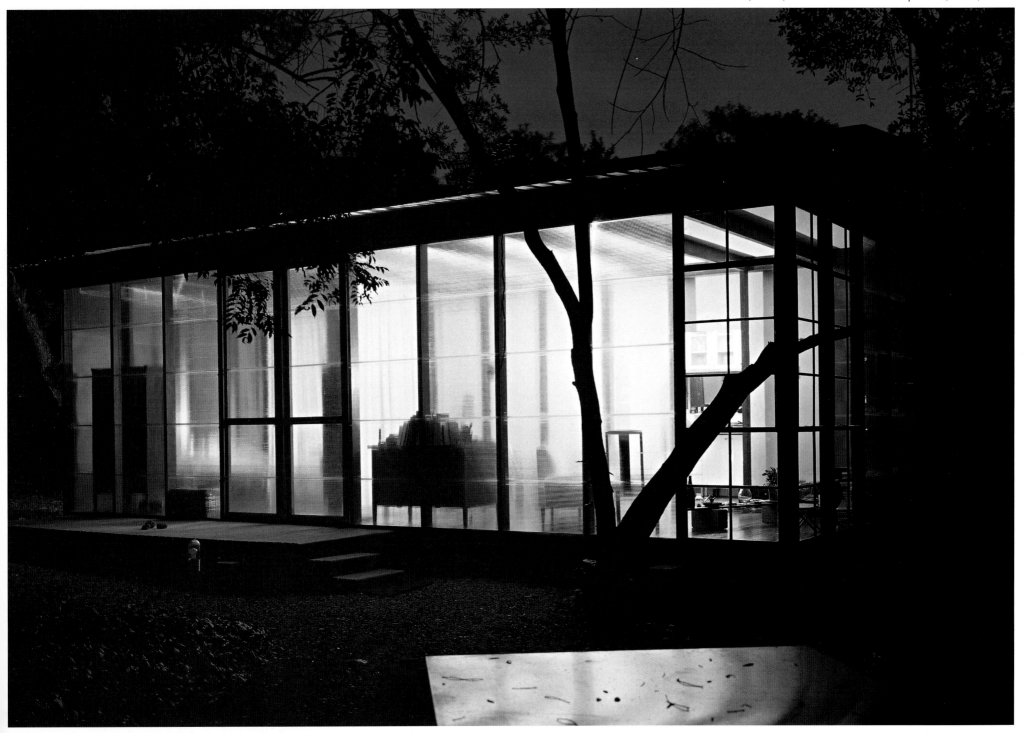

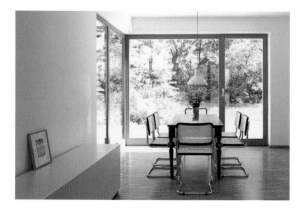

Wuthenow, Germany,
Becher + Rottkamp Architekten,
2004, 682 m^2

Four Square Home

Behr House

The clients – a couple with two children – required a small living cube that can later be added onto with a second cube. To attain the best views of lake and garden, the windows are placed to extend around the building's corners, allowing views in two directions. Unstained Siberian larch, the wood used for cladding the house, takes on a silver-gray tone with the years. The well-placed openings between the living room and kitchen, as well as clear white wall planes in combination with the oak wood flooring, all allow a generous sense to permeate the spaces in spite of their limited dimensions.

Quadratisch, Praktisch, Gut

Behr-Haus

Die Bauherren – ein junges Ehepaar mit zwei Kindern – wünschten sich fürs Erste einen kleinen Wohnwürfel, der jedoch später durch einen zweiten erweiterbar ist. Um gute Ausblicke auf See und Garten zu ermöglichen, wurden die quadratischen Fenster an den Ecken angeordnet. Die Fassade wurde in sibirischem Lärchenholz verschalt, das nach einigen Jahren einen silbrig-grauen Farbton annimmt. Öffnungen zwischen Wohnraum und Küche sowie geschlossene weiße Wandscheiben in Verbindung mit dem Eichenparkett lassen hier Großzügigkeit, auch auf kleinstem Raum, entstehen.

Maison carrée

Maison Behr

Les clients – un couple avec deux enfants – demandaient une petite maison cubique susceptible d'être complétée ultérieurement par un second cube. Afin de dégager de plus belles vues sur le lac et le parc, les baies sont placées dans les angles du bâtiment et orientées selon deux directions. Le mélèze de Sibérie naturel, bois ayant servi à habiller la maison, prend avec le temps une teinte gris argent. Les ouvertures bien placées entre le séjour et la cuisine ainsi que les parois blanches combinées aux planchers de chêne concourent à donner une généreuse impression d'espace malgré les dimensions réduites de l'ensemble.

Casa cuadrada

Casa Behr

Los dueños, un joven matrimonio con dos niños, deseaban un pequeño cubo habitable que se pudiera ampliar después con un segundo cuerpo. Para poder disfrutar de buenas vistas al lago y al jardín, las ventanas cuadradas se colocaron en las esquinas. La fachada se hizo de madera de alerce de Siberia, material que con el paso del tiempo adquiere un color gris plateado. Las aberturas inteligentemente dispuestas entre la sala de estar y la cocina, y la combinación de los blancos paneles de la paredes con el color oscuro del parquet de roble hacen que estas estancias pequeñas parezcan mucho más espaciosas.

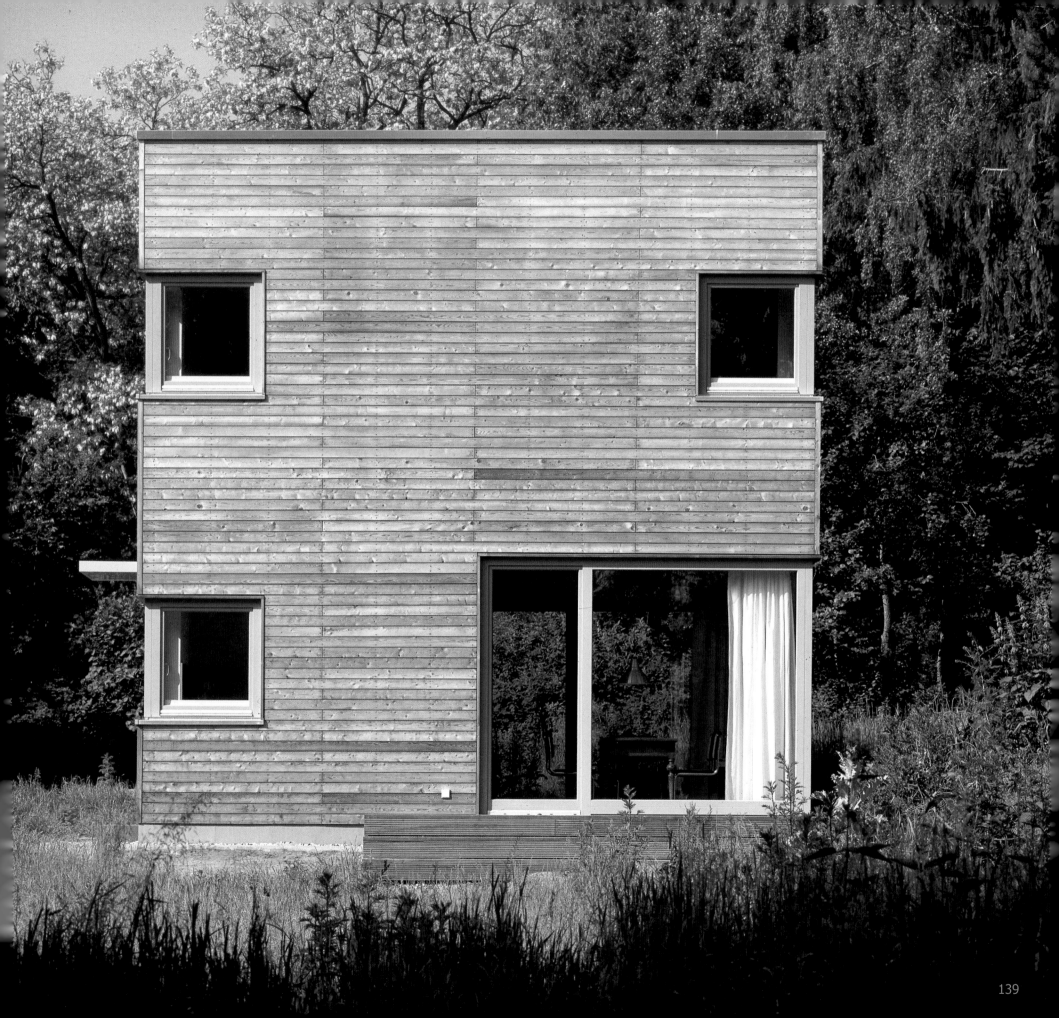

Karuizawa, Japan,
Office of Makoto Yamaguchi,
2003, 68 m²

Just landed
Villa / Gallery
Perched on a south-facing, forested slope, this house-gallery commands a view of the nearby mountains. The clients, a musician couple, asked for a flexible space to serve as a villa, an art gallery, a concert space and a place to entertain friends. A "neutral space" is the architect's response. The kitchen and bath – inevitable functions of a house – are built into the floor, making the obstacle-free spaces seem larger. The exterior stands in clear contrast to the interior. Covered in white-painted FRP (fiber reinforced plastics), its seamless skin underscores the ephemeral quality present throughout.

Soeben gelandet
Villa / Galerie
Vor dem bewaldeten Hang des Hauses öffnet sich ein Panoramablick auf die umliegenden Gebirge. Die Bauherren benötigten einen flexiblen Raum zum Wohnen, als Galerie, für Konzerte und als Ort, um Freunde zu bewirten. Daraufhin entstand ein „neutraler" Raum. Küche und Bad – Primärfunktionen eines Hauses – sind in den Fußboden eingelassen, damit die Räume größer erscheinen. Die Außenhaut steht im Kontrast zu den Innenräumen. Weiß gestrichenes FRP (faserverstärkter Kunststoff) bildet hier eine fugenlose Haut, die das geheimnisvolle Ambiente unterstreicht.

À peine posée
Villa/galerie
Perchée sur une pente boisée orientée au sud, cette maison/galerie permet d'embrasser du regard les montagnes avoisinantes. Les clients, un couple de musiciens, avaient demandé un espace adaptable servant de villa, de galerie d'art, de salle de concert et de lieu de réception. Les architectes ont répondu par un « espace neutre ». La cuisine et le bain – figures imposées dans une maison – sont intégrés au plancher, dégageant ainsi totalement l'espace qui paraît plus vaste. L'extérieur semble être en opposition totale avec l'intérieur. Revêtu de résine plastique renforcée de fibres de verre, cette peau sans couture souligne la qualité fugitive qui émane de l'ensemble.

Recién aterrizado
Villa / Galería
Ante la pendiente arbolada de la casa se abre una vista panorámica sobre las vecinas montañas. Los dueños, una pareja de músicos, necesitaban un espacio flexible en el que vivir, una galería, una sala para los conciertos y un lugar donde recibir a los amigos. Como respuesta a estos requisitos surge un "espacio neutro". La cocina y el baño, funciones indispensables de una casa, están hundidos en el suelo para que los espacios parezcan más grandes. La piel exterior de la construcción establece un contraste con las estancias interiores. Recubierta con un plástico blanco reforzado con fibras de vidrio parece una piel sin costuras que acentúa el misterioso ambiente.

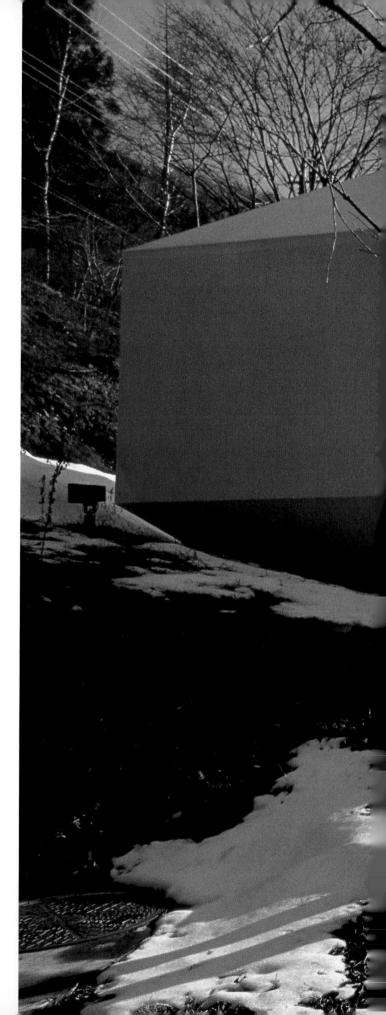

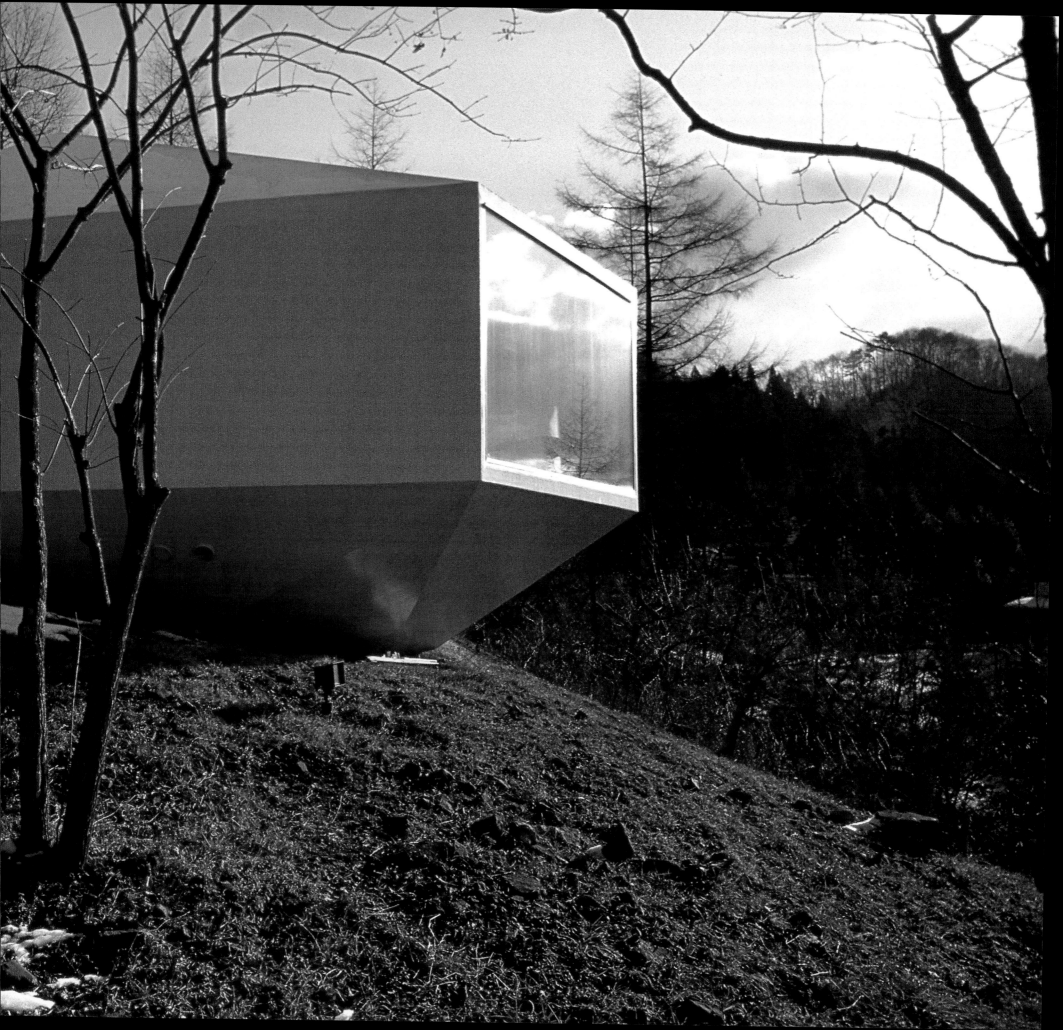

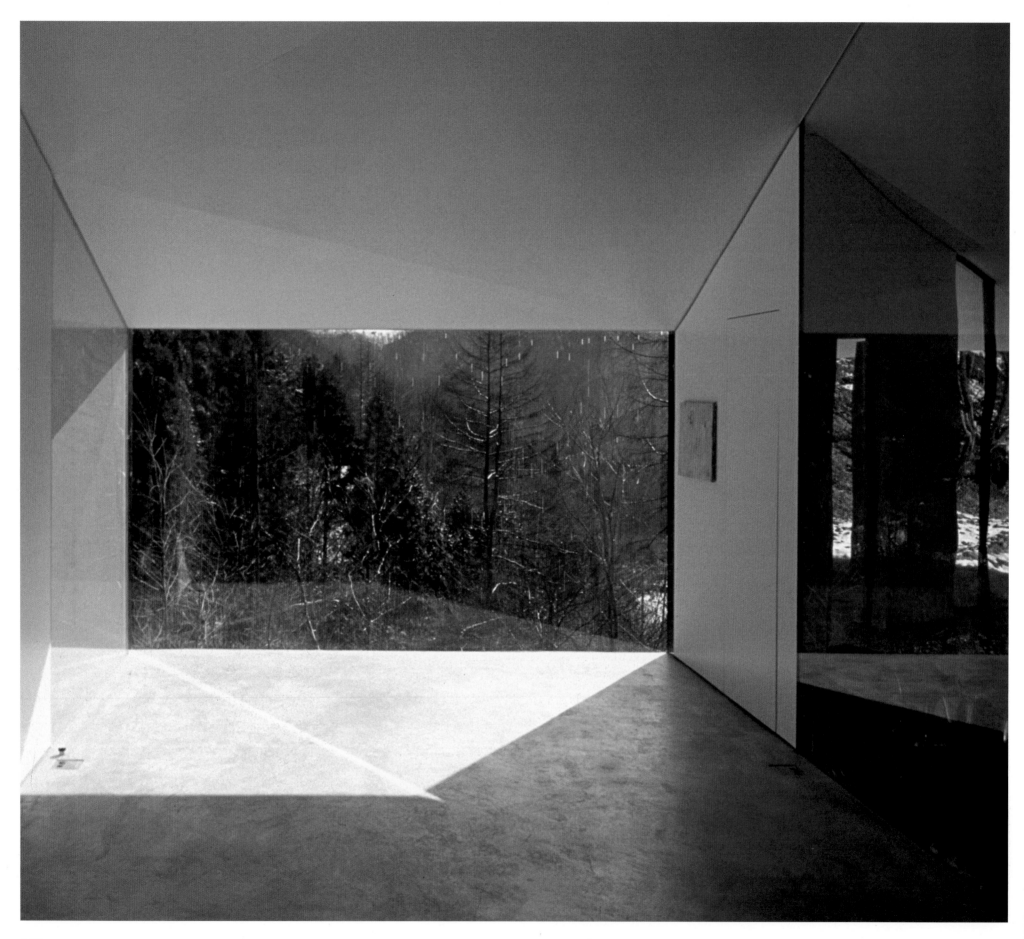

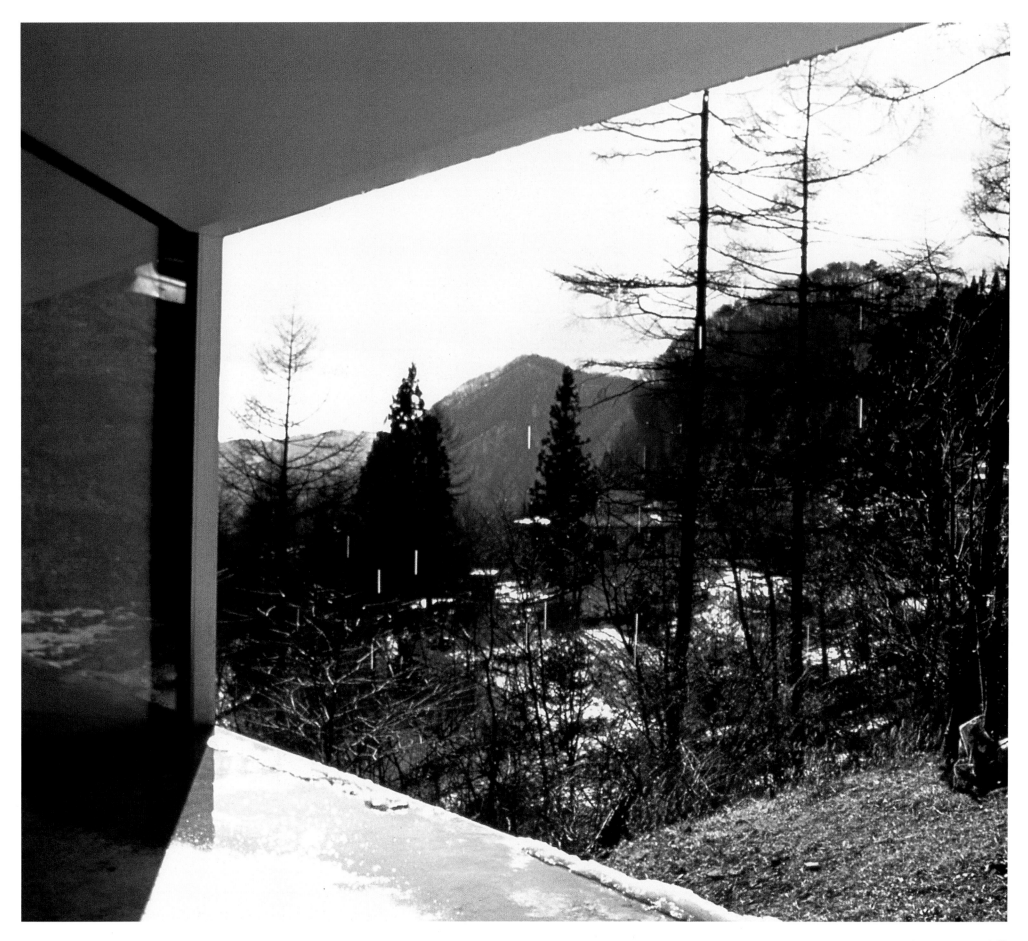

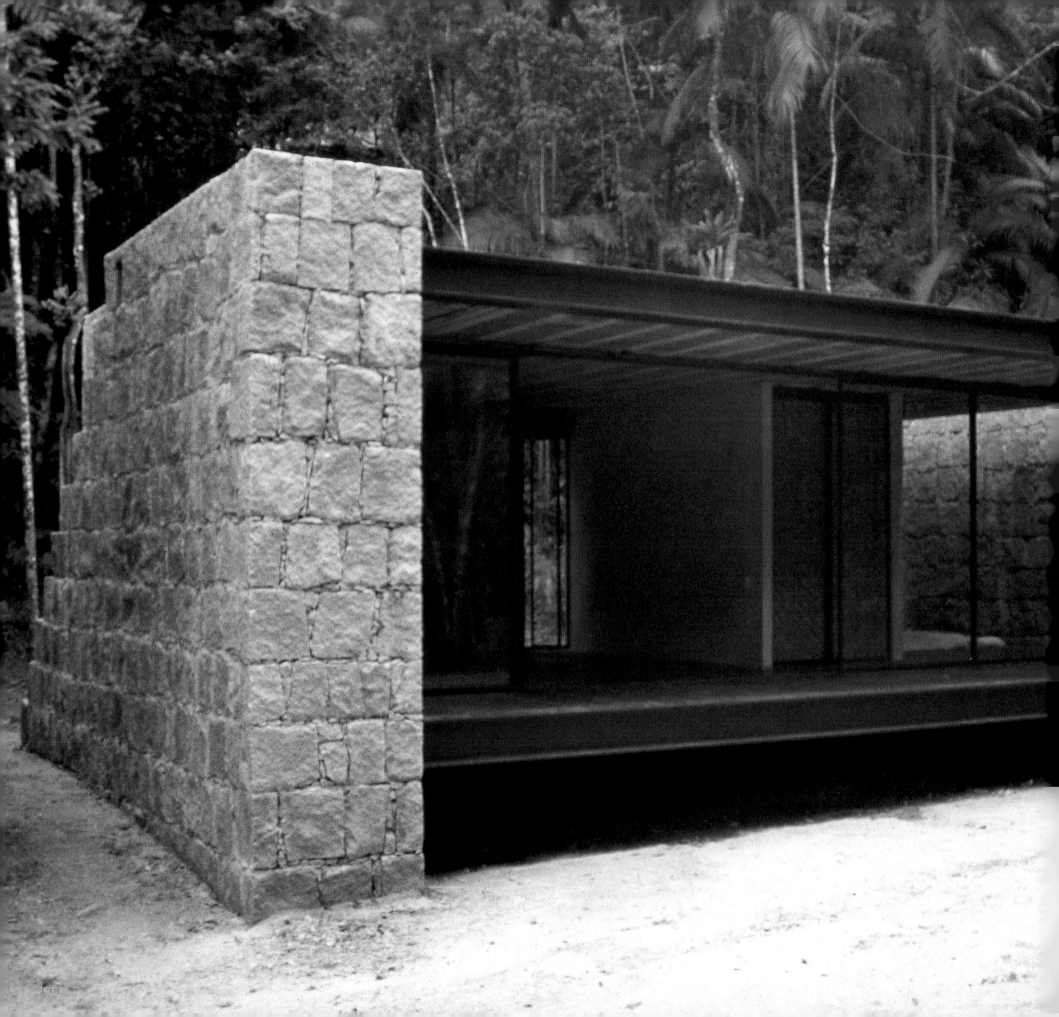

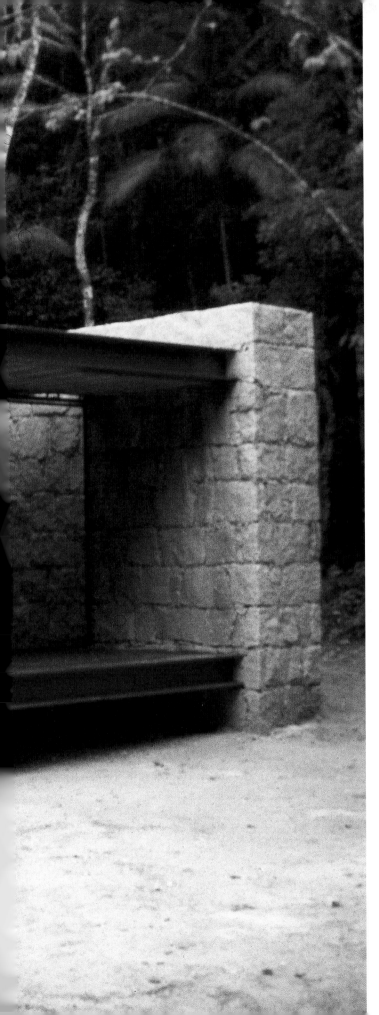

Rio Bonito - Nova Friburgo, Brasil,
Carla Juaçaba , 2000, 70 m²

Archaic Modernism

Rio Bonito House

A nature preserve is the site of this retreat-home. Two stone buttress walls support four steel beams that carry the loads of the floors and roof. The massive load bearing walls stand in contrast to the airiness of the free-span living space. The house is suspended from the ground to protect it from humidity and flooding, and to create an elevated platform from which the adjacent river can be viewed. A log stove and a fireplace are built into the stone walls to provide effective heating. Water and fire, weight and weightlessness, the archaic and the modern thus merge here to form a unique habitat.

Archaische Moderne

Rio-Bonito-Haus

Dieses Refugium liegt inmitten eines Naturreservats. Auf zwei Steinpfeilern lagern vier Stahlträger, die Decke und Dach tragen. Die massiven Wände stehen im Kontrast zu dem luftigen Wohnraum. Das Haus ist vom Erdreich angehoben, um es vor Luftfeuchtigkeit und Überflutung zu schützen und eine Aussichtsebene mit Blick auf den Fluss zu schaffen. Ein Holzofen und ein offener Kamin wurden in die Steinwände eingemauert. Somit vermengen sich solch gegensätzliche Phänomene wie Wasser und Feuer, Masse und Immaterialität, das Archaische und das Moderne, um ein einmaliges Ambiente zu bilden.

Modernité archaïque

Maison Rio Bonito

Une nature préservée accueille cette maison/refuge. Deux murs piliers en pierres soutiennent quatre poutrelles d'acier qui supportent la charge du plancher et du toit. Les murs porteurs contrastent avec la légèreté de l'espace habitable au plan libre. La maison ne repose pas directement sur le sol, ce qui la protège de l'humidité et des inondations et en fait une plate-forme surélevée dégageant la vue sur la rivière avoisinante. Un poêle à bois et une cheminée à feu ouvert sont aménagés dans les murs de pierres. Eau et feu, masse et légèreté, archaïsmes et modernité tout concourt à créer ici un habitat hors du commun.

Modernismo arcaico

Casa Rio Bonito

Este refugio se encuentra en medio de una reserva natural. Sobre dos contrafuertes de piedra descansan cuatro vigas de acero que sostienen el tejado y el techo. Las paredes masivas contrastan con el espacioso salón. La casa está por encima del nivel del suelo para protegerla de la humedad y de las inundaciones, y para conseguir una planta panorámica con vistas al río. En las paredes de piedra hay empotrados un horno de madera y una chimenea. De este modo se consigue crear un ambiente único mezclando fenómenos tan opuestos como el agua y el fuego, lo material y lo inmaterial, lo arcaico y lo moderno.

Nagano, Japan,
O.F.D.A. Taku Sakaushi,
2001, 90 m²

Shifting the View.

Ribbon Window House

The clients were enamored by this site due to the view of the nearby Yatsugatake Mountains. But the site also views out to the Tateshina Mountains and Suwa city. Hence, a triangular plan with orientation to all vistas was developed. As a sensitive response to the scale of the house as a miniscule object within the expanse of nature, the architect chose not to orient large windows toward each view. Instead, a "ribbon" window wraps around the walls and ceilings of the spaces in a conscious effort to avoid full transparency and create protected spaces with carefully composed views.

Verschobenes Blickfeld

Takus Haus

Die Bauherren begeisterten sich für diesen Ort primär wegen der Sicht auf die Yatsugatake-Berge. Doch aufgrund weiterer Sichtbezüge zu den Sugadaira-Bergen und der Stadt Suwa wurde der dreieckige Grundriss entwickelt. Als sensible Reaktion auf den Maßstab des Hauses im Verhältnis zur Weite der Natur entschied sich der Architekt dafür, keine großen Aussichtsfenster zu verwenden. Stattdessen wird ein „Bandfenster" um die Wände und Decken der Räume gewickelt. So wird eine volle Transperenz bewusst vermieden, um geschützte Innenräume mit sorgsam komponierten Ausblicken zu schaffen.

Des vues multipliées

Maison à fenêtre-bandeau

Les clients étaient amoureux du site en raison de la vue sur les montagnes voisines de Yatsugatake. Mais l'endroit révélait aussi les montagnes de Sugadaira et la ville de Suwa. D'où le choix de ce plan triangulaire offrant tous les panoramas possibles. Afin de compenser la petitesse de la maison perdue dans la vaste nature, l'architecte a choisi de ne pas placer de grandes baies directement face aux panoramas, mais de développer un bandeau de fenêtres courant sur les murs et les plafonds des espaces tout en évitant la transparence totale et en créant des zones protégées jouissant de vues soigneusement composées.

Cambiando la vista

Casa con franja de ventanas

Los dueños se entusiasmaron con este lugar debido a sus vistas sobre las montañas Yatsugatake. Además desde aquí también pueden verse las montañas Sugadaira y la ciudad de Suwa. Estas tres posibilidades fueron el motivo para desarrollar un plano triangular. Como reacción sensible a las dimensiones de la casa, minúscula frente a la naturaleza que la rodea, el arquitecto decidió no abrir grandes ventanas dirigidas hacia los tres paisajes. En vez de eso realizó una franja de ventanas que rodea las paredes y los techos. De este modo se evita conscientemente la transparencia para que los espacios interiores disfruten de vistas dispuestas como en una composición.

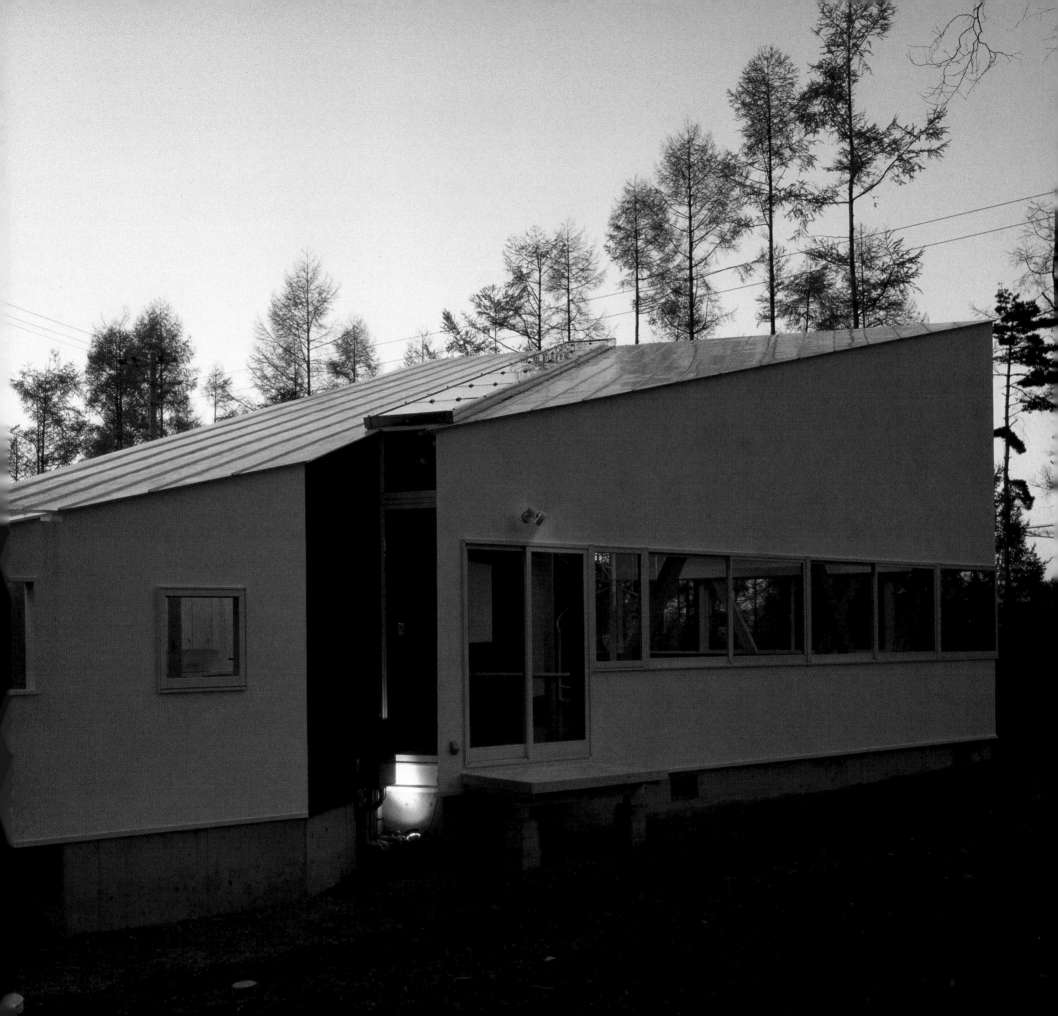

Building-Set

LV Home

This prefab house set can be delivered within four weeks after ordering. The wood frame structure is sheathed in metal panels, giving it a high-tech look that accommodates the growing design-conscious housing market. This look continues inside in light-filled interior spaces that, in contrast to the cool outer skin, emanate warmth, lightness and connectivity with the natural surroundings. Clerestory windows direct light into the spaces, allowing them to feel much larger than they actually are. To reduce costs, the simple construction system facilitates do-it-yourself building methods.

Bausatz

LV-Haus

Dieser Fertig-Bausatz kann vier Wochen nach Bestellung ausgeliefert werden. Der Holzbau wird in Metall verkleidet, was ihm ein Hightech-Ambiente ganz im Sinne des nach gutem Design verlangenden Marktes verleiht. Dieses Ambiente setzt sich in den hellen Innenräumen fort. Sie kontrastieren mit der kühlen Außenhaut durch warme, leichte Materialien und starke Verzahnung mit den Außenräumen. Oberlichtbänder führen natürliches Licht in die Räume, was sie größer erscheinen lässt. Um Kosten zu reduzieren, lässt sich das einfache System weitgehend in Selbstbauweise realisieren.

Jeu de construction

Maison LV

Cette habitation préfabriquée à monter soi-même peut être livrée dans les quatre semaines suivant la commande. La structure en bois est recouverte de panneaux métalliques qui lui confèrent un air high-tech répondant aux tendances du marché immobilier. Cet aspect se poursuit dans les espaces intérieurs remplis de lumière qui, contrastant avec la froideur de l'extérieur, donnent une impression de chaleur, de légèreté et d'union avec l'environnement naturel. Des fenêtres à claire-voie éclairent les pièces qui paraissent plus grandes qu'elles ne le sont en réalité. Les méthodes de montage à la portée du client permettent de réduire le coût de cette maison.

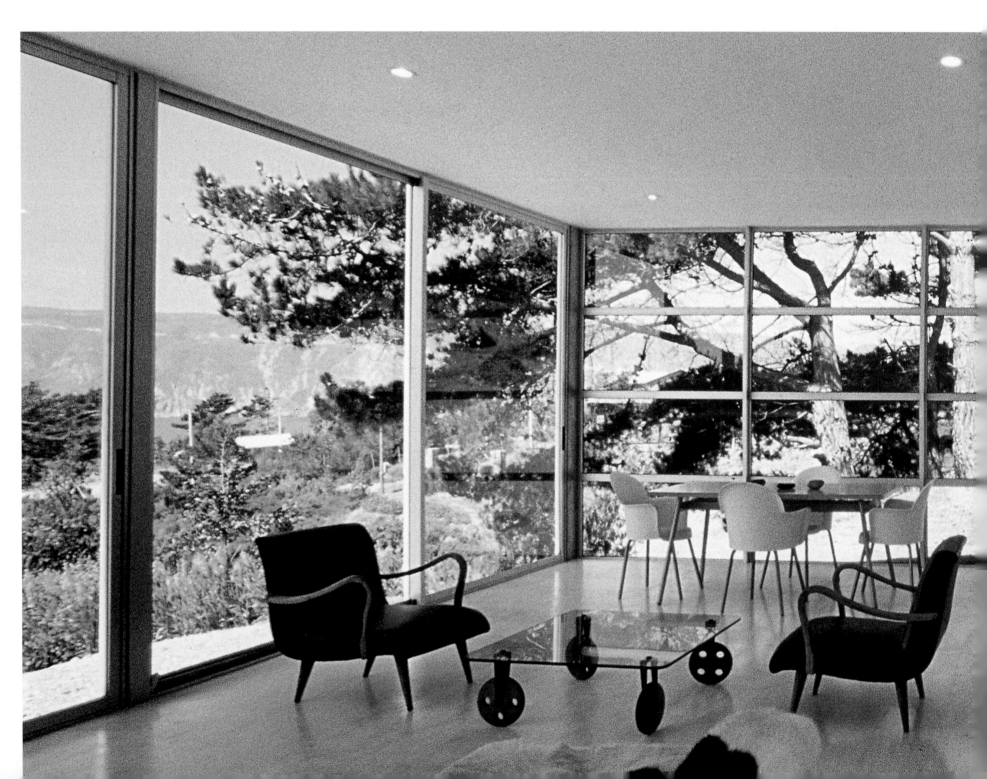

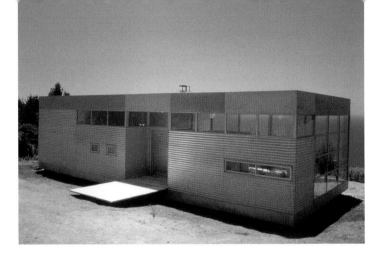

Juego de piezas
Hogar LV

La casa prefabricada puede entregarse cuatro semanas después de encargarla. La estructura de madera está revestida con paneles de metal que, según el buen diseño exigido por el mercado, le dan un aspecto de alta tecnología. Este ambiente continúa en los luminosos espacios interiores, cuyos cálidos y ligeros materiales, en armonía con el entorno natural, contrastan con la fría capa externa. Las ventanas superiores permiten la entrada de la luz, haciendo que los espacios interiores parezcan más grandes. Para reducir los costes el sistema de esta sencilla construcción permite usar métodos adaptados a las necesidades individuales.

Laguna Verde, Chile, Rocio Romero, 2000, 90 m^2

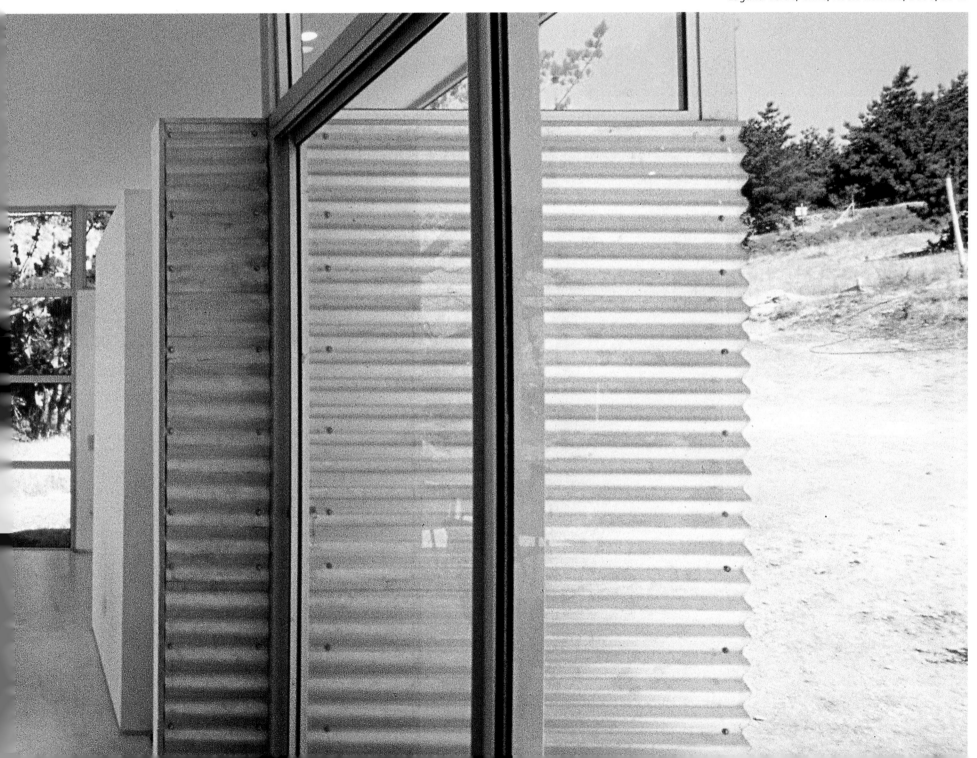

Back to Basics

Summer House

This house, sheathed in larch wood slats, contains two rooms of equal size oriented around a central core of service spaces. The northern, more enclosed, space serves as a studio/gallery for the artists who work here in this peaceful forest setting. The fully glazed window wall of the southern-facing room opens out to the adjacent wooden deck. The large windows on the western side of the house are protected from the harsh afternoon sun by sliding shutter elements made of larch slats. Wood panels made of birch plywood continue the carefully composed palette of natural materials inside.

Zurück zu den Wurzeln

Sommerhaus

Das ganz in Lärchenholz verschalte Haus beherbergt zwei gleich große Räume um einen zentralen Kern mit Küche und Bad. Der nördliche Raum mit seinen geschlossenen Wandflächen dient als Atelier und Galerie für die Künstler, die hier inmitten des Walds in Ruhe arbeiten. Der südliche Raum öffnet sich hingegen über die vollverglaste Fensterfront zum davor liegenden Holzdeck. Die großen Fenster auf der Westseite lassen sich mit Schiebeelementen aus Holzlatten vor der starken Nachmittagssonne schützen. Wandpaneele aus hellem Birkenholz setzen die sorgsam abgestimmte Materialienpalette im Inneren fort.

Retour aux sources

Maison d'été

Cette maison, revêtue de bardeaux de mélèze, est composée de deux pièces de taille égale orientées vers un noyau central contenant les zones techniques. L'espace au nord, plus refermé, sert de galerie/studio aux artistes qui y travaillent dans un décor paisible de forêt. Le mur de la pièce orientée au sud, totalement vitré, s'ouvre sur la terrasse en bois adjacente. Les grandes baies du côté ouest de la maison sont protégées du brûlant soleil de l'après-midi par des volets coulissants faits de plaques de mélèze. Des panneaux en contreplaqué de bouleau reprennent à l'intérieur cette palette de matériaux naturels judicieusement composée.

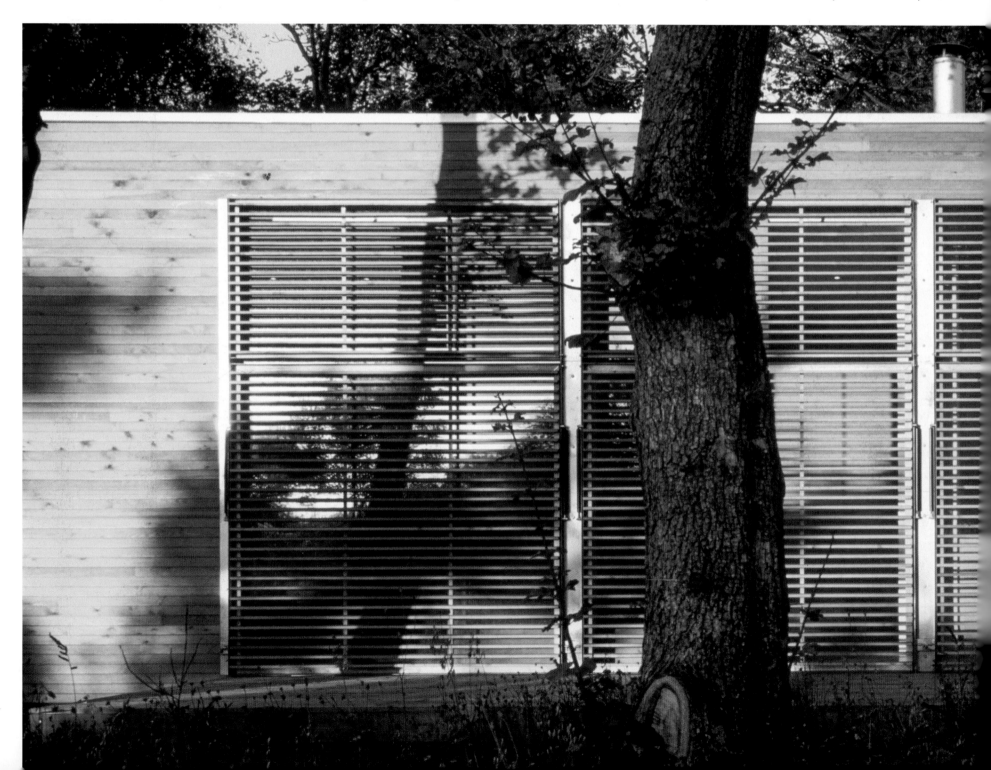

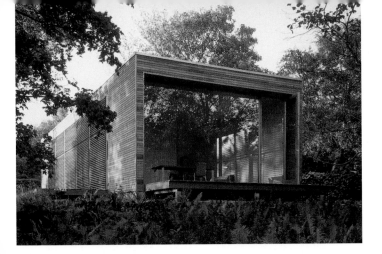

Vuelta a las raíces

Casa de verano

Esta casa, completamente revestida con madera de alarce, alberga dos estancias del mismo tamaño alrededor de un núcleo con la cocina y el baño. El espacio situado en el norte, de paredes cerradas, sirve como taller/galería a los artistas, que trabajan en la tranquilidad del bosque. En cambio la estancia con orientación sur se abre a través de la fachada totalmente acristalada hacia la terraza de madera. Las grandes ventanas del lado oeste pueden protegerse del fuerte sol del medio día con los elementos correderos de madera de alerce. Los paneles de las paredes de madera clara de abedul continúan en el interior la gama de materiales naturales cuidadosamente seleccionada.

Vejby, Denmark, Henning Larsens Tegnestue, 2000, 100 m²

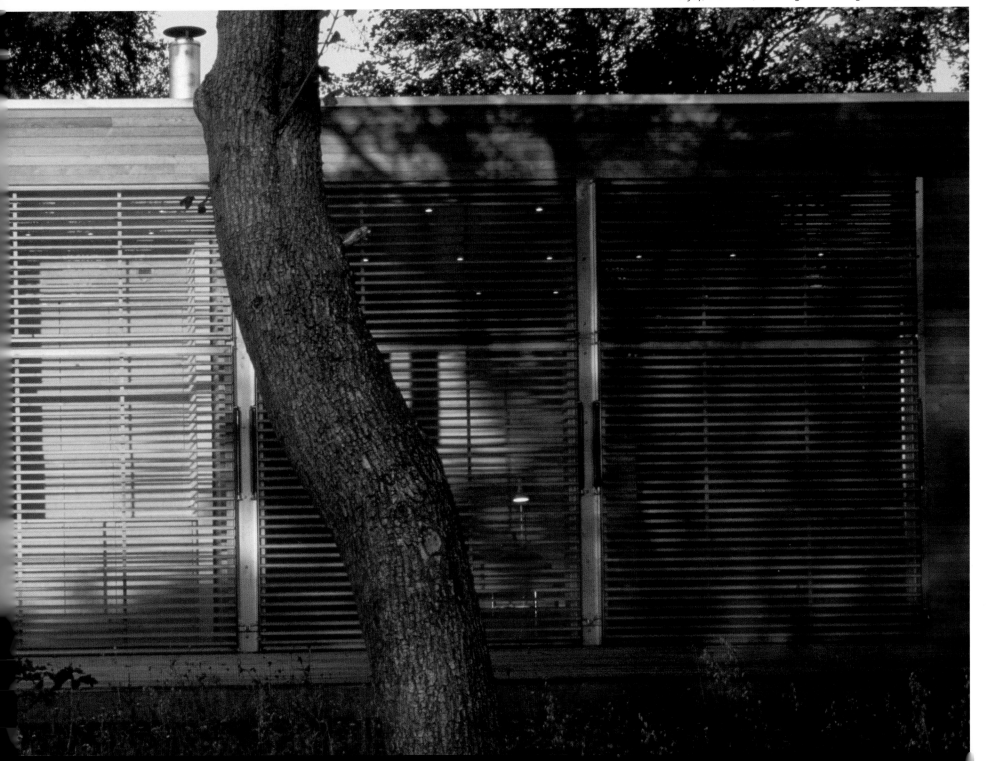

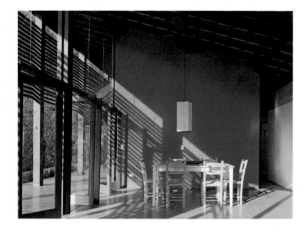

Sao Sebastio, Brasil,
Alvaro Puntoni Arquiteto,
2001, 108 m²

Simply Elegant
Juquehy Beach House
This beachside home is an exercise in simplicity and efficient use of available resources. Constructed by local residents utilizing vernacular techniques, it reinterprets Brazilian building traditions. A framework of wood trusses forms an elegant skeleton supporting the exposed roof tiles. Rising upward toward the southeast elevation, the roof defines a spacious living/dining hall and extends outside to cover the wooden deck. The bedrooms, each with deck access, are enclosed in bright blue walls. A service zone with bathrooms and the open kitchen forms a buffer on the northern street elevation.

Einfach Elegant
Juquehy Strandhaus
Das Konzept dieses Strandhauses beruht auf Einfachheit und schonendem Umgang mit vorhandenen Ressourcen. Erbaut in lokal typischer Bauweise interpretiert das Haus brasilianische Traditionen neu. Rahmen aus Holz bilden ein elegantes Gerippe, auf dem die sichtbaren Dachziegel lagern. Nach Südosten ansteigend definiert das Dach einen geräumigen Wohn-/Essbereich und setzt sich im Freien über dem Holzdeck fort. Die Schlafzimmer sind von strahlend blauen Wänden umfasst. Die Servicezone mit Bädern und der offenen Küche erstreckt sich entlang der Nordseite.

Simple élégance
Maison à Juquehy Beach
Cette résidence de plage est un exercice de simplicité et d'utilisation efficace des ressources disponibles. Édifiée par des résidents locaux utilisant des techniques courantes, elle réinterprète des traditions de construction brésiliennes. Une structure de poteaux et de poutres forme un élégant squelette qui supporte un toit de tuiles. Se relevant vers le sud-est, le toit définit un spacieux volume destiné au séjour/salle à manger et s'étend à l'extérieur pour abriter une terrasse recouverte d'un plancher. Les chambres auxquelles on accède depuis la terrasse sont closes de murs bleu vif. Un espace technique comprenant les salles d'eau et la cuisine ouverte isole de la rue sur le côté nord.

Simplemente elegante
Casa Juquehy Beach
El concepto de esta casa situada al lado de la playa se basa en la sencillez y en el empleo eficiente de los recursos disponibles. Construida siguiendo el estilo local, la vivienda reinterpreta las tradiciones brasileñas. Una estructura de madera forma un elegante esqueleto sobre el que reposan las tejas expuestas del tejado. Éste, que se eleva hacia el sureste, define un amplio salón comedor y se extiende hacia afuera sobre la cubierta de madera. Los dormitorios están rodeadas por luminosas paredes azules. La zona de servicio con los baños y la cocina abierta se extiende a lo largo del lado norte.

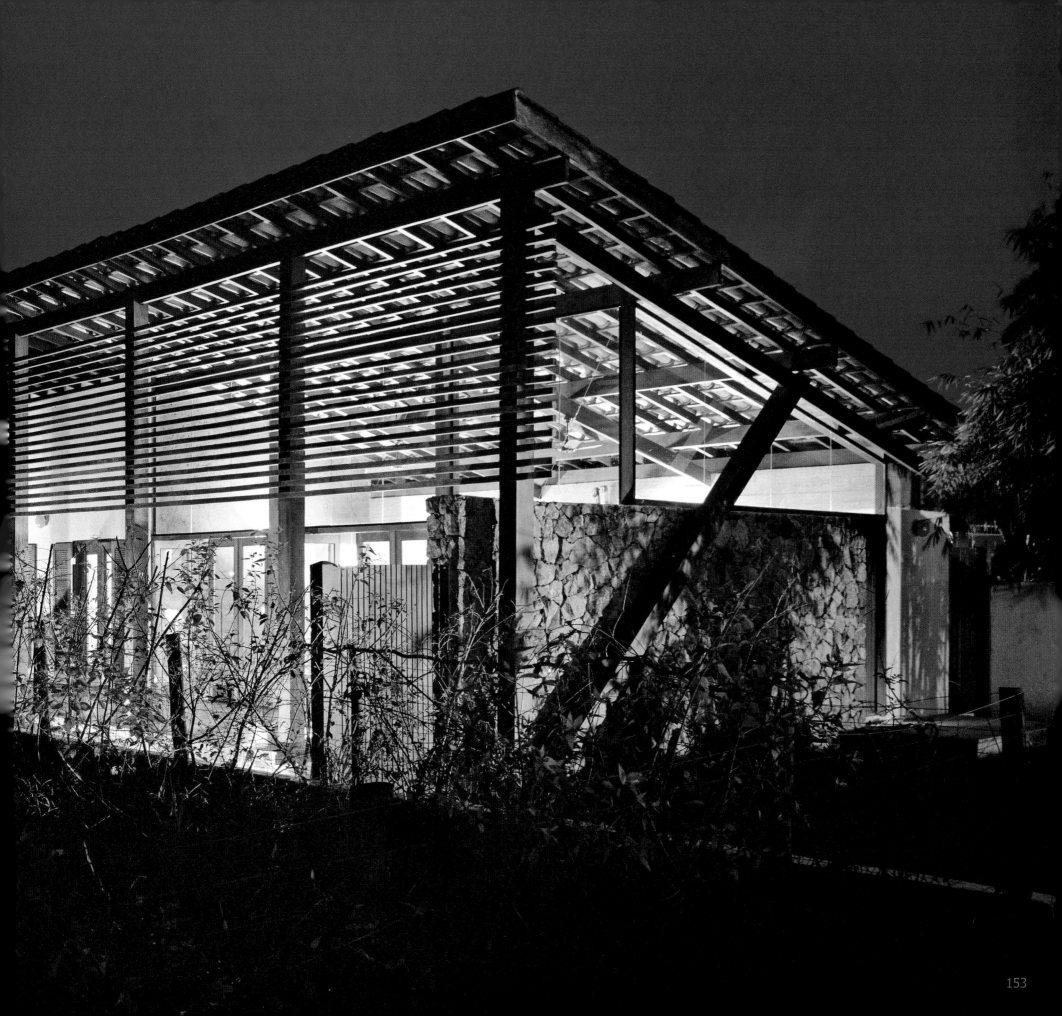

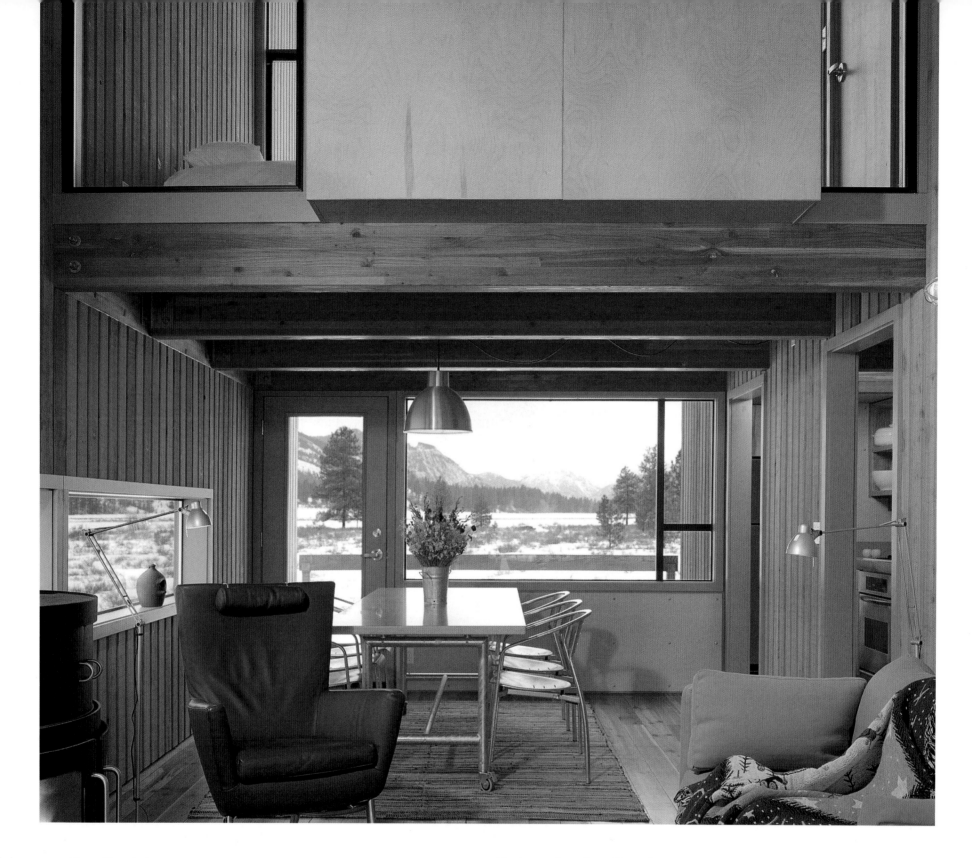

Rider on the Prairie

Methow Cabin

This retreat serves as a base for cross-country skiing and mountain biking. The owners wished to accommodate 6-8 people with a communal area for gathering and dining. The building is aligned with the valley, opening at the ends to focus on the views up and down it. The exterior cedar siding is continued through the living spaces to create a continuum of interior and exterior space. The shed roof echoes the slope of the hills beyond. It creates both a protected entry porch at the low end and a sleeping loft at the high end. The covered entry stair remains snow-free even as snow avalanches off the roof.

Reiter in der Prärie

Methow Cabin

Dieses Refugium dient als Basis für Ausflüge per Langlauf-Ski oder Mountainbike. Es beherbergt 6-8 Personen um einen geräumigen Wohnsaal. Der Baukörper nimmt die Talrichtung auf und öffnet sich an den Enden zu Ausblicken auf die Tallandschaft. Um ein Kontinuum von Innen- und Außenraum zu bewirken, setzt sich das Zedernholz der Fassaden in den Räumen fort. Das Pultdach übernimmt die Neigung des nahen Hügels. Es bildet einen geschützten Eingang am niedrigen Ende und einen Schlafloft am hohen Ende. So bleibt die überdachte Eingangstreppe auch bei starkem Schneefall schneefrei.

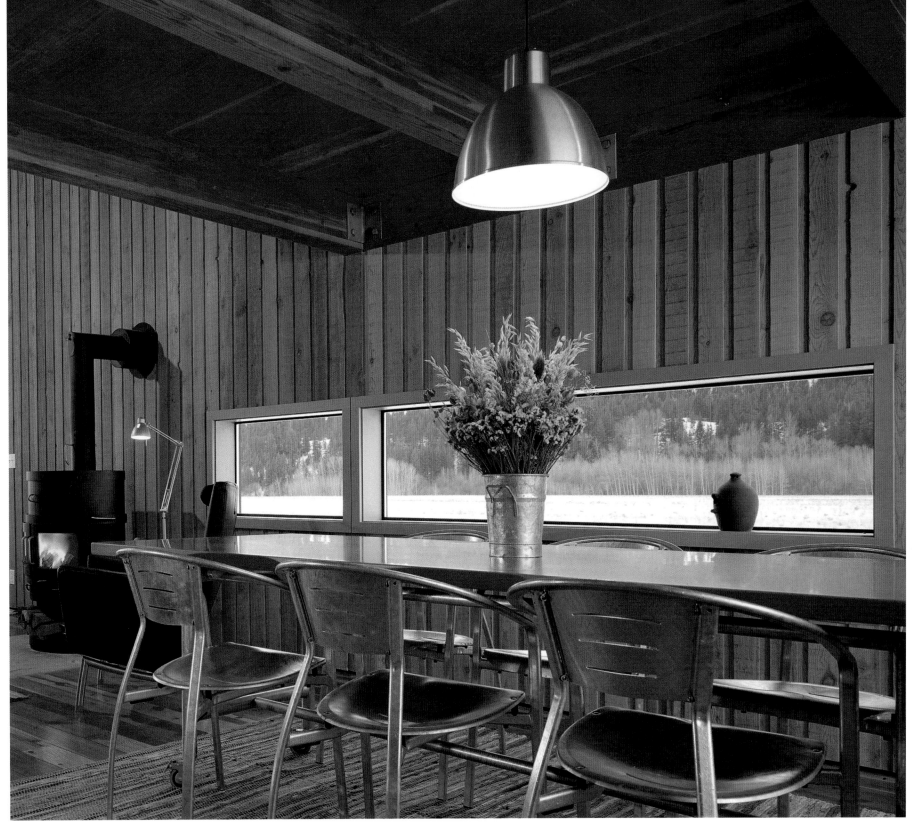

Winthrop, WA, USA, Eggleston Farkas Architects, 2002, 109 m²

Un cavalier dans la prairie

Methow Cabin

Cette retraite sert de camp de base à des activités sportives telles que ski de fond et VTT. Les propriétaires souhaitaient loger de 6 à 8 personnes. Le bâtiment est aligné sur la vallée et ses ouvertures aux extrémités donnent sur les panoramas des cimes ou des vallées. Le revêtement extérieur en cèdre a été repris à l'intérieur afin d'assurer la continuité entre les espaces intérieur et extérieur. Le toit à une seule pente fait écho au relief des collines voisines. Il définit à la fois un porche d'accès du côté le plus bas et une chambre en loft du côté haut. Le perron d'entrée couvert est donc protégé des chutes de neige, même de celles tombant du toit.

Jinete en la pradera

Cabaña Methow

Este refugio sirve de base para las excursiones con bicicleta de montaña y de esquí de fondo. Los propietarios querían acomodar en él entre 6 y 8 personas y disponer de un área común donde reunirse y comer. La construcción sigue la inclinación del valle y se abre al final para permitir la vista sobre el paisaje de la montaña. Para establecer una continuidad entre el interior y el exterior se empleó madera de cedro tanto en las fachadas como en las estancias. El tejado con forma de rampa imita la inclinación de la cercana colina y protege la entrada situada en la parte más baja y el dormitorio en el otro extremo de la acumulación de nieve.

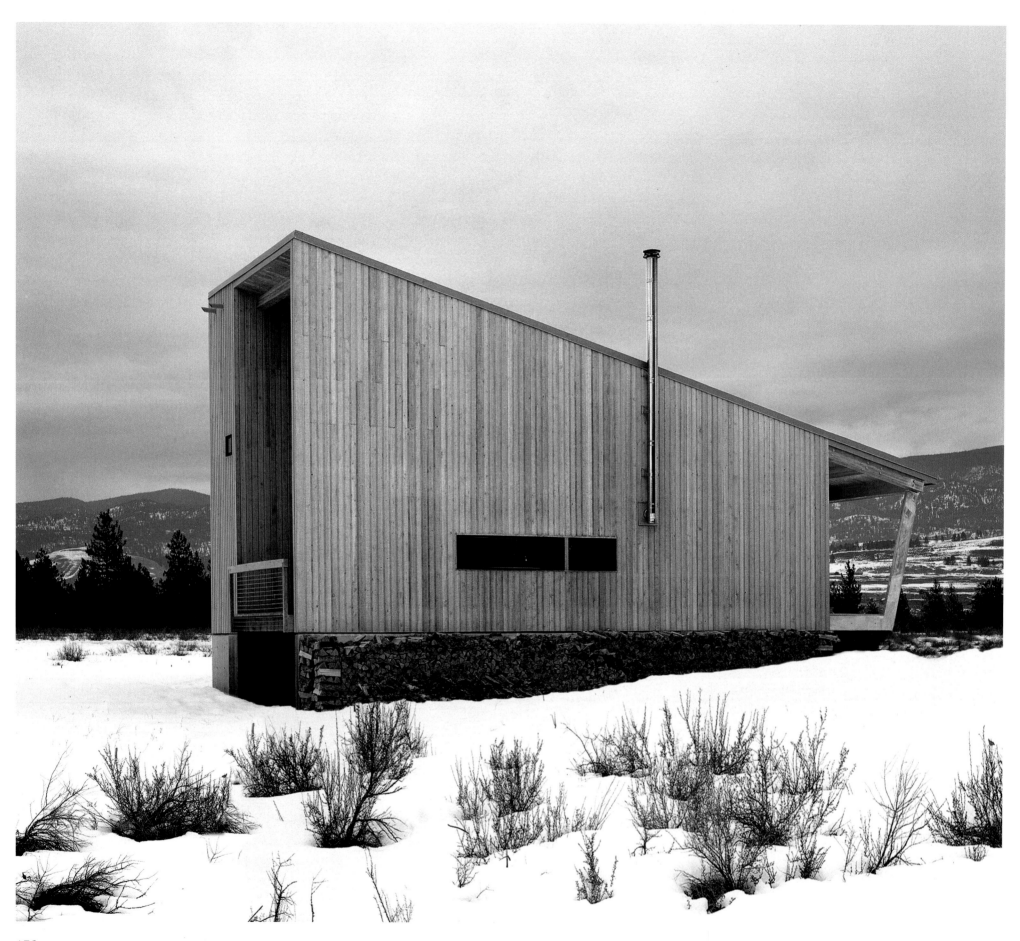

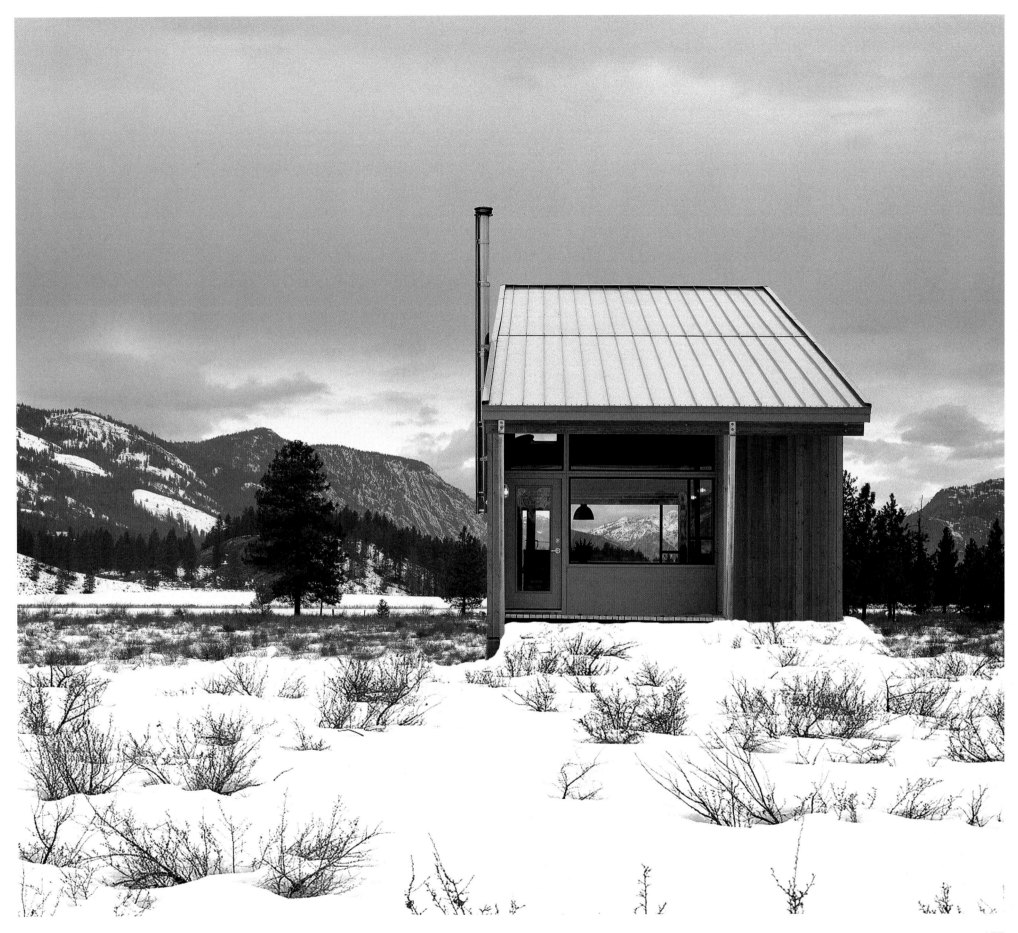

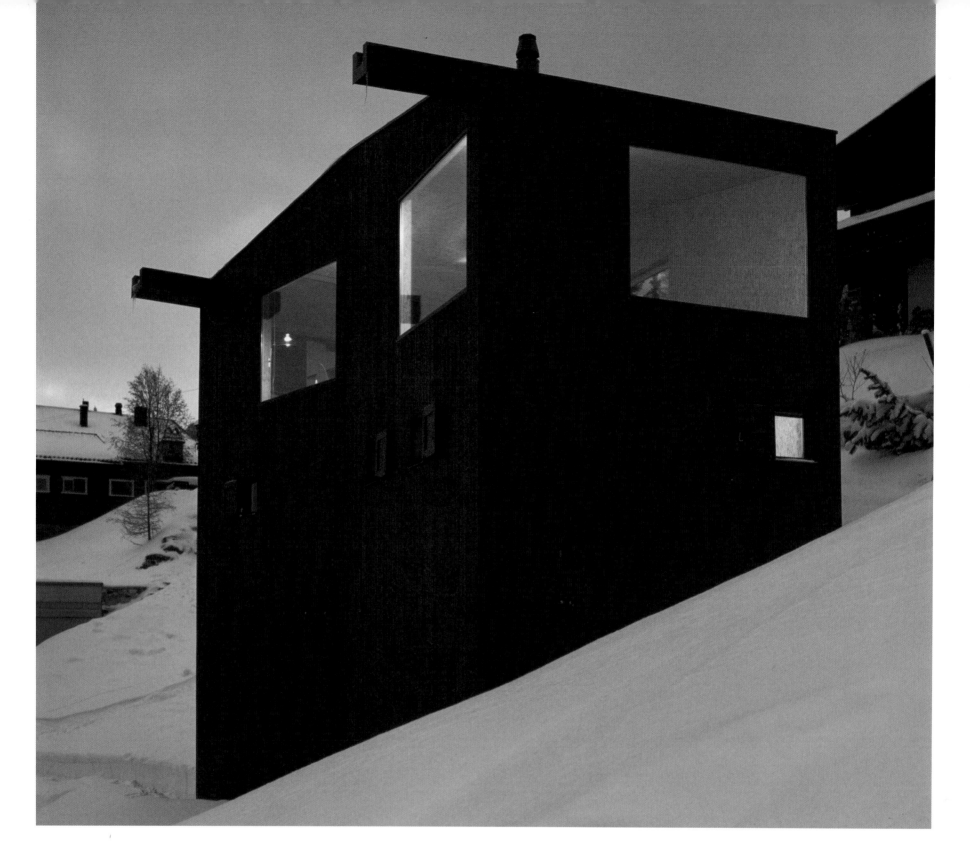

Chalet Tower

Vacation Cabin

The traditional style of Alpine villages makes them cozy and very livable. But, when this style is utilized for new buildings on the village periphery, these preconceived forms often fail to fully utilize the potential inherent to each special site. As a response to this dilemma, this house creatively translates the traditional Swiss chalet typology into a new chalet tower. A spiral stair connects all three stories and leads up to the living room and kitchen/dining space on the top floor. The windows, strewn across the seemingly folded facades, increase in size from the ground to the top floor of the wood-framed house.

Chalet-Turm

Ferienhaus in den Bergen

Der Heimatstil alpiner Städtchen lässt sie liebevoll und gemütlich wirken. Wenn aber dieser Stil auf neue Stadtteile übertragen wird, berücksichtigen die althergebrachten Bauformen selten die Lagebesonderheiten und schöpfen so das Potenzial der Grundstücke gar nicht aus. Hier hat man als Gegenmodell dazu den Typus des schweizerischen Bergchalets kreativ weiterentwickelt. Eine Wendeltreppe verbindet die drei Etagen und führt hinauf in den Wohnbereich im obersten Geschoss. Nach oben hin immer größer werdende Fenster verteilen sich locker über die leicht geknickten Fassaden des Hauses, das ganz aus Holz erbaut wurde.

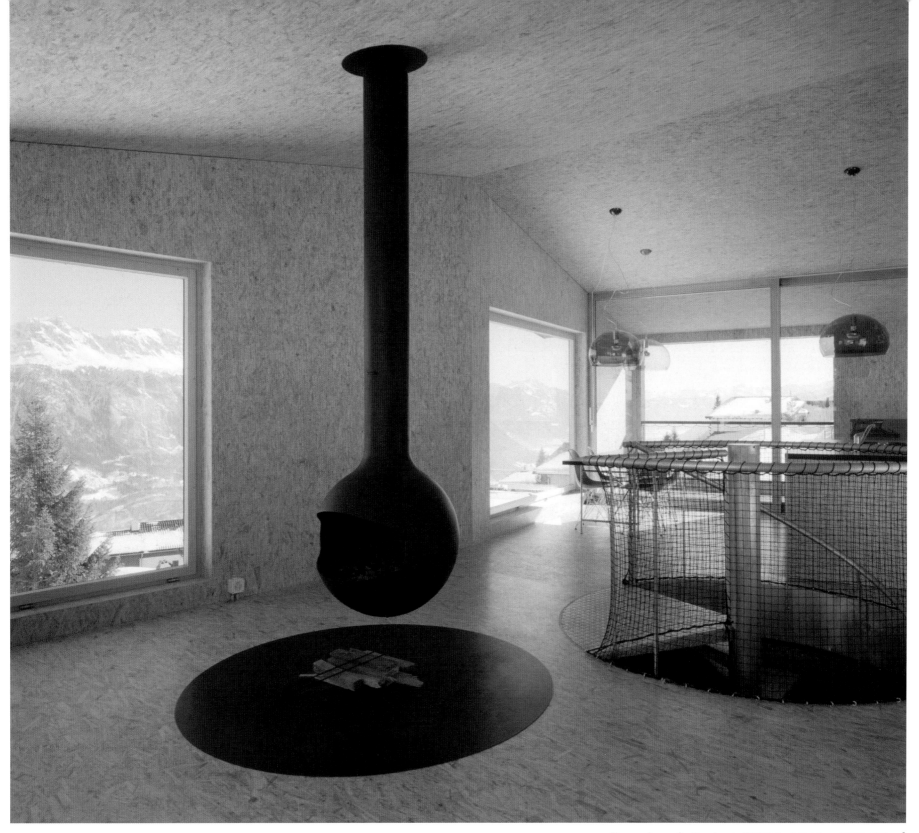

Flumersberg, Switzerland, EM2N Architekten, 2002, 110 m²

Tour-chalet

Chalet de montagne

Le style traditionnel des villages alpins les rend très chaleureux. Mais lorsque ce style est utilisé pour de nouvelles constructions situées en périphérie de village, ces formes préétablies échouent souvent dans l'exploitation totale du potentiel propre à chaque site. Aussi cette nouvelle tour-chalet est-elle une réinterprétation créative de la typologie du chalet suisse traditionnel. Un escalier en colimaçon relie les trois niveaux et mène au séjour et à l'espace repas situés au dernier niveau. Les dimensions des fenêtres réparties sur les façades qui semblent dépliées augmentent depuis le bas jusqu'en haut de cette maison, dont la structure principale est en bois.

Chalet torre

Casita de Montaña

El estilo tradicional de los pequeños pueblos alpinos les da un aspecto acogedor y muy habitable. Pero cuando esta forma se lleva a las partes nuevas de las ciudades, las edificaciones pocas veces tienen en cuenta la arquitectura tradicional y desaprovechan el potencial de los terrenos. En este ejemplo, por el contrario, se ha desarrollado de forma creativa el tipo de chalet suizo de montaña. Una escalera en espiral une los tres pisos y llega hasta el salón, en la planta superior. Conforme ascendemos aumenta el tamaño de las ventanas y su distribución desordenada por las fachadas ligeramente inclinadas de la casa, completamente recubierta con madera.

Kinderhook, NY, USA
Dennis Wedlock Architect,
1998, 125 m²

Lively Simplicity

Kinderhook House

Any striving for simplicity can easily end in lifeless monotony. The example utilizes timeless architectural vocabulary to prove that this needn't be the case. The basic house form is dramatized with a steeply pitched roof that signals the home's special presence in the landscape. Inside, the light-bathed rooms convey a congenial hospitality. Wood is the formative material used in the interior spaces where oak flooring and wood windows and doors are executed in clear detailing that skillfully mirrors the concise, yet lively simplicity of the Shaker furniture found throughout the house.

Lebendige Einfachheit

Kinderhook-Haus

Jedes Bestreben nach Einfachheit kann leicht in kalter Monotonie enden. Hier wird mit klassischem Architekturvokabular bewiesen, dass es auch anders geht. Die Grundform des Satteldachhauses erhält eine übersteile Dachneigung, die dem Haus eine besondere Präsenz nach außen verleiht. Die Innenräume werden hell und freundlich gestaltet. Holz ist hier das prägende Material, das für den Parkettboden aus Eiche und für Fenster- und Türrahmen verwendet wird. Sämtliche Holzprofile und Details wurden schlicht und zweckmäßig gezeichnet – ganz im Sinne der zeitlosen Shaker-Möbel, mit denen das Haus eingerichtet wurde.

Une simplicité pleine de vie

Maison Kinderhook

Toute tentative visant d'abord à la simplicité peut facilement donner dans la fadeur et la monotonie. Cet exemple utilise un vocabulaire architectural intemporel pour démontrer qu'on peut y échapper. La forme basique de la maison est dynamisée par un toit à forte pente qui signale la présence de la maison dans le paysage. À l'intérieur, les pièces baignées de lumière promettent une chaleureuse hospitalité. Le bois est le matériau de base des espaces intérieurs où le plancher de chêne et les menuiseries des portes et fenêtres sont ostensiblement exécutés dans le style simple et dépouillé, mais animé du mobilier Shaker choisi pour l'ensemble de la maison.

Simplicidad viva

Casa Kinderhook

Todo esfuerzo para conseguir la sencillez puede acabar en una fría monotonía. Aquí se demuestra con el clásico vocabulario arquitectónico que también puede suceder lo contrario. La forma elemental de la casa presenta un tejado con una fuerte inclinación, lo que le da un aspecto especial desde fuera. Las estancias interiores se han diseñado de una forma acogedora y luminosa. La madera es el material más presente y se ha empleado en el parquet del suelo, de madera de roble, y en los marcos de las ventanas y de las puertas. Todos los detalles y los elementos de madera llevan dibujos a imitación de los intemporales muebles Shaker, con los que se ha decorado la casa.

162

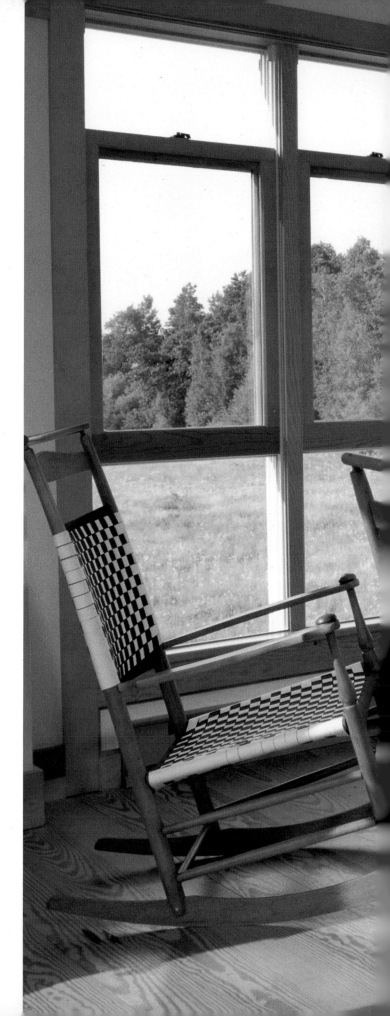

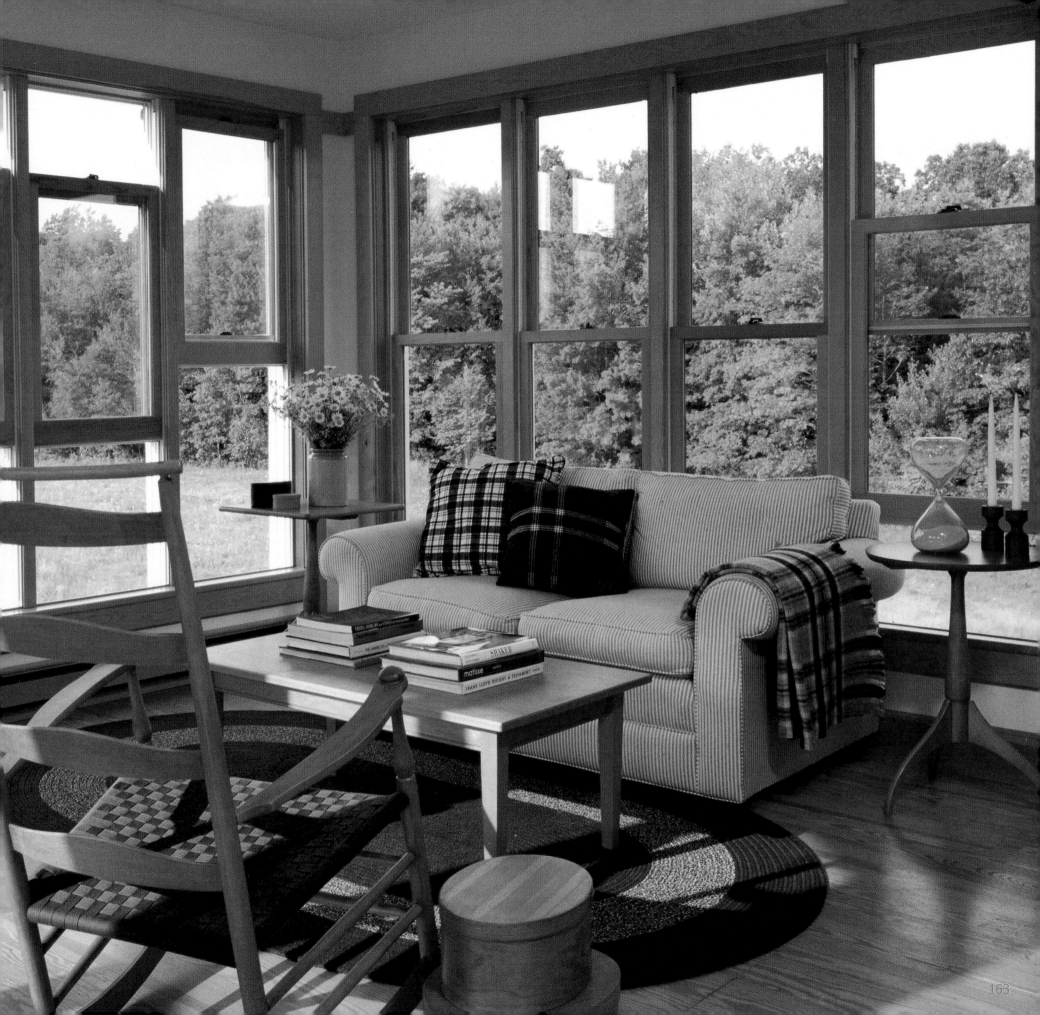

Carapicuíba, Sao Paulo, Brasil,
una Arquitetos, 1998, 127 m²

Embedded in Nature

Casa in Carapicuíba

Brazil is also witnessing the senseless destruction of urban peripheries with new buildings that are dissonantly out of tune with their natural surroundings. This house documents a more sensitive approach that respects and preserves the existing grove of trees on the site. The wood-frame skeleton allows for individual footings. Hence, strip foundations that would have destroyed the tree roots were eliminated. The straightforward simple building technology facilitates swift construction by local craftsmen. Open spaces with generous window openings onto the hillside view make the house seem much larger than it actually is.

In die Natur eingebettet

Haus in Carapicuíba

Auch in Brasilien entstehen Vorstädte, die wenig Rücksicht auf die natürlichen Gegebenheiten nehmen. Diesem Trend wirkte man hier konsequent entgegen. Das Haus wurde so auf dem Grundstück platziert, dass der Baumbestand erhalten werden konnte. Die Holzrahmenkonstruktion ermöglicht den Verzicht auf Streifenfundamente, die das Wurzelwerk der Bäume zerstört hätten, und ließ sich von lokalen Handwerkern kostengünstig und schnell errichten. Eine offene Raumfolge mit großen Fensteröffnungen zur Hangseite hin lässt das Haus wesentlich größer wirken, als es in Wirklichkeit ist.

Enfouie dans la nature

Maison à Carapicuíba

Le Brésil connaît aussi l'impassible destruction des zones périphériques urbaines par des constructions neuves qui détonent dramatiquement avec l'environnement naturel. Cette maison illustre une approche plus respectueuse visant à préserver notamment les plantations d'arbres sur le site choisi. La structure en bois permet d'utiliser des socles séparés, c'est-à-dire l'élimination de fondations à semelle qui auraient détruit les racines des arbres. Les espaces ouverts dotés de larges baies donnant sur le paysage des collines font paraître la maison plus grande qu'elle ne l'est en réalité.

Encajada en la naturaleza

Casa en Carapicuíba

También en Brasil surgen suburbios que destruyen la naturaleza de los alrededores de las ciudades. Esta construcción se opone a esta tendencia. La casa se dispuso de tal forma sobre el terreno que pudieron conservarse los árboles que había en él. El esqueleto de madera de la construcción, económico y levantado en poco tiempo por obreros locales, hace posible que se renuncie a los cimientos, que habrían destrozado las raíces de los árboles. La disposición abierta de las estancias y las grandes ventanas orientadas hacia la pendiente permiten la entrada de la luz y hacen que la casa parezca más grande de lo que realmente es.

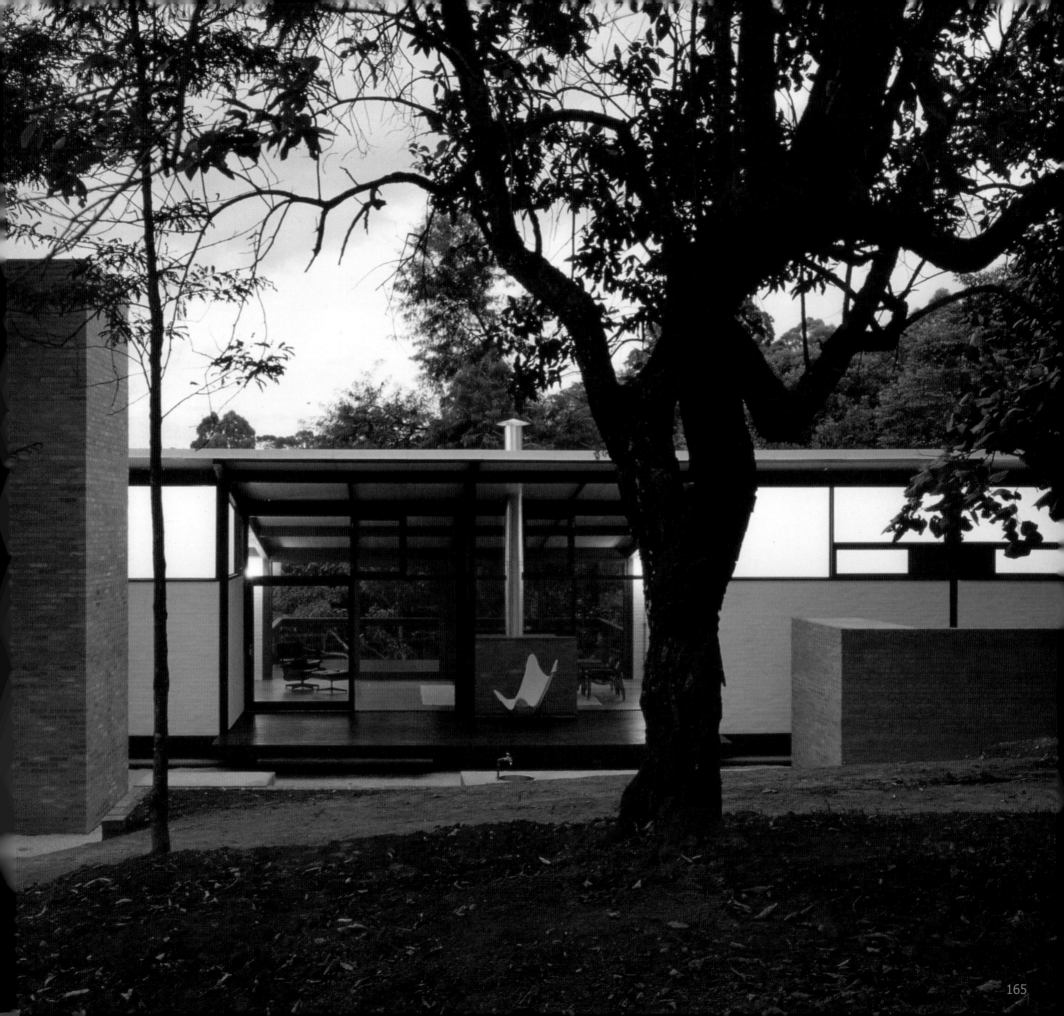

Beast of Burden
Hybrid Muscle

The dream shared by many people today of somehow achieving independence from the binding forces of contemporary society was dreamt here on the edge of a Thai rice paddy. Electricity for 10 light bulbs, the laptop and a cell phone is generated by local animals that hoist a 2-ton weight. When it is allowed to fall, power is generated. Openings all along the sides of the structure allow cooling breezes to circulate during the humid monsoon season. Crossing the borderlines between art and architecture, this project radically provokes thought on the role of "primitive" living models in the past, present and future.

Vom Netz genommen
Hybrid Muscle

Der Traum vieler Menschen, unabhängig von fremdbestimmten Strukturen zu leben, wurde hier am Rande eines thailändischen Reisfeldes baulich weiter geträumt. Der Strom für 10 Glühlampen, den Laptop und das Handy wird über Lasttiere erzeugt. Sie heben ein tonnenschweres Gewicht in die Höhe, das beim Herunterfahren Strom über einen Dynamo erzeugt. Seitliche Öffnungen über die gesamte Länge des Bauwerks erlauben Luftzirkulation im feucht-schwülen Monsunklima. Eine Gratwanderung zwischen Kunst und Architektur, die zum Nachdenken über „primitive" Wohnformen der Vergangenheit, Gegenwart und Zukunft anregt.

Bête de somme
Énergie musclée

Le rêve que partagent tant de gens de s'affranchir des contraintes de la société contemporaine est devenu réalité, ici en bordure d'une rizière thai. L'électricité nécessaire à dix ampoules, à l'ordinateur et au téléphone mobile est fournie par des animaux de traits capables de hisser une masse de deux tonnes. En redescendant sous contrôle, celle-ci produit du courant électrique. Les ouvertures ménagées dans les côtés de la structure permettent une ventilation utile en période de mousson. Aux frontières de l'art et de l'architecture, ce projet fait naître une réflexion sur le rôle des modes de vie « primitifs » dans le passé, le présent et le futur.

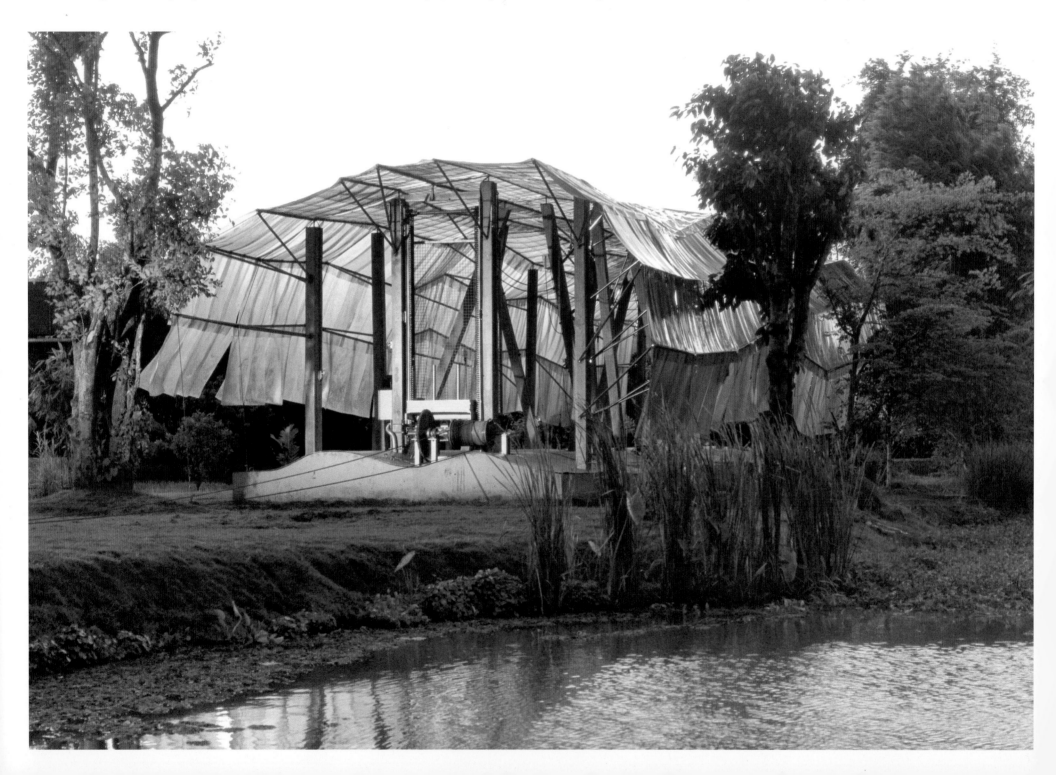

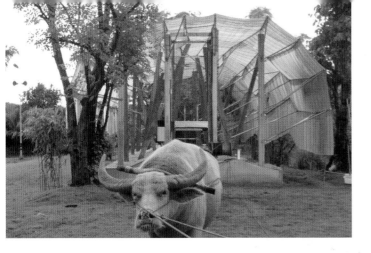

Animal de carga

Músculo Híbrido

El sueño de muchas personas de vivir sin tener que depender de las estructuras decididas por otras personas se convierte aquí, en el borde de un arrozal tailandés, en realidad. La electricidad para 10 bombillas, para el ordenador portátil y para el teléfono móvil se genera a través de animales de carga. Estos levantan un peso de 2 toneladas que al caer genera electricidad a través de una dinamo. Las aberturas que recorren los lados de la construcción permiten la circulación del aire en este clima tan húmedo y sofocante del Monzón. Este proyecto, que traspasa los límites del arte y la arquitectura, incita a pensar sobre las formas "primitivas" de vida del pasado, el presente y el futuro.

Chang Mai, Thailand, R&Sie, 2004, 130 m²

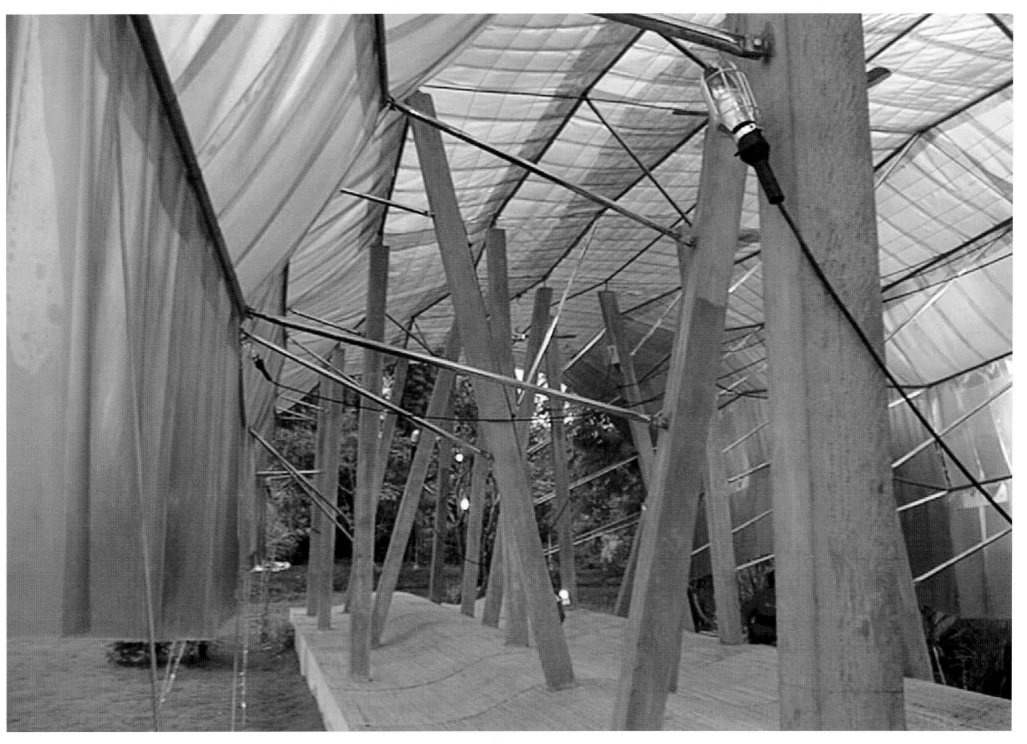

The Architects. Photo Credits.
Die Architekten. Les architectes. Los arquitectos.
Bildnachweis. Crédits photographiques. Créditos fotograáficos.

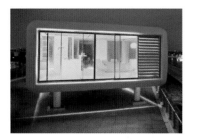

12
Loftcube, Berlin, DE
Werner Aisslinger, Berlin, DE
www.aisslinger.de
werner@aisslinger.de
Photos: cover, p. 10-13 Steffen Jänicke

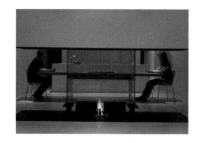

22
K-House, Tokyo, JP
Shinichi Ogawa & Associates, Hiroshima, JP
www1.odn.ne.jp/ogawa01
ogawa01@pop11.odn.ne.jp
Photos: Marie Watanabe

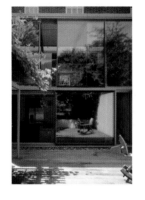

14
House for a Musician, London, UK
Blencowe Levine Associates, London, UK
studiobla@earthlink.net
Photos: Ioana Marinescu

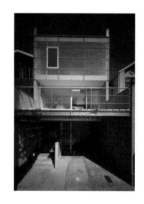

24
Standard House 2004, Kyoto, JP
Waro Kishi + K.Associates, Kyoto, JP
http://k-associates.com
kishi@k-associates.com
Photos: Hiroyuki Hirai

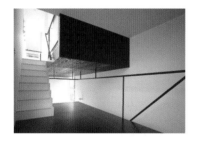

16
T-Set House, Tokyo, JP
Chiba Manabu Architects, Tokyo, JP
www.chibamanabu.com
manabuch@zg7.so-net.ne.jp
Photos: Nacasa & Partners

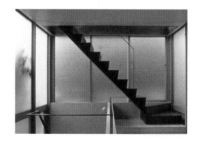

26
Tokyo House, Tokyo, JP
Hideki Yoshimatsu + Archipro Architects, Tokyo, JP
www003.upp.so-net.ne.jp/archipro
archipro@bd6.so-net.ne.jp
Photos: p. 26 Ei publishing, p. 27 Hideki Yoshimatsu

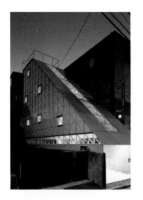

18
Natural Wedge House, Tokyo, JP
Endoh + Ikeda Architects, Tokyo, JP
www.edh-web.com
edh-endoh@mvi.biglobe.ne.jp
Photos: Tetsuo Ishii / SS Tokyo

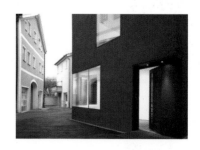

28
Atelier House in Eichstätt, DE
Diezinger & Kramer Architekten, Eichstätt, DE
www.diezingerkramer.de
architekten@diezingerkramer.de
Photos: Stefan Müller-Naumann

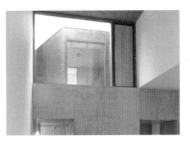

30
Anderson House, London, UK
Jamie Fobert Architect, London, UK
www.jamiefobertarchitects.com
jfa-@dircon.co.uk
Photos: Sue Barr

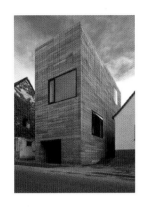

40
Ebeling House, Dortmund, DE
Archifactory.de, Dortmund, DE
www.archifactory.de
info@archifactory.de
Photos: Gernot Maul

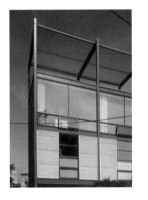

32
Tower House, Chicago, US
Frederick Phillips & Assoc., Chicago, US
www.frederickphillips.com
info@frederickphillips.com
Photos: William Kildow

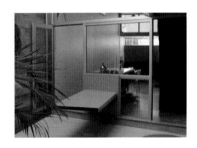

42
Slice House, Porto Allegre, BR
Procter-Rihl Architects, London, UK
www.procter-rihl.com
studio@procter-rihl.com
Photos: p. 6, p. 42-43 F. Rihl

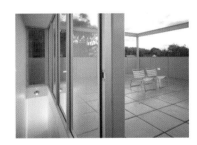

34
Dodds House, Sydney, AU
Engelen Moore, Sydney, AU
www.engelenmoore.com.au
architects@engelenmoore.com.au
Photos: Ross Honeysett

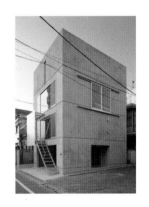

44
K-House, Tokyo, JP
Koh Kitayama architecture WORKSHOP, Tokyo, JP
www.archws.com
aws@archws.com
Photos: Daici Ano

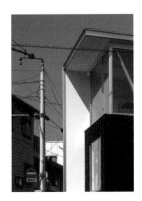

38
C-House Tokyo, JP
Kuno + Nomura + tele-design, Tokyo, JP
www.tele-design.net
tele-web@tele-design.net
Photos: Tatsuya Noaki

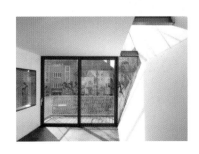

48
Kollross House, Linz, AT
x architekten Linz/Vienna AT
www.xarchitekten.com
xarchitekten@aon.at
Photos: Dietmar Tollerian

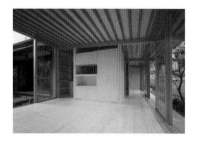

52
Thin Roof House, Kanagawa, JP
Tezuka Architects, Tokyo, JP
www.tezuka-arch.com
tez@sepia.ocn.ne.jp
Photos: Katsuhisa Kida

62
Weekend House, Hornstein, AT
STADTGUT Vienna, AT
www.stadtgut.com
office@stadtgut.com
Photos: p. 62-63 Michael Nagl
p. 63 Barbara Nagl

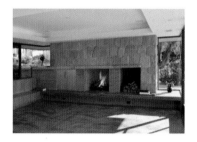

56
Guest House, Carpenteria, CA, US
Shubin + Donaldson, Culver City, CA, US
www.shubindonaldson.com
email@sandarc.com
Photos: Ciro Coelho

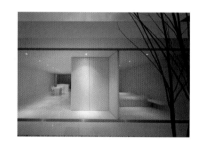

64
Abstract House, Tokyo, JP
Shinichi Ogawa & Associates, Hiroshima, JP
www1.odn.ne.jp/ogawa01
ogawa01@pop11.odn.ne.jp
Photos: Shinkenchiku-sha

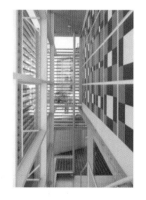

58
Vila Madalena House, São Paulo, BR
Nave Arquitetos Associados. São Paulo, BR
www.nave.arq.br
navearq@uol.com.br
Photos: Nelson Kon

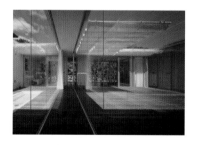

66
Machiya House, Tokyo, JP
Tezuka Architects, Tokyo, JP
www.tezuka-arch.com
tez@sepia.ocn.ne.jp
Photos: back cover, p. 66-67 Katsuhisa Kida

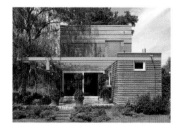

60
Lakeside House, Berlin, DE
Nägeli Architekten, Berlin, DE
www.naegeliarchitekten.de
buero@naegeliarchitekten.de
Photos: p. 60-61 Johannes Marburg,
p. 60 Walter Nägeli

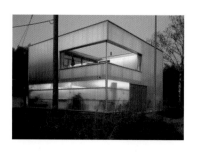

68
Boat House, Fussach, AT
Josef Fink Architekt, Bregenz, AT
josef.fink@fink-thumher.at
Photos: Ignacio Martinez

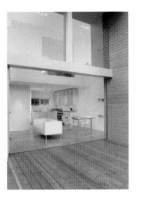

70
Westlake House, Oundle, UK
SpacelabUK, London, UK
www.spacelabuk.com
info@spacelabuk.com
Photos: Jefferson Smith

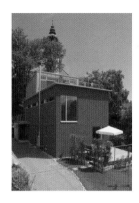

78
Entenbach House, Wals/Salzburg, AT
Simon Speigner Architekt, Thalgau/Salzburg, AT
www.sps-architekten.com
sps-architekten@aon.at
Photos: Foto Dorfstetten

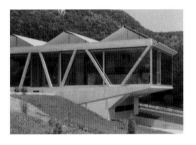

72
House in Büren, CH
Buchner Bründler Architekten, Basel, CH
www.bbarc.ch
mail@bbarc.ch
Photos: Ruedi Walti

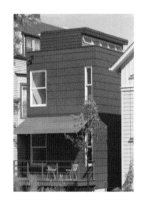

80
Factor 10 House, Chicago, IL, US
EHDD Architecture, Chicago IL, US
www.ehdd.com
m.italien@ehdd.com
Photos: Doug Snower

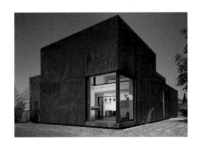

74
Atelier Gisinger-Fessler, Lauterach, AT
cp-architektur, Christian Prassler, Vienna AT
Philip Lutz Architektur, Lochau, AT
www. cp-architektur.con / www.philiplutz.at
atelier@cp-architektur.con / pl@philiplutz.at
Photos: Robert Fessler

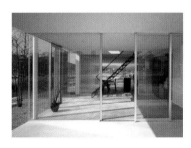

82
Misonou House, Hiroshima, JP
Suppose Design Office, Hiroshima, JP
www.suppose.jp
info@suppose.jp
Photos: Nacasa & Partners

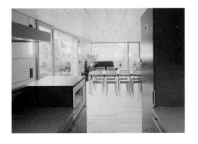

76
Moosmann/Hämmerle House, Lauterach, AT
Hermann Kaufmann, Schwarzach, AT
www.kaufmann.archbuero.com
office@archbuero.at
Photos: Ignacio Martinez

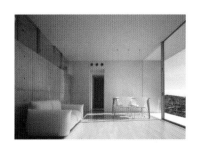

84
Y-House, Iwakuni, JP
Katsufumi Kubota, Hiroshima, JP
www.katsufumikubota.jp
webmaster@katsufumikubota.jp
Photos: N. Nakagawa

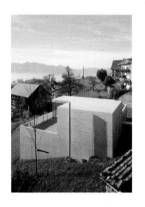

86
Marte House, Defins, AT
Marte.Marte Architekten, Weiler, AT
www.marte-marte.com
architekten@marte-marte.com
Photos: Ignacio Martinez

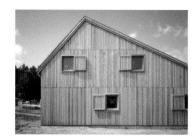

96
Steuerwald House, Rodenbach, DE
bayer | uhrig Architekten, Kaiserslautern, DE
www.bayer-uhrig.de
architekten@bayer-uhrig.de
Photos: Michael Heinrich

88
Kosnjak House, Lauterach, AT
Elmar Ludescher Architektur, Lauterach, AT
Elmar.ludescher@aon.at
Photos: Harald Gmeiner

98
Suzi-K House, Bezau, AT
O.L. Kaufmann Architekt, Dornbirn AT
www.olk.cc
office@olk.cc
Photos: Adolf Bereuter

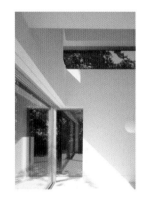

90
9x9 Haus, Augsburg, DE
Titus Bernhard Architekten, Augsburg, DE
www.titusbernhardarchitekten.com
info@titusbernhardarchitekten.com
Photos: p. 90-94, p. 176 Christian Richters

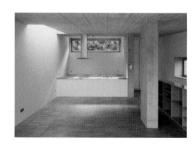

102
Hammerweg House, Winterthur, CH
Beat Rothen Architekt, Wintherthur, CH
www.rothen-architekt.ch
info@rothen-architekt.ch
Photos: Gaston Wicky

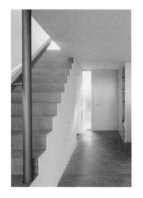

94
Weidner House, Ipsach, CH
mlzd architekten, Biel, CH
www.mlzd.ch
office@mlzd.ch
Photos: Jürg Zimmermann

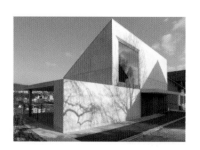

104
House at the Riverside, Windisch, CH
Liechti Graf Zumsteg Architekten, Brugg, CH
www.lgz.ch
liechti@lgz.ch
Photos: René Rötheli

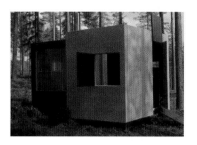

108
Summer Container, no fixed location, FI
Markku Hedman, Espoo, FI
Markku.Hedman@hut.fi
Photos: Markku Hedman

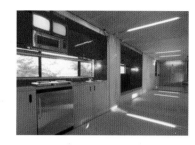

118
MDU, Mobile Dwelling Unit, no fixed location, US
LOT-EK, NY, US
www.lot-ek.com
info@lot-ek.com
Photos: p. 8, 119-120 LOT-EK

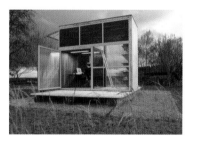

110
Zusatzraum, no fixed location, DE
exilhäuser architekten, Pfaffing, DE
www.exilhaeuser.de
x@exilhaeuser.de
Photos: p. 110 Thilo Härdlein,
p. 111 Simone Rosenberg

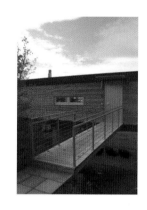

120
espace mobile, no fixed location, AT
Simon Speigner Architekt, Thalgau/Salzburg, AT
www.sps-architekten.com
sps-architekten@aon.at
Photos: Foto Dorfstetten

112
Future Shack, no fixed location, AU
Sean Godsell Architects, AU
www.seangodsell.com
godsell@netspace.net.au
Photos: Earl Carter

124
Taylor Pavillon, Edgerton, MO, US
el dorado inc
www.eldoradoarchitects.com
info@eldoradoarchitects.com
Photos: back cover, p. 124-125 Michael Sinclair

114
XBO House, Tromsø, NO
70°N architektur as, Tromsø, NO
www.70n.no / firmapost@70n.no
Photos: back cover, p. 114-116
Bent Raanes, Sarah Cameron Sørensen
p. 116-117 70°N architektur as

126
WeeHouse, Pepin, WI, US
Warner + Asmus, St. Paul, MI, US
www.warnerasmus.com
info@warnerasmus.com
Photos: Geoffroy Warner

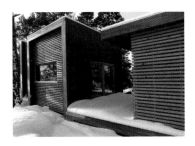
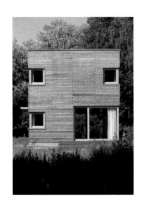
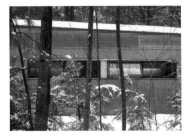
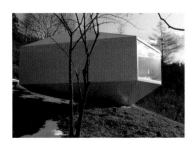
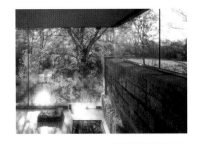
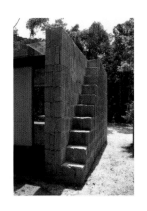
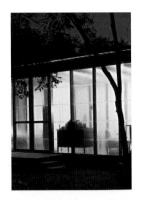
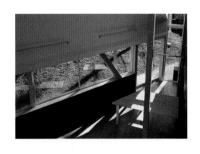

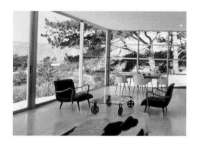

148
LV Home, Laguna Verde, CL
Rocio Romero, LLC, Perryville, MO, US
www.rocioromero.com
sales@rocioromero.com
Photos: Julio Pereira

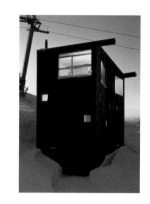

158
Mountain Cottage, Flumersberg, CH
EM2N Architekten, Zürich, CH
em2n@em2n.ch
www.em2n.ch
Photos: Hannes Henz

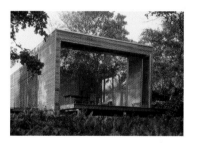

150
Summer House, Vejby, DN
Henning Larsens Tegnestue A/S, Copenhagen, DK
www.hlt.dk
hlt@hlt.dk
Photos: Jens Lindhe

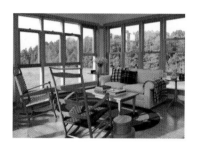

162
Kinderhook House, Kinderhook, New York, US
Dennis Wedlock Architect, LLC, NY, NY, US
www.denniswedlick.com
info@denniswedlick.com
Photos: Antoine Bootz

152
Juquehy Beach House, Sao Sebastio, BR
Puntoni Arquitetos, São Paulo, BR
www.puntoni.arq.br
alvaro@puntoni.arq.br
Photos: back cover, p. 152-53 Nelson Kon

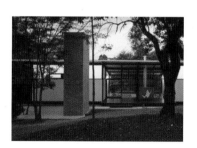

164
Carapicuíba House, Sao Paulo, BR
Una Arquitetos, Sao Paolo, BR
www.unaarquitetos.com.br
una@unaarquitetos.com.br
Photos: Nelson Kon

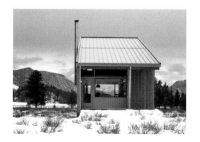

154
Methow Cabin, Winthrop, WA, US
Eggleston Farkas Architects, Seattle, WA, US
www.eggfarkarch.com
info@eggfarkarch.co
Photos: Jan Van Gundyl

166
Hybrid Muscle, Chang Mai, TH
R&Sie, Paris, FR
www.new-territories.com
rochedsvsie@wanadoo.fr
Photos: R&Sie

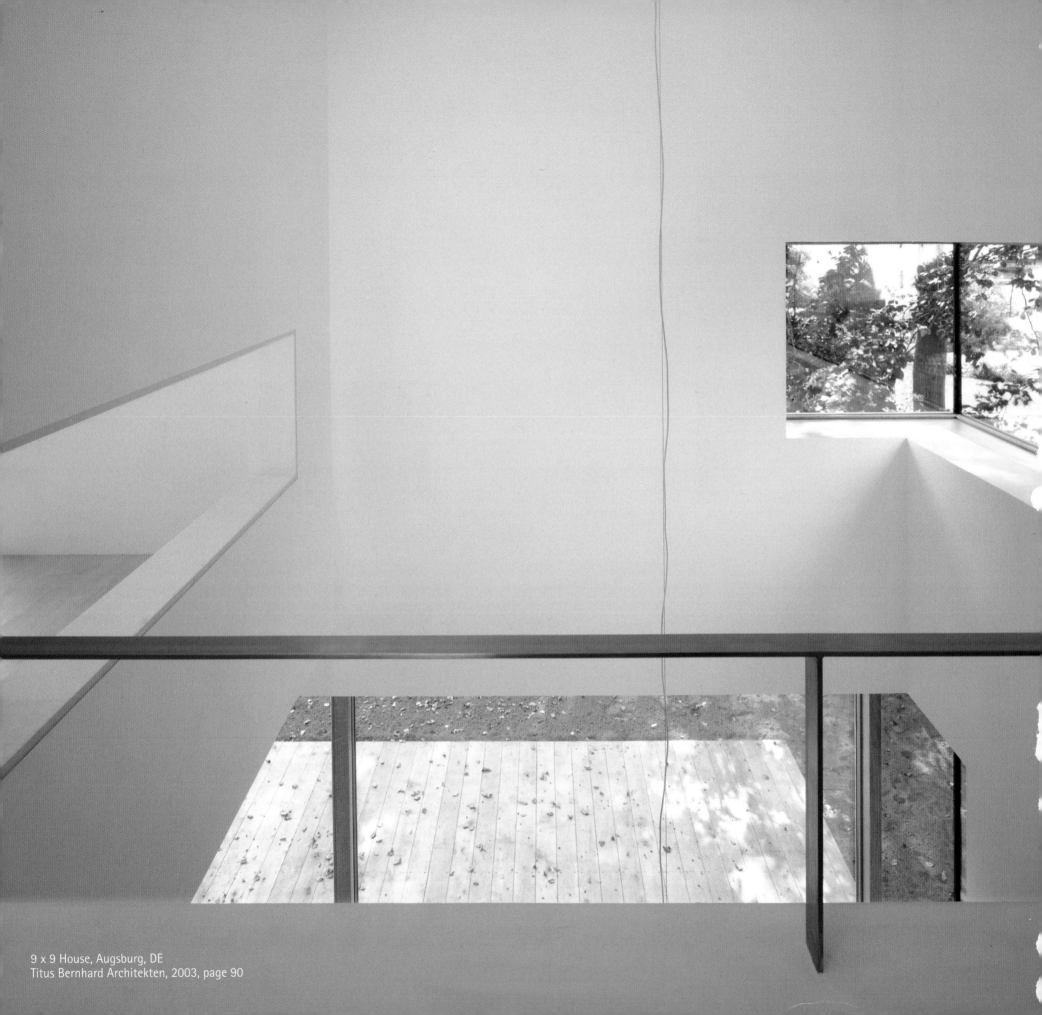

9 x 9 House, Augsburg, DE
Titus Bernhard Architekten, 2003, page 90